Langford's Starting Photography

The guide to creating great images

Sixth Edition

Michael Langford
Philip Andrews

ELSEVIER

AMSTERDAM • BOSTON • HEIDELBERG • LONDON • NEW YORK • OXFORD
PARIS • SAN DIEGO • SAN FRANCISCO • SINGAPORE • SYDNEY • TOKYO
Focal Press is an imprint of Elsevier

Focal
Press

Focal Press is an imprint of Elsevier
Linacre House, Jordan Hill, Oxford OX2 8DP, UK
30 Corporate Drive, Suite 400, Burlington, MA 01803, USA

First published 2009

Notice
No responsibility is assumed by the publisher for any injury and/or damage to persons or property as a matter of products liability, negligence or otherwise, or from any use or operation of any methods, products, instructions or ideas contained in the material herein

British Library Cataloguing in Publication Data
A catalogue record for this book is available from the British Library

Library of Congress Cataloging-in-Publication Data
A catalog record for this book is available from the Library of Congress

ISBN: 978-0-2405-2110-7

For information on all Focal Press publications
visit our website at www.focalpress.com

Printed and bound in Slovenia

09 10 11 12 12 11 10 9 8 7 6 5 4 3 2 1

Working together to grow
libraries in developing countries

www.elsevier.com | www.bookaid.org | www.sabre.org

ELSEVIER BOOK AID International Sabre Foundation

Contents

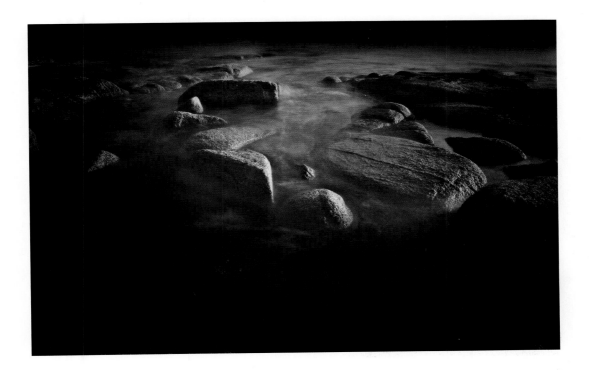

Introduction

Langford's Starting Photography is a hands-on book for those photographers just starting their love affair with photography. It equally suits shooters with entry and mid-priced level film and digital cameras, students at school or college using photography as part of art courses as well as those involved in other formal studies, such as the City & Guilds Certificate in Photography. The skills and knowledge presented in the book show you how to take and make great photographs using a highly visual step-by-step approach. Langford's Starting Photography gently guides new photographers from tentative beginnings through wobbly first steps to a level where they can confidently create their own great pictures. The photographic examples scattered throughout the text are chosen to encourage and challenge the reader, as they are all within the technical capabilities of beginners with modest gear, such as compact or single lens reflex (SLR) cameras (preferably with manual controls), and the knowledge and skill provided within.

Taking photographs is enjoyable and challenging in all sorts of ways. After all, it's a method of creating pictures which does not demand that you have drawing skills. It's a powerful means of storing memories, showing situations or expressing views which does not insist that you be good at words. But don't fall into the trap of thinking you must have the latest, expensive 'gee whiz' camera to get the most telling shots. What photography demands of you are skills of a different sort that are independent of the technology used to capture the picture. Of these, the

most important is the ability to observe – sharpen up your 'seeing' of surroundings, people and simple everyday objects in the world around you. Avoid taking these things for granted just because they are familiar. Develop your awareness of the way lighting and viewpoint can transform appearances, and be quick thinking enough to capture an expression or sum up a fast-changing situation by selecting the right moment to shoot. Become skilled in these areas and you will be a good photographer.

Don't get the wrong idea. I'm not saying that technical abilities and the latest digital equipment do not contribute to the making of great pictures – they do. It is just that you should keep in the forefront of your mind that the techniques and ideas presented in this text serve only one purpose. That is, to support the creation of images that you see with your eye first and capture with your camera second. This seems a funny way to start a book that, let's face it, is about learning the techniques of photography, but seeing is the foundation skill upon which all good photography is built and so I think that it is essential to remind you of its importance right from the start.

Although not primarily a school text, *Langford's Starting Photography* covers most of the core content and practical work for National Curriculum studies. It is also intended for City & Guilds 'Starting Photography', 'Introduction to Black and White Photography', 'Introduction to Color Photography' and Part 2 modules such as 'Landscape Photography'. Above all, the book is planned to help every beginner expand their photography and increase their enjoyment of picture making with today's cameras.

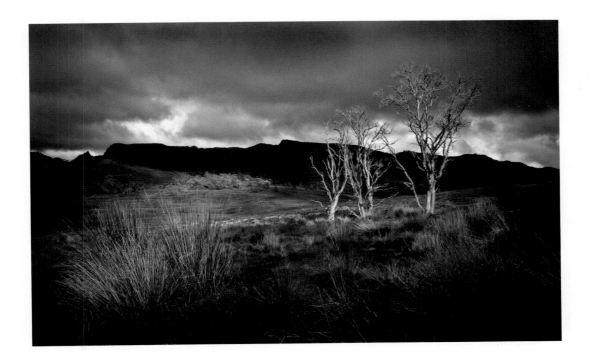

About the authors

Michael Langford was a major influence on British photographic education. He was a fellow and Course Director in Photography at the Royal College of Art and was renowned for producing a string of 24 books, translated into many languages, which have remained the standard reference works for students and professionals alike across the world.

Michael started his career at the age of 16, as a photographer's apprentice, was later assigned to the RAF Photographic Section, worked with a press photography firm and as an industrial photographer. Michael continued as a professional photographer throughout his life and his work has appeared in a range of mediums, from postage stamps and book covers to TV commercials.

Michael went on to teach full-time at Ealing Technical College (now Thames Valley University), whilst teaching evening classes at the London College of Printing, after which he moved to become Head of the School of Photography at Birmingham College for Art and Design. He served as an external assessor for several BA courses, as well as an adviser to national examination boards for photography at school and college levels. He moved to the RCA in 1967, became a senior tutor in 1973, departmental head 12 years later and from 1994 to 1997 he suitably held the position as course director.

As a result of his intimate involvement with photography courses and examination syllabuses at all levels he fully understood what a student needed from a textbook. One of his

most successful books, *Basic Photography*, was first published in 1965 and is now in its eighth edition after a complete revision. Other works include *Advanced Photography, The Darkroom Handbook, Langford's Starting Photography* and the *Story of Photography*.

As a writer, teacher and practitioner Michael Langford was a legend in the world of British photography. Along with Michael's other titles, this sixth edition of *Langford's Starting Photography* will ensure that he lives on through his work, providing guidance to everyone who shares his great passion for photography and wants to develop and learn more.

Michael Langford, photographer, teacher and writer
28 February 1933–28 April 2000

Philip Andrews is a photographic professional who is consumed by two great passions – making great images and showing others how to do the same.

He is an international best selling imaging author and currently has over 30 titles to his name. In addition several of his titles have been translated into Japanese, Spanish, German, French, Polish and Portuguese. His books include *Raw Workflow from Capture to Archives, Advanced Photoshop Elements for Digital Photographers, Photoshop: Essential Skills, Adobe Photoshop Elements – A visual introduction to digital photography, Photoshop Elements A–Z* and *Adobe Photoshop A–Z*.

He is also the author of over 4000 articles in more than 15 magazine titles over five countries. He is currently the co-editor of *Better Photoshop Techniques* (Aust.), contributing editor for *What Digital Camera* (UK) and contributes regularly to *ShutterBug* (USA) and *Better Photography* (Aust.).

He is an Alpha/Beta tester for Adobe digital photography products and acts as an Adobe Ambassador for Australia and New Zealand. He is an accomplished teacher/demonstrator who, over the last 23 years, has lectured in photography, digital imaging and multimedia at trade shows, schools, colleges, universities and online in the UK, USA and Australia.

1 Picture Making

This first section of the book is mainly concerned with developing your skills of observation – and how to select the interesting and unusual from what you see around you. It is concerned with picture-composing devices such as: framing up your shot in the camera viewfinder or LCD monitor; choice of viewpoint and moment to shoot; and picking appropriate lighting. It also discusses how to recognize pattern, line, color and tone in the subject you intend to photograph, and how to use such features to good effect. These are visual rather than technical aspects of photography and most stem from drawing and painting. They apply no matter what camera you own – cheap or expensive, digital or film, auto-everything or covered in dials and controls.

Seeing and photographing

All the world's cameras, sensors, desktop printers, scanners, films, enlargers and other photographic paraphernalia are no more than tools for making pictures. They may be very sophisticated technically, but they cannot see or think for themselves. Of course, it's quite enjoyable playing around with the machinery and testing it out, but this is like polishing up your bicycle and only ever riding it around the block to see how well it goes. Bicycles enable you to get out and explore the world; cameras challenge you to make successful pictures out of what you see around you, in perceptive and interesting ways.

Anyone who starts photography seriously quickly discovers how it develops their ability to see. In other words, not just taking familiar scenes for granted but noticing with much greater intensity all the visual elements – shapes, textures, colors and human situations – they contain. This is an exciting and rewarding activity in itself. The second challenge is how to put that mindless machine (the camera) in the right place at the right time, to make a really effective photographic image out of any of these subjects. Seeing and organizing your picture making is just as important as technical 'know-how' and it comes with practice.

To begin with, it is helpful to consider the ways seeing differs from photographing. You don't necessarily have to regard differences as a barrier. The point is that by understanding how the scene in front of you will appear on a final print you will start to 'pre-visualize' your results. This makes it much easier to work through your camera.

Pictures have edges

Our eyes look out on the world without being conscious of any 'frame' hemming in what we see. Stop a moment and check – your nose, eyebrows, glasses (if you wear them) do form a sort of frame, but this is so out of focus and vague that you are not really aware of any definite 'edge' to your vision. However, immediately when you look through a camera viewfinder the world is cut down into a small rectangle with sharply defined edges and corners. Instead of freely scanning your surroundings, you have to compose their essence within this artificial boundary.

Original scene

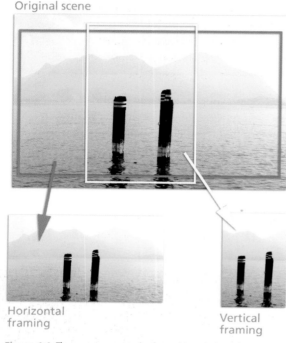

Horizontal framing

Vertical framing

Figure 1.1 The same scene can be framed in a variety of ways, producing photographs that emphasize different parts of the picture. Try turning your camera from the horizontal to the vertical to produce a different point of view.

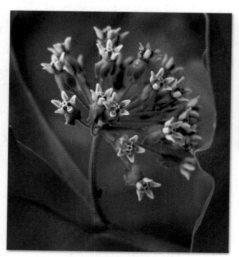

Small zone of focus used to add emphasis

Figure 1.2 Because the camera is not as selective as the human eye, photographers use a range of techniques to add emphasis to their pictures and to direct the attention of the viewer. Here a small zone of focus (commonly called minimum depth of field) is used to emphasize the flowers and de-emphasize the surrounding leaves.

The hard edges and their height-to-width proportions have a strong effect on a photograph. Look how the same scene in Figure 1.1 is changed by using a different shooting format. Long, low pictures tend to emphasize the flow of horizontal lines and space left to right. Turning the camera to form an upright picture of the same scene tends to make more of its depth and distance, as the scale between foreground and furthest detail is greater and more interactive.

Framing up pictures is a powerful way to include or exclude – for example, deciding whether the horizon in a landscape should appear high or low, or how much of an expanse of color to leave in or crop out. The edge of the frame can crop into the outline of something and effectively present it as a new shape too. Remember, though, that nothing you leave outside the viewfinder can be added later!

The camera does not select

When we look at something we have an extraordinary ability to concentrate on the main item of interest, despite cluttered surroundings. Our natural 'homing device' includes turning the head, focusing the eyes and generally disregarding any part of the scene considered unimportant. Talking to a friend outside their house, you hardly register details of the building behind, but the camera has no brain to tell it what is important and unimportant. It cannot discriminate and usually records too much – the unwanted detail along with the wanted. This becomes all too apparent when you study the resulting photograph. Drainpipes and brickwork in the background may appear just as strongly as your friend's face . . . and how did that dustbin appear in the foreground?

You therefore have to help the camera along, perhaps by changing your viewpoint or filling up the frame (if your camera will focus close enough). Perhaps you should wait for a change in lighting to pick out your main item from the rest by making it the brightest or the most contrasting color in the picture. Or you might control your zone of sharpness (a device called depth of field or DOF, discussed further on page 66) in order to limit clear detail to one chosen spot, as is the case in Figure 1.2. Other forms of emphasis are discussed on page 9.

You have to train your eyes to search the scene for distractions. When looking through the viewfinder, check the background, midground and foreground detail. Above all, always make a quick scan of everything in the viewfinder before pressing the button.

Sensors and films cannot cope with the same contrast as the eye

Our eyes are so sophisticated that we can make out details both in the dark shadows and brightly lit parts of a scene (provided they are not right next to each other). This is an ability that is beyond the capabilities of a camera sensor. Photography generally makes darkest areas record darker and lightest areas lighter than they appeared to the eye, so that the whole image becomes more contrasty. It is important to remember that your eyes will always see the contrast of a scene differently to how the camera will record it. With practice this will mean that you can anticipate the differences and therefore be able to predict more accurately how your pictures will turn out (see Figure 1.3).

Figure 1.3 The high contrast contained in this backlit scene is too great for the camera to record clear detail in both the highlight and shadow areas. Instead, the result is a silhouette.

The camera has one 'eye'

Unlike humans, the cameras we use do not have binocular vision. Their pictures are not three-dimensional. They do not photograph from two points of view. So when we want to show depth in a scene we are photographing we have to imply it through devices such as the use of converging lines (see Figure 1.4), changes in scale or changes in tones aided by lighting. To help you see more like the camera does, close one eye to forecast the camera's two-dimensional way of imaging.

Figure 1.4 Because the camera only provides a 'single-eye' view of the world, photographers have to rely on devices like converging lines to portray distance and depth in their pictures.

Converging lines showing depth

Most photographs capture just one moment in time

When things are active in front of the camera your choice of when to take the picture often 'sets' someone's momentary expression or the brief juxtaposition of one person to another or their surroundings. Capturing the peak of the action often produces photographs that are frozen moments of time (see Figure 1.5). There is often a decisive moment for pressing the button that best sums up a situation or simply gives a good design. You need to be alert and able to make quick decisions if you are going for this type of picture. Once again, the camera cannot think for you.

Figure 1.5 The camera has the ability to capture a moment in time and then preserve it frozen forever.

Color translated into monochrome

When you are shooting or printing out results in black and white ('monochrome'), the multicolored world becomes simplified into different shades or tones of gray. A scarlet racing car against green bushes may reproduce as two grays that very nearly match. Try not to shoot monochrome pictures that rely a great deal on contrast of colors unless this will also reproduce as contrasty tones. Look at colors as 'darks' and 'lights'. Remember too that an unimportant part of your subject visually much too strong and assertive (such as an orange door in a street scene) can probably be ignored because it will merge with its surroundings in black and white (see Figure 1.6).

Occasionally, when shooting in black and white you might want to adjust the way colors translate into monochrome. Historically this was done by placing a colored filter over the camera lens (page 242) and shooting onto Black and White film. Now digital photographers tend to always capture in color (even if the camera has a Black and White mode) and then convert the photo to grays using editing software such as Photoshop or Photoshop Elements. With this approach, 'shoot color and then convert to gray', they always maintain the possibilities of both color and black and white outcomes. Another advantage is that software-based conversion provides the opportunity to alter how specific colors are mapped to gray which in turn allows the photographer to translate color contrast to monochrome contrast during the conversion process.

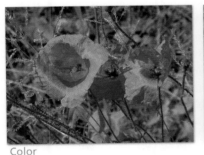
Color

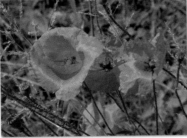
Grayscale

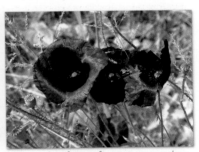
Grayscale after software conversion

Figure 1.6 Contrasting colors can become similar shades of gray when they are recorded in monochrome. If you are shooting black and white, you will need to train yourself to see your subject in terms of light and dark rather than color. Alternatively you can add separation between similar gray tones using the software conversion options in Photoshop and Photoshop Elements.

Using the viewfinder – framing up

Experienced photographers often make a rough 'frame' shape with their hands to exclude surroundings when first looking and deciding how a scene will photograph (see Figure 1.7). Similarly, you can carry a slide mount, or a cardboard cut-out, to look through and practice ways of framing up your subject. When you come to buying a camera, it is most important to choose one which has a viewfinding system you find clear and 'comfortable' to use, especially if you wear glasses. After all, the viewfinder is a kind of magic drawing pad on which the world moves about as you point the camera – including or cropping out something here; causing an item to appear in front of, or alongside, another item there. Digital cameras have the added advantage of often allowing you to frame your pictures on the camera's inbuilt LCD screen as well as through the viewfinder.

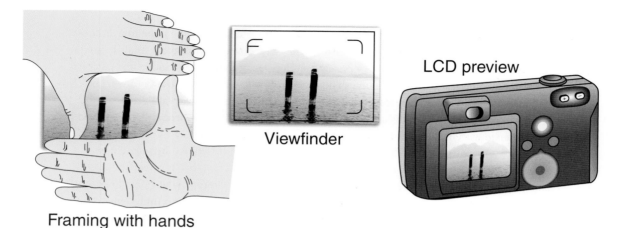

Framing with hands Viewfinder LCD preview

Figure 1.7 You can practice framing a scene in several ways – using your hands, the viewfinder in the camera or the LCD screen on the back of your digital camera.

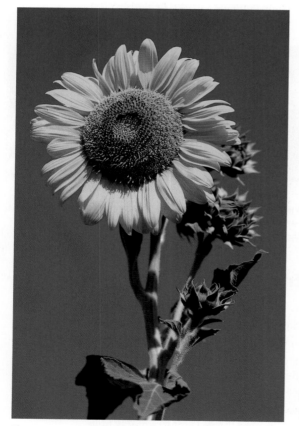

Figure 1.9 Accurate framing is essential when you are filling the frame with subjects close to the camera.

Precise and accurate viewfinder work is needed to position strong shapes close to the camera, as in Figure 1.8, to symmetrically fill up the frame. Or alternatively you might frame up your main subject off center, perhaps to relate it to another element or just to add a sense of space. With practice you will start to notice how moving the camera viewpoint a few feet left or right, or raising or lowering it, can make a big difference to the way near and distant elements in, say, a landscape appear to relate to one another. This is even more critical when you are shooting close-ups, where tiny alterations of a few centimeters often make huge changes to the picture.

The way you frame up something which is on the move across your picture also has interesting effects. You can make it seem to be entering or leaving a scene by positioning it facing either close towards or away from one side of your picture. A camera with a large, easy-to-use viewfinder will encourage you to creatively explore all these aspects of viewpoint and framing before every shot, instead of just crudely acting as an aiming device 'to get it all in'. The LCD monitor on the back of digital cameras can also be used for accurate framing. The facility to compose the image on the LCD screen is available for most compact digital cameras and is also starting to appear in digital SLR models and is often referred to as Live View.

Using foregrounds and backgrounds

Foreground and background details cause problems when you are a beginner, for in the heat of the moment they are easily overlooked – especially when you are concentrating on an animated subject. And yet far from being distracting, what lies in front of or behind your main subject can often be used to make a positive contribution to your picture.

Sometimes, for example, you are forced to shoot from somewhere so distant that even with the lens zoomed to its longest setting your key element occupies only a tiny area in the frame. It then pays to seek out a viewpoint where other, much closer, items will fill in the foreground and help to create a 'frame within a frame'. They may even make the small size of the main element an asset that adds a sense of depth and distance. With landscape subject matter you can often use nearby foliage, rock or other appropriate elements to frame a distant subject.

Even simply photographing from a low viewpoint so that the background shows only sky and very distant detail (Figure 1.10) often eliminates unwanted assertive material in the foreground. Equally, by picking a high viewpoint you can fill up your background with grass or similar plain ground – or you may find an angle from which the background is seen shrouded in shadow. On the other hand, always try to make use of background details when these will add interesting information to a shot. This is also a way of making some visual comment through comparisons between like objects, perhaps parodying one element against another – for example, people passing by giant figures on a billboard. Statues and monuments also offer good opportunities.

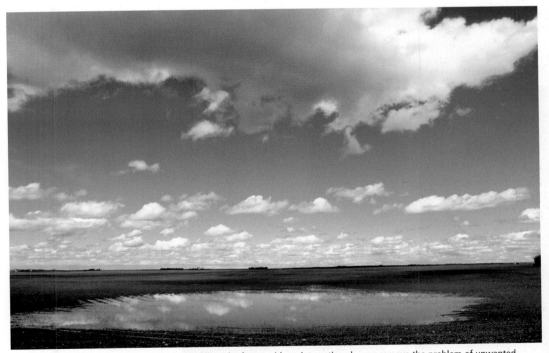

Figure 1.10 Tilting the camera upwards and filling the frame with an interesting sky can remove the problem of unwanted details in the foreground.

When framing, always try to fill up the picture area, but don't let your camera's fixed height-to-width picture proportions restrict you (2:3 ratio is standard for 35 mm film cameras). Some subjects will look better framed up in square format; others need a more extreme oblong shape. You may be able to get around this by again using a 'frames within frames' arrangement. You can also trim the picture after it has been taken. You can preview how a crop will look by hiding unwanted details or changing the picture's shape by using L-shaped cards for prints, or the Crop tool for digital files (see Figures 1.11 and 1.12). Once you have seen how crop would look using L-shapes, trim print or mount behind a card 'window mount'

Some digital cameras provide the ability to select several different formats for your photographs. The options are selected either via a control on the camera body (see Figure 1.13) or with a menu setting. Changing the format displays crop guides in the viewfinder. Using these format controls you can match the pictures you shoot with their intended outcome - 4:3 for prints and 16:9 for images to be displayed on widescreen televisions.

Figure 1.11 Don't think that the shape of your pictures is restricted to the format of the film that you are using. At the print stage you can crop out unwanted details or even change the format of the picture.

Figure 1.12 For digital shooters the task of cropping their pictures is even easier, with most image editing software containing specific Crop tools that can be used to interactively trim your images.

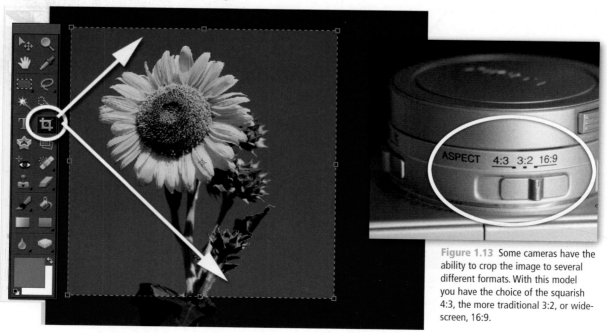

Figure 1.13 Some cameras have the ability to crop the image to several different formats. With this model you have the choice of the squarish 4:3, the more traditional 3:2, or widescreen, 16:9.

Creating a point of emphasis

Most photographs are strengthened and simplified by having one main subject or 'center of interest'. In a picture of a crowd, for example, this might be one figure waving a flag; a landscape might center on a cottage or a group of trees. Having first decided your main element, you can help to bring it into prominence and at the same time improve the structure of your shot by calling on a range of long-established visual devices used in picture composition.

In some situations you will be able to create emphasis through making the chosen item stand out relative to its surroundings because it appears to break the horizon, or perhaps is placed where lines within your picture converge. You can also give it prominence through its contrasting color or tone, or by the way the subject is shown within some eye-catching shape either in front or behind it. To achieve these results, it is once again important to learn to seek out the right camera viewpoint and compose your pictures in the viewfinder with thought and care.

Using lines

Lines are formed in a picture wherever lengthy, distinct boundaries occur between tones or colors. A line need not be the actual outline of an object but it could be a whole chain of shapes – clouds, roads and hedges, shadows, movement, blur – which together form a strong linear element through a picture. Clear-cut lines steeply radiating from, or converging to, a particular spot (as in Figure 1.14, for instance) achieve the most dramatic lead-in effects. At the same time, their shape (curved, straight) and general pattern (short and jagged, long and parallel) can strongly influence the mood of your shot too.

Figure 1.14 Radiating lines draw the viewer's attention towards a single focal point in the picture.

You can best control the appearance of lines in your picture by where you position the camera – high, low, near, far, square-on or oblique to them. As you try each of these different viewpoints, observe carefully in the viewfinder how objects overlap or appear to join up with others in front or behind them to create useful shapes and lines. Then change focal length (zoom in or out, page 81) if necessary to frame up exactly the area you need.

Positioning within the picture format

Most beginners position the main subject they want to emphasize centrally in the picture. This may work well for a strictly symmetrical composition with a child's face centered in the middle of whirling concentric circles, but it easily becomes repetitive and boring. There is, however, a viewer-researched classical guide to placing the principal element called the 'golden mean',

which artists have favored in composition over the centuries. The concept is that the strongest, most 'pleasing' position for points of interest is at one of the intersection lines dividing vertical and horizontal zones in an 8:5 ratio. A simple interpretation of this idea is often called the 'rule of thirds'. Figure 1.15 shows the four so-called 'strong' positions this gives within a 35 mm camera's picture format ratio. Many cameras have a viewfinder that displays these grid points to help aid with composing your pictures.

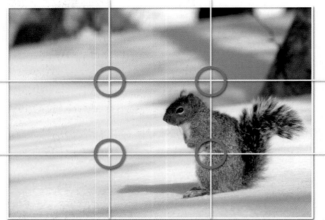

Point of focus positioned using the Golden Mean

Figure 1.15 You can add a sense of balance to an off-center composition by using the rule of thirds as a guide. Simply place the points of interest from your picture at the intersection of the grid lines.

The golden mean is an interesting guide in photography but, as with other forms of picture making, it is something that should never be slavishly adopted. Lines and tones elsewhere in pictures all contribute to photographs with unified balance and strong structure. Pictures with their main element placed very off-center against plain surroundings tend to look unstable, but they can be lively and have a spacious, open-air feel. Off-centering can work very well where another secondary element (typically on the opposite side of the frame) relates to it and gives your picture balance (see Figure 1.16).

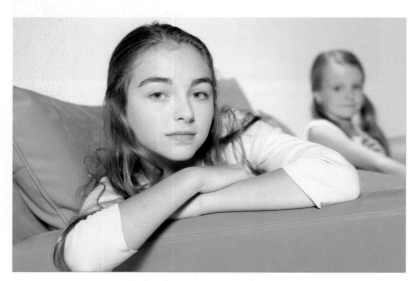

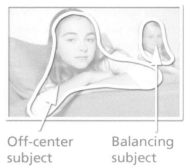

Off-center subject Balancing subject

Figure 1.16 Balance an off-center subject by positioning another object in the opposite part of the frame.

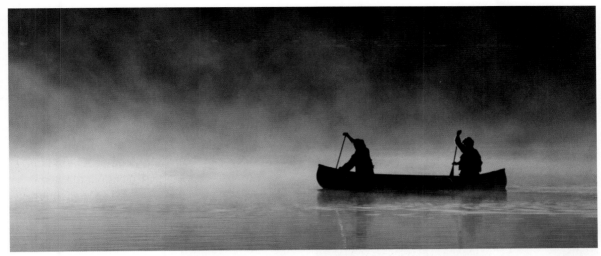

Figure 1.17 By backlighting your main subjects, it is easy to create silhouette effects. In this type of image the shape of the subjects is paramount, as texture and color are kept to a minimum.

Contrasting with surroundings

Making your main element the lightest or darkest tone, or the only item of a particular color included in the picture, will pick it out strongly. This is also a good way to emphasize an interesting shape and help set mood. For maximum emphasis pick a camera position that shows your chosen item against, or surrounded by, the most contrasting background. Bear in mind that the eye is most attracted to where strong darks and lights are adjacent, so make sure the emphasis really is where you want it to be. Often, you can use the fact that the background has much less, or more, lighting than your main subject and then expose correctly for what is the important part. Make sure your camera's exposure settings are not over-influenced by the darker or brighter areas around it (digital shooters can take a test photograph and then use camera's exposure compensation feature to add or subtract exposure to suit).

Remembering how photographs step up the appearance of contrast in a scene, preview roughly how it will record by half-closing your eyes and looking through your eyelashes. Shadows now look much darker and contain less detail. In a really high-contrast situation – like Figure 1.17 – you can expect a silhouette effect when exposure is correct for most of the surrounding scene. Having dark figures against the lightest part of the environment gives their shapes great emphasis.

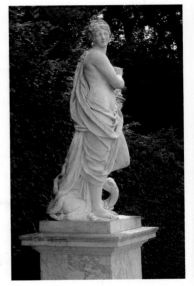

Figure 1.18 Tonal interchange: using existing contrast of tone.

The same device, known as tonal interchange, is used in the statue picture (Figure 1.18). Here, however, lighting is soft and even, and plays a minor role. Tonal differences between objects in the picture (the statue being the only white item amongst almost uniformly dark foliage) create their own tonal interchange. Contrast of tone is an especially important emphasizing device when you are shooting something in black and white.

Figure 1.19 Tonal interchange: manipulating light sources to create contrast of tone.

Tonal interchange is a device worth remembering when you are taking a portrait, where you have some control over arrangement of the lighting. Showing the lightest side of a face against the darkest part of the background and vice versa, as in Figure 1.19, picks out the shape of the head. Often, this lighting is achievable by just part closing a curtain or having someone shade the background with a card from one side.

Don't forget the value of seeking out a handy frame within a frame as the means of isolating your main subject by color or tone from otherwise confusing surroundings. Windows and doors are particularly useful – a figure photographed outside a building can be isolated by picking a viewpoint from where they appear framed in front of the dark shape of an open entrance behind them (preferably some way back, and out of focus). Similarly, a closed door may give a patch of colored background. Take care, however – this local surround should never contain color or patterning in such a strong manner that it overwhelms or camouflages your main subject.

Choice of moment

Of course, if you are photographing someone you know, or a largely 'still life' subject or landscape, you often have sufficient time to pick some means of emphasis, such as the use of line, or tone, or positioning in the frame. But in a fast-changing, active situation, often the best you can do is choose the most promising viewpoint and wait for the right moment. Sometimes this will mean first framing up a background shape or foreground lead-in, and then waiting patiently for someone to enter the picture space. On the other hand, your picture may be full of people surrounding some relatively static element. Having framed up the scene, the moment to shoot is dependent on the the various subjects in the picture. You will need to wait until the expressions and positions of your subjects are just right before releasing the shutter.

Always be on the lookout for fleeting comparisons which support and draw attention to one element – your main subject. Perhaps you can do this by showing two different 'compartments' in your picture. For example, comparing people framed in adjacent windows of a crowded bus or row of telephone booths. A mirror on the wall or some other reflective surface is another useful way of bringing two quite separate components together into your picture.

Picking lighting conditions

Most photographs (especially when you begin) are taken under 'existing light' conditions. This term means natural or artificial lighting as it exists for your subject at the time, rather than flash or lamps in the studio, which are used to provide a fully controlled lighting set-up (see the appendix pages at the rear of the book). It's easy to regard the lighting by which you see the world around you simply as illumination – something taken for granted. But as well as giving the eye the basic ability to see, it can be responsible for communicating strong emotional, subjective responses too. In fact, the effect of lighting on a subject is often the reason for taking a picture as much as the subject itself.

We have all experienced the way the appearance of something is transformed under different weather conditions or at different times of the day, due to changes in the direction, color, quality (e.g. overcast or direct sunlight) and contrast-producing effect of the light. You may not be able to exert control over these existing light conditions, but excellent pictures often result from you recognizing the right time and best camera position, choices which greatly influence the whole mood of a picture.

Figure 1.20 The strong, contrasty light from the sun creates sharp-edged shadows in your pictures. The shadows' dark tone and graphic shape mean that they play an important part in the balance and design of the photograph.

Quality and direction

The quality of the light falling on your subjects is often defined with terms such as 'hard' or 'soft'. Hardest natural light comes direct from the sun in a clear sky; objects then cast well-defined, hard-edged shadow shapes and these may contribute strong lines and patterns to a picture, as well as stark, dramatic contrast. Figure 1.20 is an example where well-defined shadow shapes on a sunny day become a key part of the picture.

In Figure 1.21, sunlight from one side, 90° to the subject, gives a strongly three-dimensional effect. Lit parts are well defined, forming a strong pattern especially where picked

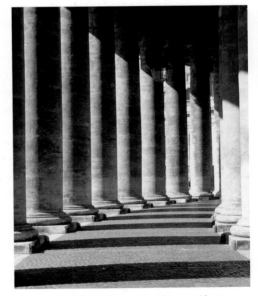

Figure 1.21 Side lighting creates pictures with strong, well-defined shapes and striking texture. Here the shadow area of one column is contrasted against the highlight area of the next, producing a pattern of alternating shades.

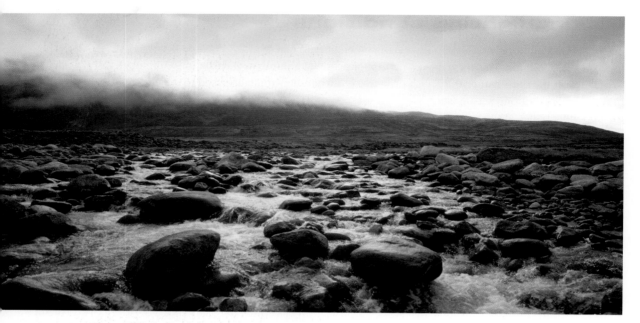

Figure 1.22 The hazy lighting produced by the low cloud has provided a soft and even, but still directional, light to the whole of this scene. Highlights and shadows are clearly present on the rocks in the foreground, but they are not as strong and distinct as they would be if the same location was photographed in midday sun.

out against an area of solid dark shadow areas. In addition to defining shape well, side lighting also creates strong texture. However, you must be careful when photographing very contrasty pictures like this. It is important to expose accurately because even a slight error either 'burns out' the lightest detail or turns wanted shadow detail impenetrably dark. Beware too of shadows being cast by one subject onto another, as this may give confusing results.

Softest quality light comes from a totally overcast sky. Shadows are ill-defined or more often non-existent, so that lines and shapes in your picture are created by the forms of the subject itself. Pictures that are full of varied shapes and colors are best shot in soft, even lighting to reveal maximum overall information without complications of shadow. Even on a clear, sunlit day you can still find soft lighting by positioning your subject totally in shadow – for instance, in the shade of a large building, where it only receives light scattered from sky alone. Results in color may show a blue cast, however, unless carefully corrected via editing software or when printing.

In Figure 1.22 you will notice how hazy sunlight gives an intermediate, semi-diffused lighting effect to the scene. Shadows are discernible but have ill-defined, well-graduated edges and there is less contrast than given by sunlight direct. Intermediate lighting conditions like this are excellent for many photographic subjects, and are especially 'kind' to portraits.

Time of day

Throughout the day, the sun moves its position around the sky; the color of its light reaching us also changes at dawn and dusk. Combined with the effects of weather and other atmospheric conditions like haze or smoke, you have a tremendously wide range of lighting opportunities.

If possible, forward plan to ensure that you are in the right place at a time when a fixed subject such as a landscape receives lighting that brings out the features and creates the mood you want to show.

Photography at dusk is often very rewarding because, as the daylight fades, the scene's appearance changes minute by minute. It is good to shoot landscape pictures during the brief period when there is enough daylight in the sky to still just make out the horizon, yet most of the buildings have switched on their lighting – not difficult to judge by eye. A firmly mounted camera with automatic exposure measurement can adjust settings as daylight dims (see Figure 1.23).

Mixed lighting

Pictures lit with, or containing, a mixture of light sources – daylight, domestic or tungsten lamps, fluorescent tubes, street lighting, etc. – will not photograph all the same color. Most color films are designed to be accurate in daylight. Many digital cameras have an auto white balance setting that automatically adjusts the capture to suit the light source. Alternatively, some models allow the user to change the setting to suit specific light sources such as daylight, domestic lamps and fluorescent tubes. When your digital camera is set to the daylight white balance setting, it will create pictures with similar color to those captured on daylight balanced film.

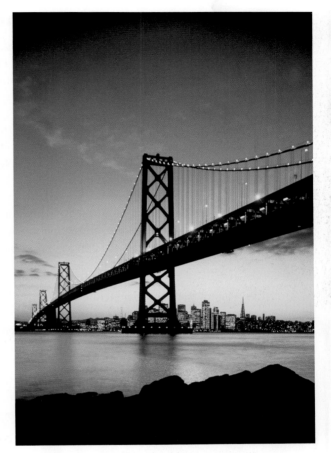

Figure 1.23 Often, the difference between taking an okay picture and one that really suits the subject is the time of day that the photograph is captured. City night scenes are often taken just on dusk when the landscape is lit by both the city lights and the remaining daylight.

Looking at a distant scene with mixed lighting you notice and accept differences of color, even though they are exaggerated when photographed. But it would be a mistake to shoot a portrait lit by the pink light of dusk, or by the floodlighting on the foreground terrace. Skin rendered pink by one and yellow by the other looks odd in isolation, and is probably beyond the ability of your processing lab to normalize in printing. Keep to using a lighting source that your film or camera 'white balance' setting is suited for.

Problems can also occur when photographing people, food, flowers and similar 'color-sensitive' subjects in surroundings with strongly tinted daylight. The greenery of sunlit grass and foliage in an enclosed garden or woods may do this, or it may be a nearby strongly colored wall or vehicle – particularly with subject close-ups. Oddly enough, wrong color becomes much more acceptable if your picture actually shows the environment which was its cause.

Pattern, texture and shape

Most photographs are 'subject orientated', meaning that who, or what, is featured in the shot is of the greatest interest. Others are more 'structure orientated' – enjoyed not necessarily so much for the subject as for the way the picture has been seen and constructed. In practice, both aspects should be present if you want a unified picture rather than a random snap.

The pattern and shapes used in photographs are like notes and phrases used to structure music. But in visual image form they are linked with texture too – each one of the three often contributing to the others. Pattern, for example, may be formed by the position of multiple three-dimensional shapes, like the house fronts in Figure 1.24. Or it might be no more than marks of differing tones on an otherwise smooth, flat surface. Then again, pattern can be revealed on an even-toned textured surface through the effect of light – as with the weatherboard on an old barn. Pattern, texture and shape should be sought out and used as basic elements of composition, provided they support and strengthen rather than confuse your picture.

Pattern

Be wary of filling up your picture with pattern alone – the result is usually monotonous like wallpaper, and without any core or center of interest. You can help matters by breaking the pattern in some way, perhaps having one or two elements a different shape or color. Another way to create variety in a regular pattern is to photograph it from a steeply oblique viewpoint, in order to get a difference in size.

Shadows frequently form interesting patterns, especially when the surface receiving the shadow is undulating rather than flat. You can see this, for instance, when the shadow of a window frame falls on pleated white curtaining.

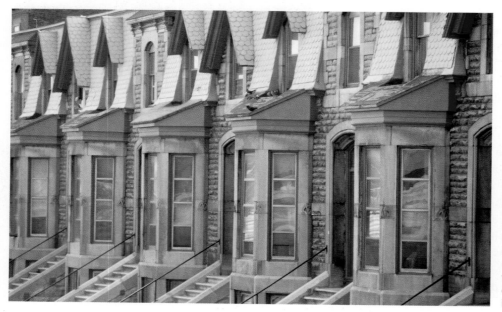

Figure 1.24 The design of this photograph of repeating house fronts is based on the structure of the image rather than its content. It is the pattern of regular shapes, repeating colors and textures that forms the core of the picture's interest.

Texture

Revealing the texture in the surface or surfaces of your subject helps to make a two-dimensional photograph look three-dimensional. Texture also adds character to what might otherwise be just flat-looking slabs of tone and color, helping to give your subject form and substance. A multitude of different and interesting textures exist all around us. Rough wood (Figure 1.25) or stone comes immediately to mind, but look also at the texture of ploughed earth, plants, ageing people's faces, even the (ephemeral) texture of wind-blown water. Or even in rugged landscapes, distant hills and mountains, as these represent texture on a giant scale.

Figure 1.25 The abstract mixture of shadow and shape keeps the audience interested in this photograph. Here the shadow has become more than just a by-product of the lighting – it is an integral part of the photograph's design.

There are two essentials for emphasizing texture. One is appropriate lighting, the other is the ability to resolve fine detail (e.g. accuracy of focusing, no camera shake, or a light recording material without a pattern of its own). Where the subject's textured surface is all on one plane, direct sunlight from one side will separate out the raised and hollowed parts. The more the angled light just grazes the surface, the greater the exaggeration of texture.

Such extreme lighting also tends to leave empty black shadows – if these are large and unacceptable, pick a time when white cloud is present in other parts of the sky, and so able to add some soft 'fill-in' light. When your subject contains several textured

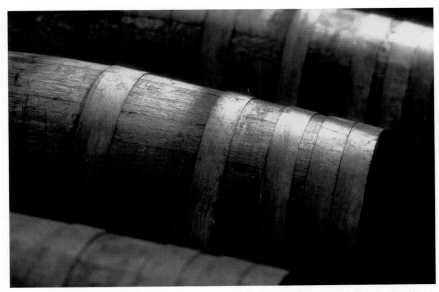

Figure 1.26 The angled lighting skimming across the old oak barrels not only visually describes the form of the barrels, but also shows off the wood's texture.

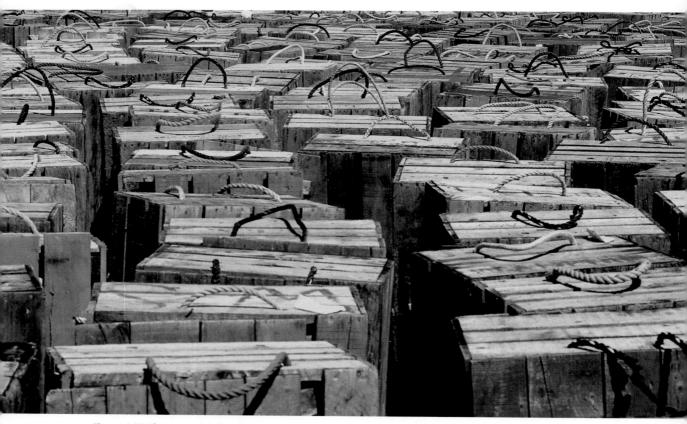

Figure 1.27 The repeated design of the crates in this photograph has produced an informal pattern of texture, shape and color.

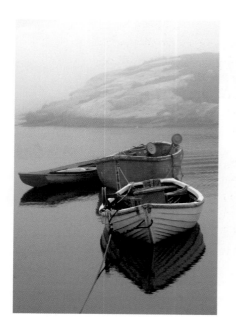

surfaces shown at different angles, the use of harsh lighting from one direction may suit one surface but lights others flat-on or puts them totally in shadow. More diffused, hazy sunlight (but still steeply directed from above or one side) will then give the best results. What you can learn from sunlight can also be applied on a smaller scale, working with a lamp or camera flash, in the studio.

Shape

A strong shape is a bold attraction to the eye, something that you can use to structure your whole picture. It might consist of one object, or several items seen together in a way that forms a combined shape. Shape is also a good means of relating two otherwise dissimilar elements in your picture, one shape

Figure 1.28 Though not identical, there are enough similarities between the boats in this group to provide a visual echo of each other's design.

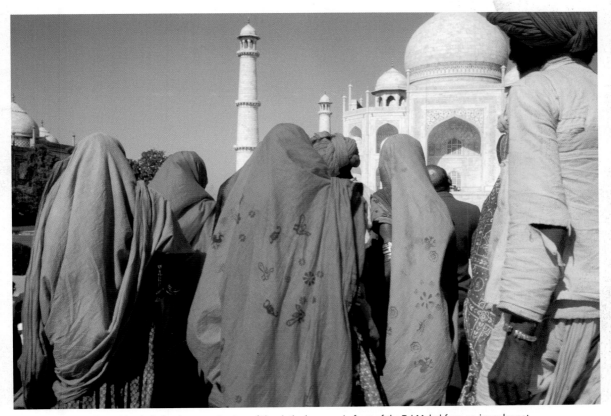

Figure 1.29 Though not identical, the shapes and colors of the clothed women in front of the Taj Mahal form an irregular pattern that adds interest to the picture's foreground.

echoing another, perhaps in a humorous way. Bear in mind too that shapes are often made stronger when repeated into a pattern – like the informal rows of crates in Figure 1.27 or (very differently) the irregular pattern of similarly shaped boats in Figure 1.28.

The best way to emphasize shape is by careful choice of viewpoint and the use of contrast. Check through the viewfinder that you are in the exact position to see the best shape. Small camera shifts can make big changes in edge junctures, especially when several things at different distances need to align and combine. If this position then leaves your subject too big or small in the frame, remain where you are, but zoom the lens until it fits your picture.

Shape will also gain strength and emphasis through contrast with its surroundings – difference in tone or color of background and lighting. A good example of this is the contrast of shape and color of the group of women in front of the Taj Mahal in Figure 1.29. Their repeating shapes add an extra dimension to the picture by providing a patterning effect. Sometimes you will find it possible to fill up a shape with pattern.

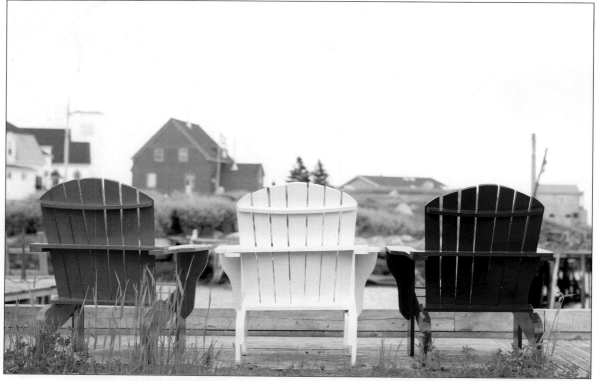

Figure 1.30 The patterns of the three chairs are made more dynamic by their contrasting colors and their positioning against the relatively muted tones of the background.

Using color

Like shape and pattern, it may be the color in a scene that first attracts your eye and becomes a dominant feature in your picture. (Just switch your TV or computer screen between color and black and white settings to prove how much color contributes to an image.) Color can help create harmony or discord. It may pick out and emphasize one important element against all others, or link things together as in Figure 1.30, by repeating the shape of the chairs and then contrasting them with different colors. A more varied pair of colors will interact and gain contrast from one another, especially if they are strong hues, well separated and 'complementary' in the spectrum. The resulting effect may then shout for attention and be lively and exciting or perhaps just garish.

It is interesting to notice, in pictures that combine contrasting colors, that the reds often seem to advance or 'come forward' while greens and blues 'stand back'. Even black or white is influential. Areas of black surrounding small areas of color can make them seem luminous and bright, as in Figure 1.31, whereas colors against white make the hues look darker.

Once again, the key to practical success is selection – mainly through tightly controlled framing and viewpoint. You should rigorously exclude from your picture any elements that confuse or work against its color scheme. Where possible, select lighting conditions that help

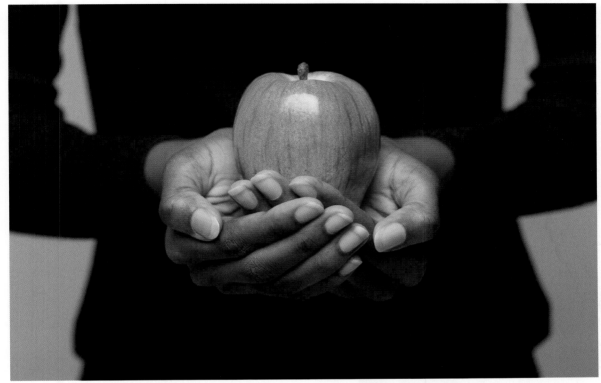

Figure 1.31 The red apple, when contrasted against the black background, seems to be more vibrant, almost glowing, than if the fruit was photographed with a brighter backdrop.

to present colors in the way you need. For example, have you noticed how a car that looked brilliant red in hard sunlight appears a diluted color in overcast weather conditions as it reflects light from the white sky in its polished surface? Similarly, atmospheric haze or mist in a landscape scatters and mixes white light with the colored light reaching you from distant objects, so that they appear less rich and saturated. Then, if dull overcast conditions change to direct sunlight (especially immediately after rain), clear visibility enriches and transforms all the colors present in your photographs.

Color of the light

The actual color of the light that falls on your subject at different times of the day and from different light sources – domestic lamps or candles, for instance – can make big differences to the emotional effect of your picture. The comfortable mood of a cottage interior may be intensified by a warm color cast from domestic lights and firelight. Bare tree branches in winter can appear cold and bleak in light from a clear blue sky, or be transformed in the orangey light of sunset.

It is important to realize that subject color is never completely constant and need not always be strictly accurate. This is especially true when atmosphere and mood are your main priorities. Contrast the cold blue of the ice scene in Figure 1.32 with the warm desert rocks in Figure 1.33. An empty ruined building can seem more mysterious in a photograph with a dominant color

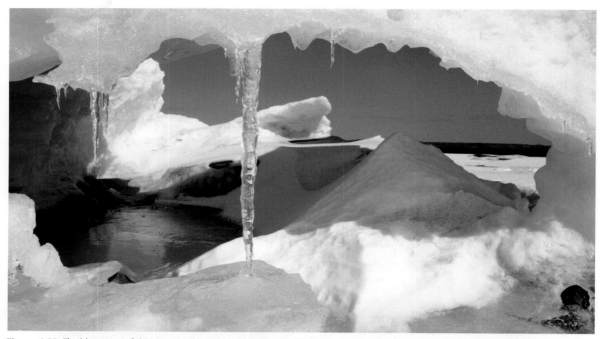

Figure 1.32 The blue tones of this picture add to the cold feeling for this icy scene. Don't be too quick to dismiss the emotive power of color to help communicate through your pictures.

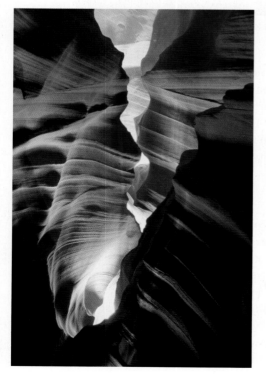

scheme of blues and gray–greens, especially when the overall tone of the picture is dark (low key) too. A 'cold' color filter over the lens may help to achieve this effect or alternatively digital photographers can simulate the effect by intentionally adding a cast to their photos using Photoshop or Photoshop Elements.

Other macabre results – inhuman-looking portraits, for example – are possible using offbeat but easily found light sources such as sodium street lighting, at night. You can judge by eye when lighting of this kind makes familiar colors such as red look just dark gray, and skin seem an unholy greenish yellow. The distortion is even stronger when your digital camera is set to 'daylight' white balance or you are using regular daylight-type color film.

Finally, don't overlook the value of blurred and 'stretched out' semi-abstract shapes and streaks of color for making pictures depicting action and movement in dynamic ways. At night, fairgrounds or just roads with busy traffic lanes will provide you with fruitful subject matter.

Figure 1.33 The rich red and ochre tones of these rocks seem to emit the very heat of the desert that surrounds them.

Developing a personal approach

This first part has been concerned with 'seeing' – with not taking simple everyday objects for granted but observing them as mixtures of shapes and forms, with various color and pattern characteristics and set against a background. Over-familiarization as to what things are actually for (or who people are) easily blunts your visual sense. Looking and photographing in a completely unfamiliar environment like a strange town or country is often more productive because newly seen things trigger perception strongly. The more you begin to see objects as potential picture subjects, the less your photography will be limited to cliché-like postcard-type views or the conventional family group.

At the same time, the various structures of picture making itself allow plenty of scope for a personal approach. For convenience, ways of composing pictures have been discussed here under framing, lighting, color, etc., but in practice almost all photographs (including most of the ones reproduced here) use a mixture of devices. One may be more effectively used for a particular set of circumstances than another, but rarely to the exclusion of all others. You have to decide your priorities and seize opportunities on the spot.

A good way to develop awareness of picture possibilities is to set yourself projects. These can be applied to subjects which interest you – family, locations, sport, etc. The example projects that follow are similar to assignments and tests in photography course programmes. You will probably be able to find subjects in your locality for most of them, even though they differ somewhat from the suggestions made. Don't slavishly copy pictures in this and other books. Approach each project as a chance to make your own discoveries – sometimes these come from producing

unexpected images (including mistakes!) that are worth following up later.

'Developing your eye' in this way will also provide a powerful incentive for learning technical aspects of photography in order to get what you want into final picture form. The way cameras work and how their controls can contribute to results are the themes of the next sections of the text.

1 Select five letters of the alphabet and then go and photograph objects or parts of objects in your local environment that look like your chosen letters. Make sure that the shapes of your objects suggest the letter shapes and where possible use contrast (in color, texture, lighting or tone) to make the letter shape obvious in your picture.

2 Often, photojournalists are required to submit two versions of the same picture – one vertical and one horizontal. This gives the paper or magazine more choice when laying out the story. Select a landscape, still-life or portrait as your subject and practice making two versions (horizontal and vertical) of each photograph you take.

3 Most cameras record their pictures in a rectangular format, but for this project I want you to imagine that your camera shoots in a square format (rectangle minus the edges). Compose five different pictures using the square format and then check the success of your results by cropping the resultant pictures as squares in your image editing program (or use cardboard 'window' mounts to frame your print).

4 The majority of cameras are used at eye level, so most photographs show the world from this height. Take six pictures of familiar subjects using your camera only below waist height or above normal head height.

5 Making appropriate use of color, lighting, composition and expression, take two portraits

(continued)

of the same person. One should show your subject as gentle and friendly, the other as sinister and frightening. Keep clothing and setting the same in each picture.

6 Make a series of three pictures of one of the following subjects: wheels, doorsteps or trees. One photograph should emphasize shape, another pattern, and the third color.

7 Shoot three transiently textured surfaces. Suggestions: rippled water; clouds; billowing fabric; smoke. Remember choice of moment here, as well as lighting.

8 Find yourself a static subject in a landscape – an interesting building, a statue, even a telephone box or tree – and see in how many ways you can vary your viewpoint and still make it the center of interest. Utilize line, tone and color.

9 Take four pictures which each include a cast shadow. Use your own shadow, or one cast by a variety of objects shown or unshown.

10 Using your camera as a notebook, analyze shapes found in your local architecture. Do not show buildings as they appear to the casual eye, but select areas that are strong in design.

11 Produce three interesting pictures of people in surroundings that can be made to provide strong lead-in lines, e.g. road and roof lines, steps, corridors, areas of sunshine and shadow. Make sure your subject is well placed to achieve maximum emphasis.

12 Machinery often has a regularity of form. Produce a set of four differing images that make this point, either through four separate mechanical subjects or using only one of them but photographed in a variety of ways.

13 Throughout this section of the book we have concentrated on looking at how controlling the elements of art and design (color, texture, pattern, line, contrast) produces strong photographs. Make a series of five photographs which feature each of these elements in turn.

14 Using landscape or urban architecture as your subject create two photos of the same environment, one using symmetrical balance and the other using asymmetrical or off-center balance.

2 Camera, Sensors and Film

Camera principles

The word photography means drawing (or writing) with light. It's a good description because every time you take a photograph you are really allowing light from the subject to draw its own picture on the sensor or film. But just how does this 'automatic drawing' take place? Have you ever been lying in bed in the morning watching patterns formed on walls or ceiling by sunlight coming through gaps in the curtains? Sometimes the shadowy shapes of trees and buildings can be made out, especially if the curtains are dark with only one narrow space between them. If you can use a room with a window small enough, cover the window completely with black paper or opaque kitchen foil. Pierce a small clean hole through the blackout with a ball-point pen. Provided the daylight is bright and sunny you should be able to see the dim outlines of the scene outside projected on a piece of thin paper held about 30 cm (1 ft) from the hole (Figure 2.1). Various shapes should be visible although everything will be upside down.

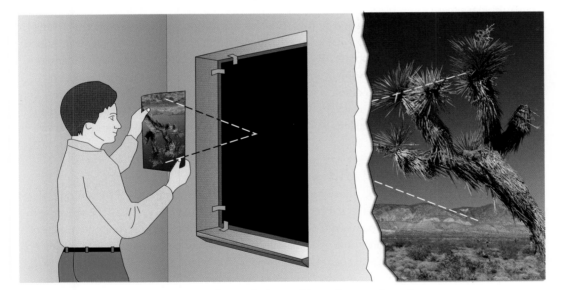

Figure 2.1 A small hole in a window blackout forms a dim image of the sunlit tree on the tracing paper.

This arrangement for making images is called a *camera obscura,* meaning 'darkened chamber'. It has been known for centuries, and all sorts of portable camera obscuras about the size of shoe boxes were made which also allowed people to trace over the image, and so help them draw scenes. Figure 2.2 shows a camera obscura you can make yourself out of an old cardboard cylinder and tracing paper. The image is upside down because light always travels

Figure 2.2 Home-made camera obscura. (Paint its inside surface matt black for best results.)

in straight lines. Light from the top of the window passing through the small hole reaches the bottom of the image on the paper viewing screen.

Enlarging the hole makes the image brighter but much more blurred. However, you can greatly improve clarity and brightness by using a magnifying glass instead of just an empty hole. A magnifier is a piece of glass polished so that its edges are thinner than its center. This forms a converging lens, which is able to give a brighter and more detailed image of the scene, provided it is the correct distance from the screen. Try fitting a lens of this kind to the hole in your camera obscura. You will find that you now need some way of altering the distance between lens and screen ('focusing') until the best position is found to give a clearly defined image. All properly made camera lenses are made up of several lenses together in a single housing. In this way, the faults, or 'aberrations', of individual lens elements and be cancelled out to give clearer, 'sharper' images.

Light-sensitive films and sensors

We have now almost invented the photographic camera, but need some way of recording the image without actually having to trace it by hand. There are many materials that are sensitive to light. Curtains and carpets and paintwork of all kinds gradually fade under strong illumination. Newspaper yellows if left out in the sun. The trouble with these sorts of materials is that they are much too slow in their reaction – exposure times measured in years would be needed to record a visible picture in the camera. For many years, most cameras used film coated with chemical compounds of silver called silver halides to record the scene. The silver halides are extremely light sensitive and change from a creamy color to black when exposed to light. To construct the film, the silver halides are mixed with gelatine and the resulting light sensitive emulsion is coated onto a plastic backing.

Scientists also discovered that it is not even necessary to wait until the silver halides darken in the camera. You can just let the image light act on it for a fraction of a second, keep the film

in the dark and then later place it in a solution of chemicals that develops the silver until the recorded image is strong enough to be visible.

With most films, processing gives us a negative picture on film. Subjects that were white appear as black metallic silver, and dark subjects as clear film. Parts of the subjects that were neither light nor dark are represented as intermediate gray density. The negative is then printed in the darkroom onto paper coated with a similar emulsion containing silver halides. After development, the image on the paper is 'a negative of the negative', i.e. the paper appears white where the original subject was light, black where it was dark and (assuming you are using monochrome materials) a suitable gray tone where it was in between. We have a positive print. The advantage of using negative and positive stages is that many prints can be run off one camera exposure. And by putting the negative in an enlarger (which is rather like a slide projector), enlarged prints can be made. So you don't have to have a big camera to make big photographs.

Figure 2.3 shows, in basic form, the optical and chemical steps in making a black and white photograph. Most pictures of course are shot in color, but the same principles apply. Color films are coated with several emulsion layers, sensitive to blue, green and red. After appropriate processing, color negative film carries images that are reversed in color (blues appear yellow, greens magenta, etc.) as well as in tone. When such a negative is enlarged onto multi-coated color paper the paper responds in a similar way to give a positive print with colors brought back to their original subject hues.

Figure 2.3 Basic stages in making a traditional black and white photograph – from loading and using the camera (top) to processing and printing the film.

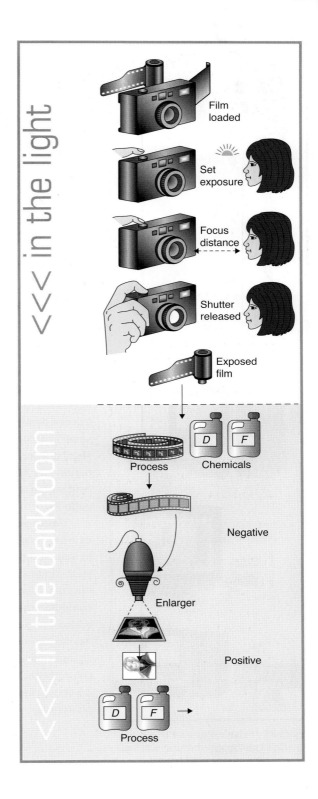

in the light

Film loaded

Set exposure

Focus distance

Shutter released

Exposed film

in the darkroom

Process

Chemicals

Negative

Enlarger

Positive

Process

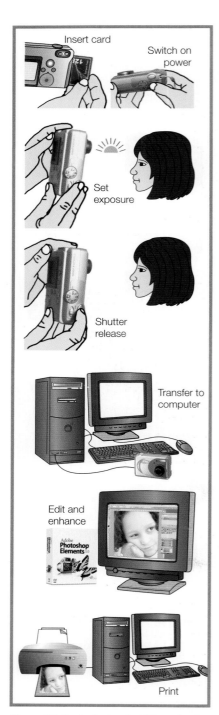

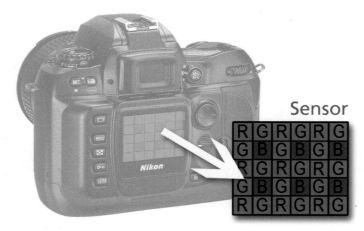

Figure 2.4 Digital cameras have a sensor in the place where film would be in traditional cameras.

The change to digital

More recently, photography has undergone a massive change in the way that we record images. Film cameras, though still readily available, are being outsold by their digital equivalents. With these cameras, the film is replaced as the light-sensitive part of the photographic process with an electronic sensor or, more accurately, a grid of sensors (see Figure 2.4). Instead of the light in a scene being recorded by silver halide grains, it is captured with small electronic sensors. Each of the individual sensors provides a small portion of the full description of the scene that makes up the digital file. After photographing the file is stored on a memory card held within the camera. For more details on how sensors work, see page 44.

Unlike with film, there are no chemical steps involved in using your digital files to make prints. The camera is connected to your computer and all the digital photographs stored on your camera's memory card are transferred into the memory of the computer. This process is called downloading. Once on the computer, the pictures can be displayed on screen, enhanced and edited using a software program called an image editor, such as Adobe Photoshop or Photoshop Elements. After all the picture changes have been made, the image is then printed using a desktop color printer or taken to a photo-laboratory for printing. Figure 2.5 shows the basic steps involved in producing a simple digital photograph.

Figure 2.5 The basic steps in taking and making a digital photograph – from exposing (top) through editing on a computer to printing.

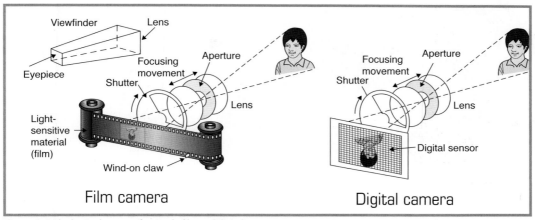

Figure 2.6 The basic elements of a simple film and digital camera.

The camera

There are so many cameras you can buy that, to begin with, it is quite confusing. Remember though, every camera is basically just a light-tight box with a lens at one end and a light-sensitive surface (e.g. sensor or film) at the other. Film and digital cameras vary a great deal in detail, but they all possess the basic features shown in Figure 2.6 in some form. These are, first and foremost, a lens positioned the correct focusing distance from the film/sensor; a shutter; a lens aperture; a viewfinder; a means of

Figure 2.7 Most modern cameras have automatic focusing systems built in, with some SLR models containing features that allow the user to switch between manual and auto-focus modes.

moving to the next picture or advancing the film; and an indicator to show how many pictures you have taken.

The lens is the most important part of the whole camera. It must be protected from finger-marks and scratches, otherwise images resemble what you see when your eyes are watering. The spacing of the lens from the sensor/film has to change for subjects at different distances. Cheapest cameras have the lens 'focus free', meaning it is fixed for what the makers regard as the subject distance for average snaps. Some have a ring or lever with a scale of distances (or symbols for 'groups', 'portraits', etc.). Operating this focusing control moves the lens slightly further from the film the nearer your subject distance setting. Most modern cameras have lenses with an auto-focusing mechanism able to alter focusing to suit the distance of whatever the camera is pointing at in the central area of your picture (see Figure 2.7). In all cases though, anything nearer than the closest subject setting the camera allows will not appear sharp, unless you switch to macro mode, fit an extra close-up lens or extension ring (see page 42).

The shutter prevents light from the lens reaching the sensor/film until you press the release button, so it allows you to decide exactly when the picture will be taken. On simplest beginners'

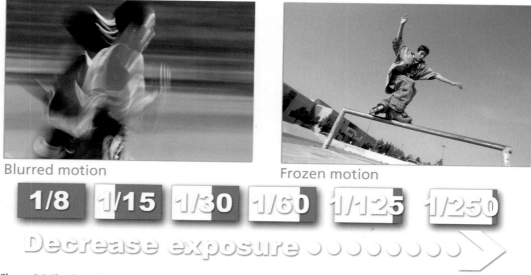

Blurred motion Frozen motion

1/8 **1/15** **1/30** **1/60** **1/125** **1/250**

Decrease exposure ○○○○○○○○○○ →

Figure 2.8 The shutter speed controls both the amount of light entering the camera and the way that action or movement is captured. Fast shutter speeds freeze the action, whereas slower settings blur the movement.

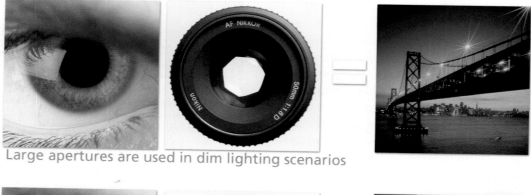

Large apertures are used in dim lighting scenarios

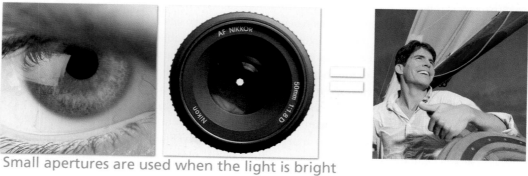

Small apertures are used when the light is bright

Figure 2.9 The aperture of the camera works like the iris in our eyes. Changing the aperture size (hole size) alters the amount of light entering the camera. Typically, small aperture holes (large f-numbers) are used for bright days and larger ones (small f-numbers) when the light is low.

cameras it may function at one speed only, typically opening for about 1/125 second, although this may not be marked. Shutters on more advanced cameras offer a range of ten or so speed settings, from several whole seconds down to 1/1000 second or less. Having a choice allows you to 'freeze' or 'blur' moving subjects, and also compensate for dim or bright lighting (see Figure 2.8). On fully automatic cameras, such as most compacts, the shutter speed is selected by the camera mechanism itself, according to the brightness of the scene and light sensitivity of your sensor/film.

The aperture (also known as the diaphragm or f-stop) is a circular hole positioned within or just behind the lens. It is usually adjustable in size like the iris of the eye – changing to a smaller or larger diameter makes the image dimmer or brighter, so again this is a means of compensating for strong or weak lighting conditions (see Figure 2.9). The shutter therefore controls the time the image is allowed to act on the film, and the aperture controls the brightness of the image. Together, they allow you to control the total exposure to light the film or sensor receives. The aperture also has a very important effect on whether parts of scenes closer and further away than the subject on which the lens is focused also appear sharp. The smaller the aperture, the greater this foreground to background sharpness or 'depth of field' (see Figure 2.10).

Very basic cameras have one fixed aperture, or two to three settings simply marked in weather symbols – 'clouds' for dull light conditions and 'sun' for bright lights. Most advanced or single lens reflex cameras offer half a dozen aperture settings, which are given 'f-numbers'. Each change of f-number lets in half or double the light; this is explained further on page 68.

 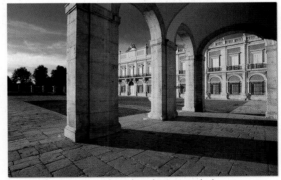

Small foreground to background sharpness Large foreground to background sharpness

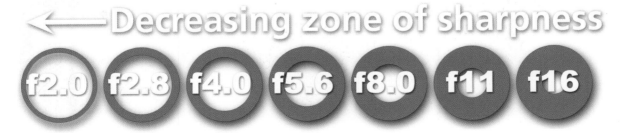

Figure 2.10 The aperture setting also controls the depth of sharpness in the picture. Smaller holes are used to create pictures where sharpness extends further into the image. Large apertures tend to restrict sharpness to just the subject that is focused.

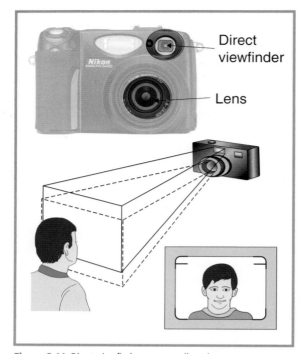

Figure 2.11 Direct viewfinder cameras allow the user to compose the picture via a viewing window that is separate from the lens.

Automatic cameras have an aperture setting selected by the camera mechanism in response to the brightness of your subject lighting, and often display no settings at all.

The viewfinder allows you to aim the camera and preview how much of your subject will be included in the picture. Some cameras (non-reflex types) have a direct viewfinder, which you can recognize by its own separate window above the lens (Figure 2.11). SLR (single lens reflex) cameras allow you to look inside the camera itself and view the actual image formed by the lens. This is the same for both digital and film SLR cameras (Figures 2.12 and 2.13). Digital cameras which look like compacts often use a combination of a direct viewfinder and a small flat display screen (LCD monitor) on the back. Since this screen is wired direct from the CCD it shows your picture when you are framing up your subject, offering the same parallax-free accuracy as an SLR film camera. Parallax error is the situation where what you see through the viewfinder is different to what is captured by the sensor.

An added advantage is that, after shooting, it displays the picture you have just taken so that you can check your results.

Direct viewfinders are bright and clear, but less accurate than SLR or LCD monitor systems for composing pictures, particularly close-ups. You have to follow correction lines denoting the true top edge of your picture at the camera's closest focusable distance.

Figure 2.12 When you look through the viewfinder of an SLR or single lens reflex camera you are looking through the actual lens that will be used to take the picture. For this reason focusing and composition are more accurate when using SLR cameras rather than direct viewfinder compacts.

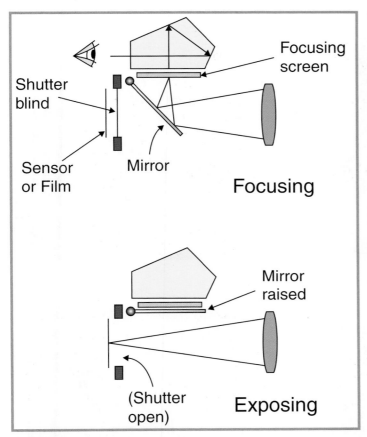

Shutter blind

Sensor or Film

Mirror

Focusing screen

Focusing

Mirror raised

(Shutter open)

Exposing

Figure 2.13 Viewing through the lens in an SLR camera is accomplished with the aid of a mirror positioned in front of the shutter and film. When you press the shutter of most SLR cameras, the mirror raises to allow the light to pass through to the film stored at the back of the camera. After the exposure, the mirror returns to its original position to allow viewing again.

Shot advance or film wind-on mechanisms

Cameras that accept 35 mm wide film in cassettes use a roller with teeth to engage in the film's two rows of perforations. Winding on after you have taken a picture (by hand or motorized) moves the film onto a built-in take-up spool. At the same time a frame number, displayed in a window on the camera body, shows how many shots you have taken and the shutter is made ready for the next picture. As digital cameras have no film to advance, the process involves storing the picture just taken onto the camera's memory card and preparing the shutter for a new exposure.

Although all the features above are found in every camera, the way they are presented to you to use (or arranged to function automatically) varies from one brand to another. Cameras fall into two main 'families':

- *Compact cameras,* which often have a direct viewfinder, limited focusing, shutter and aperture control, and tend to be all-in-one models with no add-on extras.
- *Single lens reflex cameras,* which are slightly larger and heavier, and allow you to see through the taking lens. These are often the nucleus of a kit comprising a whole range of interchangeable lenses and other attachments.

Both are made in manual and automated forms. Their parts and features can be summarized as follows (see Figure 2.14).

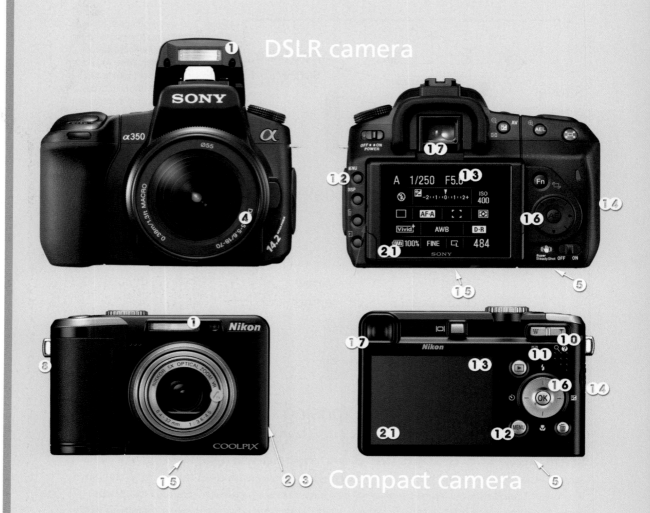

DSLR camera

Compact camera

1. *Built-in flash* – designed for night-time and inside photography to add extra light to a scene when needed.

2. *Video out connection* – to connect your camera to a television so that your pictures can be viewed on screen.

3. *USB connector* – used to connect your camera to a computer for downloading pictures.

4. *Lens* – to focus the image in front of the camera onto the sensor. On some cameras, the lenses are interchangeable. Almost all models, both digital and film based, are now supplied with a zoom lens.

5. *Battery compartment* – to hold the batteries used by your camera to power its different functions.

6. *Mode or command dial* – switches the camera between different shooting modes, such as night-time, portrait and landscape.

7. *Shutter release button* – captures the photograph when pressed.

8. *Eyelet for camera strap* – used to secure a carrying strap to your camera.

9. *Power switch* – to turn the camera on and off.

10. *Zoom buttons or controls* – adjust the lens of the camera to bring distant scenes closer (to zoom in) or capture a wider view (to zoom out).

11. *Flash mode button* – turns flash on and off, and switches between flash functions such as red eye reduction and flash with long exposure.

12. *Menu button* – used to display the camera's settings in menu form on the monitor or LCD screen.

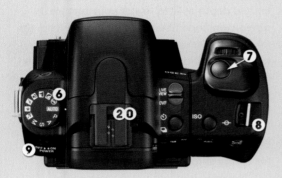

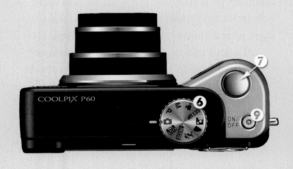

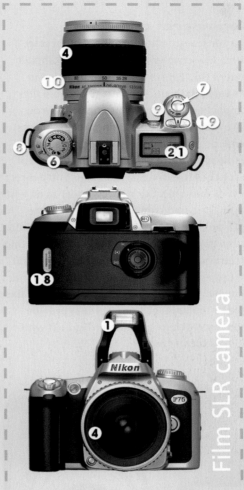

Film SLR camera

13. *Monitor/preview screen* –
a screen used to play the
pictures stored in your
camera or preview the
scene you are about to
photograph.

14. *Memory card chamber* –
insert the memory card here
that will be used to store
your photographs.

15. *Tripod socket* – screw a tripod
to this socket when taking
pictures with a long shutter
speed.

16. *Multi selector button* – used
to change camera or picture
options or settings.

17. *Viewfinder* – used to
compose the scene before
capturing the photograph.

18. *Film chamber* – used to house
the film whilst it is being
exposed.

19. *Film release/rewind button* –
press here before rewinding
the film into the canister.

20. *Flash hot shoe* – a connector
used to hold and control an
additional external flash.

21. *LCD information panel* –
displays your camera's current
settings and functions.

Figure 2.14 Modern film and digital
cameras are full of functions that will help
you capture the best image possible in
a range of different shooting scenarios.
Getting to know your camera's various
parts and features will help you make the
most of these shooting functions and the
creative opportunities they afford. See text
for explanation of numbered items.

Beginners' cameras

New, or young, photographers often start with a low-cost, entry-level digital compact camera (see Figure 2.15). Also included in this category is the simplest reloadable film compact cameras as well as disposable or, more accurately termed, single use cameras. Cameras in this category either have have a simple viewfinder window (with eyepiece at the back of the camera) that gives you a direct view of the subject or no viewfinder at all with the image being composed directly on the LCD monitor. Most settings are 'fixed' or fully automatic, so all you have to do after inserting a memory card or loading the film is to point the camera and press the shutter. This sounds ideal, but with some models the lens has a fixed fixed or limited focus settings that provide good general coverage but are limited with subjects such as macro.

Figure 2.15 Low-cost, entry-level cameras are a good place for kids and new photographers to start. Though there is little control over the shutter speed, aperture and focus, good images can still be taken in well-lit situations.

Typically these cameras have a limited range or shutter and aperture settings that can be used to capture well lit subjects. The available shutter speeds are fast enough to avoids camera shake effects when you shoot hand-held, but often are too slow to freeze fast subject movement. The limited aperture range means that it is more difficult to adjust for correct exposure for all lighting conditions and not easy to choose between deep or limited depth of field to suit your picture. A direct viewfinder, being an inch or so from the taking lens, 'sees' your subject from a slightly different position. This difference of viewpoint or parallax error becomes greater the nearer your subject. Remember to use the correction lines or, better still, digital photographers can use the preview on the LCD monitor at the back of the camera as a more accurate guide for composition.

Nevertheless, with care reasonable photographs can be taken with a simple compact provided you understand and work within its limitations. (Otherwise, you may start with a simple camera, expect too much of it and end up disheartened.) Film users should load fast (ISO 400) film for correct exposure in cloudy conditions and slow (ISO 100) film for bright sunshine, and use flash indoors.

As a general rule simple compact digital cameras have many of the same limitations of their film equivalents, including limited focus and exposure control. The cheapest cameras have a relatively small number of sensor sites and therefore produce pictures that are only suitable for viewing on screen or producing small prints. For example, a sensor grid having 640 × 480 pixels gives a just acceptable image viewed on a small computer monitor, but to get 6 in × 4 in photo-quality color pictures out of your computer printer the camera must have several million pixels. Since, unlike film, you can't change the camera's sensor, pixel (number of sensors) count has to be considered when you buy the camera and is very much linked to price.

Advanced compacts

Top-of-the-range compact cameras are more expensive than the entry-level models. They are fitted with lenses giving higher resolution images (noticeable when you make bigger enlargements) and wider apertures (to cope with dimmer light). Advanced compacts are designed to handle most things automatically, but more and more models are being released with manual override for features such as aperture and shutter speed. This is especially true in the area of digital cameras, where good quality compact cameras hold most of the market. Whether used manually or in automatic mode, these units give technically good results over a wide range of lighting conditions and subject distances.

Such control is gained through sophisticated electronic automation. For example, a camera as shown in Figure 2.16 will be able to automatically match the level of light in the scene with the aperture/shutter speed settings and chip sensitivity to create a good exposure in a wide range of situations. A sensor near the lens measures the brightness of your subject. The camera then uses this information to set an appropriate aperture and shutter speed – ranging from smallest aperture and fastest speed in brilliant lighting, to widest aperture and slowest holdable speed in dim light.

Other sensors judge the distance to your main subject and as you press the release button, the lens adjusts its focusing position to suit this distance. If the subject is too close, the camera signals a warning in the viewfinder; if lighting is too dim, another signal warns you and may automatically switch on the camera's built-in flash or even activate the flash automatically. When the flash is in use it will sense how much light to give out, according to subject distance, and whether other lighting is present. For the film-based models, a motor winds on the film one frame after each shot and once you have taken the last picture on the

Figure 2.16 Fully automatic advanced compacts with zoom lenses and built-in flashes are the most popular of all film and digital cameras. More and more models are now offering manual and semi-manual modes to cater for those photographers who want to regain a little more control of the process.

film it winds it all back into the cassette ready to unload.

Despite this level of sophistication internally, often the photographer is presented with a few simple buttons and dials with many of the features being adjusted by the cameras menu system. That said most compacts also contain a built in zoom with a dedicated 'wide' or 'long' button, which makes the image bigger or smaller. In this way you get more (or less) of a scene to fill your picture without having to move further back (or closer) – see page 80. The camera's viewfinder automatically zooms too, adjusting to match these focal length changes. It may also tilt slightly according to the distance of your auto-focused subject, to help to compensate for parallax error and so more accurately show what you are getting in.

Towards the upper end of the compact camera market many of the models possess the ability to override the automatic features either partially or completely. Bear in mind that having a camera with settable controls is often an advantage, as you will see in later chapters.

Single lens reflex (SLR) cameras

All SLR cameras have a clever optical system (as shown in Figure 2.13), which allows you to view an image of the subject formed by the lens. It is a true 'what you see is what you get' (WYSIWYG) system. Unlike a compact camera, the shutter is not in the lens but in the back of the camera just in front of the film or sensor.

Looking into an eyepiece at the back of an SLR you observe a small, ground-glass focusing screen, onto which the scene is reflected by a mirror. So you see what the lens sees, and as you focus the lens it is easy to examine which parts of the subject are in focus and sharp and which areas are blurry. When you are satisfied that the picture is correctly composed, you press the shutter release button. The mirror then rises out of the way, blocking out the focusing screen briefly and allowing the image to reach the back of the camera, where the shutter opens to expose the sensor or film. As the distance from lens to film is the same as lens to screen (via the mirror), what was focused in the viewfinder will also be sharp on the film/sensor. In addition, because we view through the lens there is no viewfinder parallax error no matter how close the subject.

Since the shutter is at the back of the camera body, you can remove the lens and fit others of different focal length, even in the middle of a film roll or when the camera card is half empty. In fact, single lens reflexes are 'system cameras', meaning that the makers offer a wide variety of lenses and accessories, ranging from close-up rings (page 42) to special dedicated flashguns. So, starting off with a camera body and regular lens, you can gradually build up quite an elaborate camera outfit bit by bit as you become more experienced.

Cameras of SLR design include manual types, where you set most of the controls, automatic models that work with built-in programs and those that combine both systems. Both manual and automatic approaches have their advantages and limitations, so let's take a closer look at each design.

Figure 2.17 Fully manual SLR cameras provide the photographer complete control over all aspects of focus and exposure.

Manual SLRs

A typical manual-only camera, like the one shown in Figure 2.17, is very rare these days as most SLR cameras have some form of automatic control built in. A manual SLR has setting dials for shutter, aperture and focus, and also a film wind-on lever and a rewind knob. Having loaded and set the speed of your film, you look through the eyepiece and turn the lens focusing ring until the most important part of your picture appears sharp. Typically, you then set a shutter speed such as 1/125 second if you are hand-holding the camera (see page 64). Look through the eyepiece, half depress the shutter release and turn the aperture control until a signal light or needle next to the focusing screen indicates that the exposure set is correct. Alternatively, you can first make an aperture setting because depth of field is important (see page 66) and then alter the shutter setting until correct exposure is signalled. Pressing fully on the release then takes your picture, and you must use the wind-on to advance the film by one frame ready for the next shot.

As you can see from this sequence of steps, a manual SLR camera requires you to know something about choice of technical settings, but it will tackle a wider range of lighting conditions and subject distances than all but the most advanced compacts. Since it only uses electronics for its exposure meter, the camera will still take photographs with its (tiny internal) batteries flat.

Fully manual cameras are film only. Though most digital SLR cameras have a manual mode that allows you to set your camera as above, there are no manual-only digital SLR cameras on the market. All models contain at least some automatic modes along with their manual options.

Automatic SLRs

A technologically advanced SLR (Figure 2.18) has features such as auto-focusing, film speed sensing, built-in flash, the ability to take a sequence of pictures with rates of five pictures per second and more, and what is known as 'multi-mode' functioning.

Multi-mode means that by selecting one mode you can have the camera function as if it were manual, or by selecting another have it totally auto-programmed (just point and shoot). Yet another mode will allow you to choose and set shutter speed, but makes every other setting automatically, whilst a fourth mode allows you to make the aperture your priority choice instead.

An SLR camera like this may also offer you five or six modes covering different ways of exposure reading and making settings, plus an almost overwhelming range of other options. You can even program the camera to take a rapid 'burst' of three pictures when you press the button, each one giving a slightly different exposure. Virtually all the camera actions are battery powered – from its internal focus sensor, motor drive for film advancement, to the electronically timed

shutter providing a much wider setting range (typically 1/8000–30 seconds) than a manual camera. The digital version of these cameras also includes the ability to change the sensitivity of the sensor frame by frame, adjust the camera to suit shooting under different colored lighting conditions and even alter the contrast or color saturation of specific photographs.

Figure 2.18 Advanced multi-mode (auto, semi-auto and manual) SLR cameras contain many features and controls. These cameras are available for both film-based and digital photography.

Typically, all the information concerning the chosen mode, shutter and aperture settings made and number of pictures left appears on a display panel on top of the camera body or on the LCD monitor on the back of the camera. Some of this data is also shown alongside the focusing screen when you look through the eyepiece. Digital cameras often record this information along with details about the picture itself in the digital file. These settings can be displayed by calling up the information (sometimes called metadata) in an image editing program such as Photoshop or Photoshop Elements.

Specialist shooting modes

Some cameras contain a range of shooting modes designed to take the guesswork out of adjusting camera settings to suit different shooting scenarios. Selecting these modes will automatically change your camera's functions to the most appropriate setting for the photographic task at hand. The guide below will give you an idea of when best to use which mode.

N.B. Not all modes will be available on all cameras and some modes are digital-only options. Check your manual for details of what specialist modes your camera contains.

Figure 2.19 Portrait mode.

Portrait. Designed for portraits producing a picture where the main subject is sharply focused whilst other details in the background are softened or left unsharp. The degree to which the background is unsharp will depend on the amount of light that is available

Figure 2.20 Party/Indoor mode.

Party/Indoor. This mode is designed for use in low light situations, where detail is required both in the foreground and background. This setting uses a slow shutter speed, so be sure to hold your camera very still or use a tripod.

Figure 2.21 Night Portrait mode.

Night Portrait. You should use this mode if you want to create a good balance of lighting between the foreground subject and the background lights. It is great for photographing portraits against a background of night scenery. With this setting the flash is activated to light the foreground and a long shutter speed is used to capture the night lights. When using this mode be careful of camera shake.

Figure 2.22 Beach/Snow mode.

Beach/Snow. Brightly lit, lightly colored subjects often fool your camera, resulting in dark muddy images. This mode rectifies this problem by adjusting the camera so that light tones in beach and snow scenes are recorded correctly.

Figure 2.23 Landscape mode.

Landscape. Designed to enhance the color and detail of distant scenes, this mode is great for making landscape pictures. With this setting the flash is turned off automatically and the camera's focusing system is locked at the most distant setting.

Figure 2.24 Sunset mode.

Sunset. Designed to preserve the strong colors often found in sunsets, this mode automatically turns off the flash for the camera. This means that foreground

objects appear silhouetted against the sunset sky. Use a tripod or hold your camera very still to stop camera shake when using this mode.

Figure 2.25 Night Landscape mode.

Night Landscape. As a slow shutter speed is in this mode to capture the dimly lit tones of a night landscape, a tripod is recommended when shooting with this setting. In addition, the flash is automatically turned off and the focus set to the most distant setting.

Figure 2.26 Museum mode.

Museum. For use indoors when flash is not permitted, this setting is perfect for capturing pictures in museums or art galleries. The flash is turned off automatically and, where available, a function like the Best Shot Selector (BSS) is activated to ensure that only the finest quality photograph is saved.

Figure 2.27 Fireworks Show mode.

Fireworks Show. This mode fixes the focus at the most distant setting, turns off the flash and uses a slow shutter speed to capture the expanding burst of light from a firework. For best effect follow the trail of the ascending firework, releasing the button at the start of the burst.

Figure 2.28 Close Up mode.

Close Up. The camera is set to focus on subjects very near to the lens (10 cm or less). This setting is also called 'macro' mode. Be sure to hold the camera steady or use a tripod to reduce camera shake when capturing these close-up photographs.

Figure 2.29 Copy mode.

Copy. This setting is designed to provide clear photographs of maps, documents or business cards. The mode works best with black and white type or printed documents with high contrast.

Figure 2.30 Back Light mode.

Back Light. Use this mode when light is coming from behind your subject. The camera's flash is turned on automatically and fills in the shadows in the foreground of the picture.

Off. Turns off all preselected camera mode settings, allowing the photographer to choose how the camera is set up.

Figure 2.31 Shooting modes are selected using the mode dial on the top of the camera or via the settings menu.

Accessories

A great range of accessories is available for cameras – although almost all are designed for SLR types. Figure 2.32 shows the most useful items.

- *Extra lenses.* Provided your camera body accepts interchangeable or supplementary lenses, you can fit a wide angle or telephoto type in place of its standard focal length or zoom lens (the advantages of doing this are explained on page 84).
- *Extension tubes.* Fitted between the lens and body, these allow you to work very close up to your subject. Digital cameras often contain a specialist macro shooting mode that changes the way that the camera lens works, so that you can get in closer to your subject. Some models can focus down to 1 cm (0.4 in).
- *Tripod with tilting top.* A firm support when you want to use exposure times that don't allow the camera to be steadily held by hand (longer than 1/60 second, for instance). Most compact cameras as well as SLRs have a threaded baseplate to accept a tripod.
- *Shutter release extension.* As long as your camera's shutter button is either threaded for a cable release or has connections for a cable switch, this accessory minimizes risk of camera shake when you give a long exposure. For some cameras not accepting either form of release it may be possible to fit an adapter or you can use the self-timer option to allow the camera to settle before the shutter is released.
- *Flashgun.* Even if your camera has a built-in flash, a separate, more powerful, unit that can be attached and used instead will allow far more interesting lighting opportunities (see page 156).
- *Lens hood.* A much underrated accessory, the lens hood not only shades the lens from flare created by strong back or side light on your subject, but it also helps protect it from knocks. For sharp, well-saturated pictures, always use a lens hood wherever possible.
- *Filters.* Push-on or screw-on color filters can be helpful in black and white photography (see page 240), and color correcting filters help neutralize color photographs taken under unusual lighting. There is also a whole range of filters designed for creating special effects.

Figure 2.32 Useful camera accessories. (1) Extra lenses. (2) SLR eyepiece corrector. (3) Extension tube (close-up ring) between SLR body and lens. (4) Tripod and camera clamp. (5) Cable release or remote release. (6) Flashgun, fits on the hot shoe connector. (7) Lens hood. (8) Lens filters.

So which camera is best?

There is no ideal camera, which is why so many variations exist even within the types discussed here. Even if money is no object and you buy the most expensive multi-mode SLR, just having so many options available can be confusing, overwhelming your picture making. And yet keeping it set to 'auto-program' is wasteful if you then never use its other possibilities.

A modern, automatic-only compact camera is easy to carry and quick to bring into use. It is a truly pocketable camera, lightweight and small. You don't have to carry accessories either, which encourages you to take the camera everywhere. Without the delays caused by you having to adjust your camera's settings, you can concentrate on composition, viewpoint and people's expressions when taking pictures, knowing that technicalities like focus and exposure are taken care of.

If you want a bit more image control, without having to understand any technicalities, a compact with zoom lens gives you helpful image size adjustment. The wider the zoom range though, the more a camera increases in size and price. If you buy a low-cost compact camera, remember that poorly lit or fast-moving subjects will be generally beyond its capabilities, as well as accurate and sharp close-ups. Digital compacts with LCD preview or monitor screens and SLR cameras are unrivalled for framing accuracy and close working, but they are more expensive and, in the case of SLR equipment, definitely generally heavier and more bulky.

Figure 2.34

Automatic modes or automatic-only cameras work using programs that ensure a high level of technical success (e.g. sharp focus, correct exposure) under most conditions. The trouble is that, when using these modes, you are unable to make individual settings – such as distance, shutter speed and aperture – which means that you deprive yourself of many of the creative visual possibilities, as shown here in the next parts of this book. For someone who wants to understand photography and is prepared to learn to set the controls, it is still difficult to beat an advanced compact with a manual mode or an entry level SLR. Such cameras generally accept a great range of accessories. For SLRs in particular, this includes the same high-quality lenses used on the makers' most expensive models. Again, if you buy an SLR with a choice of modes, make sure one of these is 'manual'. Then, having really learnt the controls, you are in an informed position to know whether changing to a semi-automatic or fully programmed mode offers a short cut for particular subject conditions, but will still give the result you want.

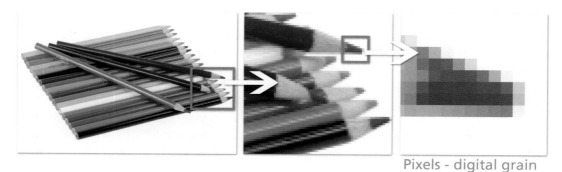

Pixels - digital grain

Figure 2.35 Digital photographs are constructed from a grid of colored rectangles called pixels (picture elements).

Sensors

For most new digital camera owners it comes as a bit of surprise when they find out that their beautifully colored and delicately textured photographic prints are in fact constructed of a grid of rectangular colored boxes. These boxes are the basic building ingredient of any digital photography and were originally called 'picture elements'.

These days, most readers will know them by their common title – pixels – but their original description as elements from which a picture is made still holds true. Traditional film-based photography has a similar image component called grain, and for this reason some writers have also started to call pixels 'digital grain'. Whatever the terminology you use, you cannot escape the importance of pixels when creating great pictures.

Each pixel represents both color and tone. Together, many pixels create the shapes and details in your images in much the same way that the great mosaics of Roman times depicted scenes using small pieces of tile. But unlike the mosaics, the grid-like structure of the digital image is not noticeable when the picture is seen from a distance, or the pixels are printed very small. Our eyes mix the colors and tones so that what we see is a photographic image containing smooth graduations and sharp details, and not a collection of discrete blocks arranged in rows and columns (see Figure 2.35).

Figure 2.36 Sensors replace film in digital cameras. When the shutter button is pressed, the image (individual RGB colors and tone) is captured by each cell of the sensor and a digital photograph results.

Creating pixels

Creating images in this form is essential if they are to be edited or enhanced by computers. There is no doubt that computers are amazing machines. Their strength is in being able to perform millions of mathematical calculations per second. To apply this ability to working with images, we must start with a description of pictures that the computer can understand. This means that the images must be in a digital form. This is quite different from the way our eyes, or any film-based camera, see the world.

With these devices we record pictures as a series of 'continuous tones' that blend seamlessly with each

other. To make a version of the image the computer can use, the tones need to be converted to a digital form. The process involves sampling the image at regular intervals and assigning a specific color and brightness to each sample. Each of these areas, or samples, becomes a pixel in the resultant digital file, and in this way the pixel grid is constructed.

The grid can be made by taking pictures with a digital camera or by using a scanner to convert existing prints or negatives into pixel-based form. Most digital cameras have a grid of sensors, called photosites, in the place where traditional cameras would have film. Each sensor measures the brightness and, more indirectly via a series of filters, the color of the light that hits it. When the values from all sensors are collected and collated, a digital picture made up of a grid of pixels results (see Figure 2.36).

Scanners work in a similar way, except that these devices use rows of CCD sensors that move slowly over the original, sampling the picture as they go. Generally, different scanners are needed for converting film and print originals; however, some companies are now making products that can be used for both.

What is all this fuss about megapixels?

With the rapid rate of change in the development of digital cameras, photographers and manufacturers alike have been searching for ways to compare the many different models that fill the marketplace. To this end, the number of 'megapixels', or millions of pixels, contained in the camera's sensor is often used as a means of comparison.

The general consensus from most quarters is that the 'more megapixels the better', and as a general rule this is probably true. This is certainly the case if your goal is to produce the biggest photographic quality prints possible. In this scenario, more pixels from the sensor translates into bigger print sizes. But this is certainly not the whole story. For instance, some compact cameras with moderate megapixels create files that are clearer and contain less noise than similar models with sensors of a higher pixel count.

Table 2.1 Chip dimensions and associated print sizes.

Chip dimensions (pixels)	Chip resolution (megapixels) (1 million = 1 megapixel)	Maximum print size at 200 dpi (inches) (e.g. photo print)	Maximum image size at 72 dpi (inches) (e.g. web use)
640 × 480	0.30	3.20 × 2.40	8.80 × 6.60
1440 × 960	1.38	7.40 × 4.80	20.00 × 13.20
1600 × 1200	1.90	8.00 × 6.00	22.00 × 16.00
2048 × 1536	3.21	10.20 × 7.58	28.40 × 21.30
2304 × 1536	3.40	11.50 × 7.50	32.00 × 21.30
2560 × 1920	4.92	12.80 × 9.60	35.50 × 26.60
2816 × 2112	6.0	14.80 × 10.56	39.10 × 29.30
3504 × 2336	8.20	17.52 × 11.68	48.60 × 32.40
4368 × 2912	12.80	21.84 × 14.56	60.66 × 40.44

It is worth thinking about what you are going to use your digital files for. If we can identify the 'end use' of our image files first, then we can relate this back to camera sensor sizes. For example, if you intend to produce web pages exclusively, there is little reason for you to have a 10 or 12 megapixel camera. You simply will never use this number of pixels for screen-based presentations. Similarly, if you intend to print your pictures from an A4 desktop printer only, then a 6.0 megapixel camera will be sufficient to guarantee you fantastic photo-quality images.

It pays to remember the old adage 'horses for courses' when selecting the right sensors for your shooting requirements. Too few pixels and your prints will not be photo-quality at the size you want, too many and you will pay for image detail you don't need (see Table 2.1).

Sensor sensitivity (ISO equivalence)

Like film, digital sensors have an amount of light that is optimum for making well-exposed pictures. Films are rated with an ISO value according to their sensitivity – the higher the value, the greater the film's sensitivity to light (see Part 10 for more details). With digital cameras the restrictions of being locked into shooting with a single film with all its particular abilities and flaws have been lifted. The ISO idea still remains, though strictly we should refer to it as 'ISO equivalence', as the original ISO scale was designed specifically for film not sensors. Most digital cameras have the ability to change the ISO equivalent setting for the sensor, with a growing number offering settings ranging from 100 to 1600. Each frame can be exposed at a different 'ISO' value, releasing the digital shooter from being stuck with a single sensitivity through the whole shooting session.

Entry-level digital cameras usually contain chip sensitivity that is fixed by the manufacturer and can't be altered by the user, but as you start to pay a little more, the level of sophistication and control of the camera's ISO begins to increase. Most middle-of-the-range and prosumer cameras now contain a variety of sensitivity settings. Changing the ISO is usually a simple matter of holding down the ISO button whilst turning a command dial. The changed setting is reflected in the LCD screen at the back of the camera and, in some cases, in the viewfinder as well (see Figure 2.37).

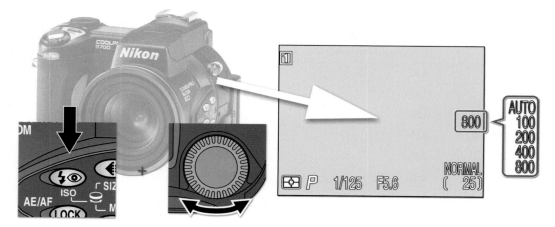

Figure 2.37 With most mid- to high-level digital cameras, it is possible to change the ISO (ISO equivalence) of the chip from frame to frame.

Some digital cameras also contain an Auto ISO setting that can be selected instead of specific sensitivity values. This feature keeps the camera at the best quality option, usually 100, when the photographer is shooting under normal conditions, but will change the setting to a higher value automatically if the light starts to fade. It's a good idea to select and use this option as your camera's default setting. It's good for most situations and you can always change to manual when specific action or low light scenarios arise.

Sensor size compared to film

The physical dimensions of most digital sensors are smaller than a 35 mm film frame. The exception being two 'full-frame' DSLR cameras (EOS 1DS Mark II and EOS 5D) developed by Canon that contain sensors the same size as a 35 mm film frame.

For compact cameras where the lenses are matched with the sensor there is no real need to know the physical size of the chip for everyday shooting, but with DSLR cameras the situation is a little different. If the sensor is smaller than the 35 mm frame then a multiplication effect comes into play with lens lengths. Depending on your camera model this may mean that a 200 mm lens, when coupled to a camera with a small sensor, provides the same view as a 300 mm lens would if used on a full frame or 35 mm film camera.

Many people believe that the lens' focal length is increased and they use a multiplication factor published by the camera companies to compare the changes. As an example, the Canon EOS-1D and the EOS-1D Mark II both have a multiplication factor of 1.3. So when these cameras are coupled to the Canon EF 100-300 F/4.0-5.6 lens most people believe that it would become a 130–390 mm lens. Technically, that is not correct.

In fact, there is no change of focal length as you switch the lens from a film (or full frame sensor) camera to one with a smaller sensor. The actual change is that the picture angle of the lens is narrowed on the digital format because the sensor is smaller than a 35 mm frame. Focal length and reproduction ratio remain constant for the comparable viewed portions of the image. It is only the picture angle that changes. When shooting digitally with small sensor DSLRs, it is like we are just cutting the middle section out

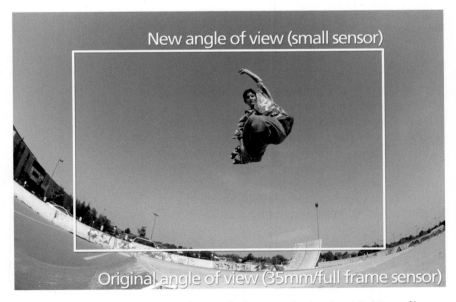

Figure 2.38 Because most sensors housed in DSLR bodies are smaller than the original 35 mm film format, the angle of view will be reduced. Depending on the size of the sensor and therefore the 'multiplication effect' this may mean a change in the angle of view by as much as 1.6, making a 100 mm lens on a small sensor camera record a similar angle as a 160 mm lens on a full frame camera.

of a picture taken with a film, or full frame sensor, camera (see Figure 2.38). For more details on using lenses with DSLR cameras containing sensors smaller than a 35 mm film frame go to Part 3.

Capture formats

Alongside sensor design and function the file format that you choose for saving your captured photos in-camera has a direct impact on the quality of the images. For a few years at the beginning of the digital revolution all photos were saved to the memory card in the camera in the JPEG format. Designed specifically for digital photography the JPEG format does a great job of squeezing large image files into small documents so that they don't take up too much space on the memory card or your computer's hard drive. The small file sizes also mean that they are suitable for use on web pages or for e-mailing to friends or relatives all over the world.

Figure 2.39 Selecting the file format to use to save your captured pictures onto the camera's memory card affects not only the space that these photos consume but also the final quality of the picture.

The downside of the format (you knew there had to be one!) is that to save space some of the original image detail captured by your camera's sensor is discarded. Now for most photographs that have been captured with good exposure and printed to small sizes, such as 5 × 7 inches or postcard, it is pretty hard to tell the difference between a compressed JPEG version of the photo and a version where all the original capture detail is still present.

This said, most photographers who are concerned about producing the best quality photos choose to save their images in formats which maintain all the detail in the original capture. For this task there are two main formats to choose from, TIFF or RAW. Neither format loses any picture detail during the save-to-card process but they do handle the information in very different ways.

Capture formats explained:

JPEG (Joint Photographic Experts Group) – This format is the industry standard for compressing photos destined for the World Wide Web (www) or for storage when space is limited. JPEG compression uses a 'lossy compression' (image data and quality are sacrificed for smaller file sizes when the image files are closed). The user is able to control the amount of compression. A high level of compression leads to a lower quality image and a smaller file size. A low level of compression results in a higher quality image but a larger file size. It is recommended that you only save to the JPEG file format for web work and only after you have completed all your image editing.

TIFF (Tagged Image File Format) – This file type is the industry standard for images destined for publishing (magazines and books). TIFF uses a 'lossless' compression (no loss of image data or quality) called 'LZW compression'. Although preserving the quality of the image, LZW compression is only capable of compressing images a small amount.

RAW – RAW file formats differ from one camera manufacturer to another but they all contain the full description of what the camera 'saw' in the image file. Unlike other capture formats, choosing RAW stops the camera from processing the color information from the sensor and reducing the image's bit depth, and saves all the picture detail in an unprocessed form. To edit or enhance a RAW file you will need to either convert it to a regular file format using a conversion utility or open the file in a RAW enabled editing program such as Adobe's Lightroom or Apple's Aperture.

Common RAW file format extensions			
Canon	.CRW	Nikon	.NEF
Sigma	.X3F	Fuji	.RAF
Kodak	.DCR	Sony	.SRF
Canon	.CR2	Minolta	.MRW
Olympus	.ORF	Adobe	.DNG

Figure 2.40 Different camera manufacturers use different RAW file formats to save the image detail from sensor. Each format has a different file extension indicating file type and manufacturer.

A TIFF file is ready to use straight from the camera and can be easily printed, edited and enhanced with most image editing software packages. A RAW file, on the other hand, requires further processing before it can be manipulated inside programs such as Photoshop and Photoshop Elements. This is not necessarily a problem as both packages contain a RAW conversion utility (Adobe Camera RAW) that is designed for the job, but it does mean that the photographer needs to undertake an extra processing step in the workflow from capture to print. The reward for this extra work is that the photographer gets to determine how the RAW file is processed and for many image makers this extra level of control is worth the effort.

In the last couple of years both Adobe and Apple have developed image enhancement programs designed to work with RAW files without the need to convert them first. Add to this the fact that initially the option to save in RAW was only available on the most expensive DSLR cameras, but now this feature is also appearing on a variety of advanced compact cameras, more and more photographers are using the format as their primary way to save their captured files. Go to Part 7 for details on the RAW conversion process.

Table 2.2 Advantages and disadvantages of different capture file formats

FILE TYPE	ADVANTAGES	DISADVANTAGES
RAW	• Provides potentially the best image quality • Allows the photographer to handle the conversion process • Uses lossless compression	• Bigger file sizes than JPEG • Slow to read/write files from/to memory card • Requires an additional processing step • Requires conversion utility
TIFF	• Uses lossless compression	• Very big file sizes • Very slow to read/write from/to memory card
JPEG	• Produces small files • Level of compression is variable • Fast to read/write from/to memory card	• Uses lossy compression • Repeated saving after editing steps degrades the picture further

Table 2.3 **Capture format versus file size** – The capture format you select directly affects not only the way the file is saved and its visual quality but also the size of the final file. JPEG produces the smallest files but uses a 'lossy' compression system to do so. In the JPEG format you can adjust the level of compression used when saving the photo. In this table the Fine setting uses the least compression and the Basic option the most. Both TIFF and RAW formats preserve all the image detail and any compression used with these formats is 'lossless'.

CAPTURE FILE SIZE COMPARISONS	JPEG file size (Fine setting)	JPEG file size (Normal setting)	JPEG file size (Basic setting)	TIFF file size	RAW file size	RAW file size (compressed)
Example file 1	2997 Kb	1555 Kb	782 Kb	17708 Kb	9777 Kb	5093 Kb
Example file 2	2466 Kb	1575 Kb	748 Kb	17712 Kb	9776 Kb	4275 Kb

Saving digital photographs

Before the days of digital, the film was both the capture medium as well as the storage device for our precious photos. Now the two tasks are split. The sensor handles the capture part of the process and the camera's memory card is responsible for the storage (at least until it is transferred to your computer). There are several different types of cards and they also vary in capacity (how many photos they can store) and transfer speed. For readers with cameras with high resolution chips the faster the transfer speed of the card the quicker the pictures will be written to and read from the card. Memory card prices have fallen dramatically in the last couple of years so you should buy the largest capacity and fastest transfer speed that you can afford (see Figure 2.41).

CARD TYPE:	MERITS:	CAMERA MAKES:
Compact Flash	Most popular card for most advanced DSLR and some compact cameras. Matchbook size	Most Canon, Nikon, Hewlett-Packard, Casio, Minolta, and pre-2002 DSLR Kodak
Secure Digital (SD)	Postage stamp size. Credit card thickness	Used with most compact cameras (bar Fuji, Olympus and Sony) and some enthusiast DSLRs
xD Picture Card	Smallest of all cards. About the size and thickness of a thumbnail	Fuji and Olympus cameras
Memory Stick	Smaller than a stick of chewing gum. Longer than other card types	Used almost exclusively in Sony digital cameras, camcorders, hand-helds, portable music players and notebook computers

Figure 2.41 Memory cards store the pictures captured by the digital sensors. Different manufacturers favor different card types. Check which type your camera uses before purchasing additional cards.

(a)

(b)

(c)

(d)

(e)

Figure 2.42 A range of film types. From the top: (a) 35 mm color negative; (b) color slide; (c) black and white negative; (d) black and white slide; (e) APS color negative (now discontinued). All actual size.

Films (see Figure 2.42)

ilm records the time exposed onto it in your camera, using light-sensitive chemicals (silver halide crystals) coated as a gelatine emulsion on a plastic base. The size, shape and how tightly packed these silver halides are basically determines the speed of a film – from fine grained and relatively 'slow' in reaction to light, to coarser grained and 'fast' in sensitivity.

Color negative films

These are the most popular and are made in the widest range of types and speeds, particularly in 35 mm size. From color negatives it is possible to have enlargements made cheaply in color or (in some labs) in black and white. Labs can also scan negatives and slides and save them to a CD ready for input into a home computer system.

Black and white films

Black and white films make a refreshing change. Pictures are simplified into monochrome without the realism (and sometimes distraction) of color. However, few labs now offer a black

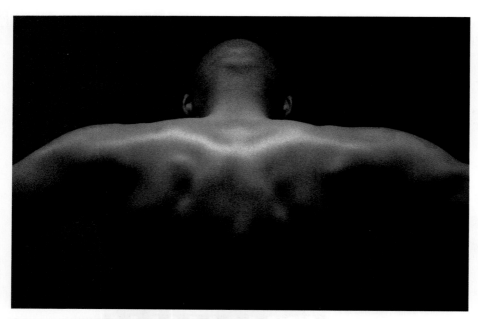

Figure 2.43 High ISO films (or sensor settings) allow the photographer to capture pictures under low light, but contain large and sometimes distracting grain (or noise in the case of digital).

Figure 2.44 Slow films or those with a low ISO number (or sensor setting) record the finest detail and the smoothest gradation of tone and color.

and white processing service. One solution is to use the type of monochrome negative film – Kodak TMAX-TCN or Ilford XP2, for example – which labs can process in their regular color chemicals and produce black and white results. Black and white is also your best choice to start your own traditional processing and printing (see Appendix).

Color slide films

Color slide films are designed to be 'reversal' processed so that positive color images are formed in the film instead of negatives. You can then project these pictures as slides. It is possible to have color prints made off 35 mm slides, but (as with the purchase and processing of the film itself) this is more expensive than making the same prints from color negatives. You must be more accurate with exposure when shooting slides and, where necessary, have a filter to correct the lighting.

Film information

The film box gives you all the important information. Apart from type, brand and size, it shows the number of pictures, film speed, type and the 'use by' date.

Table 2.4 Benefits and disadvantages of different ISO settings

	ISO and ISO equivalent setting		
	100	**200**	**800**
Benefits	• Low noise (fine grain) • Good color saturation • Good tonal gradation	• Good noise/sensitivity balance • Good sharpness, color and tone • Can be used with a good range of apertures and shutter speeds	• Very sensitive • Can be used with fast shutter speeds, large aperture numbers or long lenses • Good depth of field
Disadvantages	• Not very sensitive • Needs to be used with fast lens or tripod	• Not the absolute best quality capable by the camera • May not be fast enough for some low-light or action scenarios	• Obvious noise (grain) throughout the picture • Poor picture quality
Best uses	• Studio • Still life with tripod • Outdoors on bright day	• General hand-held shooting	• Sports • Low light situations with no flash • Indoors

Film speed

Light sensitivity is shown by your film's ISO (International Standards Organization) speed rating. Every doubling of the ISO number means that a film is twice as fast. Regard films of about ISO 100 or less as slow in speed, ISO 200 and 400 as medium, and ISO 800 upwards as fast.

Choose a fast film if all your pictures will be shot under dim lighting conditions with a simple camera, or when you don't want to have to use a slow shutter speed or wide lens aperture. However, expect resulting prints – especially big enlargements – to show a more visible granular pattern. Sometimes 'graininess' suits a subject, as in Figure 2.43. But since it destroys fine detail and coarsens tones, it would not be the best choice for an image with fine pattern and texture. Fast film is also more expensive.

A slow film suits bright light conditions, where you don't want to be forced into using a fast shutter speed or small lens aperture. It's clearly the best choice if you want prints with the highest image resolution. For most situations though, a medium-speed film offers the best compromise. Always check that your camera is properly set for the ISO rating of the film it contains.

Table 2.4 summarizes the benefits and disadvantages of different ISO settings. Use it as a guide when selecting which value to use for your own work.

| 1 | 2 | 3 | 4 | 5 | 6 |
| 7 | 8 | 9 | 10 | 11 | 12 |

DX coding

Figure 2.45 The DX coding on the outside of film canisters informs the camera about the characteristics of the film. The characteristics conveyed by each conductive position are: positions 1 and 7 always set; positions 2–6 used for ISO value; 8–10 for number of exposures per film; 11 and 12 for exposure latitude of the film.

Expiry date

The expiry date is the 'use before' date on the film box. It assumes average storage conditions away from fumes, heat and humidity. Outdated film becomes less light sensitive, and colors may suffer. To extend shelf-life, store your films (sealed) in the main compartment of your refrigerator.

35 mm film

The biggest range of film is made for 35 mm cameras. Double perforated 35 mm wide film comes in a light-tight cassette you load into your camera's empty film compartment with its paler, light-sensitive surface facing the back of the lens. As you take pictures, the film winds onto an open take-up spool within the camera. It therefore has to be rewound back safely into the cassette before you open the camera and remove your exposed film. Never load or remove film in bright light – especially direct sunlight. (The slot in the cassette through which the film protrudes has a velvet lining, but intense light may still penetrate.) Always find a shady area or at least turn away from the sun. Speed, length and type are also encoded in a chequer-board silver pattern on the side of the cassette (Figure 2.45). Electrical contacts inside the film compartment press against this pattern and so read and program the camera's exposure measuring circuit for film speed, etc.

Number of pictures

The standard picture format given by a 35 mm camera is 24 mm × 36 mm, and you can buy cassettes containing sufficient length of film for either 24 or 36 pictures. A few come in 12 exposure lengths.

APS films and cameras

The Advanced Photo System (APS) is a film format that was introduced in 1996 and is now disontinued. APS films are only 24 mm wide, giving negatives slightly over half the area of pictures on 35 mm film. They do not fit 35 mm cameras, and so a whole range of scaled down cameras from compacts to single lens reflex designs have been introduced for APS photography.

APS film when available came in an oval-shaped cartridge (Figure 2.46) that, when inside the camera, opens and pushes out the leading edge of the film to automatically load it. After the last shot is taken the film rewinds automatically and you hand in the cassette for processing. APS film carries a transparent magnetic coating used to record information from your camera to instruct the processing laboratory machinery. For example, a picture shape setting on your camera allows selection of either 'H' format (4:3 ratio), 'widescreen' (9:16 ratio), 'classic' format (2:3) or 'panoramic' 1:3 ratio. This causes the lab printer to crop the particular picture to the shape you selected when framing up your shot.

Emulsion

APS cartridge 35mm cassette

Figure 2.46 APS (Advanced Photo System) catridge (left) and 35 mm film cassette (right).

Manual film loading

Automatic film loading

Figure 2.47 Inserting and loading a 35 mm film into a manual or auto-loading camera. Manual loading instructions: (1) Pull out rewind knob and lay cassette in film chamber. Replace knob. (2) Push film tip fully into take-up spool slot. (3) Wind over enough film to bring both sets of perforations onto teeth. (4) Close camera and wind on two frames before starting to shoot. Auto-loading instructions: (1) Insert film cassette (motor-driven cameras have no rewind knob). (2) Pull out enough film to lay across and touch far end. (3) Close the camera back. The window in the back allows you to read film data off the cassette. (4) Closing triggers film advance and the counter moves from S to 1.

Scanners

Though much of the big hype surrounding digital photography is concentrated on the new camera technologies, the humble desktop scanner is still a great way to convert existing prints or negatives into high-quality digital images. In this section we will look at the features and functions that make a good scanner, as well as the steps involved in making your first scan.

Film and print scanners

For the most part, scanners can be divided into two distinct varieties – print and film.

Print scanners, which are sometimes also called flatbed or reflection scanners, are designed to convert standard photographs into digital images by reflecting light from the surface of the picture onto a sensor. The film variety captures digital information from negative or slide originals. With these machines the image is scanned by passing light through the film to a high-resolution sensor. This process is the reason why these types of devices are sometimes referred to as 'transmission' scanners. The capture process involves recording the color and brightness of the image, converting these values to digital form and then saving the file to computer (see Figures 2.48 and 2.49).

As most negative and slide originals are smaller than their print counterparts, film scanners generally have higher specifications and are therefore more expensive than flatbeds.

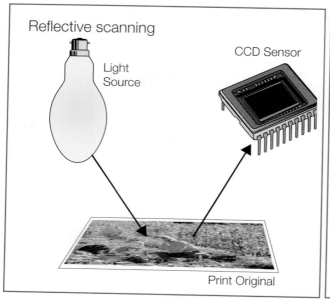

Reflective scanning

CCD Sensor

Light
Source

Print Original

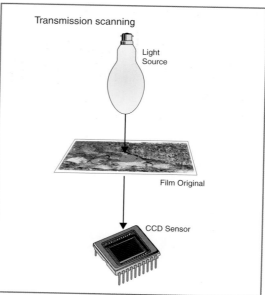

Transmission scanning

Light
Source

Film Original

CCD Sensor

Figure 2.48 Reflective scanners, sometimes called 'flatbeds', are used for prints and documents.

Figure 2.49 Transmission scanners are specially designed for use with negatives and transparencies, and are usually referred to as film scanners.

Figure 2.50 Dedicated film scanners can obtain very good quality results from negative and slide originals.

Figure 2.51 Hybrid film scanners have the advantage of being able to scan prints as well as negatives/slides.

Scanner types

Up until a few years ago, the technology needed to capture each of the photographic media types meant that photographers had to buy two completely different pieces of equipment to handle their prints and negatives/slides. Though it is still possible to buy dedicated print and film scanners, many manufacturers are now producing combination or hybrid products that are capable of capturing both media.

Dedicated film. This device is set up specifically for negative or slide capture. Some models such as those designed specifically for 35mm film are usually restricted to this single format but others such as medium format film scanners can be used with a variety of film size. The hardware is not capable of reflective scanning. If your business involves the repeated capture of images of the one film type, a dedicated scanner is a good investment (see Figure 2.50).

Hybrid. These scanners are capable of both reflective and transmission scanning. This means that both film and print images can be captured by the one device. Starting life as flatbeds with added transparency adapters, these scanners have developed into multi-function devices that are capable

of producing quality files from both types of originals (see Figure 2.51).

Dedicated print. The scanners in this category are the most affordable and easily obtainable of the three types. If you can't afford a digital camera of the quality that you desire and you have loads of prints in boxes lying around the house, then spending a couple of hundred dollars here will have you enhancing high-quality digital versions of your pictures in no time (see Figure 2.52).

Figure 2.52 Print scanners are the most economical way to generate high-quality digital images.

Figure 2.53 The software that controls your scanner will differ from manufacturer to manufacturer and model to model.
1. Document type
2. Scan settings
3. Color, brightness and contrast controls
4. Preview button
5. Scan button
6. Preview image
7. Scan selection marquee

Controlling your scanner

The software that controls the scanner is often called the scanner driver. These programs are supplied by the manufacturers in two forms – stand-alone and plug-in.

The *stand-alone* software is a self-contained program that allows the user to control the scanner settings, capture the image, make some basic adjustments to the digital file and then save the results to disk. If the scanner is capable of automatically scanning several images from the one roll of film then these settings will also be contained here (see Figure 2.53).

The *plug-in* sits between the scanner and your photo editing program. The software is activated from inside a host program by selecting the scanner from the File > Import menu. The plug-in controls the scanner settings and will contain much of the same tools and functions as the stand-alone software. Once the scan is completed rather than saving the file, the plug-in window shuts and you are left with the image in your photo editing program.

Built into the driver software are controls for adjusting the size and the dimensions of the file to be created from the scan. Other features include the ability to control the brightness, contrast and color of the scan. Images can be lightened, color casts eliminated and contrast reduced using these tools. Some scanner software also includes dust and scratch removal, color restoration and descreening (removal of the fine dots from scans taken of magazine photos) features as well.

Figure 2.54 Common scanner parts and features. See text for explanation of numbered items (note that items numbered 8 and 9 in text are not shown here).

Scanner parts

Getting to know your way around your scanner will help you make digital versions of your treasured prints and negatives more quickly and easily.

Many companies provide a printed instruction manual as well as online help files that will introduce you to your scanner's particular functions and features, but here we provide a visual guide to the most common scanner parts and features (see Figure 2.54):

1 *Power button* – used to switch the scanner on and off. Some models do not have a power button, with the unit being turned on and off via the computer.

2 *Quick scan button* – many newer scanners have several one-step buttons at the front of the unit. These are designed to help make the job of everyday scanning quick and easy. The quick scan button creates a scan with a single click.

3 *Copy button* – used to provide a one-step copy or 'scan and print' option for those users who want to make 'photocopies' of documents or papers.

4 *E-mail button* – used to provide a one-step scan and e-mail option for those users who regularly want to send pictures to friends via the web. After the picture is scanned, your e-mail program will open automatically and the picture will be inserted as an attachment to a new message. Simply address and add a few words of explanation and mail away.

5 *Photocopy or direct print button* – a single-step process that scans a picture and then prints it with the press of one button. Some companies provide a little pop-up window, which looks very much like the key pad of

a photocopier to be used with this feature.

6 *Scanning area* – the part of the scanner where your original is placed. This usually takes the form of a glass plate for print scanners or a negative holder for film scanners.

7 *Negative holder* – supports the film as it is scanned. These devices are hinged, with the film inserted and sandwiched between two plastic supports. Care has to be taken so the edges of the holder match up with each of the negative frames.

8 *Power light* – indicates that the scanner is turned on. Some models also use a blinking version of this light as a way to show that a scan is in progress (not shown).

9 *Scanning light* – the light source that illuminates the surface of the print. In film scanners the negative is positioned between the light source and the sensor (not shown).

10 *Power socket* – used to connect power to the scanner. Some units combine the power and computer (data) connection in the one cable and so don't contain a separate power socket.

11 *Computer socket* – connects the scanner to the computer and is used for transferring the picture data. Depending on the scanner model, this connection might be in the form of a USB, Firewire, SCSI or Parallel port socket.

12 *Transparency adapter* – provides a way to scan your negatives using a flatbed or print scanner. These adapters are usually purchased separately as an optional extra. If you have a varied collection of photographs, in both print and negative forms, this type of scanner might be a good option.

Analog to digital

The act of scanning, be it using a flatbed model or one designed for film stock, involves converting continuous tone images into digital files. Photographs in either print or negative (or slide) form contain a range of subtle tones and colors that blend smoothly into each other. These are referred to as continuous tone images. For instance, in a black and white image it is difficult to see where one shade of gray starts and another one finishes. The effect is a smooth transition from the deepest shadows through to delicate highlights.

Computers are clever machines but they have difficulty handling images in this form. So, in order for the photograph to be used in an image manipulation program like Photoshop or Photoshop Elements, it must be changed to a digital file. The file describes the image as a series

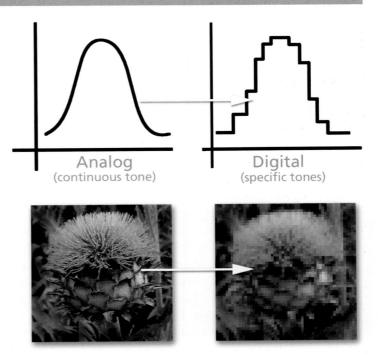

Figure 2.55 Scanners convert continuous tone images such as prints or negatives into the same pixel-based files that we obtain from digital cameras. In this exaggerated detail you can see how individual areas of tone and color are digitized.

of discrete colors and tones. When we scan a negative or slide we make this conversion by sampling the picture at regular intervals. At each sample point, a specific color is chosen to represent the hue found in the original. In this way, a grid of colors is put together to form a digital version of the continuous tone original (see Figure 2.55).

What scanning settings do I use?

Knowing what is the best resolution, or scanning quality, for a particular task can be a daunting question. Some scanning software allows users to pick from a list of output options such as 'web use', 'laser print' and 'photo quality print'. The program then selects the best resolution to suit the selection. This makes the process of selecting easier. If the software that you are using doesn't have this feature use the details in the table below as a starting point.

Table 2.5 Starting points for scanning settings for different image applications.

What the scanned picture will be used for	Print scan quality to produce the same size as the original	Film scan quality of a 35 mm frame to produce a 6 × 8 inch print
Web or screen	72 spi*	600 spi
Draft quality prints	150 spi	1200 spi
Photographic quality prints	200–300 spi	1600 – 2400 spi
Magazine printing	300 spi	2400 spi

* spi stands for Samples Per Inch and refers to the number of times the scanner samples the original (film or print) in the space of an inch. Some scanning software refers to this setting as dots per inch or dpi but this is strictly a setting for printing as it refers to the number of ink dots per inch and shouldn't be used with scanning applications.

Film scanners versus flatbed scanners

The current crop of print or reflection scanners are quality machines that are capable of creating good quality, high-resolution images containing millions of colors. Most mid-range and even some entry-level devices are more than capable of capturing the full range of image content and picture details present in your photographic prints. New, and perhaps tentative, scanner users might find it useful to cut their teeth using economical flatbed technology. This option provides the cheapest way to gain access to the world of digital photography. Despite my comments in the next few sentences, very good results can be obtained from files captured using this type of technology.

Until recently, the cost of most film scanners was out of the range of most desktop imaging budgets, but new technology advancements and more competition in the market now mean that these pieces of kit are more affordable. This fact should have serious digital image makers dancing in the aisles.

Why? Because scanning from film gives you the chance to capture more of what your camera saw when you pressed the button. This is for the simple reason that the information contained in a negative or slide is greater than what can be printed. Some of the detail and spread of tones that was initially captured on your film is lost when it is converted to print.

If you carefully compare a negative and its print you will probably be able to see details in the shadows and highlights that have failed to make it to the print. With careful printing, using

techniques like burning-in and dodging, or split grade filtration, these details can be made more evident, but they will never be recorded as well as they were in the film original. It follows then that a quality film scan will capture more information than the flatbed version made from the print.

Dedicated film scanners have the advantage of being specifically designed for the job of transmission scanning. These units generally can capture high resolution, large numbers of different colors and detail in both highlight and shadow areas. The new range of hybrids have been designed from the ground up as two separate scanners that are then built into the one box. Sure, they use the same scanning head but they are a lot more than a reflective model with an add-on. In this way, manufacturers such as Epson have been able to provide a single solution for both transmission and reflective needs.

Choosing which of type of scanner to buy will be largely dependent on the way that you work, your budget and your existing equipment.

If you don't own a scanner, then a flatbed is a cheap and easy way to get your digital hands dirty. If, on the other hand, you already own a flatbed and regularly shoot one film size such as 35 mm or have hundreds of archived pictures, then a dedicated scanner might be a good investment. For the photographer with a little more to spend, who is looking to buy a first scanner, likes to photograph with a range of film stock (35 mm, 6 cm × 6 cm, 5 in × 4 in) and wants to scan prints as well, then a good quality hybrid scanner will provide a one-unit solution for all scanning needs.

Making your first scan

Use this nine-step guide to help you through the process of making your first scan. Keep in mind that the time you take to adjust your settings correctly at the scanning stage will pay dividends in the production of high-quality digital originals. You should take as much time and care in the scanning process as you would when photographing a great scene. Just as with the photographic process good exposure and color control will ensure that you capture as much of the original as possible.

Step 1: Start the scanner
Some computers won't recognize the scanner unless it is turned on first so make a habit of switching on the scanner before starting the computer.

Step 2: Clean print/negative
Making sure that your negatives/ prints are clean before scanning can save a lot of time spent removing marks from the picture later. Use a soft cloth or a blower brush to remove surface particles before placing the film strip into the holder or the print on the platen and don't forget to clean the glass as well.

Step 3: Place print
Check with your manual to see which way the film or print should be placed in the scanner. For flatbed scanners, place the photograph face down on the glass surface, making sure that the edges are parallel with the scanner's edge. For negatives ensure that you have the film strip the correct way up before inserting.

Step 4: Open the software

Select the scanner name from the Import (Photoshop Elements: File > Import), WIA or Twain menus. Some scanners are supplied with a stand-alone version of this software that you can access from your program's menu without having to open an editing package first.

Step 5: Select media type

For film scanning select the film type – negative or transparency. For prints select Photo or Reflective. Choose the type of the original – color, black and white or line, and resolution. Select the size that you want the picture to be after scanning – this is sometimes called output document or image size and is usually measured in inches or centimeters.

Step 6: Create a preview

To check your settings click on the Preview or Pre-scan button. This will produce a quick, proof, version of the picture. Some scanners perform this function automatically as soon as you select the scanner. This way you are presented with a preview as soon as the scanning software window opens.

Step 7: Select area to scan

Using the selection or marquee tool, drag a rectangle around the part of the preview that you want to scan. This selection box is the boundary between what is included and what is left out of the scan. If the preview is small, making a precise selection difficult, draw the box a little bigger so that it encompasses more of the picture than you need. The excess can be cropped down later in your image editing program.

Step 8: Alter output size

Drawing a selection marquee on the preview will change your output picture size, so it is at this point that you should check that the final size of your scan displayed in the software is still suitable for your needs. If it is too small increase the output dimensions to suit.

Step 9: Adjust brightness, contrast and color

Using the software control tools, change the brightness and contrast of the image. Be sure not to lose subtle dark or light details by making the image too bright/dark or too contrasty. It is also a good idea to eliminate obvious color casts in this part of the process. With all features adjusted click on the Scan button to start the final conversion process.

3 Creative Use of Camera Controls

Each of the camera's technical features introduced in the previous part – lens focusing, shutter, aperture, etc. – is there for two purposes. Firstly, it helps you to get clear, accurately framed and properly exposed pictures of subjects – distant or close, under dim or bright lighting conditions. But each control also has its own creative effect on the image. This allows you some interesting options – in other words, you can choose a particular setting for its creative influence, and then adjust the other controls if necessary to still maintain correct exposure. Clearly, the more controls your camera offers and the wider their range, the more choices you will be able to make. Fully automatic-only cameras work from set programs based on choices set by the manufacturer, but as you will see, even here a measure of control is possible – for example by loading fast or slow film.

Shutter speeds and movement

A shutter set for 1/125 second should safely avoid overall blur due to camera movement when you are trying to hold it stationary in the hand. This setting will also overcome any blurring of slower moving subjects, particularly if some distance away.

If you want to 'freeze' action subjects you will need a camera offering faster shutter speeds. The movements of athletes in most sporting activities can be frozen using a shutter speed of 1/250 second or faster. Cycle races and autocar events will probably need 1/1000 or 1/2000 second to lose all blur, but much depends on the direction of movement and how big the moving subject appears in your picture, as well as its actual speed. Someone running across your picture will record more blurred than the same runner moving directly towards you. Filling up your picture with just part of the figure – by shooting close or using a telephoto lens – again exaggerates movement and needs a shorter shutter speed to freeze detail.

With a manually set camera select a fast shutter setting, then alter the lens aperture until the meter signals that the exposure is correct. On a semi-automatic or multi-mode camera choose 'shutter

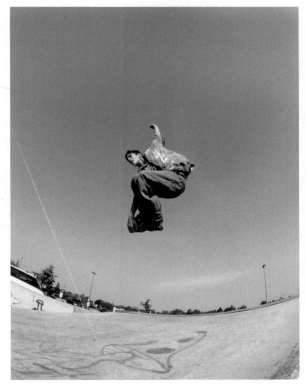

Figure 3.1 Using a fast shutter speed can freeze the movement of subjects in your photographs.

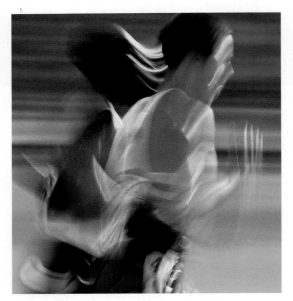

Figure 3.2 In this example you can see how different parts of the runners are more blurred than others, depending on how much they moved during the long shutter speed used for exposure.

priority' ('Tv' or 'S'), pick a fast shutter speed and the camera will do the aperture setting for you. An auto-only camera loaded with fast film will set its briefest shutter speed, in strong light. In fact, shooting on film of between ISO 400 and 1000, or equivalent setting for digital cameras, is advisable with all cameras using briefest shutter settings, to avoid underexposing. If you have a simple, one-fixed-shutter-speed camera, try instead to swing ('pan') the camera in the same direction as the moving subject (see page 236). This can give you a reasonably sharp picture of your subject against a blurred background. Another alternative is to freeze the motion using a short burst of light, such as a flash (see page 145).

Slow shutter speeds, say 1/30 second, or as long as several whole seconds may be necessary just to get a correctly exposed result in dim light, especially with slow film. These longer times also allow you to show moving objects abstracted by different degrees of blur. Look at the blurred runners in Figure 3.2. Notice that different parts of the body show different amounts of blur depending on how much these areas moved during the long exposure. Often, action can be suggested more strongly this way than by recording everything in frozen detail.

Working with these longer exposures, however, means taking extra care to steady the camera, or camera shake will blur everything instead of just those parts of your subject on the move. Figure 3.3 suggests several ways of improving steadiness when using your camera hand-held. Learn to squeeze the shutter release button gently – don't jab it. Even then, if you use settings of 1/30 second or longer, find a table, doorway or post and press the camera firmly against this. With some models your camera may display a 'shake' warning when it automatically selects a slow shutter speed. Be careful too when using a telephoto lens, because the larger image it gives magnifies camera movement, like looking through binoculars. A

Figure 3.3 When using slow shutter speeds it is important to ensure that you keep the camera as steady as possible during the exposure. Here are a few techniques that you can use to make sure that you obtain blur-free photographs.

tripod, or even a clamp, which will secure your camera to the back of a chair, will allow steady exposures of unlimited length. Make sure that the tripod has a pivoting head so you can angle the camera freely before locking it in place (see page 42).

The range of slow shutter speeds offered on many compacts and manually set SLR cameras only goes down to about 1 or 2 seconds. For exposures longer than this, SLRs (and a few compacts) offer a 'B' or time setting. With this feature the shutter stays open for as long as the release button remains pressed, and you time your exposure with a watch.

In practice, it is best to use an extension shutter release (Figure 2.32) to avoid camera shake. Advanced SLR cameras may set timed exposures of 30 seconds or longer. Exposure times of several seconds open up a whole range of blur effects that you can first experiment with and then increasingly control – although results always have an element of the unexpected. Pick something light and sparkling against a dark background. At night fairgrounds, fireworks or simply street lights and moving traffic, make good subjects. Use a low ISO setting (or a slow film) and a small lens aperture so that you can give a long exposure time without overexposing. (Some manual SLR camera meters will not measure exposure for B settings, in which case 'cheat' the meter as described on page 234.)

Focus and aperture

Selectively focusing your camera lens on a chosen part of the subject is a powerful way of drawing attention to it, subduing unwanted details at other distances, and helping to give your picture a sense of depth. In Figures 3.4 and 3.5, for example, emphasis has been switched from the flowers to the background simply by changing the focus setting. Think carefully about where your location of greatest sharpness should be. In portraits, it is best to focus on the eyes; with sports events you might pre-focus on the crossbar of the high jump or just the sports track lane a runner will use.

A manually focused SLR camera allows most scope to actually observe how a particular point of focus makes the whole picture look. With an auto-focusing (AF) camera you will probably need your point of focus filling the auto-focus frame in the your viewfinder (see Figure 3.6). Then, if you want to compose this point off-center, operate the camera's AF lock (often half pressure on the shutter button) to maintain the same focus while you reframe the picture before shooting.

The degree of auto-focusing accuracy your camera will give depends upon the number of 'steps' (settings) it moves through between nearest and furthest

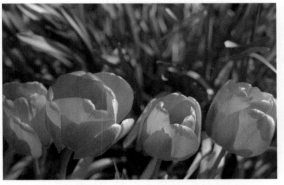

Figure 3.4 Focusing on the flowers only draws the viewer's attention towards this part of the frame. In this way, the photographer can direct the way that his or her audience looks at their pictures.

Figure 3.5 Switching the focus to the background directs the attention to the leaves first, as they are the sharpest part of the picture. This is despite the fact that the flowers are a vibrant color and, for this reason, would usually attract our attention first.

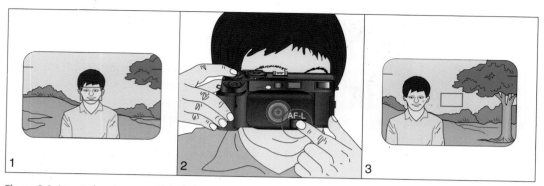

Figure 3.6 An auto-focus camera with AF lock allows you to sharply focus a main subject you compose off-center. (1) First, center the subject in the auto-focus rectangle. (2) Half depress the shutter release to make the lens focus, then operate the AF-L control. (3) Now you can compose the subject anywhere within the frame before shooting.

focusing positions. Fewer than ten is relatively crude; some have over 100. Where a good AF scores most is when faced with a moving target. Here it will adjust continually to maintain your subject in focus as subject distance changes. However, most auto-focusing SLR and advanced compact cameras allow you to change to manual focusing if you prefer to work this way.

Aperture and depth of field

The adjustable size aperture in your lens has an effect on how much of your picture appears sharply focused (see Figure 3.7). The smaller the diameter of the hole (large f-stop number), the greater the range of items, at distances closer or further away, that will appear sharply focused (along with the specific subject that you actually focused on). A photograph with objects spread over a wide range of distances, where all are clearly focused, is said to have a large depth of field.

The opposite to large depth of field (small or shallow depth of field) is created when you photograph a scene using an aperture with a large-diameter hole (small f-stop number). These images generally have a single object sharply focused, with the rest of the image blurry or unsharp. Using a shallow depth of field is a great way to ensure that your audience is concentrating on the part of the picture that you, as the photographer, deem as important.

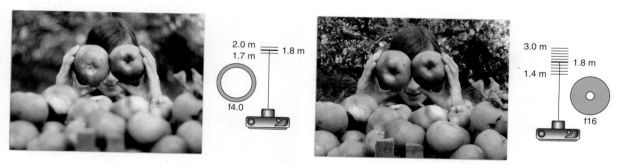

Figure 3.7 The effect of aperture. In both pictures, the lens focus setting remained the same, but changing from f4.0 to f16 greatly increases depth of field. Notice how more of the image appears sharp in the picture on the right which corresponds to more bars in the illustration.

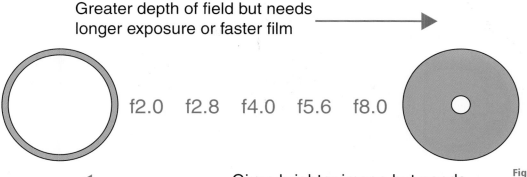

Greater depth of field but needs longer exposure or faster film

f2.0 f2.8 f4.0 f5.6 f8.0

Gives brighter image but needs shorter exposure or slower film

Figure 3.8
F-number aperture settings.

Aperture size is described by an 'f-number', and if your camera lens has manual control this will carry a scale of f-numbers as set out in Figure 3.8. Advanced digital compacts and SLR cameras also display the aperture setting on a small readout screen located on the top of the camera. Unlike the numbers marked on the lens barrel, which represent full f-stop changes, the settings displayed on the small LCD screen often change in part or third of an f-stop jumps.

Notice how the wider the aperture, the lower the f-number. To see this in action, look at the picture of the girl with apples (Figure 3.7). In both shots the lens was focused on the girl's hands. But whereas one picture was taken at a wide aperture (an f-number of f4.0), the other was taken at a small aperture (f16). The f4.0 result has a very shallow depth of field. Only where the lens was focused is really sharp – apples in the foreground and trees in the background are very fuzzy. The other version shows much greater depth of field. Almost everything nearer and further away than the point of focus, the hands, now appears sharp.

Of the two versions, the one on the left works best for this subject because it concentrates your attention on the two apple 'eyes'. The same applies to the edges of the flower's petals shown in Figure 3.10. But on other occasions – the sand dunes shown in Figure 3.9,

Figure 3.9 Using the aperture to control the amount of the picture that appears sharp is a great way to control the look of your image and to direct your viewer's attention to the important parts of the picture. In this photograph, a large depth of field has been used to ensure that detail is sharp from the foreground right into the distance.

Figure 3.10 In contrast, a shallow or small depth of field is employed in this image to ensure that only a portion of the whole photograph is sharp.

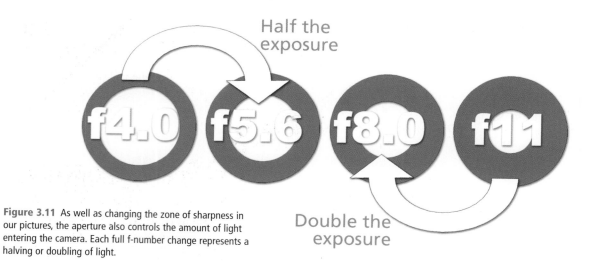

Half the exposure

Double the exposure

Figure 3.11 As well as changing the zone of sharpness in our pictures, the aperture also controls the amount of light entering the camera. Each full f-number change represents a halving or doubling of light.

for example – you may want to show all the pattern and detail clearly from just in front of the camera to the far horizon. So controlling depth of field in a picture by means of the lens aperture setting is a useful creative tool.

As well as changing the zone of sharpness in a picture, each f-number in the series also doubles, or halves, the brightness of the image (see Figure 3.11). The wider the maximum aperture provided by a lens, the more expensive and bulky the lens becomes). A simple fixed-aperture camera may only offer a single aperture of f5.6; many compacts have lenses which 'open up' to f4.5 and 'stop down' to f16. SLR standard lenses may offer a longer range of f-numbers – from f1.8 or f1.4, through to f16 or f22 (see Figure 3.12).

SLR cameras are designed so that you always see the image on the focusing screen with the lens held open at the widest aperture, which is brightest to view and most sensitive to focus. This situation is deceptive, though, if you have set a small aperture – just as you release the shutter the aperture changes to the size you set, so the picture is recorded with far more depth of field

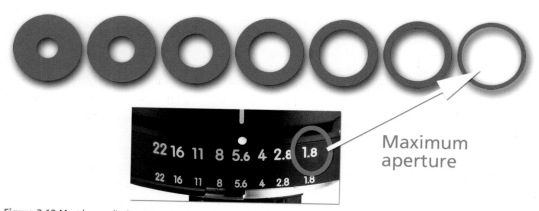

Maximum aperture

Figure 3.12 Most lenses display the available apertures on the barrel of the lens, with the widest aperture (biggest hole) being represented by the smallest f-number.

than you originally saw on the screen. Some single lens reflex cameras have a depth of field preview or 'stop-down button'. Pressing this while you are looking through the viewfinder reduces the aperture size to whatever you have set, so you can visually check exactly which parts of a scene will be sharply recorded. (Although, at the same time, the smaller aperture makes the image on the screen become darker.)

Another way of working, if you have time, is to use the depth of field scale shown on some SLR camera lenses (Figure 3.13). First, sharply focus the nearest important detail – in the example shown, this reads as 3 m on the focusing scale. Next, refocus for the furthest part you also want sharp, which might be 10 m. Then, refer to the depth of field scale to see where to set focus between the two, and what f-number to use in order to embrace both 3 and 10 m – in this case f8.

Many digital camera users have the advantage of being able to preview the results of their aperture selection on the LCD screen immediately after the image is taken.

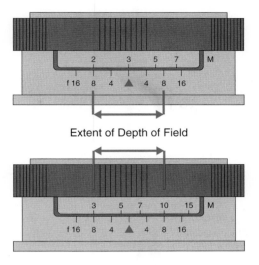

Extent of Depth of Field

Figure 3.13 Depth of field scale on SLR lens. (Top) Lens focus at 3 m; lower scale shows that f8 gives sharpness from 2 m to nearly 6 m. (Bottom) Focus 5.5 m, depth 3–10 m at f8.

Unlike film users, they have the advantage of being able to check their zone of sharpness straight away. Using this preview technique it is possible to shoot a range of images at different aperture settings and, after reviewing the depth of field results in each picture, make a final aperture selection.

Maximum depth of field (see Figure 3.14)

Pictures taken with an automatic-only camera will show greater depth of field with brighter light and/or when fast film is loaded or a high ISO setting is selected in the case of digital cameras. This is because, in these conditions, the camera automatically sets a small aperture (along with brief shutter speed) to avoid overexposure. A simple fixed-focus disposable camera is likely to have its lens set for about 4 m with a fixed aperture of about f8. In this way, you get depth of field from about 2 m to the far horizon. But remember that it remains unchangeable in every shot.

To adjust the depth of field when using a manually focused lens, you should first set the lens for the key element in your picture or, if there is not one, then focus for a distance of about one-third of the way into the scene. So, if the nearest important details are about 2 m (7 ft) and furthest detail 7.5 m (25 ft) from the camera, a difference of 5.5 m (18 ft), set your focus at about 4 m (13 ft). Select your smallest lens aperture (such as f16 or f22), then alter the shutter speed until the meter reads correct exposure.

Using a semi-automatic or multi-mode camera, choose 'aperture priority' ('Av' or 'A'), set the smallest aperture your lens offers and the camera will adjust the shutter speed to suit. In poor light, unless you are using fast film, this may lead you to a slow shutter speed – so be prepared to use a tripod or some other means to steady the camera when you are trying to capture large depth of field images.

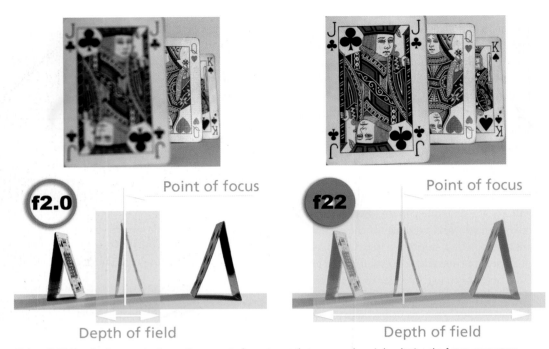

Figure 3.14 The simplest way to change the amount of your image that appears sharp is by altering the f-stop or aperture setting. Choosing a high aperture number will increase your depth of field.

Minimum depth of field

To get minimum depth of field you need a camera with a wide aperture lens and a really accurate method of focusing. But remember, using apertures such as f2 means that a fast shutter speed will probably have to be set, to avoid overexposure. In bright lighting, such as a summer's day, it will be helpful to load slow film (for digital users set a low ISO number) into your camera to account for the big aperture hole.

There are two other methods for creating a shallow depth of field – use a longer focal length lens or move closer to your subject. Changing to a telephoto lens (or setting your zoom control to the longest setting, sometimes marked as 'T') gives less depth of field even if you keep to the same f-number. Remember, however, that this use of shallow, selective focus means there is no margin for error in setting the lens for your chosen subject distance. This is especially true with close-ups or macro subjects, where the depth of field is often measured in millimeters (fractions of an inch). Use Table 3.1 as a quick guide for setting up your camera for either shallow or large depth of field effects.

Table 3.1 Create pictures with shallow or large depth of field effects using the following camera set-ups

DOF effect required	Best aperture numbers	Best focal lengths	Best subject-to-camera distance
Shallow	Low (e.g. f2.0, f2.8)	Longer than standard (e.g. 120 mm)	Close
Large	High (e.g. f22, f32)	Shorter than standard (e.g. 28 mm)	Distant

Depth of Field Guides

For readers whose cameras don't contain a depth of field preview button there is an alternative for working out the where and how big is the zone of focus for particular settings. ExpoAperture2 from ExpoImaging is a handy tool for calculating depth of field. Looking like a circular slide rule the tool can be used in two ways:

- To determine the aperture for a desired depth of field, or

- To determine the depth of field produced by a chosen aperture.

As we have already seen, depth of field is determined by three factors - focal length, subject distance and aperture. So when using the ExpoAperture2 it is this information that you need to set on the disc. In addition, you will also need to select the sensor/film size.

Let's now look at the disc works in action.

Figure 3.15 ExpoAperture2 is a great tool for helping photographers not only predict the zone of sharpness (DOF) in their images but also understand how DOF works.

How to: Determine the aperture needed for a desired DOF

1. On the Focus Zone side select sensor/film size (this is also called the CoC on the dial) See chart below.

2. Select focal length of lens

3. Flip the disc over and select the subject distance (focus distance).

4. Choose the desired depth of field range (i.e. 5' to 7½').

5. Count the depth of alternating gray and white zones that cover the depth of field range (here it is 2 zones).

6. Flip the disc over and locate the number of zones in the gray area.

7. Look immediately above the number of zones to locate the depth of field require to achieve the depth of field desired.

How to: Determine the DOF produced with a specific aperture

1. On the Focus Zone side select the sensor/film size.

2. Select the focal length of the lens.

3. Locate the aperture f-stop on the blue ring.

4. Note the number of zones shown directly beneath the aperture on the gray zone ring (i.e 2 zones).

5. Flip the disc over and locate the subject distance (focus distance).

6. Using the subject distance as the center point count half the zones on either side of the subject distance (in this case 1 zone either side). The range indicated will be the DOF for the specific settings you are using.

Table 3.2 Sample Camera Sensor Circle or Confusion (CoC) reference chart

Camera	Model	CoC	Camera	Model	CoC
Canon	EOS5D	30	Olympus	EVOLT E-500, E-400, E-330	17
	EOS1D	23	Pentax	K10D, K110D, K100D, ist DL2	20
	EOS D30, D60, Rebel	use 1.6x setting	Sigma	SD14, SD10, SD9	17
Nikon	D200, D100, D80, D70, D50	20	Sony	DSLR-A100	20

Choice of exposure

Essentially, giving 'correct' exposure means letting the image formed by the camera lens act sufficiently on your light-sensitive film or digital sensor to give a good quality picture. Good exposure, then, is a balance of neither too much nor too little light falling on the film or sensor. Remember, setting your aperture and shutter speed controls the amount of light entering your camera and therefore the degree of exposure that the film or sensor receives.

Notice in the image series in Figure 3.16 that the picture that is correctly exposed has plenty of detail recorded in both the darkest shadows and the brightest parts of the picture. The picture on the left, however, has been seriously underexposed (received too little light). Dark parts of the picture have been recorded as detail-free black – and appear heavy and featureless when printed. Only the very lightest parts of the image, such as the girl's blouse (on the right), could be said to show as much detail as the correctly exposed version.

In contrast, the picture on the right has been overexposed. So much light has recorded in the highlight (lightest) parts of the subject they appear white and 'burnt out' on the print. Only the hair area shows the same detail that was evident in the correctly exposed shot.

To summarize, too much exposure and delicate light shades or highlight details in the image are lost, too little light and subtle shadow tones are converted to pure black. This is true for both digital and film-based images. When you are shooting slides the same final differences apply, although there are no negatives involved.

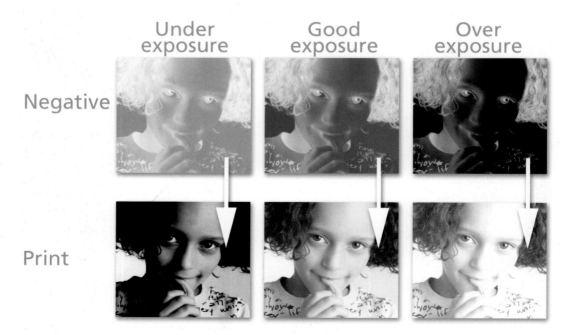

Figure 3.16 Correct or good exposure produces good prints. Images that are overexposed (too much light) or underexposed (too little light) result in prints with poorer image quality. Overexposure causes the highlights in the print to burn out and lose detail. Underexposure produces the reverse effect, losing detail in the shadow area.

The exposure controls

Most cameras make settings that will give correctly exposed results by:

1 Knowing the ISO speed rating of the film you have loaded or ISO setting you have selected.
2 Measuring the brightness of the subject you are photographing.
3 Setting a suitable combination of shutter speed and aperture, either directly or by signalling when you have manually made the right settings.

The simplest film cameras have no exposure adjustments and they expect you to load an appropriately fast or slow film for your lighting conditions (page 53), then rely on the ability of modern films to give prints of fair quality even when slightly over- or underexposed.

If you are using a manual SLR, you point the camera at your subject and alter either the shutter speed or lens aperture until a 'correct exposure' signal is shown in the viewfinder. Being able to choose aperture and/or shutter speed is like filling a bowl of water either by using a fully open tap (big aperture hole) for a short time (fast shutter speed) or a dribbling tap (small aperture hole) for a long time (slow shutter speed). Figures 3.17 and 3.18, for example, are both correctly exposed although one had 1/30 second at f2.8 and the other 1 second at f16.

The f-numbers associated with aperture sizes on your lens are set out in a special series, where each change in number represents a doubling or halving of the light entering the camera. Each change to a higher f-number halves the light, so f16 lets in only one-thirtieth of the light let in by f2.8, five settings up the scale. The pictures differ greatly, though, in other ways. Figure

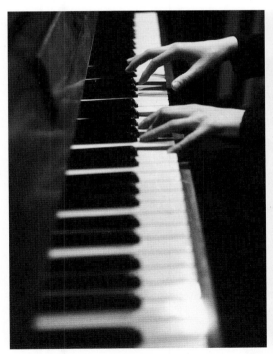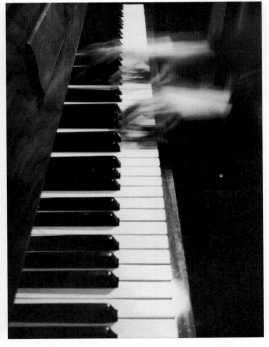

Figures 3.17 and 3.18 Metering will tell you how the f-numbers and shutter speeds line up. Left picture: 1/30 second at f2.8. Right picture: 1 second at f16. Both are correctly exposed but very different in appearance.

3.17 has very little depth of field but frozen hand movements; Figure 3.18 shows nearly all the keys in focus but the moving hands have blurred during the slow exposure.

A fully automatic camera makes settings according to a built-in program or mode. This might start at 1/1000 second at f16 for a very brightly lit scene then, if the light progressively dims, changes to 1/500 second at f16, and 1/500 second at f11, 1/250 second at f11 . . . and so on, alternating shutter speed and aperture changes to account for the changing light conditions. Such an automatic program would never give results like either Figure 3.17 or Figure 3.18. It is more likely to set 1/8 second at f5.6.

If your camera, like most compacts, is fully automatic only you will always get maximum depth of field (combined with freezing of movement) in brightest light, especially if fast film is loaded. This is why multi-mode cameras, mainly SLRs and advanced compacts, also offer aperture priority mode, allowing you to set the f-number and so control depth of field. Alternatively, by selecting shutter priority mode you can choose and set shutter speed to control blur.

Advanced cameras may contain more than one fully automatic program designed to make intelligent exposure setting decisions for you. For example, when you change to a telephoto lens the program alters to a set-up using the aperture mostly to adjust exposure, leaving the shutter working at its faster speed to counteract the extra camera shake risk from a long focal length. Other models contain specialist shooting modes that alter the camera's set-up to suit a range of photographic situations – portrait, sunset, landscape, action, etc.

Standard shooting modes

(see Figure 3.19)

These basic modes can be found on all but the most basic or entry-level film and digital cameras, and determine how the camera sets the correct aperture and shutter speed settings from the light available in the scene.

- *Auto or Program* – the camera determines the shutter and aperture settings automatically based on the light in the scene.

- *Shutter priority* – the shutter speed is set by the photographer and the camera adjusts the aperture automatically to suit the light in the scene.

- *Aperture priority* – the aperture is set by the photographer and the camera adjusts the shutter speed automatically to suit the light in the scene.

- *Manual* – both the shutter speed and the aperture are set by the photographer.

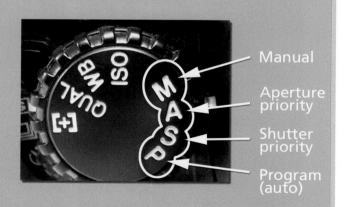

Figure 3.19 The four basic shooting modes, found on many cameras as standard, provide different approaches for the setting of the camera's aperture and shutter speed to suit the light in the scene. Manual provides the photographer with the most control and the Auto or Program setting the least. Aperture and Shutter priority allow the photographer to determine one aspect of the exposure combination (shutter speed and aperture) with the camera automatically adjusting the other.

Measuring the light

Some compact cameras have a small, separate window next to the viewfinder. This window holds a sensor that responds to light reaching it from the whole of the scene you can see in the camera viewfinder. Most models, however, use a sensor that averages the light as it passes through the lens. These so-called 'general' light readings are accurate enough for average subjects, such as those in Figures 3.20 and 3.21. In both photographs, the areas taken up by dark parts are roughly equal to the areas occupied by the brightest parts, with the rest of the scene in tones approximately halfway between the two. A general reading of the whole lot averages out all these differences, and the camera settings that are made have produced an exposure that is a good compromise for everything in the picture.

Figure 3.20 In this photograph, a general light reading works well as all the elements included in the scene combine to form a balance of light and dark tones.

Contrasty subjects

Simply averaging the whole subject area in this way is not suitable for all subjects. Sometimes this approach can let you down, especially when the subject is full of mainly dark or light subjects.

For instance, an overall reading of the scene will not work if you want to shoot a picture, such as Figure 3.22, where the majority of the picture is filled with the light background. A general reading here would have been over-

Figure 3.21 Despite the light background in this photograph, when all the picture parts are averaged with a general light reading, detail is held throughout.

Figure 3.22 General light readings are not suitable for scenes containing large areas of light or dark tones, as these picture parts will overly influence the final exposure settings. To maintain detail in the face in this photograph, you need to alter the aperture and shutter speed selected by the camera to add extra exposure.

Figure 3.23 Using settings based on a general light reading only will cause the important face detail in this example to be too dark in the final photograph. Here we see how the camera's meter has overcompensated for the bright white background, making the whole photograph too dark.

influenced by the (unimportant) lighter background, averaging out the scene as quite bright, and so providing settings which underexpose the girl's face. The result might even be a black, featureless silhouette such as Figure 3.23, as the camera does not know that detail in the girl's face is vital. Much the same thing can happen if you are photographing a room interior by existing light, and include a bright window.

In pictures like Figure 3.24, you meet the opposite problem. A general reading here would be influenced by the large shadowy dark areas that form the majority of the picture. It would cause the camera to select settings that would render the lighter areas, and the delicate details they contain, overexposed and bleached out. With the correct exposure, the camera indicated exposure less 1.5 stops, the picture maintains the original feeling of the lighting whilst keeping detail throughout all the important areas.

If your automatic camera has an exposure lock, you can first tilt the camera towards the area that you want to expose correctly so that the entire frame is filled. Then, by pressing the shutter

halfway down or pushing the exposure lock button, the light reading is memorized and does not change when you compose the shot as you originally intended (see Figure 3.25).

With a camera set to manual mode you should use the same frame-filling procedure, adjust aperture or shutter speed to get a 'correct exposure' signal, and keep to these settings (even though over- or underexposure may be indicated when you recompose).

Automatic cameras with an 'exposure compensation' control will also allow you to override the aperture or shutter speed values and allow an increase or decrease of the overall exposure from that suggested by the camera's meter. To double the exposure, for scenes with predominantly light subjects, you change the setting to '+1'. To reduce the exposure by half for scenes filled with dark objects, adjust the feature to '−1'.

Most entry-level cameras use a so-called 'center-weighted' light measurement, designed to take more account of the broad central part of the picture, where the majority of main subjects are deemed to be placed. Advanced compacts and many SLRs offer a 'multi-pattern' form of metering light. Measurements are taken from several parts of the picture and the camera then calculates the exposure from the variety of brightnesses in the scene. The more sophisticated versions of this system also take into account which segments should most influence the exposure for a given scene. This 'matrix' metering mode

Figure 3.24 In this dark and moody portrait, the camera's meter is confronted with the opposite problem. A general light reading will cause the resultant photograph to be recorded as too light. Adjusting the camera settings so that it uses 1.5 stops less exposure maintains the dark and moody feel.

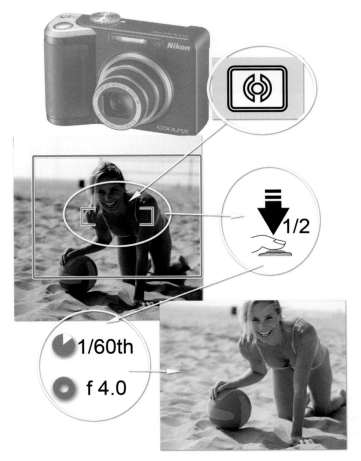

Figure 3.25 By pressing down the shutter button halfway it is possible, with many cameras, to lock the exposure settings used to capture a scene. As the metering system will try to average the scene's tones to match a mid-gray, photographers should carefully choose the parts of the picture that they use as exposure references. Pick a subject that is too dark and the picture will be overexposed. Use a section of the scene that is too light and the image will be underexposed.

provides the most accurate exposure measurements for the majority of scenes and should be the mode that you keep as the default on your camera.

Some models also contain a 'spot' reading mode, whereby just a tiny area, shown centrally in the focusing screen, measures the light. You can position this over any key part, such as a face, even when some way off. A spot reading is very accurate and convenient, provided you don't let it stray to a completely wrong part of the scene.

Figure 3.26 To ensure that your sunset shots are not recorded as too light and washed out, tilt the camera towards the sky to take your exposure reading first before recomposing. This way, the dark foreground detail will not affect the overall exposure of the picture.

Deciding priorities

It is important to learn to recognize situations where special care over the way the light is read will greatly improve a shot.

For instance, in situations where the sun is lighting a small but important portion of a distant scene, you can overcome the meter's tendency to suit the exposure for the general view by temporarily filling the viewfinder with a similarly lit subject close at hand. Using a similar approach, you can measure the exposure for people's faces by reading off the back of your own hand (as long as both subjects have the same lighting and skin tone) and adding an extra stop of exposure. The extra stop accounts for the difference between most caucasion skin tones and the middle gray value that camera meters are calibrated for. If your camera is equipped with a zoom lens, then it may also be possible to zoom in to take a reading from the important area of the scene and then zoom back to take the photograph.

Sunsets against tree shapes are often disappointingly colorless when exposure is measured by a general reading. For Figure 3.26, the camera was first angled so only sky filled the frame to make the exposure reading. Even when you make use of an exposure technique like this, it is best to take several shots of contrasty situations, 'bracketing' your exposure settings, i.e. use the exposure override or aperture or shutter settings to give twice and/or one-half the metered exposure.

Digital shooters, on the other hand, can use a shoot and review approach, checking the exposure of the picture just taken on the preview screen on the back of the camera, to ensure the correct settings have been used before proceeding.

Film users will need to make sure that contrasty pictures like these are followed up with sympathetic printing by your processing lab. Otherwise, the lab could strain to 'correct' the very effect you wanted to produce. If necessary, ask for a reprint, explaining what you were aiming for.

Seven Commandments for better exposure

Use the following Exposure Commandments list as a guide to making better exposures.

camera viewfinder

NORMAL
(24)

P 1/125 F5.6

shutter speed aperture

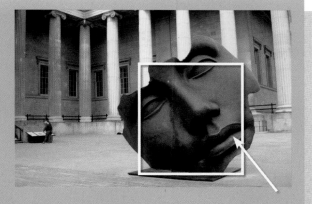

1. Use the camera as a guide.

The metering system in your camera is a very sophisticated device and for the most part your camera will choose the right exposure settings for a scene. All but the most basic models will allow you to see the settings for shutter and aperture in the viewfinder or on the LCD screen. Start to take notice of these settings and recognize how your camera reacts to different lighting situations.

2. Fill the frame with your subject.

Most meters use the subject that is in the center of the frame as a guide for the exposure of the whole image. A good way to ensure that your image is well exposed is to make sure the most important parts of the picture feature in the center of the frame and are therefore used to calculate exposure. Be warned though, filling the center of the frame on all occasions for the sake of good exposure can lead to monotonous symmetrically balanced compositions.

3. Off-center can mean bad exposure.

In wanting to be more creative with your compositions you may wish to try designing the frame with your subject a little off-center. Doing this may help the look of your images but your exposures may suffer. To solve this it is helpful to know that most cameras have the ability to lock exposure (and focus) by pushing down the shutter button halfway. For the situation where you want to create an off-center shot, point your camera at the subject and press the button halfway and then, without removing your finger, recompose the picture before pushing the button down fully to expose the photograph.

using the recommended decreasing exposure
exposure setting by 1 stop

4. Watch out for dark subjects.

The camera's meter works on averages. When you point your lens at a scene the meter averages the various colors, tones and brightnesses in that scene to a mid-gray. The shutter speed and aperture recommended by the camera is based on reproducing this mid-gray. Now for most multi-

colored scenes this is a good approach but in special circumstances it just doesn't work. Mostly dark subjects is just such a scene. Here the camera will try to suggest using settings that will result in the picture being too light (overexposed). Knowing this you can adjust your settings to compensate. Simply increase your shutter speed setting by one, or two speeds, or close down your aperture by a couple of f-stops. The amount you will need to alter these settings will be determined by your scene, but the beauty of digital is that you can preview your results straight away and reshoot if necessary.

colored subjects. Leave the camera to its own devices and you will end up with muddy, under-exposed (too dark) pictures. The solution is to add more exposure than what is recommended by the camera. You can do this manually as detailed in Commandment 4 or try using the Exposure Compensation feature on your camera. Usually labelled with a small plus and minus sign, this feature allows you to add of subtract exposure by simply pressing and turning the command dial. The change in exposure is expressed in fractions of f-stops. For the beach and snow scenes add 1.0 or 1.5 stops using this control.

using the recommended setting

adding 1.5 stops exposure

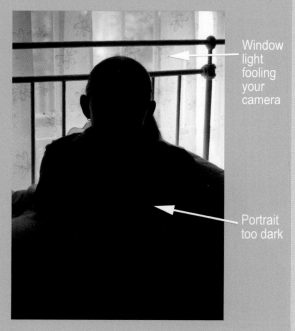

Window light fooling your camera

Portrait too dark

5. Keep an eye on light color scenes.
For the same reason you should always be wary of light colored scenes as well. Prime examples are the type of images that we all take on holidays to the beach or the snow fields. Most pictures in these environments contain large areas of lightly

6. Be careful of backlighting.
A nice portrait taken in front of an open window with a beautiful vista in the distance sounds like the scenario for a great photograph, but often the results are not the vision of loveliness that we expected. The person is too dark and in some cases is even a silhouette. Now this is not necessarily a bad thing, unless of course you actually wanted to see their face. Again your meter has been fooled.

The light streaming in the window and surrounding the sitter has caused the meter to recommend using a shutter speed and aperture combination that cause the image to be underexposed. To rectify this increase the amount of light entering the camera either manually, or with your camera's exposure compensation feature. Shoot the portrait again and preview the results on screen. If need be change the settings and shoot again.

7. Histograms to the rescue.

Being able to preview your work immediately on the LCD panel on the back of your camera is a real bonus for digital photographers. This means that a lot of the exposure mistakes made during the days when 'film was king' can be avoided via a simple check of the picture. Any under- or over-exposure problems can be compensated for on the spot and the image reshot. But let's not stop there. Many cameras also contain a built-in graphing function that can actually display the spread of tones in your image. This graph, usually called a histogram, can be used to quickly and easily diagnose exposure problems. A bump of pixels to the right-hand end of the graph means an underexposed picture, a bump to the left end means overexposure.

Changing focal length

As well as providing a way for the light (and image) to be focused onto the sensor or film, the lens on the front of your camera also has a creative side. The creative controls your camera lens offers include:

- focus control (allowing a sharp image of things at your main subject distance, and so giving them emphasis); and
- aperture control (allowing changes in depth of field as well as helping to control the amount of exposure).

Figure 3.27 The focal length of the lens you use (or the zoom setting you pick) determines how much of the scene will fill your camera's viewfinder. Long or telephoto lenses magnify distant parts of the view, whereas wide-angle lenses are used to encompass as much of the vista as possible.

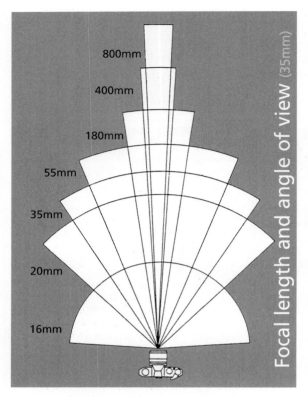

800mm

400mm

180mm

55mm

35mm

20mm

16mm

Focal length and angle of view (35mm)

Figure 3.28 The angle of view of a lens is a measure of the amount of the scene that a lens includes in the photograph. Wide-angle lenses have a small focal length but a large angle of view; long lenses are the opposite.

But your camera offers a third possibility, which is to alter its lens focal length. When you change focal length you alter the image size. This makes a difference to how much of your subject the camera now 'gets into the frame'.

Two practical advantages stem from changing the focal length of the lens that you use:

1 You can fill up the frame without having to move closer or further away from your subject.
2 The perspective, or look, of your picture can be altered by changing your subject distance and altering focal length.

'Normal' focal length

A normal (or 'standard') lens for a film-based 35 mm SLR camera has a focal length of 50 mm. On a 35 mm compact, a lens of 35 mm focal length or less is often fitted as standard, mainly for space-saving reasons. These lenses give an angle of view of 46° or 60° respectively. A 50 mm lens is accepted as making the images of objects at different distances in a scene appear in about the same proportions as seen in real life (judged from a typical size final print held at reading distance).

Changing to a lens of longer focal length (also described as a telephoto lens) makes the image bigger. So you have a narrower angle of view and fill up your picture with only part of the scene. A change to a shorter focal length (a wider angle lens) has the opposite effects (see Figures 3.27 and 3.28). But beware, the more extreme these changes are from normal focal length, the more unnatural the sizes and shapes of objects at different distances in your picture begin to appear.

Normal lenses and digital cameras

One of the factors that determines what is a standard lens is the size of the film or sensor in relation to the focal length of the lens. As most digital cameras have a sensor size that is smaller than a 35 mm frame, normal lenses for these cameras tend to have focal lengths shorter than 50 mm. This is even true for the SLR digital cameras that use the same lenses as the film camera version. To accurately compare the perspective of digital camera lenses, look for values that indicate the lens's '35 mm comparative' focal length. This converts the actual lens size to its equivalent on a 35 mm film camera.

In addition, knowing the Lens Multiplication Factor for a specific DSLR camera will enable you to calculate the difference in angle of view that results from using a sensor that is smaller in physical dimensions than a 35 mm frame. For instance, the multiplication factor for most Nikon DSLR cameras is 1.5. This means that if I attached a lens that would be considered standard

when shooting film – 50 mm – it will provide the angle of view equivalent to a 75 mm lens (50 mm × 1.5 = 75 mm) when used with a Nikon DSLR camera. This means that if I need a lens that will work as a normal lens on a Nikon DSLR then you will need to select a wider than normal lens to suit, i.e. a 35 mm lens on a digital DSLR has the same angle of view as a 52.5 mm lens on a film body.

Use the Lens Multiplication Factors listed in Table 3.3 as a guide to the angle of view changes with different lens and body combinations.

DSLR Camera	Lens Multiplication Factor	Equivalent lens length for a 50 mm standard lens on a film camera body
Canon EOS-30D	1.6	80 mm
Canon EOS-1D Mark II	1.3	65 mm
Canon EOS-1Ds Mark II	1.0 (full frame sensor)	50 mm
Canon 5D	1.0 (full frame sensor)	50 mm
Canon 400D	1.6	80 mm
Fujifilm FinePix S3	1.5	75 mm
Nikon D200	1.5	75 mm
Nikon D80	1.5	75 mm
Nikon D2Xs	1.5	75 mm
Nikon D40	1.5	75 mm
Sony A100	1.5	75 mm
Pentax K100D	1.5	75 mm

Table 3.3 The angle of view of lenses changes when they are attached to digital camera bodies which use a sensor that is smaller than a 35 mm film frame. Camera manufacturers commonly publish Lens Multiplication Factors to help users determine the changed angle of view compared to how it will appear when the lens is used with a film body. This table details the Lens Multiplication Factor for common camera models.

How changes are made

Compact cameras have non-removable lenses, so changes of focal length have to take place internally. Most compacts have a zoom lens, meaning it will change focal length in steps or by smooth continuous movement, which is usually powered by a motor. Pressing a 'T' (telephoto) button progressively increases focal length and narrows the angle of view. Pressing 'W' (wide angle) has the opposite effect. The zoom range, as written on the lens rim, might be 35–70 mm. This lens makes image details twice as large at 70 mm than at 35 mm and is described as a 2× zoom. The compact's viewfinder optics zoom at the same time, to show how much your picture now includes.

Single lens reflex cameras have detachable lenses. You might start off with a normal 50 mm lens, which combines a large maximum aperture (f1.8) and a very reasonable price (because of the large numbers made). This normal lens can be interchanged with any of a very wide range of wide-angle or telephoto fixed focal length lenses. They could include anything from an extreme 8 mm fish-eye (see Figure 3.28) through to an extreme 1000 mm super telephoto. Alternatively, the most popular lens that you can attach to your SLR is a variable zoom lens, where the focal length is controlled by a ring on the lens mount. Most SLR cameras are supplied with this type of lens as the default (see Figure 3.29).

Zoom lenses can cover a middle range (35–70 mm) or a tele zoom (70–210 mm, for example) or wide-angle range (18–35 mm). More recently, some manufacturers have even started to produce super-zooms that can cover a focal range as broad as 28–200 mm. Bear in mind, though, that general, non-professional, versions of these lenses – zooms, wide-angles or telephotos – tend to offer a maximum aperture of only f3.5 or f4 at best. Zooms and telephotos are also bigger and heavier than normal fixed focal length types. Professional models offer better maximum apertures but at a price and weight premium.

All this said, one of the real advantages of using a zoom lens with an SLR camera is the fact that any changes in focal length, depth of field and image size are all accurately seen in the viewfinder, thanks to the SLR camera's optical system and for some models, the Live View feature, which displays the scene directly on the camera's LCD screen.

Using a longer focal length

A very useful reason for changing to a longer focal length telephoto lens is so that you can keep your distance from the subject and yet still make it fill your picture. In portraiture photography, changing to 70 or 100 mm allows you to take a head-and-shoulders type photograph without being so overbearingly close that you make the person self-conscious, or creating steepened perspective which distorts the face. Candid

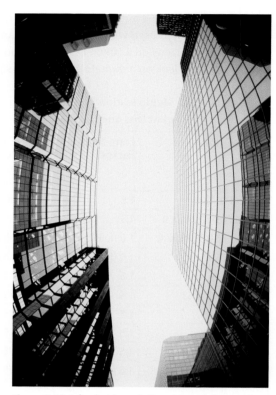

Figure 3.29 A fixed wide- and ultra-wide-angle lens can be added to many cameras and produces dramatic images displaying highly exaggerated perspective.

Figure 3.30 Fixed focal length lenses provide a single angle of view and are less popular than zoom lenses, which can be adjusted to provide a variety of focal lengths and therefore angles of view.

Zoom lens or variable focal length lens - 24mm - 85mm

Fixed focal length lens - 50mm

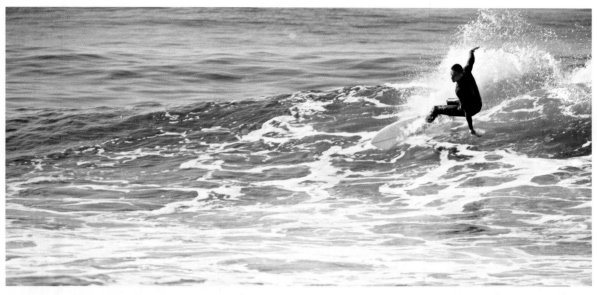

Figure 3.31 Long lenses are great for capturing close-up versions of distant scenes.

shots of children or animals are more easily shot with a 135 or 150 mm focal length lens from a greater distance, where you can keep out of their way. At sports events too, you are seldom permitted to approach close enough to capture action details with a normal lens. Both here and when photographing animals or birds in the wild, a lens of 210 mm or longer is worthwhile (see Figure 3.31).

Long focal length lenses are also useful for picking out high-up, inaccessible details in monuments or architecture, or to shoot a landscape from a distance so that mountains on the horizon look relatively large and more dominant.

Remember, however, that longer focal length means less depth of field, so you must be very exact with your focusing. The more magnified image also calls for greater care to avoid camera shake than when using the normal focal length. So keep a tripod handy to help steady those zoomed-in photographs.

Using a shorter focal length

Zooming or changing to a shorter, wider angle, focal length (28 mm, for example) is especially useful when you are photographing in a tight space – perhaps showing a building or the interior of a room – without being able to move back far enough to get it all in with a normal lens. It will also allow you to include sweeping foregrounds in shots of architecture or landscape. The differences in scale between things close to you and objects furthest away are more exaggerated with wide lenses (see Figures 3.32 and 3.33). This effect can make people seem grotesque, even menacing. When you use lenses of 24 mm or shorter they begin to distort shapes, particularly near the corners of your picture. Another change you will notice when using a short focal length lens is the extra depth of field it gives, relative to a normal or a telephoto lens used at the same f-number setting.

Figure 3.32 Wide-angle lenses provide quite a different perspective, making close subjects appear large in the frame and distant image parts much smaller.

Figure 3.33 The wider the lens, the more dramatic the exaggerated perspective effect becomes. This is the reason why these lenses are not recommended for portrait photography and should be used with care for images where it is important not to show the type of distortion evident here.

Controlling perspective

It used to be said that the camera cannot lie, but using different focal length lenses you have almost as much freedom to control perspective in a photograph as an artist has when drawing by hand. Perspective is an important way of implying depth, as well as height and width, in a two-dimensional picture. A photograph of a scene such as a landscape shows elements smaller and closer together towards the far distance, and parallel lines seem to taper towards the background. The more steeply such lines appear to converge (the greater the difference in scale), the deeper a picture seems to the eye and the greater visual depth.

As Figure 3.34 shows, it's all a matter of relative distances. Suppose you photograph (or just look) at someone from a close viewpoint so that their hands are only half as far from you as their face. Instead of hands and face being about equal in size, normal human proportions, the hands look twice as big.

Perspective is steep. But if you move much further back, your distance from both hands and face becomes more equal. Hands are only 1.2 times as big as the face. Perspective is flattened. Of

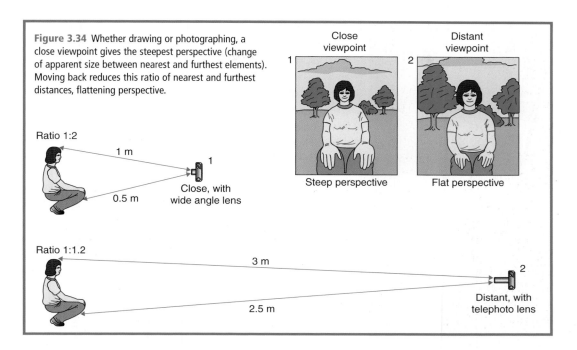

Figure 3.34 Whether drawing or photographing, a close viewpoint gives the steepest perspective (change of apparent size between nearest and furthest elements). Moving back reduces this ratio of nearest and furthest distances, flattening perspective.

Close viewpoint
1
Steep perspective

Distant viewpoint
2
Flat perspective

Ratio 1:2
1 m
0.5 m
1
Close, with wide angle lens

Ratio 1:1.2
3 m
2.5 m
2
Distant, with telephoto lens

course, being further away too, everything is imaged smaller – but by changing to a longer focal length lens you can fill up your picture again.

So to steepen perspective the rule is to move closer and then get everything in by either zooming to wide or changing to a wide-angle lens. A shot like Figure 3.35 makes you feel close to the person with the hat and distant from the cottage across the river. It was shot using a 35 mm lens with the camera some 10 m from the fenced tree. In Figure 3.36, the camera was moved to three times this distance and then the lens changed to a 100 mm to restore the tree to about its previous image size. But look what has happened to the cottage and the seated figure! There is now much less scale difference between foreground and background elements. With the camera further away, perspective has been flattened (painters would call this 'foreshortening') and the photograph has a cramped-up feel. Figure 3.37 also makes use of this foreshortening technique to flatten the distance between the two buildings in the picture.

Figure 3.35 Changing both distance and focal length.

Figure 3.36 Changing both distance and focal length.

Extremely short or long focal length lenses give results so unlike human vision they are really special effects devices. Figure 3.38, shot with an 8 mm fish-eye lens on an SLR, demonstrates its extreme depth of field as well as plenty of distortion (the building behind was one long straight wall). Lenses of this kind are very expensive, but lower cost 'fish-eye attachments' that fit over the front of a normal lens provide a more affordable option.

Figure 3.37 Longer lenses flatten the distance between the subjects in a scene. Here the buildings almost look as if they are sitting right next to each other rather than across the street.

Figure 3.38 Fish-eye lenses (or lens attachments) provide a highly distorted view of scenes that with some lenses equals a 180° view. Notice also the large depth of field produced by virtue of the fact that this is an ultra-wide-angle lens.

Set for digital success

Along with swapping film for a sensor, shooting with a digital camera also includes the ability to change a variety of in-camera capture settings that aren't available to film shooters. In particular, digital camera users can modify the following capture characteristics on a frame-by-frame basis:

- **Color strength** – Options for altering the vibrancy or saturation of the color recorded.
- **White balance** – The ability to match the color of the light source in the scene with the way that the camera processes the color in order to achieve cast-free photos.
- **Contrast** – Controls for adjusting the contrast of the tones recorded.
- **Sharpening** – The ability to apply sharpening filters to photos during the capture and save process.
- **ISO sensitivity** – Changes the ability of the camera to record images in low light situations or when using very fast shutter speeds or small apertures.
- **Noise reduction** – Reduces the appearance of noise in high ISO or long exposure images.

Understanding how these 'digital only' capture characteristics work and the impact that they have on your image making is key to helping you create the best images that you can. This section introduces these controls and guides you through their use.

Altering color saturation

The saturation, or vividness, of color within your images can either make, or break, them. Sometimes color is the cornerstone of a picture, providing both the focal point and design for the whole image. In these circumstances, desaturated or pastel hues will only serve to weaken the strength of the picture. In contrast, strong color elements can distract from important subject matter, causing the viewer to concentrate on the color rather than elsewhere in the image.

Digital shooters can take more control of the color content of their images by selecting just how dominant or vivid the hues will be in their pictures. For shots that rely on color the vividness can be increased, for those that work more effectively with subdued hues, the color strength can be reduced by way of the camera's 'saturation' control. The effectiveness or suitability of each setting should be previewed and, if necessary, several images with different color settings can be captured and the final choice made later. Though not as critical for retention of details as the contrast settings, it is important to capture as much color information as possible when shooting. This does not mean that you shoot all subjects with maximum saturation, it is just a reminder that if color is important consider changing the saturation settings to suit your needs and your objectives (see Figure 3.39).

Many digital photographers leave the saturation setting at normal, preferring to adjust the strength of the color back at the desktop. This is especially true of black and white shooters who capture in color and then convert to gray using image editing software such as Photoshop or Photoshop Elements.

Color strength

On most cameras you have the following saturation options:

Maximum – to produce vivid color in your images,

Normal – capture standard colors that are not boosted or reduced, good for most circumstances,

Moderate – to create a picture with a slight reduction in color strength,

Minimum – used to create low saturation color photographs, and some models also have

Black and White – or more correctly no color produced by reducing the color saturation so much that only the tone remains, and

Sepia – a simulation of the brown toned monochrome images of old.

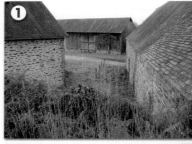
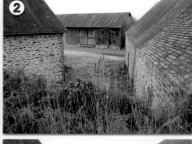
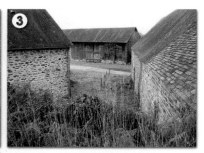

Figure 3.39 Adjusting the saturation in your image will change the strength of its colors. Reducing the saturation to zero will produce a black and white image, increasing the color strength to maximum will create a vivid picture. Some cameras even have the option to record the picture as a tinted monochrome like an old sepia print. (1) Minimum. (2) Normal. (3) Maximum. (4) Sepia. (5) Black and White.

White Balance options

Most mid- to high-end digital compacts as well as all DSLR cameras provide a vast array of White Balance options that should have you shooting 'cast free' in any lighting conditions. The selections include:

- Auto,
- Fine or Daylight,
- Incandescent,
- Fluorescent,
- Cloudy,
- Speedlight or Flash, and
- White Balance Preset or Custom setting.

Balancing the color of light

Our eyes are extremely complex and sophisticated imaging devices. Without us even being aware they adjust automatically to changes in light, color and level. For instance, when we view a piece of white paper outside on a cloudy day, indoors under a household bulb or at work with fluorescent lights, the paper appears white. Without realizing it our eyes have adapted to each different light source. Unfortunately digital sensors are not as clever. If I photographed the piece of paper under the same lighting conditions, the pictures would all display a different color cast. Under fluorescent lights the paper would appear green, lit by the household bulb (incandescent) it would look yellow and when photographed under cloudy conditions it would be a little blue. This situation occurs because the default settings of camera sensors are designed to record images without casts in daylight only. As the color balance of the light for our three examples is different to daylight – that is, some parts of the spectrum are stronger and more dominant than others – the pictures record with a cast. The color of the light source illuminating the subject in your picture determines the cast that will result.

Traditional shooters have been aware of this problem for years and because of the limitations of film, most photographers carried a range of color conversion filters to help change the light source to suit the film – tungsten light to daylight film, fluorescent light to daylight film, etc. Digital camera producers, on the other hand, are addressing the problem by including 'White Balance' functions in their designs. These features adjust the captured image to suit the lighting conditions it was photographed under. The most basic models usually provide automatic white balancing, but it is when you start to use some of the more sophisticated models that the choices for white balance correction can become a little confusing.

Shot 1 -Selected WB

Shot 2 - + Red

Shot 3 - + Blue

Figure 3.40 The White Balance Bracketing features available in some cameras capture several images with different settings, giving you the opportunity to select the best result back at the desktop.

Auto white balance

The Auto white balance function assesses the color of the light in the general environment and attempts to neutralize the midtones of the image. As with most 'auto' camera features, this setting works well for the majority of 'normal' scenarios. The feature does a great job with scenes that contain a range of colors and tones, but you may strike some difficulty, with subjects that are predominantly one color, or are lit from behind. Also keep in mind that some subjects, such as cream lace, are meant to have a slight color shift and the use of the auto feature in this case would remove the subtle hue of the original.

Apart from these exceptions most cameras' auto features produce great results that require little or no post-shooting color correction work. So it's my suggestion that if in doubt try the auto setting first. Check the results on the preview screen of the camera and if there is a color cast still present, then move onto some more specific white balance options.

Light source white balance settings

The Daylight (Fine), Incandescent, Fluorescent, Cloudy and Flash (Speedlight) options are designed for each of these light types. With this group of settings the camera manufacturers have examined the color from a variety of each of these sources, averaged the results and produced a white balance setting to suit each light source. If you know the type of lighting that your subject is being lit by, then selecting a specific source setting is a good move.

Again, for the majority of circumstances these options provide great results, but for those times when the source you are using differs from the 'norm' you will also find a fine-tuning adjustment. With the light source set, the command dial is turned to adjust the color settings to suit a specific source. For example, with Nikon cameras set to the Daylight, Incandescent, Cloudy or Flash option, selecting positive values will increase the amount of blue in the image. Alternatively, negative numbers will increase the red/yellow content. In contrast if you have selected Fluorescent as your light source then the fine-tuning feature will generally allow you to adjust the white balance settings between green and magenta.

Applying fine-tuning automatically

If you are like me and find manually fine-tuning hampers the flow of your photography – shoot, stop, switch to menu, fine-tune white balance, shoot again, stop, switch to menu … you get the idea – then check to see if your camera has an Auto White Balance Bracketing option. This feature automatically shoots a series of three images starting with the standard white balance settings and then adding a little blue and finally a little red.

I find white balance bracketing particularly useful when shooting difficult subjects like multi-colored hand-blown glass or the collection of rubber bands in Figure 3.40. As three separate images are saved I can make decisions about the most appropriate color by previewing them on my workstation's large color calibrated monitor later rather than the small preview screen on the back of my camera in the field (see Figure 3.40).

Customizing your white balance

In a perfect world the scene you want to shoot will always be lit by a single source. In reality most scenarios are illuminated by a variety of different colored lights.

For instance, what seems like a simple portrait taken in your lounge could have the subject partially lit by the incandescent lamp stand in the corner, the fluorescent tube on the dining room ceiling and the daylight coming through the windows. Because of the mixed light sources a specific white balance setting is not appropriate. Instead, you should use the customize, or pre-set, white balance option in your camera.

This feature works by measuring the light's combined color as it falls onto a piece of white paper or gray card. The camera then compares this reading with a reference white swatch/gray card in its memory and designs a white balance setting specifically for your shooting scenario. With the process complete you are now set to shoot your portrait secure in the knowledge that you will produce cast-free images. Always remember though, because this is a customized process, if you decide to turn a light off, or move your subject to another position in the room, then you will need to re-measure and re-set your white balance (see Figure 3.41).

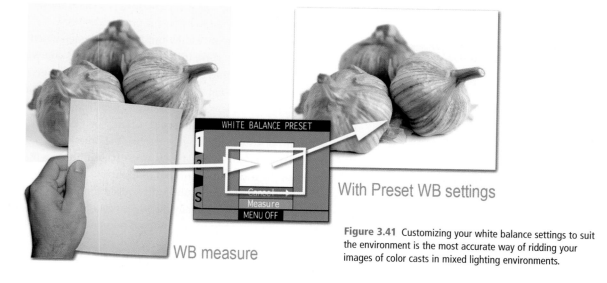

With Preset WB settings

WB measure

Figure 3.41 Customizing your white balance settings to suit the environment is the most accurate way of ridding your images of color casts in mixed lighting environments.

Creating custom white balance with ExpoDisc

Another approach to ensuring accurate color is to employ a front of camera device known as the ExpoDisc when creating a custom white balance setting. The ExpoDisc is a filter that is attached to the camera lens before creating a custom white balance setting.

With the disc attached, the camera is pointed towards the main light source that is illuminating the scene. In the case of a studio portrait, this involves placing the camera in the location of the subject and pointing the lens back towards the position where you are taking the photo. The light falling on the disc is then used as the basis for creating the Custom White balance setting.

When photographing outside on a cloudy day, the camera, with disc attached, is pointed towards the sky. On a sunny day the camera again with disc attached is directed towards the sun. NB: Never point your camera towards the sun without the ExpoDisc attached as this action could cause permanent damage to your camera's sensor.

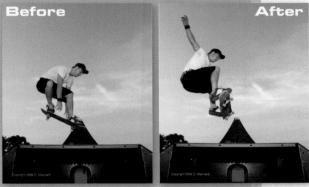

Figure 3.42 The front-of-lens ExpoDisc is used for creating custom white balance settings from mixed or non-standard light sources.

How to: Use the ExpoDisc

1. Snap the ExpoDisc over the front of the lens (white side towards the camera). If the disc is larger than the lens, hold it in position.

2. If the camera needs to focus to enable the creation of a custom white balance setting, change the camera to manual focusing.

3. Use the Aperture, Shutter or Program mode to automatically set exposure, or if you are working in Manual mode, adjust the f-stop and shutter speed yourself.

4. Aim the camera towards the main light source. This generally means positioning the camera in the place of the subject and pointing it back towards the position you will be taking the photo from.

5. Set the custom white balance for your camera. The procedure for this varies from manufacturer to manufacturer and model to model, so check your manual. This white balance setting will be applied to the photo in-camera if you are shooting JPEGs or with RAW file capture it will show up as the 'As Shot' setting in raw conversion software.

6. Finally remove the disc, return your camera to the focus and exposure setting you require and photograph the scene. You can continue to photograph with this custom white balance setting until either you change scenes or lighting.

Contrast control

Over the years film shooters have had little control over the contrast in their images. Sure, dedicated black and white photographers could (and still can) manipulate the contrast in their multi-grade prints using filters and in their films using techniques like the Zone system, but on the whole the contrast that was present in the scene when you captured the frame is what you are stuck with. This is especially true in color photography, where these specialized development techniques do not apply.

Thankfully this is not the case for most digital photographers. Almost all intermediate to high-end cameras contain a series of settings that control how the range of brightness in a scene is recorded to memory. With some camera manufacturers, contrast control features are even becoming available on modestly priced entry-level models.

Contrast choices

Generally you will have a choice between contrast increasing and contrast decreasing options with some camera models also providing an auto setting:

Auto – With this option the contrast setting is selected and set by the camera according to the lighting conditions in the scene. Subjects with a large brightness range will be recorded with a low contrast setting, whereas flatly lit scenes will be improved with a high contrast setting. This is a good option to store as your camera's default.

Normal – In this mode the contrast setting is fixed. This setting is useful for standard 'normal' lighting conditions, but should be used cautiously if the brightness in the scene is fluctuating. Some photographers prefer to keep their camera at this setting and apply any contrast correction at the desktop using their favorite image editing program.

More Contrast – Used for low-contrast shooting conditions to enhance the tonal values of the captured image. This setting is designed for images shot under overcast skies, landscapes and general low-contrast scenes.

Less Contrast – This option reduces the contrast of brightly lit scenes. It should be used in situations such as sunlit beaches and snow shots or situations where strong light creates dark shadows.

Contrast control in action

For the true seeker of quality images the contrast control is one of the most useful features for the digital camera owner. When you are faced with shooting a beach, or snow scene, on a sunny day the range of brightness between the lightest and darkest areas can be extremely wide. Set to normal your camera's sensor can lose detail in both the highlight and shadow areas of the scene. Delicate details will either be converted to white or black. Changing the setting to 'less contrast' will increase your camera's ability to capture the extremes of the scene and preserve otherwise lost light and dark details.

In the opposite scenario, sometimes your subject will not contain enough difference between shadows and highlights. This situation results in a low-contrast or 'flat' image. Typically pictures made on an overcast winter's day will fall into this category. Altering the camera's setting to 'more contrast' will spread the tonal values of the scene over the whole range of the sensor so that the resultant picture will contain acceptable contrast (see Figure 3.43).

'How do I know that my scene either has too much or too little contrast?' The beauty of shooting digitally is that we can preview our image immediately. There is no waiting around for processing – the results are available straight away. If you are in a situation where you feel that the image may be enhanced by altering the contrast, shoot a couple of test pictures and assess the results. Check in particular the shadow and highlight areas. Any noticeable loss of detail in either of these two places will warrant a contrast change and a reshoot.

Some cameras have a histogram function that will visually graph the spread of the pixels in the image. This feature takes the guesswork out of determining whether your image is too flat or too contrasty. A bunching of pixels in the center of

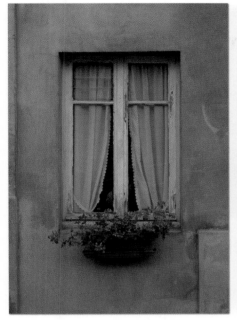

IMAGE ADJUSTMENT

A () Auto
Normal
()+ More Contrast
-Less Contrast
+Lighten Image
-Darken Image
MENU OFF

Figure 3.43 Most mid- to high-end digital cameras provide some control over how a scene's contrast is processed. Selecting the 'More Contrast' setting will increase the recorded contrast for an otherwise flat or low-contrast scene.

No contrast adjustment Increased contrast

the graph usually indicates a need for more contrast, whereas a mass grouping at both ends requires a reduction in contrast.

Along with good exposure control, selecting the right contrast setting is critical if the greatest amount of the scene's detail is to be captured, processed and saved. A little time and care taken to adjust your contrast and exposure options so that they better suit the subject will always pay big dividends in terms of great image quality.

Sharpening in-camera

Despite the high resolution of many modern sensors and specially developed digital lenses the captured image contains a degree of softness that is a direct result of the capturing process. To help create crisper images camera manufacturers include in-camera sharpening as one of their enhancement options. Designed to improve the crispness across the picture, these features enhance the edge of objects by increasing the difference in tones between adjacent pixels. In essence, the sharpening function boosts the contrast of the image at a pixel level. This change, when viewed from a distance, produces a noticeable increase in overall visual appearance sharpness.

Sound confusing? Well it doesn't need to be. You don't really need to worry about how the feature works, but it does pay to remember that the act of sharpening changes the pixels in your image and just like any other enhancement tool (in-camera or on-desktop), too much sharpening can destroy you picture. So select your enhancement level carefully.

I use the terms 'appearance' and 'visual sharpness' on purpose as it is important to make a distinction between the sharpness that comes from quality lenses, well focused and steadily held, and techniques used to enhance the image such as the features discussed here. After all, no

Not sharpened Sharpened

Figure 3.44 Applying a little sharpening during the save process will make your images appear crisper. Sharpening can also be applied after capture in the image editing stage.

Sharpening settings

Photographers have a range of settings when it comes to selecting the type of in-camera sharpness to apply:

Auto – This option allows the camera to search for the optimum settings for each individual image. The picture is analyzed and sharpening applied to the edges of contrasting objects. The way that sharpening is applied will change as the subject matter changes. If you don't want to sharpen on the desktop this is a good default setting.

High or Maximum – This option drastically increases the overall sharpness of all images. In some cases the change is so great that the sharpening is very obvious and distracting. Use this setting carefully, reviewing your results as you shoot.

Normal or Standard – This option applies the same level of sharpening to all images irrespective of subject matter. Designed as the 'most' suitable setting for 'most' subjects 'most' of the time there will be occasions when this selection applies too much sharpening as well as situations when not enough sharpening occurs. Generally Auto provides a better all round option.

Low or Minimum – This option is for shooters who worry about what their camera is doing to their images. This setting applies the least sharpening. A good choice if you generally apply sharpening via an image editing package.

No – This option is for dedicated image editors only. The pictures captured with this setting will appear soft if you do not apply some desktop sharpening. Making this the default on your camera commits you to manually sharpening every image you take. Select carefully.

amount of in-camera sharpening will 're-focus' a blurry picture!

Auto, high, low or no sharpening?

How do I know what settings to use? There are two schools of thought for deciding when and where to apply sharpening to your images. Some shooters apply sharpening in camera, using one of the specific settings (high, normal, low) or the auto option. Others prefer to leave their images untouched, or use the minimum setting so that they can use the sharpening tools built into their favorite image editing program to enhance their pictures.

Most basic digital cameras provide the option of turning the sharpening feature off. Doing this does means that you take back control over 'where and how' sharpening is applied to your image, but it also adds another, sometimes unwanted, step to the enhancement process. For situations where you have plenty of time to tinker, and where absolute quality is required, this approach certainly does produce great results, but for most day-to-day imaging applying a little sharpening in-camera is the best option.

ISO equivalence settings

For those of us growing up with film, the idea of an ISO number (or if I really show my age – ASA number) indicating how sensitive a particular film is to light is not new. These values, ranging from slow (50 ISO) through medium (200 ISO) to high speed (1600 ISO), have been one way that photographers have selected which film stock to choose for particular jobs. Each film type had its advantages and disadvantages and selecting which was best was often a compromise between image quality and film speed. If the day's shooting involved a variety of different subjects then the decision was always a difficult one, as once the choice was made you were stuck with the same stock for the whole of the roll.

In the digital era the restrictions of being locked into shooting with a single film with all its particular abilities and flaws has been lifted. The ISO idea still remains, though strictly, we should refer to it as 'ISO equivalence' as the original ISO scale was designed specifically for film not CCDs. Most cameras have the ability to change the ISO equivalent setting for the sensor, with a growing number offering settings ranging from 100 to 1600. Each frame can be exposed at a different 'ISO' value, releasing the digital shooter from being stuck with a single sensitivity through the whole shooting session. Oh happy days!

Unlike changing film, where one photographic recording device was swapped with another that was either more or less sensitive, changing the ISO setting of a digital camera doesn't swap the old sensor with a new one. Instead, selecting a higher ISO amplifies the output signal from the sensor, which allows the photographer to capture images with less light. The downside of this freedom is that amplifying the signal has the undesirable effect of increasing the noise or grainy look of our digital files. So you should take care when choosing to work at high ISO values as such a decision does have a direct effect on the image quality of your captured files.

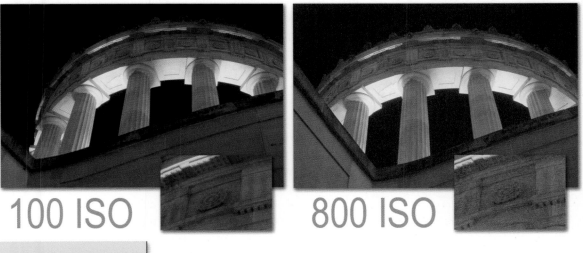

Figure 3.45 High ISO settings are generally used to capture photographs in low light situations but care should be taken when using high values as they can produce photos with noticeably more noise than the same picture taken with a lower ISO setting.

ISO equivalence

Where you are provided with a choice of ISO settings use the following guide to help you select which value to use for specific shooting scenarios:

100/200 ISO – Low ISO settings provide the best overall image quality with good detail and gradation of color and very little, if any, noise. Be careful of camera shake or subject movement when shooting with these settings as they often require you to use comparatively slow shutter speeds. Use these settings when there is plenty of light or when you have a tripod available to hold the camera steady.

400 ISO – Values around 400 ISO often provide a good balance between noise and sensitivity when shooting with overcast or winter light or even indoors. With most modern cameras the level of noise introduced at this setting is still acceptable and the overall color and detail are also of a high standard.

800/1600 ISO – Generally the highest ISO values available on your camera will enable you to photograph in very low light or with extremely fast shutter speeds but this flexibility comes at a price. Though much improved in recent years the performance of all but the most expensive sensors at these ISO values is such that the noise is very apparent and degrades both the detail and the color gradation of the photos. You should only use these settings when not employing them will mean missing the photograph. A far better alternative is to use faster lenses (ones with a large maximum apertures such as f1.4 or f2.0) coupled with a tripod in low light situations.

Adjusting sensitivity

As we have already seen earlier, most entry-level digital cameras usually only have fixed or fully auto ISO settings, whereas more expensive prosumer and professional models provide a variety of ISO settings. Changing the ISO is usually a simple matter of holding down the ISO button whilst turning a command dial. The changed setting is reflected in the LCD screen at the back of the camera and, in some cases, in the viewfinder as well.

The Auto ISO feature

For most scenarios it is a good idea to leave the camera set to the Auto ISO setting. This option keeps the camera at the best quality setting, usually 100, when the photographer is shooting under normal conditions, but will change the setting to a higher value automatically if the light starts to fade. In specific shooting circumstances, that require higher ISO values, you always have the option to manually override the auto setting and select a specific ISO value suited to the scene.

Irrespective of if you decide to select your ISO manually, or let the camera automatically adjust the chip's sensitivity for you, always keep in mind that choosing the lowest setting possible will give you the sharpest and best quality images overall – so use it when you can.

Pro's Tip – When using higher ISO settings turn off the camera's sharpening feature as this function can tend to exaggerate the noise that is present in the image.

What is sensitivity?

Sensitivity in digital terms is based on how quickly your camera's sensor reacts to light. The more sensitive a chip is the less light is needed to capture a well-exposed image. This means that higher shutter speeds and smaller aperture numbers can be used with fast sensors. Sports shooters, in particular, need cameras with sensitive chips, to freeze the action. The same is true for tasks that require photographing in low light situations.

With such advantages we would all be shooting with our cameras set to the highest sensitivity possible, but there is a downside. Just as films with high ISO values produce images with large grain, using the more sensitive settings for your digital camera will increase the amount of noise (digital grain) present in your images. The photographer needs to weigh up the merits of higher sensitivity with the disadvantages of lower image quality when choosing what ISO equivalent value to use for a specific shooting task.

Figure 3.46 The example is taken with settings of both a high ISO and long exposure, producing noticeable noise in the shadow areas of the image. A second exposure was made with the noise reduction feature activated and the results show much less noise, especially in the shadow areas of the photo.

ISO: 400
Shutter Speed: 2 secs
Noise Reduction: Off

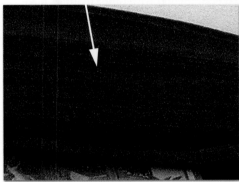

Noise Reduction Off

Noise Reduction On

The problem of noise

Noise is usually seen as a series of randomly spaced, brightly colored pixels that sometimes appear in your digital images. A large amount of noise in an image will reduce the overall sharpness and clarity of the picture. Particularly noticeable in shadow areas, there are two distinct factors that control the amount of noise present in a picture:

- **High ISO** – Increasing the ISO setting of your camera will increase the level of noise in the image. Images exposed with an 800 setting will contain more of these randomly spaced and brightly lit pixels than the same photograph exposed with a 100 ISO setting.
- **Long exposure times** – Pictures taken with exposure times longer than 1/2 second will contain more noise than those shot with a fast shutter speed. The longer the exposure the more noticeable the noise becomes.

As both these factors come into play when shooting in low light situations you will find that the images you take at night are more susceptible to noise problems than those photographed on a bright sunny day.

Noise reduction

More and more digital cameras now include noise reduction (NR) features as part of their standard feature set. Many models activate the feature automatically, and sometimes without the photographer knowing, when high ISO settings and/or long exposure times are used. Other models provide a manual control, letting the photographer choose when and with which images the noise reduction system is used.

Features for reducing noise

In a perfect world there would never be an occasion when there was a need for photographers to use either a high ISO value or a long exposure and so all the images produced would be beautifully noise free. But alas this is not the case and all too regularly you will find yourself shooting in environments with very little light. Does this mean that we have to put up with noise-filled images for the sake of shooting convenience? The answer is no.

Most mid- to high-range digital cameras now contain specialized noise reduction or suppression features that help to minimize the appearance of random pixels in images produced with either high ISO or long exposure settings. These tools attempt to isolate and remove the errant pixels from the image, creating much cleaner and sharper images in the process.

For example, some cameras in the Nikon range, have a choice of two noise reduction systems that function in slightly different ways:

- **NR (Noise Reduction)** – This is the standard noise reduction setting that functions on all of the camera's different resolution settings as well as in conjunction with other features such as Best Shot Selector and Exposure Bracketing. Taking at least twice as long as a standard image to process and record, the camera's in-built software attempts to identify and eliminate noisy pixels in the image.
- **Clear Image Mode** – This setting minimizes noise and increases color gradation by capturing a sequence of three images of the one scene. The first two pictures are exposed with the shutter open, the third with the shutter closed. Using some sophisticated processing the three images are then compared and a single 'noise reduced' image is recorded. As several images are recorded it is recommended that a tripod be used when employing this feature.

The noise reduction features are activated via the camera's menu system. When noise reduction is in effect and the shutter speed is less than 1/30th of a second a small NR appears in the viewfinder. So when you are selecting a high resolution or long exposure time consider using your camera's noise reduction techniques to increase the quality of the resulting images. See Figure 3.46.

Why don't I just leave the noise reduction feature turned on?

Photographers want the best quality images all the time so why not set up your camera so that the noise reduction features are left permanently on? In theory this sounds fine but in practice the extra processing and recording time taken to reduce the level of noise in an image would greatly increase the time period between successive shots. In most normal shooting circumstances, where noise isn't a problem, the extra time lag between shots would hamper the photographer's ability to shoot successive images quickly.

There is also a school of thought that says that any image enhancement activities (including noise reduction) are best undertaken back at the desktop with photo editing software such as Photoshop or Photoshop Elements. Photographers are then able to carefully customize the noise reduction process to suit each image which, in turn, should produce better results than the automatic and speedy approach used by the in-camera feature.

The impact of shooting RAW

In the last section we looked at how many new cameras now offer the option to save captured photos in the RAW file format. We also saw that RAW capture brings with it an extra processing step that is required to convert the RAW image data to a format that is more easily edited with programs such as Photoshop and Photoshop Elements. What we haven't yet explored is the impact that shooting RAW has on the digital-only camera characteristics examined here. But to do that we need to look at the RAW format a little more closely.

So what is in a RAW file?

It is helpful to think of a RAW file as having three distinct parts (see Figure 3.47):

- **Camera data**, usually called the EXIF or metadata, including things such as camera model, shutter speed and aperture details, most of which cannot be changed.
- **Image data** which, though recorded by the camera, can be changed in a RAW editing program such as Adobe Camera RAW (ACR) and the settings chosen here directly affect how the picture will be processed. Changeable options include color depth, white balance, saturation, distribution of image tones (contrast), noise reduction and application of sharpness.
- The **image** itself. This is the data drawn directly from the sensor in your camera in a non-interpolated form. For most RAW-enabled cameras, this data is supplied with a 12 or 16 bits per channel color depth, providing substantially more colors and tones to play with when editing and enhancing than found in a standard 8 bits per channel camera file.

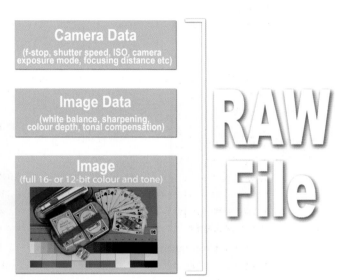

Figure 3.47 RAW files are constructed of three basic parts – camera data, image data and the image itself. As the majority of the image data settings, such as white balance, sharpness and contrast, can be changed or fine-tuned in the RAW conversion process, many photographers do not spend the time adjusting these capture settings at the time of shooting. Instead they prefer to make these alterations later at the desktop via a RAW conversion utility such as Adobe Camera RAW.

But how does this impact on my day-to-day shooting?

Most experienced photographers pride themselves on their ability to control all the functions of their cameras. Often their dexterity extends way beyond the traditional controls such as aperture, shutter speed and focus to 'digital-only' features we have examined here, such as white balance, contrast, sharpness, noise reduction and saturation. For the best imaging results they regularly manipulate these features to match the camera settings with the scene's characteristics.

For instance, a landscape photographer may add contrast, boost saturation and manually adjust the white balance setting of his or her camera when confronted with a misty valley shot early in the morning. In contrast, an avid travel photographer may choose to reduce contrast

and saturation and switch to a daylight white balance setting when photographing the floating markets in Thailand on a bright summer's day. It has long been known that such customization is essential if you want to make the best images possible and are capturing in a JPEG or TIFF format. But as we have already seen, settings such as these, though fixed in capture formats such as TIFF and JPEG, are fully adjustable when shooting RAW (see Figure 3.48).

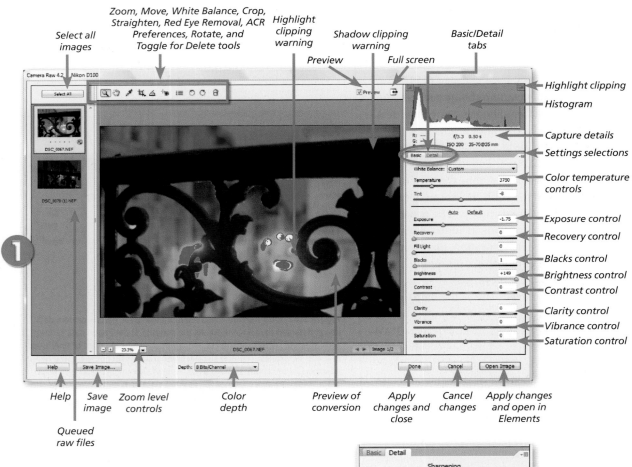

Figure 3.48 When you open a RAW file in Photoshop Elements or Photoshop the Adobe Camera RAW editor is activated, providing you with a range of sophisticated controls for the enhancement and conversion of your RAW files. Many of the digital-only capture characteristics are still adjustable at this stage in the conversion process using the controls grouped here.
(1) Adjust tab options.
(2) Detail tab options. Photoshop Elements version of Adobe Camera RAW.

What does this mean in our day-to-day photography? Well, if after documenting some interiors you accidentally forget to switch the white balance setting from tungsten back to daylight before commencing to photograph outside, all is not lost. The white balance setting used at the time of capture is recorded with the RAW file but is only applied when the picture is processed. This means that when you open the images in a RAW converter, the picture is previewed using the capture setting (tungsten), but you can easily select a different option to process the file with. In this example it would mean switching the setting from tungsten back to daylight in the white balance menu of the conversion software. All this happens with no resultant loss in quality. Hooray!

The same situation exists for other digital controls such as contrast, saturation and, with some cameras, sharpness and noise reduction. As before, the settings made at the time of shooting will be used as a basis for initial RAW previews but these are not fixed and can be adjusted during processing. This leads some people to believe that there is no longer any need to pay attention to these shooting factors and so consequently they leave their cameras permanently set to 'auto everything' (auto contrast, auto white balance, standard saturation), preferring to fix any problems back at the desktop. Other photographers continue to control their cameras on a shot-by-shot basis, believing that an image captured with the right settings to start with will end up saving processing time later. Both approaches are valid and which suits you will largely get down to a personal preference and the choice of whether you would prefer to spend your time manipulating your camera or computer.

1 Shallow depth of field. Set your camera lens to the smallest f-stop number and longest focal length it contains. Proceed to photograph a series of objects at the closest distance possible. Notice how the long focal length, small f-stop and close distance create images with very small depth of field or areas of focus.

2 All things sharp. Shoot a second series of pictures with the reverse settings to those above – i.e. use wide-angle lenses (or zoom settings), big f-stop numbers and medium 'subject-to-camera' distances. Notice that the images you create with these settings have large zones of focus extending from the foreground into the distance.

3 Dramatic architecture using exaggerated perspective. Many wide- and ultra-wide-angle lenses produce images displaying highly exaggerated perspective. Subjects close to the lens loom large and those in the distance seem microscopic in comparison. This type of perspective not only gives us a wider angle of view, but also provides us with a great opportunity to create some very dramatic pictures. Graphic architectural photographs with strong hard- edged lines and contrasting shapes and colors work particularly well. Using a modern building in your local area as a starting point, compose and photograph a series of dramatic, wide-angle architectural images. Don't be afraid to try a range of different angles – shoot up, shoot down, move in closer, try a little further back.

(continued)

5 White balance precision. Using a simple household bulb as the main light source, set up and shoot a still-life photograph using a range of white balance settings. Be sure to try the preset or custom option as well as those designed to match the light source (flash, tungsten, daylight, etc.). Import the pictures into your editing program ensuring not to alter the color of each photo in the process. Assess which photo provides the most neutral (cast-free) result.

4 Panning techniques. As we have seen, using a slow shutter speed blurs the moving subjects in an image. An extension of this technique involves the photographer moving with the motion of the subject. The aim is for the photographer to keep the subject in the frame during the exposure. When this technique is coupled with a slow shutter speed, it's possible to produce shots that have sharp subjects and blurred backgrounds. Try starting with speeds of 1/30 second, gradually reducing them to around 1/4 second. Practice by shooting a subject that contains repeated action, such as a cycling or amateur motor sports event.

6 Experiment with blur. With a camera offering settable shutter speeds, expose a series of images at settings of ISO 100 and 1/8 second. Include people and traffic on the move, preferably close. Use your camera hand-held, on a support, and panning (in various directions). Compare results.

7 Advance a sunset. Take a quick sequence of four color pictures of a landscape at late dusk. Give the first one correct exposure, progressively halved as you continue. Which print gives the most atmospheric result?

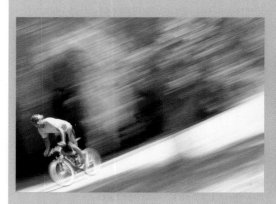

(*continued*)

8 Angles of view. Using a cardboard frame sliding on a transparent ruler, simulate the use of different focal length lenses. A 24 mm × 36 mm slide mount positioned 50 mm from your eye matches the angle of view of a 35 mm SLR normal lens.

9 Matching contrast. On a sunny day capture a series of photos in JPEG or TIFF format with and without the use of the camera's contrast reduction setting. Under the same lighting conditions photograph a second group of pictures using the RAW format. Process the RAW files twice, once with no contrast change and the second time using the contrast controls in the conversion software to reduce contrast. Compare your results.

10 Maintaining monochrome contrast. Using the Black and White or No Saturation option on your digital camera, photograph a series of flowers of varying colors. Try to predict how each of the colors will be converted to grayscale by the camera. Look for a set of subject colors that retain the same contrast when shot in black and white as they do when photographed in color. If your camera doesn't have a black and white option photograph in color and then perform the conversion using the tools in Photoshop or Photoshop Elements.

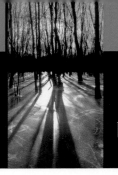

4 Tackling Different Photographic Subjects

Many aspects of picture composition apply to all photography, as the examples in Part 1 showed. Technical controls too, such as the camera settings you make, choice of lenses and uses of flash, also play an influential role. But then again, the kind of subject you choose to photograph presents its own possibilities and problems. This part looks, therefore, at a range of subject situations with these points in mind. Potentially interesting subjects include people, places, animals, landscapes, small objects in close-up . . . the list is almost endless. Despite the range of these topics, it is probably true to say that all of us at some time will want to, or need to, photograph people, so this is where we will start.

People

Subjects here may be individuals or groups, posed or unposed, ranging from family and friends you know and can control, to candid shots of strangers. In all instances, it pays to pre-plan your shot as far as you can, which means concern for background and setting, direction of the light, and how 'tight' to frame the person (full length, half length, head and shoulders, head shot). At the same time, you must always remain able to respond quickly to any fleeting expression or unexpected moment of action or reaction, as it may occur. For example, the excitement and joyful expression on the face of the swinging child in Figure 4.1 could be lost a moment later; similarly, the baby's quizzical expression in Figure 4.2.

Babies are the least self-conscious people. The main problem with these young subjects is how to manoeuvre or support a young baby so they are not just shown lying down. Try photographing over the shoulder of the supporting adult, or have the baby looking over the back of an armchair. Avoid direct, harsh sunlight. If your camera offers a zoom lens, set this to its longest focal length (T) or change to a

Figure 4.1 Candid photography requires quick work and a sense of anticipation in order to capture the fleeting expressions that can sum up the character of a subject or the feeling of the moment.

long focal length type. A lens of 85 or 100 mm is ideal for a 35 mm camera; even used at its closest focus setting, such a lens will give you a large but undistorted image.

As children begin to grow up, they quickly become conscious of the camera. It is often better then to give them something to do – set up simple situations that are typical for the child, then wait for something to happen without over-directing the occasion. The girl on the swing in Figure 4.1 was just such a 'can you see me?' activity for the individual concerned, improvised on the spot for the photograph.

Figure 4.2 Plenty of patience is needed when photographing children and pets, as both subjects are unpredictable and great expressions like this one cannot be delivered on demand, but rather need to be waited for and then quickly captured.

Pairs

Portraying people in pairs allows you to relate them to each other in various ways. The relationship may be simply to do with comparative shapes and the individuals themselves remaining anonymous. Or it may be the highly personalized warmth and friendliness of the two brothers (Figure 4.3), both to each other and the person behind the camera. In this semi-posed shot, the boy in black stole into what was planned as a single portrait. The pale background helps to create a strong combined shape, and plain garments avoid distraction from faces. Lighting here was flash bounced off a white ceiling.

In other instances, expressions can have quite different connotations. The candid shot of the elderly Italians (Figure 4.4) has a rather sinister air. The hats, the corner location and the surrounding empty tables seem to suggest some plot or business meeting. A whole story can be dreamt up around such a picture – when, in fact, it was probably just a few old pals on a day out.

Your shot may be a largely constructed situation or taken incognito, but picking exactly the right moment can be quite difficult when two facial expressions have to be considered. Expect to take a number of exposures; you may find out anyway that a short series of two or three prints in an album forms an interesting 'animated'-type sequence that has more depth than a single photograph.

Groups

Organizing people in groups is rather different to photographing them as individuals or in pairs. For one thing, each person is less likely to be self-conscious – there is a sense of safety in numbers, and a touch of collective purpose and fun. This is a good feature to preserve in your picture rather than have everyone wooden-looking and bored. For similar reasons, don't take too long to set up and shoot (see Figure 4.5).

Groups of large numbers of people tend to call for a formal approach, and here it helps to prepare some form of structure, perhaps one or two rows of chairs. This guides people to where

Figure 4.3 Clothes, pose and plain background help to give the picture of this pair an overall cohesive shape.

Figure 4.4 Expressions and environment give this casual meeting of friends a conspiratorial air.

to sit or stand, and your camera position can also be prepared in advance. Smaller groups can be much more informally organized, participants jostling together naturally and given freedom to relate to one another, although still under your direction.

Most groups are linked to occasions and it is always helpful to build your group around a center of common interest – which might be the football and cup for a winning team, or a new puppy with its family of proud owners. Begin by picking an appropriate setting. Often, this means avoiding distracting and irrelevant strong shapes or colors in

Figure 4.5 Spontaneous interaction between the subjects in your picture often creates a picture that is more full of life than one that is carefully composed or orchestrated.

the background. With close, small groups you can help matters by having everyone at about the same distance from you, but keeping background detail much further away and out of focus (see depth of field, page 66).

Sometimes, though, showing the detail of the environment contributes greatly to your shot. Leaving space around the casual group in Figure 4.6 helps to convey the idea of an adventurous gang of holiday makers.

If at all possible, avoid harsh direct sunlight that will cast dark shadows from one person onto another or, if the sun is behind your camera, causes everyone to screw up their eyes. Aim to use soft, even light from a hazy or overcast sky. Alternatively, try to find a location where there is some large white surface (the white painted wall of a house, for example) behind the camera. This will reflect back diffused light into the shadows to dilute and soften them. For small groups, fill-in flash may also be a possibility.

Always try to locate the camera far enough back from the group to allow you to include everyone using a normal focal length lens. Working closer with a wide-angle or zoom lens at shortest focal length setting can make faces at the edges of a group appear distorted.

Every group shot calls for your direction to some degree. Consider its overall structure – gaps may need closing by making people move closer together (see Figures 4.7 and 4.8). With large formal groups you can aim for a strictly regular pattern of faces and clothing. To help with the composition of small groups, some photographers try to form a triangle shape with the main subject parts of their picture (see Figure 4.9). Ask if everyone has unobstructed sight of the camera lens. Always shoot several exposures because of the practical difficulty of getting everyone with the right expression, eyes open, etc. Having several versions also gives you the opportunity to digitally mix heads into one composite.

Figure 4.6 Showing surroundings can usefully add a sense of place – it would be wrong to tightly crop this informal group.

Candids

To take portraits of friends and strangers without them being aware calls for delicate handling.

Figure 4.7 When shooting pairs of subjects, try to ensure that there isn't too much visual space between the two sitters. Here the distance was closed by overlapping the foreground sitter with the subject at the rear.

But results can be rewarding in warmth and gentle humor. Candid shots of strangers are easier if you begin in crowded places like a market or station, where most people are concentrating on doing other things. Observe situations carefully, especially relationships (real or apparent). These may occur between people and pets, or notices, or other people, or just the way people fit within a patterned environment.

Figure 4.8 When working with the subjects, encourage them to interact closely so that there is little gap between the sitters in the final photograph.

Figure 4.9 Creating a good composition with the members of a small group can be a difficult prospect. Here the photographer has chosen to arrange the subjects in a triangle shape.

An auto-focus, auto-exposure camera is helpful for candids, but working manually you can often pre-focus on something the same distance away in another direction, and read exposure off the back of your hand. Avoid auto-wind cameras with noisy motors. Remember not to obstruct people when photographing in the street, and always ask permission to shoot on private property.

Places

Unlike people, places of habitation – towns, cities, buildings, etc. – are obviously fixed in position relative to their surroundings. This does not mean, however, that picture possibilities are fixed as well, and you cannot produce your own personal portrait of a place. It is just that good, interpretive shots of permanent structures require more careful organization of viewpoint and patience over lighting than most people imagine. The best picture is seldom the first quick snap.

Decide what you feel strongly about a place – this might be easiest to do when you visit the area freshly for the first time, or it may come from a longer stay giving greater insight into what the environment is really like. Compare Figures 4.10 and 4.11, which both show architecture. The Battersea power station in London, photographed from a stationary train through the scratched window on a gloomy day, provides a very personal view of the familiar site. The photographer

Figure 4.10 The blurred smoke stacks of Battersea power station as seen through a scratched train window provide a personal and emotive view of a well-known scene.

Figure 4.11 A more traditional and less personal view of the Basilica of Sacré Coeur taken from the same spot as many other tourist photographs.

has concentrated the viewer's eye on the scratches using a shallow depth of field to ensure they are the only part of the image that is sharp. The towers are recognizable by their shape only. In contrast the Basilica of Sacré Coeur in Paris has received a totally different and much more mundane treatment. The building has been photographed in the same way from the same position and with the same perspective many times before and apart from accurately recording a pictorial description of the architecture the image speaks little of the photographer's emotions or feelings towards the place.

Choosing the lighting

Lighting also has a big part to play in the look and feel of your place pictures. Direct sun side-lighting falling across your scene can pick out specific landmarks and contrast them against dark backgrounds or shaded backgrounds. This can be a good technique to use to direct the attention of your audience to a specific part of the scene. Softer lighting can create a flattening, downbeat effect, reflecting the gray of the lighting. Overcast conditions do have the advantage of ensuring that details are recorded in the lightest (well lit) and darkest areas (shadows) of the scene.

Figure 4.12 A building's texture, pattern and form change appearance as the sun moves direction during the day.

Figure 4.13 The texture of hieroglyphs brought out by afternoon sunlight streaming across the surface of the column.

Whenever possible, think out the sun's position moving from east to west throughout the day and its relation to the subject or scene you are photographing. If the sun is in the wrong position it may be necessary to come back at a time when its direction will best suit the subject matter (see Figure 4.12). The same applies to choosing a day when weather conditions give direct sunlight or soft diffused light. Harsh, glancing light is essential to show the surface texture of objects such as bricks, cobble streets or surface decoration (see Figure 4.13). On the other hand, the pattern of varied chimney-pot designs photographed across the roofs of local houses would be over-complicated by their shadows if recorded in harsh light (see Figure 4.14). Overcast conditions here, together with choice of viewpoint, help to keep the picture on one flat

Figure 4.14 Edinburgh chimney-pots, simplified by flat lighting and perspective.

plane. The result is a sense of the eccentric or surreal.

Remember that the best times for interesting, fast-changing lighting effects are either in the early morning or late afternoon. But be prepared to work quickly when sun-cast shadows are an important feature – they change position minute by minute (or may disappear altogether) while you are adjusting the camera. Again, don't overlook the transformation of building exteriors at dusk, when internal lighting brightens the windows but you can still separate building shapes from the sky.

You can often sum up a whole city or village by just showing part of one building. Look for images that suggest the atmosphere and culture of the environment. But try to avoid hackneyed shots; instead, try suggesting the famous or well-recognized landmarks through a reflection or shadow. Signs and logos can form titles. Or you may want to bring together a 'collection' of shots of selected details such as mail-boxes, house names or interesting doors and windows. All these 'sketches' of what strikes you as special and most characteristic about a place will build up a highly personalized set of photographs. Leave the general views of famous sites to the excellent work of professionals shooting under optimum conditions – on sale at tourist centers.

People and places

Several other visual devices are worth remembering to help strengthen things you want to say through your pictures. For example, the size and scale of a structure can be usefully shown by

Figure 4.15 Including walking figures in this city scene provides the viewer with a sense of scale.

the inclusion of figures (see Figure 4.15). Provided the figures you include relate to the environment in the photograph they can be also used as symbols – for example, showing the solitary outline of a person at a window in a vast, impersonal office block communicates more about the place of humans generally in the built environment rather than the life of the individual depicted specifically (see Figure 4.16).

On the other hand, the complete absence of inhabitants may also be important. Often, it is the hints of life that are left

behind in a picture that can speak louder about how individuals live, work and dwell within a space than if the images were full of people. The audience is left to use their own imaginations to populate the space (see Figure 4.17).

Even when a destination is unexpectedly cold, bleak and empty, instead of sunny and colorful as anticipated, it can be worth shooting some pictures. Try to make them express this paradox in your glum impression of the day, perhaps by combining the sun and sea as depicted on painted signboards with the awful reality of the bleak day.

Whatever your personal reaction to a new place – perhaps good, maybe bad – aim to communicate it through your photography. New York City is impressive with its soaring architecture, but perhaps you notice too its features of public neglect (holes in the road, garbage) contrasting with corporate splendor (marble-faced commercial buildings). The discordance you recognize may become the basis of the images that you record of your visit.

Pictures of places don't always have to be linked to vacations and travel. You can practice your skills locally – encapsulating a street or an industrial park . . . even your own school or workplace. For a longer-term project, you may choose to take pictures once or twice every year from the same spot to create a series documenting the development of a garden. By always including family members in the shots, the images will also show how children grow and develop.

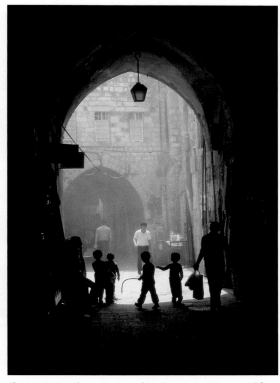

Figure 4.16 Arab quarter, Jerusalem. Exposure was measured for the central area, to preserve the darkness of the foreground.

Figure 4.17 Newsagents in a quiet English village, at lunchtime.

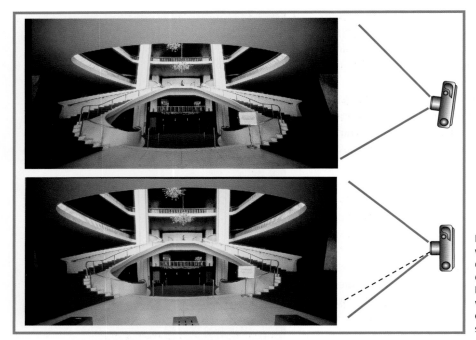

Figure 4.18 (Top) Parallel vertical lines appear to converge when you tilt your camera upwards. (Bottom) Keeping the camera back vertical and later cropping off excessive foreground is one solution.

Interiors of buildings

If you are a beginner, then making pictures of the interiors of buildings may sound difficult, but the abilities of modern camera equipment has made this task easier than ever before. A wide-angle (or at least a shorter than normal focal length) lens is usually necessary. This is because there seldom seems to be enough space to get back far enough to include what the eye sees

Figure 4.19 Both Photoshop and Photoshop Elements contain perspective correction features designed to remove lens distortion and correct perspective problems associated with capturing with wide- and ultra-wide-angle lenses.

when looking around an interior. Entry-level compact cameras with their 30 or 35 mm standard lenses have an advantage here. A 28 mm lens (or equivalent on digital cameras) is probably ideal, as shorter focal lengths start to create distortion of shapes near the corners of your picture. Digital SLR shooters need to remember to account for the Lens Multiplication Factor when considering what focal length is considered wide angle.

Be cautious about tilting the camera when it is fitted with wide-angle lenses. Such an action creates images where the edges of buildings taper as they move away from the camera. This effect is often called 'converging verticals' and is acceptable to the eye when the photograph is obviously looking upwards or even down. But there is nothing more distracting than slightly non-parallel vertical lines in a straight-on view of a building or architectural interior. As Figure 4.18 shows, you can eliminate this effect by keeping the back of the camera vertical and either moving back or cropping off the unwanted extra foreground from your final image.

For those occasions when it is not possible to keep the back of the camera parallel to the subject, or where the use of an ultra-wide-angle lens is the only solution, both Photoshop and Photoshop Elements contain perspective correction features. These tools provide a software solution for converging verticals as well as other lens problems such as barrel distortion (see Figure 4.19).

Even though you will tend to use wide-angle lenses for most of your architectural pictures, you will also find that a long focal length lens, such as 100 or 135 mm, is useful for photographing out-of-the-way details within a large interior. Picking out interesting architectural features can suggest the whole.

Interior lighting

The main problem here is contrast, and to a lesser extent the dimness and color of the light. The lighting range between, say, the most shadowy corner of an interior and outside detail shown through a window is often beyond the exposure capabilities of your film or sensor. To avoid this problem you could exclude windows, keeping them behind you or to one side out of frame, but where windows need including as an important architectural feature:

1 **Shoot when the sky is overcast.**
2 **Pick a viewpoint where windows in other walls help illuminate interior detail.**
3 **Capture a series of bracketed exposures from which you can select the best image later. After all, some degree of window 'burn out' may prove atmospheric and acceptable provided you have retained important detail in shadow areas. Alternatively, the bracketed pictures can be used to assemble a High Dynamic Range (HDR) photo using the tools inside Photoshop. This photo type is capable of storing images with huge contrast ranges.**
4 **With smaller domestic size interiors, fill-in flash from the camera can reduce contrast, but don't expect success using this technique in a space as vast as a cathedral, especially using a camera with a tiny built-in flash!**

Figure 4.20 Dome of St Peter's, Rome. Wide-angle lens, exposed for 1/8 second at f5.6, pressing the camera firmly to a handrail.

Figure 4.21 Mass in St Peter's. Mixed artificial light and daylight. The altar area records orange on daylight film.

Figure 4.22 Paris fountains. Exposure was read from the central, lit water area.

Dimness of light need be no problem provided your camera offers long exposure times and you have some kind of firm camera support – improvised or, preferably, a tripod (see Figure 4.20). Some cameras offer timed exposures of up to 30 seconds. By selecting aperture priority mode and setting an f-number chosen for depth of field, the camera's metering system will automatically hold the shutter open for a calculated period. If you time this with a watch you can then change to manual mode and take shots at half and double this exposure time to get a range of results. Or better still, if your camera has an exposure compensation system, simply adjust the feature to add one stop more and one stop less exposure.

Even during daytime, the interiors of large public buildings are often illuminated by artificial light mixed with light through windows and entrances. In most cases, the interior light is a warmer color than daylight – a difference barely noticed by the eyes of someone there at the time but exaggerated in a color photograph (see Figure 4.21). In such a mixture of lighting, it is still best to continue to use normal daylight-type film, with no color correction filtering, as totally removing the orangey artificial light can turn daylit areas unacceptably bluish. As we have already seen most digital camera users have the advantage of being able to take several versions of the same mixed lighting image with different white balance settings. Later on, with the series of pictures displayed on screen, they can select the picture with the best overall color.

Cities at night

At night, floodlit monuments and city vistas have a special magic (see Figure 4.22). They are transformed from the mundane into a theatre-like spectacle. As with interiors, contrast is your main problem with these photographic subjects. Shooting at dusk is helpful, but sometimes the sparkle and pattern of lights against a solid black sky can really make your picture (see

Figure 4.23 The sparkle of city lights against the dusk sky creates a theatrical and dramatic picture. Shooting the same scene on a moonless night, and at a later time, will produce a series of small pin lights against a predominantly black scene, but photographing at dusk means that there is enough light in the sky and on the water to provide texture, detail and color.

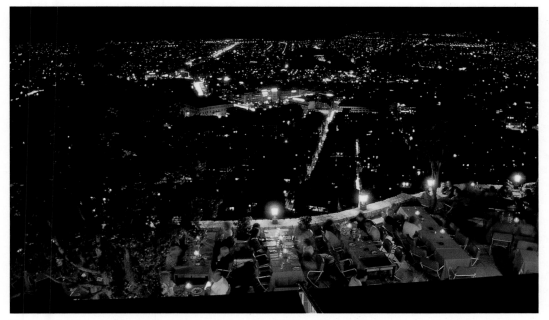

Figure 4.24 Athens. An SLR set to Av mode gave 12 seconds at f8. Mixed lighting with domestic lamps in foreground café.

Figure 4.25 Not all of your low light pictures need to be clear, crisp, cast and blur free. Try a range of different shooting techniques when photographing in low light. Even try breaking the 'rules' to see what interesting results you can achieve.

Figures 4.23 and 4.24). Wet streets after rain, reflecting illumination from shop windows and street lamps, will also help reduce contrast. But even so, dark objects still just showing detail to the eye will become silhouettes in photographs when you expose correctly for brightly lit areas. So pick a viewpoint that places interesting and relevant black shapes in the foreground, where they can add depth to the picture.

Advanced compacts and all SLRs can expose correctly for floodlit subjects (typically 1 second at f5.6 on ISO 200 film). Just ensure that you measure illumination from close enough to fill up the frame with the brightly lit surfaces. Note also that film behaves as if it is less sensitive when used for long exposures in dim light. For instance, for exposures of 10 seconds or longer, most color films halve their sensitivity. To compensate for this effect, set your lens aperture to one f-number wider (smaller number) or use the camera's exposure compensation system to override the exposure settings.

Gearing up for low light photography:

Shooting at night time requires just as much planning as any other photographic task where quality image making is the goal. In fact, ensuring that the following items are already in your kitbag will go a long way towards becoming a successfully low light photographer:

Torch – Not strictly a piece of photographic equipment but at the top of our list. A small torch is invaluable when you are trying to change functions, read settings or even find the exposure compensation button in the dark.

Tripod – Low light often means that you need to use a long exposure to gain enough light to make a good photograph. Long exposures make using a tripod to photograph at night a necessity rather than a luxury. So if you intend to be shooting regularly in low light make sure that a good tripod is at the top of the next Christmas list.

Fast lenses – Fast lenses are those that have a wide maximum aperture which lets plenty of light into the camera and are therefore particularly well suited for low light shooting tasks. Zoom lenses with a maximum aperture of f4.0 or f2.8 are great; those with values of f5.6 and f8.0 are okay as well but will require longer exposures to account for their slowness.

Noise Reduction feature – Check your camera manual to see if your model has a noise reduction or clear image feature built in. If it does, be sure to become familiar with the feature before heading out for your first shoot.

Extra batteries – Long exposures, noise reduction features and back of camera monitors are all camera functions that eat up battery power. So make sure that your batteries are fully charged and that you have a spare set, equally charged, handy as well.

Flask – You would be surprised at how much your photographic skill grows when you have a little warm coffee inside you. Again a flask of coffee is not a piece of photographic equipment but it will help you take better night-time photographs, especially when the temperature is getting a bit chilly.

Moonlight and long exposures

Just as the sun is the key light source for many an image taken during the day, the moon plays this role with photos taken at night. Unlike the sun though, the moon's intensity changes throughout its 29.5 day cycle. It is at its brightest when at the full moon stage of the cycle, providing typical exposure times of f2.0 at 30 seconds for an ISO setting of 100. Take advantage of this time of the month to decrease the size of your aperture and increase your depth of field. Just before, and just after a full moon, is a good time for balancing exposures between street lights and the moonlight in a scene, where as a moonless night allows you to concentrate on recording star trails.

Metering at night

As the meters contained in most cameras are designed to work within the shutter speed range of the camera, many models can't be used to measure exposure beyond 30 seconds or so. To solve this problem try

Figure 4.26 Working with strong silhouettes, great colour, and mirrored reflections, this moon lit landscape draws the viewer into the picture as the eye moves towards the distant mountains and rim lit clouds.

metering the scene with the lens at the widest aperture first. Note down the settings and then extrapolate the required exposure for a smaller aperture setting. For example, a setting of 30 seconds at f2.0, is the same as 60 seconds at f2.8, 120 seconds at f4.0, 240 seconds at f5.6 and 480 seconds at f8.0. Remember to double the exposure time for every full aperture setting change.

The serious night shooter can obtain more accurate results using a sensitive hand held meter. The best models are very sensitive and after measuring the available light, provide a range of shutter and aperture combinations that you can use with the scene. If your budget doesn't run to this level, then the best option is to make a test exposure and using a 'best guess' shutter and aperture combination. Next check the resultant image. In particular, switch the playback option to display both image and histogram. Check the look of the histogram to make sure no detail is being lost in the highlights or shadows. If necessary, adjust the camera settings and shoot again.

Full Aperture and Shutter Speed settings

With many cameras it is possible to change the aperture in fractions of a whole f-stop. It may also be possible to alter the shutter speed selection in smaller increments than is traditional. This can make life a little tricky when you are trying to recalculate the correct exposure for a night shot from one aperture shutter speed combination to another. Use the following aperture and shutter speed sequences to help you recalculate your settings.

Full aperture f-stops: f1.4, f2.0, f2.8, f4.0, f5.6, f8.0, f11, f16, f22, f32

Full shutter speed settings: 1/30, 1/15, 1/8, 1/4, 1/2, 1, 2, 4, 8, 16, 32, 64 seconds

Figure 4.27
Don't let a cloudy night put you off venturing into the dark. Here the moon is diffused by the cloud providing a dramatic background for the silhouetted trees.

Exposures beyond your camera's longest shutter speed

Keep in mind that to obtain exposures longer than the maximum setting for your camera you will need to switch to the 'Bulb' mode (and strap the camera to a sturdy tripod). This special shutter speed setting keeps the shutter open while the shutter button is depressed. Once the button is released the shutter then closes. It is very difficult, no make that almost impossible, to keep the camera steady whilst holding the shutter button down for minutes at a time, so if you regularly want to photograph under low light conditions invest in a cable release that can be locked in the open position. Couple the remote release with a small count down timer, and torch, and you are ready for executing the truly long exposure times necessary for creating moonlit images.

Figure 4.28 Night turns to day, albeit a day filled with strange colors, as this simple country scene is lit with a mixture of moon and street lights. The key to revealing these colors is ensuring that you have enough exposure.

Starting Exposures for low light shooting (at ISO 400)

Brightly lit street scene – 1/60 sec f4.0

City skyline at night – 1 sec f2.8

City skyline just after sunset – 1/60 f5.6

Campfire – 1/60 f4.0

Fireworks against dark sky – 1 sec f11

Landscape with full moon – 8 secs f2.0

Fireworks

A not-to-be-missed part of most village fairs and a mandatory inclusion in all backyard bonfire nights, photographing fireworks is a great way to flex your new-found low light shooting muscles. Capturing these brilliant explosions of color and light is not as hit and miss as it may first appear. This is especially true for digital shooters as the results of our efforts can be easily reviewed on the spot via the monitor on the back of the camera.

Figure 4.28 Using a cable release you can keep the shutter of the camera open long enough to record the full burst of the fireworks. To record multiple bursts cover the lens of the camera with a dark cloth or black baseball cap in between individual fireworks explosions.

The explosion of a firework takes place over a period of a few seconds. There is the initial thump or sound of the mortar as the shell is launched skywards. This is followed by the first explosion, maybe a series of smaller bursts and a host of trails of twinkling light. To ensure that you capture the full effect you will need to use a long exposure. So start by setting your camera on a tripod and point it to the general location in the sky where the first few bursts occur. Try to avoid including complex backgrounds or well-lit structures in the frame as these will distract from the fireworks themselves (and may over-expose your sensor given the long exposure times). This said, judicially positioned horizon detail does provide a sense of scale for your images. So check out the environment. Take a few test shots before making up your mind.

Next turn off the auto-focus mechanism and manually focus the lens into the distance. For most situations the 'infinity' setting works fine but it also pays to check this focus setting with the first couple of photos and adjust where necessary. Next attach a cable release to the camera. If you don't have one of these set the shutter speed to 4 seconds (this is a starting point and can be altered later when you review your first few shots). Now that you are set up simply open the shutter when next you hear the thump of the mortar and keep the shutter open for the full length of the burst, releasing the button only when the last trails die away.

Figure 4.29 Lightning is a lot less predictable to photograph than fireworks but no less spectacular.

And don't forget to try your hand at capturing lightning, nature's own fireworks, the next time you are in the midst of an electrical storm. Though not as predictable as shooting a fireworks show, successfully photographing these spectacular strikes uses all the same principles outlined above.

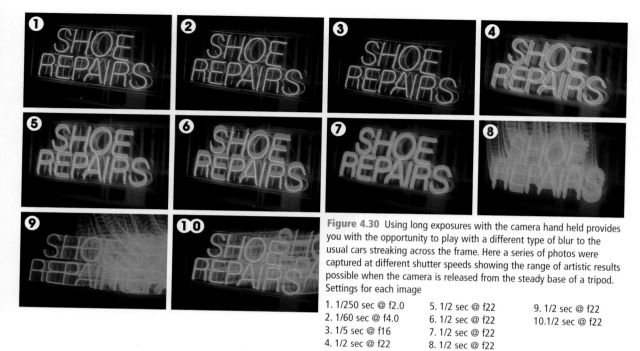

Figure 4.30 Using long exposures with the camera hand held provides you with the opportunity to play with a different type of blur to the usual cars streaking across the frame. Here a series of photos were captured at different shutter speeds showing the range of artistic results possible when the camera is released from the steady base of a tripod. Settings for each image

1. 1/250 sec @ f2.0
2. 1/60 sec @ f4.0
3. 1/5 sec @ f16
4. 1/2 sec @ f22
5. 1/2 sec @ f22
6. 1/2 sec @ f22
7. 1/2 sec @ f22
8. 1/2 sec @ f22
9. 1/2 sec @ f22
10. 1/2 sec @ f22

Low light time and motion

When most people think of shooting cityscapes at night they envisage images full of twisting light streaks of speeding cars set against the expanse of illuminated office blocks. This type of imagery is so familiar because the very act of shooting with low light levels necessitates longer shutter speeds than we would normally employ in the day light hours. Longer shutter speeds mean moving objects are not frozen in the frame, but rather are recorded as streaks flowing through the photo. The speed of the movement, the position of the subject in the frame and the length of exposure all contribute to the way that the subject is recorded.

Controlling the movement

Long exposures provide low light shooters with a unique situation to record subject movement in ways not normally available. Designing how the photo will look when so much of the picture's impact is based on moving subjects can be tricky though. The three way combination of shutter speed, aperture and ISO setting determine the way that the movement is recorded. For images with less blur, use a higher ISO setting (400, 800, 1600) and smaller f-stop values (f2.0, f2.8, f4.0). These settings will then enable faster shutter speeds which will, in turn, help to freeze the motion. Alternatively longer exposure times will produce more streaks and more blur. To obtain the slowest shutter speeds, employ bigger f-stop values (f11, f16, f22) , and at the same time use lower ISO settings (200, 100, 50).

Subject movement versus camera movement

Don't restrict your blurred motion experiments to tripod-based captures of subject movement. Turn this idea on its head. Release the camera from its steady base and try photographing static subjects hand held. You may need to turn off the camera's, or lens's vibration reduction system, in

order to get the most artistically, blurry photos, but experimenting with different shutter speed settings will produce a variety of effects.

Anti-blur systems

Most modern SLR camera systems contain special features designed to reduce the incidence of blur caused by camera shake. In the Nikon range this feature is called VR, or Vibration Reduction, and is built into many of the company's lenses. With Sony DSLR cameras, the system is called Super Steady Shot and is built into the camera body, rather than the lens, providing a steadying function across all lenses. These systems compensate for the shake associated with holding the camera with wobbly hands, or shooting while standing on the deck of a moving boat. Most photographers leave this system activated to help ensure sharp, clear, photos, but if your aim is to produce arty, blurred images, then switch the system off.

The problem of noise

In a perfect world there would never be an occasion when there was a need for photographers to use either a high ISO value or a long exposure, and so all the images produced would be beautifully noise free. But alas this is not the case and the low light shooter will regularly find themselves using both long exposures and high ISO settings. Does this mean that we have to put up with noise filled images for the sake of shooting convenience? The answer is no.

Most mid to high range digital cameras now contain specialized noise reduction features that help to minimize the appearance of random pixels in images produced with either high ISO or long exposure settings. These tools attempt to isolate and remove the errant pixels from the image, creating much cleaner and sharper images in the process. Be warned though, most noise reduction features do take time to process the captured file, so turn the system off if you need to shoot several images quickly, and employ a post capture technique for noise reduction (see Part 7 for some software based Noise Reduction techniques).

Figure 4.31 Many camera manufacturers now offer vibration reduction systems in their compact and DSLR ranges. Some companies house the system in the lens, while others, like Sony, base the feature in the body of the camera making it available with all lenses.

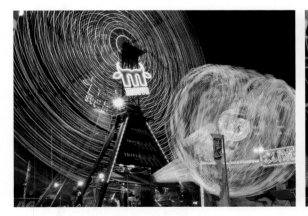

Figure 4.32 Using a long shutter speed in this carnival atmosphere converts the motion and lights of the rides into fascinating light sculptures. For best results shoot and review your images on the camera's LCD screen adjusting the shutter speed settings as you go. Capture details – 3.2 secs @ f16 @ ISO 100.

Figure 4.33 In comparison, this semi-frozen alternative of the same scene employs a much higher ISO setting and smaller aperture value so that a faster shutter speed can be selected. Capture details – 1/20 sec @ f6.3 @ ISO 1600.

Animal portraits

Photographing family pets and rural animals is rather like photographing young children. You need a lot of patience because they cannot be told what to do; they are unselfconscious (although capable of showing off) and their relationships with people are a great source of situation pictures (see Figure 4.34).

For best results always take the camera to the animal rather than the reverse. In other words, don't put the animal in a false or unfamiliar environment just because this is more convenient for your photography. Animals do not really belong in studios.

Showing character

As much as possible, try to convey the individual character of the animal you are photographing. Often, you can do this by showing the bonds between a pet and its owners, particularly children. It is also possible to show the interaction between animals, although you may have to keep your distance and so avoid disturbing them by your presence (see Figures 4.35 and 4.36).

Decide what is a typical activity and environment for your particular animal. Large pets like ponies and big dogs are often more placid than small dogs and kittens. Even so, it is not helpful to overexcite them by making the photography a 'big event'. You can suggest size by including other things in the picture to give a sense of scale. Also, make good use of camera viewpoint. A looming great horse can be shown close from a low angle, but use a normal or long focal length lens – coming in close with a wider angle gives ugly, steep

Figure 4.34 Portraits of your pets should be no less full of life and character than those of your friends or family, but just like these images, such personality-filled pictures require much patience and skill to capture.

Figure 4.35 A self-satisfied animal with its owner. The low angle here gives strong shapes, and comfortable relaxed relationship between owner, pet and photographer enables this candid portrait to be recorded.

perspective. A small cat or puppy looks tiny cradled in someone's arms, or photographed from a high viewpoint, perhaps in front of a pile of crates and casks. Create candid images of your pet by photographing from the end of the garden, inside the house or across the street with your zoom lens on telephoto setting.

Figure 4.36 On a hot day, horses behave a bit like humans.

Small active animals are often by nature excitable and difficult to control. If this is a valid part of your pet's character it should be shown. Maybe it is good at leaping for balls, rolling on its back or just lapping up milk? Try setting up simple attractions – a ball on a string or a throwable stick – and then await natural developments patiently . . . But don't over-manage and degrade your pet by, say, dressing it up or putting it into ridiculous situations. The movement of an animal rushing around might be portrayed via a short series of shots, like a sequence of stills from a movie. Try to keep your viewpoint for the series consistent, so that the action appears rather as if on a stage. Another approach is to pan your camera to follow the action (easiest with the lens zoomed or changed to tele) and shooting at 1/30 or 1/15 second. The blurred surroundings and moving limbs then become a feature of your pictures, although you will need to take plenty of shots on a hit-or-miss basis.

Have a helper – preferably the owner – to control the animal and if necessary attract its attention just at the key moment. But make sure you brief the helper to stand near you behind the camera, and not to call the animal until requested. Another approach is to give the animal time to lose interest in you and your camera and return to its normal activities, even if this is just dozing in the sun.

Figure 4.37 Cradling in a helper's arms provides scale and also keeps this lively young animal under control.

Lighting and exposure

As in human portraiture, soft, even daylight is usually 'kinder' and easier to expose for than contrasty direct light. Try to avoid flash indoors, or if you do use it, bounce the light off the ceiling. 'Red eye' from flash on the camera is just as prevalent with animals as human beings. So be sure to use the red eye reduction techniques outlined in the portrait section. Load medium/fast film, say ISO 400, or set the ISO to a high value for digital cameras, so that you can still use a fast shutter speed with the available light.

If you have a multi-mode exposure system camera, select shutter priority (Tv or S) and set the shutter to 1/250 for outdoors use unless you want subject movement blur. When using a

Figure 4.38 One scared kitten sees a dizzy world through its front door.

manual camera set this same shutter speed, then change the aperture setting until a reading off the animal's coat signals correct exposure. Having all your camera controls set in advance will avoid loss of pictures due to fiddling with adjustments at the last minute. You need to combine patience with quick reactions, watching your animal through the viewfinder all the time, to be ready to shoot the most fleeting situation. A rapid auto-focus camera is helpful when an animal is liable to move about unexpectedly, especially if it is also close.

Backgrounds

Think carefully about the surroundings and background against which your subject will be shown. Many animal pictures are ruined because assertive and irrelevant details clutter up your photograph. Animals cannot be directed in the same way as people, and what may start out as a good background easily changes to something worse as you follow your subject into a different setting. The safest background to pick is a relatively large area of similar color, tone and texture. A large stretch of grass is a good option, especially when the camera viewpoint is high enough to make this fill the frame. Alternatively, by bending your knees and shooting from a low angle you can use the sky as a background.

Better still, pick surroundings showing something of your particular animal's own habitat, adding character and enriching the portrait. A scared kitten neurotically observing a confusing world through its reeded glass front door is one case in point; a pair of horses gently dozing under the shade of a tree is another.

Not all animal portraits are set up, of course. Always look out for opportunist pictures (for which a compact camera is the quickest to bring into operation). Just like candid shots of people, you will discover a rich source of animal relationship pictures at gatherings – pet shows, livestock markets, pony races, farmyards, even dogs' homes – where plenty of 'animal action' is always going on.

Shooting in the wild

Unlike the wildlife photographer who makes their living by catching magnificent beasts in their natural habitat, the closest that most of us will get to snapping photos of these kinds of animals is through the bars of the local zoo or wildlife park. But don't be dismayed – these locations can provide you with access and proximity that a pro would need to travel for days and maybe patiently wait for weeks to achieve (see Figure 4.39). So seek out the options that are available locally. Check out the range of animals that each attraction has and find out how the exhibits are housed in a single location.

The parks whose exhibits mimic the wild habit of the beasts on show make for the best photographs. Old style zoos are not as conducive for capturing natural-looking photographs but if this is your only option don't let it deter you. Go ahead and capture the best images you can using the shooting techniques detailed here to help minimize the intrusion of these unnatural elements.

Get permission

Choosing where to photograph is a decision that will either increase or decrease your shooting opportunities depending on how conducive the park/zoo owners are to having you photograph their exhibits. Most companies realize that photography is an integral part of any visit but few are prepared to accommodate any disruption to their show schedules or other patron's enjoyment, in order that you get the shots that you want. If you are planning a big day's shooting it is worth phoning ahead and checking out the photographic policy of the park or zoo. Many will not allow you to use a tripod or flash when taking pictures. Tripods can be a hazard to other patrons and at worst block walkways or restrict the view of the audience at shows. The use of pop-up or on-camera flash is also often restricted because it can frighten or startle the animals.

Figure 4.39 Creating great wildlife images is not an activity limited to the professionals. In fact, photos like the one above are possible by digitally montaging several pictures taken during a visit to the local wildlife park.

In addition to considering such pragmatics of shooting as these, many parks also have restrictions over how you can use the images that you take whilst on their property. Photographs that are intended to adorn the walls of living rooms or sit on pages of a family album are generally not a problem, but if your intention is publication or resale, then the park's owners will definitely want to know about it. This doesn't mean that they will disallow the activity. In most cases you will just need to sign a photographer's agreement stating where and when the images will be used.

Plan your day

Most parks have specific times of the day when certain animals will be displayed or, at the very least, encouraged to make an appearance for the paying customers. If possible obtain a copy of the typical schedule used in the park for the day that you plan to visit beforehand. Organize a shooting schedule for your day and base it around the timing of the shows and the appearances of the animals you most want to photograph.

Keep in mind the orientation of the exhibits and where the sun will be in relation to the animals at the time of the shows. The sun is your main light source and its position alters according to the time of day, so estimate the sun's angle and how it will light the exhibits before deciding when to shoot what. Most shows or feeding times occur at least twice during the day

Solving shooting problems

Sun behind the subject can cause some tricky problems, including the chance of:

- **Flare spots** in the picture as the sunlight reflects off the glass elements in the lens and
- the dreaded **Silhouette** effect where subject appears dark and without detail because the camera's metering system has been fooled by the extra light coming from behind the subject.

Solutions for flare spots:

- Add a lens hood to your camera lens and ensure that it is shading the front element.
- Move slightly around the subject so that the sun isn't shining directly into the lens.
- Have someone use an umbrella or piece of card to shade the front element of the lens.

Solutions for silhouette effect:

- Zoom in so that the main subject fills the viewfinder and hold your shutter button down halfway. This will fix the focus and exposure based on the subject. With the button still down halfway zoom back out and then press the button fully to take the photo.
- Use the camera's exposure compensation feature to add 1–2 stops (or EV) extra light to the settings that the camera recommends for the scene. Take a test photo and check your results on the camera's LCD monitor. Adjust the exposure compensation setting if necessary to add more or less light. Photograph the subject and then return the feature to the normal or zero setting.

and so if the sun is incorrectly positioned for one event time, schedule the alternative as your shooting period.

What to consider when photographing

Now that we have sorted the where and when let's concentrate on the how. Many habitats are quite large and with the subjects roaming freely it is possible that you will need to be able to cover a range of between 3 and 30 meters (10 to 100 feet) in the one enclosure. Add to this the necessary flexibility of capturing headshots, full body photographs as well as wider pictures that include the surrounding habitat and you will quickly see that you will need a lens or, more likely, a couple of lenses that cover a wide zoom range.

Most camera and lens manufacturers now produce super-zooms capable of a truly amazing range of focal lengths. These pieces of kit work well in good lighting conditions and provide a vast array of framing options and so are well suited for most zoo photography. The comparatively small maximum aperture of these lenses may be a problem if you are photographing later in the day. The mixture of low lighting levels, no tripod and small maximum lens aperture can cause blurriness in your pictures. To solve this problem try increasing the ISO setting on your camera or, if you have the option, switching to a faster lens.

When confronted with the impossible task of photographing through bars or a protective net to your subject beyond, use a small f-stop number setting to blur the foreground detail.

Be careful of the direction of your lighting. Observe the way that the light fills the habitat and make sure that you wait until the subject is well lit before pressing the shutter.

Landscapes

Successful photography of landscapes (meaning here natural scenes, principally in rural locations) goes beyond just accurate physical description. The challenge is to capture the atmosphere and essence of location, perhaps in a romanticized or dramatized way. The colors, pattern of shapes, sense of depth and distance, changes of mood which go along with variations in weather conditions, all contribute here. In fact, a landscape is rather like a stage set (see Figure 4.40).

However, photographs often fail to capture what it felt like to actually be there. Of course, elements such as sounds and smell, the wind in your face, the three-dimensional feeling of open space are all lost in a two-dimensional picture. But there is still plenty you can retain by careful selection of when and from where your shot is taken.

Figure 4.40 Just like a stage set, where the lighting, props, scenery and players all need to work together for a good performance, so too do many different elements need to combine to create a great landscape photograph. Many of these elements are out of the control of the landscape photographer, whose best skill is being in the 'right place at the right time'.

Paramount of all the factors that affect the way that landscape images are recorded is lighting, and since we are dealing here with natural light, the time of day, the weather, even time of year, all have a strong influence on results. You can argue that not much of this is under your control, and certainly there is always an element of seizing an opportunity when by luck you find yourself in the right place at the right time. But you can also help yourself by anticipation. Don't shoot second best – notice when conditions are not quite right and aim to return again earlier or later in the day when the weather is different or perhaps when you can bring a different item of photographic equipment with you (lens, film type, tripod, etc.; see Figures 4.41 and 4.42).

A landscape is basically immobile but it is certainly not unchanging, and there is often a decisive moment in its appearance that will not reappear for another week . . . or another year. Good landscape photographers therefore have to be good planners. They aim to get themselves into the right location before the right time – set up and patiently awaiting a scene to 'unfold'.

Lighting

If you look through the viewfinder at a landscape as if it were a stage, your framing up and composing is like stage-setting. But then comes the all-important lighting of this theatrical space. Time of day affects mainly the direction of the light; weather conditions affect its quality

The essential equipment for the landscape photographer:

Tripod – A tripod is not a nicety, it is a necessity for landscape work. The varying light conditions coupled with the use of large aperture numbers means that often you will be shooting with shutter speeds that cannot be successfully hand held. Choose a model that is sturdy but not too heavy – remember you will have to carry the tripod to all locations.

Camera – This sounds like an obvious inclusion in the gear round-up but the features on the camera you use can make a lot of difference to the quality of work you produce. Options like RAW file capture, manual or aperture priority exposure modes, depth of field preview button, exposure compensation system and self-timer can all contribute to the creation of better landscape photographs.

Lens – Wide-angle lenses are the usual lens of choice for landscape shooters, enabling them to squeeze very wide vistas into their camera frames. Most of the major camera companies now manufacture either fixed length or zoom wide-angle lenses suitable for use with digital SLR cameras. Look for models that have a high maximum aperture number (f16, f22) and keep in mind that most digital sensors are generally smaller than a 35 mm film frame and therefore a wide-angle lens on a film camera has a reduced angle of view when attached to a digital body. This change is usually called the camera's multiplication factor and varies between models and manufacturers – for Nikon digital SLR cameras, for instance, it is a constant 1.5. This means that a 20 mm lens will have an angle of view equivalent to a 30 mm lens when attached to a digital body. If you are not using an SLR have a look at some of the great auxiliary wide-angle lenses that screw to the front of existing lens.

Weather protection – 'Be prepared' is the best advice when it comes to accounting for changes in weather – after all is it so common for a beautiful day to end up windswept, overcast and raining. Make sure that you and your camera gear are kept warm and dry. For your camera, this means using a waterproof backpack when not shooting and an umbrella or rainproof housing when you are. For yourself, a pack-a-mac or splash jacket should always be stored in the camera bag just in case.

Backpack – Use a comfortable backpack to carry your equipment. Models with weather protection, good padding and a belt strap are best. Make sure that the backpack is adjusted to suit your size and shape and that the weight is evenly distributed between shoulders and hips. And remember only carry the equipment you really need.

Memory cards – Although it mightn't seem like it when you are paying out the cash, memory cards are the cheapest part of the landscape shooting exercise. Most of the

trouble and expense is involved in getting to the location, so once you are there make sure that you have enough memory space to take plenty of shots. It may be tempting to take along a portable storage device such as the Nikon Coolwalker or the Nixvue Vista but often the extra weight and space taken up by one of these devices means that extra or larger memory cards are more practical in the long run. This is especially true with companies like Lexar now producing 8 Gb compact flash cards.

Level – Use a spirit level to ensure that your camera is sitting plumb on the tripod. This will keep your horizons straight and ensure that trees do not lean inwards at the top of your photos.

To help with accurate positioning some tripods have a built-in spirit level, or you can purchase a special level that slots into the hot shoe bracket of your camera.

Notebook – Take down notes about where, when and how you photographed a scene. Not only are these important for helping you duplicate specific techniques at a later date, but they can also prove useful as a diagnostic tool when trying to figure out what when wrong.

Remote release – A remote release is not essential but helps ensure no accidental movement when releasing the shutter. If you don't own one of these then try using the self-timer feature. By the time it has counted down most of the wobbles will have gone.

Batteries – Sometimes the best locations are also the most remote so make sure that you have plenty of batteries on hand to power your picture-taking exploits. Ensure that all rechargeable batteries are fully charged and that you have spares of any auxilliary batteries to use in the camera. Remember in cold weather batteries become less efficient so always carry spares of all power sources when things turn a little chilly.

Good shoes – Now I am really sounding like your mother but good walking shoes are worth the investment if you plan to trudge through tropical rainforest or climb over mossy rocks in search of the perfect photograph.

(hard, semi-diffused, soft) as well as its distribution across the scene. Picture, for example, a mountainous landscape complete with wind-blown cloud cover providing dappled patches of direct sunlight that constantly move across the scene. Every moment the appearance of the landscape changes, which means firing the shutter just when a patch of illumination is in the right place to pick out an important feature or focus point like a few scattered houses (see Figure 4.43).

Cloudless sunny days, so common in the tropics, often provide monotonous lighting. Under these conditions it is more interesting to shoot early or late in the day. Shadows during these periods are long and contribute strongly to the texture of a picture. It is also important to notice that clear direct light displays the colors in the scene at their most vibrant. In contrast, hazier conditions give the same hues a more pastel appearance (see Figure 4.44).

The combination of lighting, weather and season of the year has a powerful influence on a landscape's appearance, particularly noticeable in temperate parts of the world such as Europe. Changes in season bring about great changes in the way that the landscape appears (see Figures 4.45–4.49). Remember that, visually, the most rapidly changing, interesting seasons

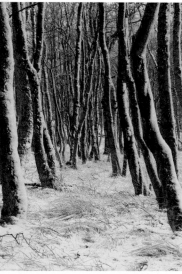

Figures 4.41 and 4.42 The weather and light play a critical role in the look and feel of the final landscape photograph. As seen in these examples, the same type of landscape can take on many dramatically different appearances, depending on the conditions at the time.

Figure 4.43 Lighting dramatically transforms mountainous landscapes. This deep valley in Madeira kept changing as patches of sunlight drifted through.

for landscapes are spring and autumn. Snow-covered scenes in winter need direct sunlight in order to 'sparkle', unless you want a moody, somber effect. Very hazy conditions are good for atmosphere but can easily become dull. It may be best then to shoot against the light and base your picture on silhouetted foreground shapes linked to grayer shapes further away.

Figure 4.45 Spring, April.

Figure 4.46 Summer, July.

Figure 4.47 Autumn, October.

Figure 4.48 Autumn, November.

Figure 4.49 Winter, January.

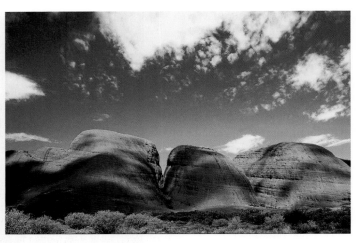

Figure 4.44 The strong lighting provided by the direct sunlight in this image is tempered by the addition of carefully positioned clouds (and their shadows) in the overall image. The landscape photographer needs to be patient when waiting for the lighting conditions and moving elements, like clouds, to be positioned in such a way that it suits the whole picture.

Camera technique

The basic elements when framing up a landscape are its foreground, middle ground and background. Each of these areas should relate in some way, and be relevant to the others (see Figure 4.50). Consider how high to place the horizon – a decision that often determines the ratio of the three parts. Beginners often position the horizon dead center. Don't overdo this though, for unless you consciously plan a symmetrical composition, splitting the picture into equal halves can make it weaker and indecisive. Always avoid tilting the horizon, which seems to happen most easily when you use the camera on its side to shoot a vertical format picture. Keep the foreground interesting or at least filled, preferably in some way that provides a lead-in to the main elements in your picture. Even a plain foreground looks good if in shadow, contributing depth to the picture when contrasted against a lighter background.

A zoom lens that offers a short focal length or a wide-angle lens of about 28 mm are very useful for landscape work – particularly when the foreground is important or when you just want to 'open up' the whole of a scenic view. Secondly, a lens of moderately long focal length such as 135 mm is occasionally handy when you want a distant element in your picture – mountains on the horizon, for example – to loom large relative to mid-distance and foreground.

When your lighting is uneven, decide the key part of your landscape and measure exposure for this part – perhaps turning and reading off nearby ground that is receiving the same light. Some photographers use a number 2 graduated gray filter attached to the front of their camera lens to prevent overexposure bleaching important sky detail when setting the correct exposure for darker ground area. Other filters that are useful for landscape work include a deep orange color and a polarizing filter. The former is used for black

Figure 4.50 Using a large depth of field to keep most image parts sharp can help combine foreground, middle ground and background elements.

and white photography, to darken the monochrome reproduction of blue sky and so make white clouds appear more bold. The polarizing filter, which appears overall gray, is also useful for color photography. It can reduce the glare or sheen of light reflected from surfaces such as glossy foliage, water or glass, as well as darkening blue sky at right angles to the direction of clear sunlight. The polarizing filter can therefore help to intensify subject colors, although colorless itself.

Finally a small, easily carried tripod greatly extends the possibilities of landscape work. It frees you from concern over slow shutter speeds when time of day, weather conditions and dark tones of the scene itself combine to form a dim (but often dramatic) image.

Color in landscape

The intensity of colors in landscape photography is enormously influenced by atmospheric conditions, plus the color, type and intensity of the light and technical matters such as choice of film or saturation setting for digital shooters and the use of filtration. For instance, direct, warm evening light shortly after a downpour can give intense and saturated colors. Water provides a very interesting foreground for landscapes. Changes in its surface – from still to rippled by breeze – mix colors, reflections and shapes.

A much more formal man-made landscape, like the gardens at Versailles, already has a scheme of tightly restricted colors built in. In hard, clear sunlight, the brilliance of red and green and a touch of yellow appears most strongly to the eye (see Figure 4.51).

For film users, the choice of color film (and the color paper that negatives are printed on) can fine-tune results, emphasizing the richness of certain hues in a landscape, or give more muted, subtle results. Experiment with different maker's brands. And if you produce your own color prints through a computer printer, various software programs will allow you to 'tweak' the final color balance in different directions. Don't overdo this manipulation, though.

Figure 4.51 Gardens at Versailles, a shot that needed careful framing to exclude colors outside this restricted range.

Skies

Clouds, sunsets, vapor trails and rainbows all form an important and ever-changing element in land and seascapes. The contents of skies can also form abstract images of their own. American photographer Alfred Stieglitz called his photographs of clouds 'equivalents' – their shapes and tones evoking emotions such as love, foreboding, exuberance, even ageing and death.

The best times of year for interesting skies are during spring and autumn. Cloud shapes appear most dramatic when back- or side-lit, in ways which strongly separate them from the general tone of the sky. For example, the sun may have just set, leaving a brilliant sky background and silhouetted shapes. Conversely, during unsettled weather, clouds can appear intensely bright against a dark background bank of storm clouds. Often, a 'skyscape' needs a weight of tone to form a base to your picture. You might achieve this by composing darker parts of a cloud mass low in the frame or by including a strip of land across the bottom of the shot. Where possible, make elements in this lower part of your picture complement sky contents in some way. Trees may be useful in helping to frame the sun when this figures in your image.

Even though the sun is not shown in many sky images, you must decide carefully how you will measure exposure for these pictures. It's easy to overexpose when your camera metering system becomes too influenced by a darker land mass also in the picture. The consequence is that cloud texture and sky colors appear burned out. Choose which part of the picture should finally appear a midtone – midway between darkest and lightest details – then fill the entire frame with this or a visually matching area while you measure and set exposure (then set the AF lock on automatic exposure cameras). If possible, make one or two bracketed exposures, giving less rather than more exposure. Make sure your final picture is printed dark enough to give exactly the feeling for shadow and light that you wanted.

Warning: The sun's bright globe loses its energy and can be harmlessly imaged late in the evening, when the light passes through miles of haze. But never point your camera directly at the sun in clear sky at other times of day. Like using binoculars under such conditions, the intensity of light can damage your eyes. The camera's exposure meter too is temporarily blinded and can give rogue readings for several minutes afterwards. Also, digital sensors may be permanently damaged if used to capture a photograph of the sun directly.

Figure 4.52 Be sure that composition in the pictures that you convert to grayscale is based on non-colour based design ideas such as pattern, tone, or in this case, line.

Creating black and white images

Though some digital cameras still have an option to shoot in black and white (grayscale) largely this mode has been removed from the features list of many current models. Consequently most photographers, no matter how 'in love' with monochrome images and printing they are, shoot color all the time, choosing to convert their pictures to black, white and gray, after capture, and with the aid of their favorite software program. But as many of you can probably already attest, shooting great monochrome pictures is quite a different art to the act of capturing wonderful color photographs. Here we will look at how best to shoot color when you have monochrome in mind.

See tones not color

The most important fact to consider when creating monochrome pictures is that at some stage during the process the color that you see before you in the scene will be converted to a series of grays. Even in the days of film this was the case. It was the skilled photographer who understood the conversion process and could predict how certain colors would be recorded. They trained their eyes to downplay contrasts in color within the scene and encouraged their sight to emphasize how the other design elements, such as pattern, texture, line and, the most important of all, light, played in the photograph. In this way, although seeing in color, they could

account for the characteristics of the conversion to black and white and adjust the way that they shot to make best monochrome pictures possible.

Even if your camera has the option of shooting grayscale, I recommend that you should always capture in glorious color. This approach will never limit your options. The same picture can be processed as a color photograph or skilfully converted to a series of grays and spend its life as a rich velvety monochrome print.

Compose using the other design rules

In some ways the strength of your composition is more important when the color is removed from a picture and it is stripped down to just the bare tone of the image. It is as though we are examining the very structure of the photograph without the distraction of any colorful embellishments. For this reason it is critical that you revisit the basics of composition and spend your viewfinder time ensuring that the frame is well balanced. Examine the whole of the scene checking that details in the fore-, mid- and background are all consistent with the picture layout. Make the most of the design elements that don't rely on color for their visual strength. Use pattern, texture, tone, and line to both balance the subjects in your photograph as well as direct the viewer's eye to the picture parts that you deem as important.

Light is king

In the absence of color, light moves to the forefront of the queue of visual factors to consider when shooting. Where soft and diffused lighting may be appropriate for an image that contains a group of brightly colored subjects, strong and textural side-lighting will help bring drama to your monochrome images. This doesn't mean that you should religiously take all your pictures

Figure 4.53
The strength of this monochrome image is drawn from its great use of strong and direct light. Pictures that contain subjects that have little contrast in themselves need to be strongly lit to ensure dramatic results.

with contrasty lighting but black and white pictures do live or die based on the quality of the light within them.

Softly lit photographs have to rely more heavily on the contrast of the tones within the picture itself rather than the differences that come from a dramatic change of the light falling upon the surface of the subjects in the scene.

Aim for quality

The decades of beautifully produced and richly toned monochrome prints that preceded the birth of digital photography have left us with a hard black and white act to follow. Practitioners like the famed Ansel Adams and Minor White prided themselves on the careful recording and production of technically magnificent and visually stunning prints. They were true masters of the silver tradition and it is in their foot steps that our own digital monochrome production must follow.

Though the technology has changed, the methodical approach that they advocated is still as relevant today as it was then. Their workflow entailed matching the subject brightness range of the scene (the difference between shadow and highlights) with the capture medium (in their case film), nurturing the recorded tones through the production process (chemical developing) and finally squeezing the results into a black and white fibre based print. Our version of the process still contains capture, process (editing and enhancing on the desktop) and printing. Translating their concerns to our workflow would mean that we should:

- Ensure that all images are captured at the best quality capable by our cameras or scanners. This means RAW where available, TIFF and JPEG (highest quality/least compression) where it is not.

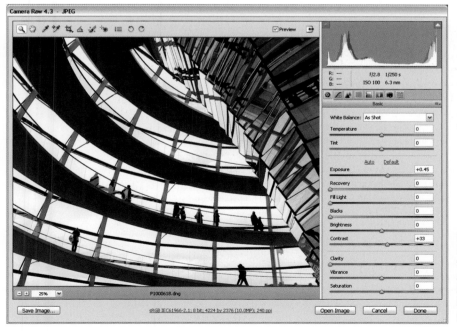

Figure 4.54
RAW file capture, together with the options for enhancement in Adobe Camera Raw, provides the best quality image which can then be used as a starting point for grayscale conversion.

- Capture with enough resolution (total number of pixels) to ensure enough detail for the maximum print size you require.
- Make sure that capture settings record both highlight and shadow areas equally and that no tones are clipped in the process.
- Make all editing and enhancement changes to your pictures in 16 bit mode to take advantage of the extra tones available with this option.
- Carefully peg black and white points and adjust midtone values of your picture with sophisticated tools such as Levels and Curves. Do not use features such as the Brightness/Contrast sliders which can easily cause valuable tones and details to be lost.
- Use a calibrated monitor for all editing and enhancement changes. This increases your ability to make fine tuning changes to your pictures that are predictable and consistent.
- Use a calibrated or ICC profiled printing system. It may seem strange but color calibration is even more critical when outputting 'neutral' black and white prints. Using a profiled system means that you can spread the considerable detail in your original photograph across the full extent of the printer's, ink's and paper's capabilities predictably and accurately.

Photoshop is your friend

In seeking to create the best quality pictures from capture to print, software like Photoshop or Photoshop Elements are by far the monochrome shooter's best friends. Starting with the package's ability to import and process RAW files right through to the sophistication of its tonal control features (ie. Curves and Levels) and the way that it employs a full ICC profile color management system, the king of editing packages gives you the fine level of adjustment that is necessary for the production of quality black and white prints.

Gearing up for monochrome production

This technique's gear list is a little oblique. Rather than just include the equipment needed for the capture of good pictures that will eventually end up as great monochrome prints, we have also thrown into the mix the other components (some of them software based rather than hardware) of the process that are just as important.

RAW or 16bit TIFF capture option – Check to see what is the highest quality setting for your camera and scanner gear. Use RAW where it is available, failing that trawl through the manual for the possibility of using a 16 bit TIF file format.

Careful exposure control – Though not strictly gear related, the impact of quality exposure on the production of high class monochrome prints can not be overstated. Slight under or over exposure may be tolerable but go a little further away from the optimal exposure and you will quickly find you will lose details in your shadow or highlight areas.

Good conversion process – Ensure that you use a quality colour to grayscale conversion process. The best results are rarely obtain by simply changing the color mode from RGB to Grayscale, instead employ techniques that make use of alternative approaches such as multiple Hue/Saturation adjustment layers,

using the 'L' channel from an image in LAB mode or the Channel Mixer feature.

Quality editing and enhancement steps – Continue the quality workflow by applying changes in brightness and contrast with tools like Curves and Levels and with the image in 16 bit mode

Matched paper and ink set - Reduce the possibility of creating cast-ridden black and white prints by using matched paper and ink sets along with the ICC profile created for the media.

Monochrome-ready printer – For best results use one of the photographic printers that contains extra light black (gray) cartridges to help with the creation of neutral gray tones.

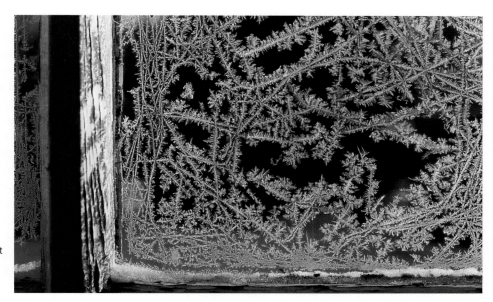

Figure 4.56 Backlit frost on a shed window. Dark garden behind shows up the pattern.

Close-up subjects

Working close up (within 30 cm or so of your subject) opens up a whole new spectrum of picture possibilities. You can not only record small objects so that they fill the frame, but interesting, even dramatic pictures can be made from details of relatively ordinary things that you might not otherwise consider for photography. A cabbage, or a few clothes pegs, or just the page edges of a thick book are examples of hundreds of simple subjects that can be explored for hours in close-up. Along with plants and flowers, and weathered or corroded materials, they provide a rich source of pictures based on color, shape, pattern and texture (see Figure 4.56).

Close-up photography is also useful to record possessions for identification purposes. Items of special value to you can be logged in detail, against possible damage or theft, leading to an insurance claim. If you are an enthusiast then your collection of stamps, coins or model cars can be visually catalogued this way and then scanned into a computer file. Photographing inanimate objects in close-up is also an excellent self-teaching process for control of lighting and picture composition generally, working in your own time.

Technically, the main challenges in close-up work are to:

1 Sharply focus and accurately frame your subject.
2 Achieve sufficient depth of field, which shrinks alarmingly with close subjects.
3 Arrange suitable lighting.

Focus and framing

The closer your subject, the more the camera lens must be located further forward of the film or sensor to give you a sharp image. Basic, fixed focus cameras do not sharply image subjects nearer than about 1.5 m, unless you can add a supplementary close-up lens. A typical 35 mm

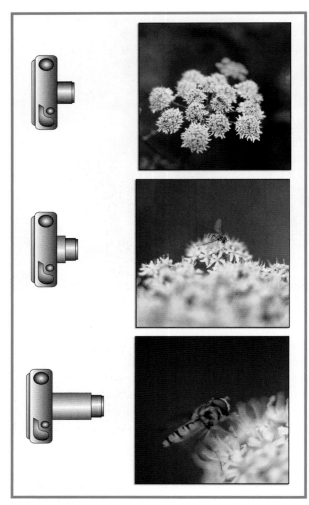

Figure 4.57 Close focusing with an SLR. (Top) Fifty-millimeter lens used at its closest setting, no ring. (Center) With a 1 cm ring added. (Bottom) Using a 5 cm ring instead.

compact camera allows focus adjustment down to 0.6 m (20 in) and the more expensive models to 0.45 m (12 in). The latter means that you can fill the picture with a subject about 6.5 cm wide. Some cameras have a so-called macro setting for their closest focusing distance. It may mean there is a gap between the lens's continuous focusing adjustment and its positioning for the closer distance. This is more limiting than to be able to focus 'all the way down' but will still enable you to capture good close-up pictures (see Figure 4.57).

The macro setting on many digital compact cameras allows you to focus extremely closely. In some newer models, this can be as close as 2 cm from the front lens element. This, plus the ability to review the image immediately, makes these cameras prime candidates for close-up work.

One way to adapt any camera for close subjects is to fit a close-up lens element over the main lens, which shortens its focal length. These supplementary lenses, like reading glasses, are rated in different dioptre power according to strength. Fitting a +1 close-up lens to a fixed focus 50 mm lens camera, for example, makes it focus subjects 87 cm distant. Used on a focusing compact with a camera lens set for 0.6 m, it sharply focuses subjects 30 cm away.

The main difficulty using a close-up lens on a compact camera is that the separate viewfinder system becomes even more inaccurate the nearer the subject. A close-up lens is more practical on a digital camera, where you can observe focus and composition accurately on the electronic display screen. Similarly, any single lens reflex film camera has a viewfinding system that allows you to see exactly what is being imaged.

However, close-up lenses – particularly the most powerful types – do reduce the overall imaging quality of your main lens. This is where an SLR camera scores heavily over a compact. For, instead of adding a lens, you can detach its regular high-quality lens from the camera body and fit an extension ring between the two. The extra spacing this gives reduces the minimum focusing distance. This might mean that your normal lens, which focuses from infinity down to 0.45 m, now offers a range from 0.45 to 0.27 m (so the subject is imaged on film about one-quarter life size).

By using extension rings of different lengths – singly or several at once – you can move in closer still. The degree of extension, and therefore how close a subject can still be focused, is even greater if you fit a bellows unit rather than extension rings. Generally, when using bellows

The gear you need to get up close

Tripod – Getting in close exaggerates the slightest camera or subject movement. For this reason it is essential to use a tripod to steady your gear when photographing.

Cable or remote release or self-timer – Even with your camera locked down to a study tripod the action of pushing the shutter button can still produce a blurry image when you are shooting with longer shutter speeds. To help stop the shakes use a cable or remote release to fire the shutter. Alternatively, try using the self-timer feature to release the shutter several seconds after you have pushed the button.

Macro lens – If you own a major brand digital SLR then you can purchase specialist macro lenses designed to get you in very close to your subjects. These pieces of glass are a serious investment but still represent the best way to obtain high-quality macro shots. If you want the class without the expense then try hiring one of these beauties for the day from your local professional gear outlet.

Reflector and extra lighting – Great images require great lighting. Make sure that you don't forget to take just as much time lighting your close-up pictures as you would illuminating a studio portrait. This means ensuring that you have reflectors and even an extra light source handy to fill shadows or add a highlight.

Dedicated macro light – For the truly dedicated Nikon has a dedicated macro ring light attachment for their series of Coolpix cameras. Called the Cool Light SL-1, the device screws directly onto the lens of some models and via a step-down ring for others. This attachment is not a flash but rather provides a permanent and continuous light source for macro shooting from a series of 8 white LEDs. As many of the cameras in Nikon's range can focus down to as little as 2 cm, such an attachment makes the job of lighting subjects that are very close to the camera much easier.

or extension rings, auto-focus lenses have to be manually focused (see Figure 4.58).

Most SLR zoom lenses offer a macro setting on the focusing scale. This adjusts components inside the lens so you can sharply focus subjects an inch or so from its front surface. Often, the range of subject distances is very restricted. For best quality and greatest flexibility in close-up work, change your SLR camera lens to a more expensive macro lens, specially designed for close subjects. Its focusing scale allows continuous focusing down to about 0.2 m and thereafter closer still if you add rings or bellows.

If you have no macro lens, you can achieve maximum magnification with your SLR camera equipment by combining your shortest focal length lens with your longest extension tube or bellows. In other words, if you own a simple extension ring, fitting it behind a 28 mm lens instead of a normal 50 mm type will sharply focus your subject about 30 per cent larger. However, you will be working much closer, which may result in the camera casting a shadow. This close proximity also makes three-dimensional subjects record with steepened perspective.

Figure 4.58 A bellows unit for close work with an SLR camera.

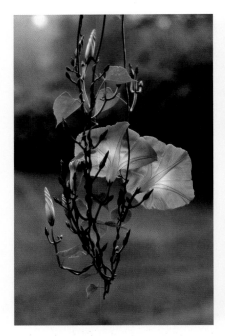 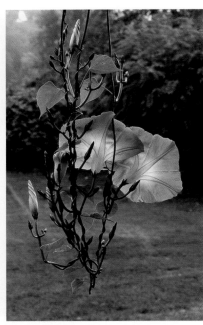

Figure 4.59 Morning glory. (Left) Using f4 and 1/250 second. (Right) Using f16 and 1/15 second. The former version has a less distracting background and looks more three-dimensional. Hazy daylight from above and behind helps to reveal form.

Depth of field

Depth of field decreases as you move closer to your subject, even though you use the same lens aperture (e.g. a lens focused on something 1.5 m away might give nearly 20 cm depth of field, but this shrinks to only 3 cm depth when the same lens is focused for 0.45 m). This means that your focusing must be very precise, there is little latitude for error. Where possible, arrange your camera viewpoint so that all the parts of the subject you need to show pin sharp are about the same distance from the lens. Provided that every part of the subject where you must show detail is sharp, rendering things at other distances out of focus helps to isolate them, erasing clutter. A manual camera with depth of field preview button is very useful here – observing image appearance as you alter the lens aperture setting will give you a good idea of the extent of sharp detail (although you must get used to the screen getting darker as the aperture is reduced in size). Alternatively, digital camera users can use the 'shoot and review' process to ensure that the zone of focus is where you want it (see Figure 4.59).

Figure 4.60 Good lighting is essential for close-up work, as low light levels can contribute to aperture and shutter speed settings that produce shallow depth of field and perhaps even some camera shake.

Garden flower close-ups

Flowers are a rich source of color, pattern, texture and form. Lighting is therefore very important. Shooting against diffused sunlight out in the garden is a good way to show the transparency of petals and leaves, emphasized by shadowed background. Back- or side-lighting also reveals the stalks and other structural detail in a three-dimensional way. Direct sunlight from

the side is good for emphasizing texture (see Figure 4.60). Even when sunlight is diffused, fit a lens hood or shade to your lens to minimize light scatter and flare caused by light falling on the front element of the lens. Measure the majority of your exposure from the delicate petal detail – if this approach results in dark stalks it is still more acceptable than burnt-out flower colors. Use soft, even lighting for strongly patterned flowers, as it will cause less confusion than direct light, which will add shadow and texture to the picture as well.

One advantage of working so close to a small subject is that it is not difficult to modify natural light to suit your needs. Something as simple as a piece of tracing paper hung between a plant and direct sunlight will bathe everything in soft, even illumination. A hand mirror can direct sunlight into the shadow areas and a white card held close behind the camera reduces the excessive contrast of back lit shots.

Movement blur

A feature of working outdoors you will discover is that small movements of the flower caused by the slightest breeze are magnified by image size and recorded as blur. As a result, if the subject keeps swaying out of focus there will be an increased risk of movement blur (see Figure 4.61).

Figure 4.61 In breezy conditions, ensure that you are using a fast shutter speed and then be prepared to shoot several images of the one flower set to ensure that one of the series is captured with no subject movement.

A shield made of card on the windward side and positioned just outside the picture area will help reduce the movement. In addition, selecting a high ISO value or a fast film will allow you to set a combination of brief shutter speed (perhaps 1/125 second to reduce blur and allow camera hand-holding) plus a really small aperture to produce sufficient depth of field.

Be careful, though, as the faster the film or higher the ISO value, the more grain is apparent in the final picture. Too much grain and you will destroy the finer qualities of your image, especially if you plan a big print. The best approach is to work using a tripod, or at least partly support the camera on top of a stick or 'monopod' reaching to the ground. A monopod with the camera attached can minimize movement blur yet still allow quick adjustments to distance.

When using a manual or semi-automatic camera on aperture priority mode, first set an aperture to achieve the depth of field you need and then shoot at the shutter speed indicated to give correct exposure. Clamping the flower in some way, perhaps holding its stem with your hand just outside the picture area, will also help.

Flash is a handy source of movement-freezing illumination in a close-up situation. If possible, have a flashgun on an extended lead – so that you can position it from the best angle for the subject features you want to show, using the light either direct or diffused with tracing paper. Flash on or near the camera can be useful when working with daylight to dilute or lighten shadows, leaving sunlight from above to pick out the form. Flash will also suppress unwanted background or surroundings by under-lighting them, but take care that this does not give you unnatural looking results.

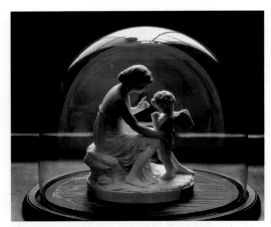

Figure 4.62 This piece was lit by a wide rear window. Shooting from a distance avoided steep perspective and hid camera reflection.

Close-ups indoors

Being able to work close up means that you can find all kinds of subjects indoors. You may use these subjects for factual record purposes, or to create artistic pictures. You might, for example, create a 'portrait' of someone through a still-life group of related possessions and personal memorabilia. For a child, this might be the contents of their schoolbag; for an aged relative, it may be pictures and objects displayed on a bureau. Much of this work can be done by using the existing daylight as your source of light. Hazy sunlight through cloud (not blue sky) will give most accurate color, and if you can work in a room with a large window, this will help to avoid uneven illumination. Figure 4.62 was photographed this way. For this type of indoors work a tripod is practically essential – it not only gives you the freedom to give longer exposures without camera shake, but anchors viewpoint and distance in one spot while you build up your picture, bit by bit.

Copying flat surface subjects

The most important factors in photographing or making copies of physically flat subjects such as drawings, sheets of stamps, etc. are:

1 **To be square-on to your subject.**
2 **To have it evenly lit.**

Unless the back of your camera is truly parallel to the surface you are copying, horizontal and/or vertical lines will converge. Look very carefully around the edges of the frame to ensure that the borders of your subject line up – don't be tempted to tilt the camera a bit if the picture is not quite central (shift it sideways instead).

Figure 4.63 Copied on a window sill, lit by soft overcast daylight from above, and white card below the lens to fill in.

When using daylight through a window, come close to the glass so you have the widest possible width of illumination, e.g. lay your subject flat on a bay window sill. Evenness is further improved if you place a white card vertically facing the window on the room side of your subject just outside the picture area. Be careful about measuring exposure when your subject is on a background sheet of a very different tone, as in Figure 4.63. Stamps displayed on a black, or white, page will be over- or underexposed respectively by a general light reading. It is best to cover the whole page with a mid-gray card and measure off this surface, set the aperture and shutter speed, and then remove the card before exposing.

Figure 4.64 Shot with a 50 mm lens and extension ring. Tracing paper diffused daylight.

Figure 4.65 Same lens and ring; f16 was used to get eye and distant window sharp.

Reflective subjects

Reflective surfaces such as glass or shiny metal need special lighting care; otherwise, shadowy reflections of the camera will confuse detail. Sometimes you can help matters by shooting from further away, using a longer focal length lens on an extension tube. This way, the camera can be far enough back to be a small, unsharp, almost invisible reflection (see Figure 4.64). A large sheet of tracing paper used close to your subject is the best way of controlling reflection. Angle the camera so that the tracing paper surface (through which all the lighting passed) is shown as an even white reflection off the reflective surface.

Some close-up shots stretch depth of field to its limits. For instance, with extreme close-ups of a face it can be almost impossible to get nose, eyes and ears all sharp. For the biggest depth of field possible, set the lens to the smallest aperture (f22 or f32) and, with the depth of field preview button pushed, examine the dim image as you move the camera fractionally backwards and forwards; all the important elements in your picture are just within the depth-of-field boundaries (see Figure 4.65). If you stick can't get the depth that you need try using a slightly wider lens as this too will increase the amount of the subject that will be sharp.

Action and sports photographs

A lot of photographers shy away from shooting action or sports images because they feel that these areas are the strict domain of professionals only. Others say that they don't have the equipment needed to make great action photographs. In some respects these statements are true. Great action images can take a lot of skill and good equipment to produce but this shouldn't be a barrier keeping new photographers, or the occasional action shooter, from trying their hand.

Photography should be an enjoyable and memorable activity. And nothing could be more so than spending the afternoon shooting a local village football match, or the kids on the carousel on Brighton beach. And whether you like it or not, to capture great images from these activities you will need some of the skills of the action photographer.

Figure 4.66 Great action photography is like good comedy, it is all about the timing. Anticipating the action is as much a part of capturing photos like this one as being able to handle your equipment appropriately.

In fact, I believe that shooting action or sports events will help develop a range of skills that might be missed if the photographer avoided the area. Timing, thinking ahead, seeing and working seamlessly with your equipment are all skills that can be learnt 'having a go' at shooting action or sports images. With this in mind let's make a start …

It's all in the timing!

Timing is crucial. Famous Magnum photographer, Henri Cartier Bresson, called it the 'decisive moment' and the name has stuck. For him it was the point when all the elements in the frame came together in one perfect composition. We probably all recall his famous street scene that captured the precise moment when a man was jumping a puddle. He was frozen forever in the air, his reflection skimming off the water's surface. Bresson was no sports photographer but he knew the importance of timing and anticipation.

Even in this age of digital and new technology we can still learn a lot from the lessons that he and other 'greats' pass down to us. It's the photographer's job to look and anticipate where and how the action is going to unfold, and then be ready to capture it (see Figure 4.66). In a sports context the area where the action will be is fairly predictable, bounded by sidelines, and governed by the norms and rules of the game. In football, for instance, you know, or rather hope, that there will be some action around the goalmouth. The pitch and the game's structure itself dictate this.

If timing is the key then how does a new photographer develop great photographic timing? Simple – practise, practise, practise!

Do some pre-planning

My old photography teacher used to say that 'Scouts and photographers are very similar, they both need to be prepared', and as with most photographic activities, a little pre-planning goes a long way towards guaranteeing the success of your first action shoot.

If possible, it is worth checking out the location beforehand. Look to see where the best vantage points are, and assess how far you will be from the action. A rough rule of thumb is that for each 10 meters you are from your subject you will need 100 mm of lens length if your subject is to fill a standard vertical 35 mm frame (remember to take into account the Lens Multiplication Factor for DSLRs). In practice this means that if you are shooting basketball from the sideline (near baseline) then a 100 mm lens should give you full frame shots. If, on the other hand, you are photographing a football match and you are 30-40 meters from the penalty area then you will need a 300–400 mm lens to achieve similar results. In sports like cricket it is not unusual for some

photographers to be using lenses of 600 mm or more with 'doublers' attached, giving an effective lens length of 1200 mm.

Being close enough is only part of the equation when choosing your shooting spot. Watch out for distracting backgrounds. It's true that some of the distraction of the crowd in the background can be minimized by using a shallow depth of field, but it is best to have as clear a background as possible. This will help your subject stand out.

Expect the worst ... from the weather, that is. When shooting outdoors it's also worth assuming that the weather is going to turn bad. This doesn't mean that you need to be laden down with all manner of wet weather gear. A 'pack-a-mac' and a couple of plastic bags will see you and your valuable equipment through all but the most torrential downpours.

Ensure that your camera's batteries are fully charged and that you have a spare set stashed in a side pocket of your bag. Auto-focus cameras are notorious for their power consumption, and this is even more of an issue when you are asking the camera to drive a long lens back and forth during the whole of a sports event.

Check that you have plenty of memory card space (or rolls of film). Arriving at an event with cards already partially filled will hamper your ability to shoot freely. Make sure that you have

enough space to cover the whole event and account for anything unusual that might happen. Action shooting has a higher ratio of shots taken to shots used than other types of photography, so expect to capture many frames during the course of the event. It's better to have too much space rather than too little.

Know the game or event

Good action photographers have, at the very least, a good working understanding of the sport or activity they are shooting. This gives them the chance to maximize their chances of

Digital continuous shooting modes:

Many digital cameras have the option for shooting a sequence of pictures rapidly. The rate at which sequential images are captured and the total number possible for a single burst varies from camera to camera. If you plan to take action sports shots regularly then this feature is one that you should check carefully before purchasing new equipment. Use the following ideas as a checklist:

- Check the frame rate. This should be in frames per second.
- Find out the sustain rate. Look for how many frames can be shot at the fastest rate before slowing.
- Research which file formats work with the fastest frame rates.
- Check the compression level used if the mode is only available in JPEG format. Low-compression images process faster but have less quality.
- Look at the picture dimensions for each mode. Having a very fast mode that only produces pictures with enough pixels to print a postage stamp is not that useful.
- Check the type of memory card used for the statistics, as the speed with which the card saves the files can also affect the overall frame rate.

Figure 4.67 Understanding where the action is in any event will help you capture more dramatic images. Here the swimmer is photographed just as he rises from the water to catch a breath.

being in the right place at the right time. Having some idea about the natural flow of the activity will mean that you can pre-empt where some of the action will be.

Pick the peak shooting points of the action. In every action there is a moment which typifies the activity. In golf, it's the end of the swing at the moment of contact with the ball, in the high jump it's the clearing of the bar when the participant is at the top of the jump's arc and on the ballet stage it's the point at which the lead dancer is in full graceful flight. It's these moments that the photographer needs to capture. They exemplify the action and the achievement of the participants. You need to think about the nature of the action and try to capture the parts of the activity that are most visually descriptive (see Figure 4.67).

When analyzing the action you are not just looking for the most aesthetically representative moment but also the one that can most easily be captured by your camera. Take a competitive diver as an example. There is a point in the execution of the dive when just after leaving the platform the upward motion ceases and for a fraction of a second the diver is suspended in mid-air. In photographic terms this part of the action can be frozen more easily than at the fastest point of the activity where the diver enters the water. If you are shooting indoors then the difference in the speed of the action might be crucial if you are trying to achieve crisp, frozen images.

The same is true for motor sports. Trying to photograph a speeding car or bike as it passes you on the straight doing over 150 miles an hour is much more difficult than photographing the same vehicle as it slows to take a corner. It pays to know your sport or activity and plan the shooting points according to the access you have available, the nature of the action and what is photographically possible.

The final pre-planning activity is to check with organizers about restrictions that surround the event. Often photographers are confined to a particular part of the arena. Depending on where this places you in relation to the action this will determine the type of equipment that you need and the range of shots you will be able to get. Other restrictions that you might confront could include not being able to use flash or in the case of theatrical performances not being able to shoot at all. This particular problem is solved by stage shots being taken during full dress rehearsals rather than performances.

The important thing to remember is that a lot of difficulties on the day could be overcome by making some simple enquiries to the organizers the week before. Better to be prepared than to end up with shots taken from the 35th row of a packed stadium because you didn't get a clearance to photograph from pitch side.

Action and sports shooting techniques

Freezing the action

Stop motion or freezing the action is the aim for a lot of sports photographers. A quick look at a range of sports publications shows that these are also the images most selected by the picture editors for publication. The images are clear and sharp, with the main subject jumping out from the background. If these are the type of images you want there are essentially two techniques you can use to achieve them:

Fast shutter speed – Sounds simple enough, select a high shutter speed and fire away, but there is a direct link between aperture, shutter speed, ISO value and the light in the scene. Put simply, to be able to use speeds that will freeze motion you need a fast lens, high ISO setting and good light.

Fast light source – The alternative to shooting with a fast shutter speed is exposing with a light source that has a very short duration. In most instances this source will be a portable flash. Most on-camera flash systems output light for durations of between 1/800th and 1/30,000th sec. It is this brief flash that freezes the motion. Don't be confused with the shutter speed that your camera uses to sync with the flash – usually between 1/125th and 1/250th sec – the length of time that is used to expose your frame is very short and is based on the flash's duration. Although there are not too many sporting or stage events that allow flash photography there are plenty of other action activities where using flash will help capture that decisive moment.

Blurred motion techniques

In some instances, images where the motion is frozen completely don't carry the emotion or atmosphere of the original event. They appear sterile and even though we know that they are a slice of real-time motion something seems missing. In an attempt to solve this problem photographers throughout history have also played with using slower shutter speeds to capture moving subjects. The results, though blurry, do communicate a feeling of motion.

Slow shutter speed – There is no secret formula for using this technique. The shutter speed, the direction of the motion through the frame, the lens length and the speed of the subject are all factors that govern the amount of blur that will be visible in the final image. Try a range of speeds with the same subject, making notes as you go. Too fast and the motion will be frozen, too slow and the subject will be unrecognizably blurred or, worse still, not apparent at all. Your tests will give you a starting point which you can use next time you are shooting a similar subject.

Extended blurred motion techniques

Panning – An extension of the slow shutter technique involves the photographer moving with the motion of the subject. The aim is for the photographer to keep the subject in the frame during the exposure. When this technique is coupled with a slow shutter speed it's possible to produce photographs that have sharp subjects and blurred backgrounds. Try starting with speeds of 1/30th sec.

Flash blur – To achieve this effect you need to set your camera on a slower than normal sync shutter speed. The short flash duration will freeze part of the action and the long shutter will provide a sense of motion. The results combine stillness and movement.

Focusing issues

Viewfinder focusing areas – In the viewfinder of a modern AF system you will see at least one, but probably more than one, focusing area. For the camera to focus accurately, the subject must be in this area. In entry-level cameras the area is positioned in the center of the frame. In the viewfinders of more expensive examples you will not only find multiple focusing areas but you will also notice that they are distributed across the viewfinder. With the aid of a dial, or a thumb toggle, the photographer can choose which area will be used for primary focus. This enables the focusing of subjects that are off center.

Zone focusing – There are a range of activities that allow the photographer the chance to predict where the subject will be with reasonable accuracy. In swimming, for instance, the lanes and the end points of the pool are well defined. To use this technique the photographer would pre-focus (in manual mode) on one point in the pool and wait for the subject to pass into this zone before pressing the shutter.

Single and constant auto-focus – In AF terms these two modes determine the way in which the auto-focus system works on your camera. In single mode when the button is held halfway down the lens focuses on the main subject. If the user wishes to change the point of focus then they will need to remove their finger and repress the button. If the subject moves whilst using this mode, then you must refocus.

The constant or continuous focusing mode also focuses on the subject when the shutter button is half pressed, but unlike the single mode, when the subject moves the camera will adjust the focusing in order to keep the subject sharp. This is sometimes called focus tracking. Some AF systems have taken this idea so far that they have 'pre-emptive focusing' features that not only track the subject but analyze its movement across the frame and try to predict where it will move to. This in turn helps to keep the main subject fully sharp.

Figure 4.68 Watch out for any images that show more of the human side to competition. Here a reflective moment has been captured providing a good back drop to the more action based pictures.

During shooting

This is the stage where all your good planning bears fruit. Position yourself well. Make sure that all your gear is set. Anticipate the action and capture your images, concentrating on your pre-planned shooting points. There is an old sports photographer's adage that says 'if you see the action through the viewfinder then you've lost it', and this is largely true. At the moment of exposure for SLR users, the viewfinder goes blank to allow the mirror to retract and the shutter open. So if you see the action then you have missed the chance to record it. It takes a bit of practice but anticipating the action point is one of the most important skills needed to take good images.

Shoot plenty of images – after all exposing digital frames essentially costs nothing. Wherever it is possible use the continuous shooting feature on your camera to capture action sequences or, better still, if your camera is up to it, shoot 'through' the action and select the best images later at the desktop.

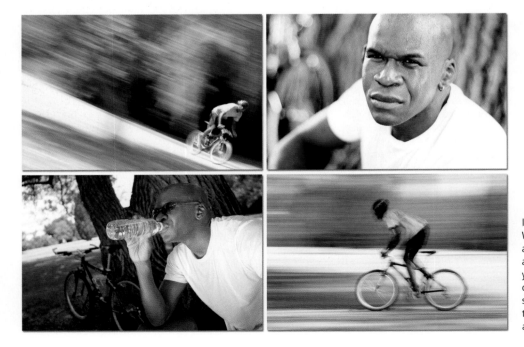

Figure 4.69
When photographing action or sports activities don't limit yourself to pictures containing motion, spend time capturing the periods before and after the action.

Make sure that you make the most of the location. Eventually you will get to a stage where, in your own mind, you feel that you have covered a particular section of the meet or event; it's then time to move around and find a new vantage point. In photographer's language, this is called 'working the location'.

Concentrate on the action but don't forget that there are stories to be had behind the scenes as well. Try shooting the participants as they are preparing or after they have finished. To make a more complete set of images it could even be worthwhile following the progress of one individual through their warm-ups, heats, the big event and the aftermath, be it jubilation or despondency. There is always drama to be had for the photographer who is prepared to look (see Figure 4.68).

Vary your shots. You should make sure that you use a range of different focal lengths so that at the end of the event you will have a variety of images ranging from the close-up, through mid, and onto long range shots. A couple of good quality zoom lenses can help cover an astonishing range of focal lengths, providing the contemporary photographer with no excuses for ending up with a bunch of similar images (see Figure 4.69).

Keep in mind that there are a variety of techniques that you can use to photograph action. These range from those designed to freeze a precise moment to those that give the feeling or sense of movement and those that are a combination of the two. When you are out shooting for the day, remember keep thinking, keep looking and keep shooting.

Going with the flow

With over 70 per cent of the world's surface being water it would be unusual if at some stage during your photographic lifetime this liquid asset didn't appear in your photos. But just because it is plentiful doesn't mean that many of us actually spend much time considering how best to photograph it. Like other tricky subjects, water needs special care and attention if we are really going to capture its true essence in our photos. In this section I'll look at some of the techniques you can use to capture the water images that surround you.

Figure 4.70 The classical blurred water shot consists of a mountain stream running through a green landscape. The long exposure changes the water to a silken blanket which contrasts nicely against the rich hue of the foliage. You can easily replicate this yourself using a tripod and a series of exposures made with long shutter speeds.

Static or in motion

Whether it is the local stream after a little rain or a giant waterfall in a famous national park there is something intoxicating about the sound and the look of moving water. When including such features in a picture the landscape photographer is immediately faced with a multitude of decisions. Composition aside selecting the shutter and aperture combination is usually based on the exposure needed first and then depth of field or sharpness considerations. But in choosing the shutter speed the photographer is also deciding how the moving water will appear in the final photograph.

Selecting a slow shutter (less than ¼ second) will produce a photo where the moving water appears like threads of loosely spun silk. This is a look that some photographers refer to as 'angel's

Figure 4.71 Using fast shutter speed and the camera switched to continuous-shooting mode is the best way to try to capture a frozen droplet shot like this one.

Figure 4.72 The short duration time of the light that is emitted from your top of camera flash unit is great for freezing the movement of water close to the camera.

hair'. Alternatively picking a faster speed will freeze the movement preserving the intricacies of the eddy and flow of the stream in sharp focus for all to see.

Both approaches have definite merit and generally a couple of test shots will quickly reveal which direction should be used for a particular environment. There is no golden rule here; it is definitely a matter of 'shoot and see'. For this reason you should carry a small (but sturdy) tripod to ensure that you always have a choice when it comes to how you will capture water movement in your photos.

Freezing movement: an alternative

'Apart from using a high shutter speed how else can I freeze the movement of water in my photos?' Well I am glad you asked. Another option that you may not have readily considered is to add a portable flash into the equation. For most models the duration of the flash burst that exits the unit can be measured in tens of thousandths of a second. This is much faster than the quickest shutter speed on all but professional stop motion cameras. What's more, the advanced exposure system of modern digital systems can easily combine sunlight and fill-flashlight in the same exposure without the risk of over exposure.

These two factors combine to provide you with the ability to use your 'top of camera flash' to light the moving water detail in the foreground of a scene and, in doing so, freeze its movement. The clarity from these flash frozen photos is truly amazing and beyond what is generally possible with shutter control alone.

See beneath the surface

Sometimes in our haste to embrace all that is digital we forget some of the lessons of the past. This is definitely the case when it comes to using such essential pieces of equipment as the polarizing filter. Designed to cut down the reflections or glare in a picture (and improve the overall saturation of the photo) sadly the polarizing filter is not the 'must have' accessory it once was.

Figure 4.73 Adding a polarizer to your lens will not only darken and saturate the colors in your picture but will also reduce the reflections from surfaces like water allowing you to see the detail beneath the waves.

This is a shame as this humble little filter has great benefits for the water shooter. When the sun is correctly positioned and the polarizer attached to your camera lens a couple of quick turns of the filter and magically the surface reflections will disappear. In this way water vistas captured with a polarizing filter record both the scene above water and also allow the viewer's gaze to penetrate beneath its surface.

Move in closer

Some of the most interesting images are found when you start to move closer into your water based subjects - the last droplet on a drooping leaf after rain or the dew condensing on a spider's web early in the morning. Be careful though as successfully filling your frame with water requires you to not only pay attention to composition and macro focusing but also to how the subject is lit.

The translucent nature of water means that it is best lit from behind or the side as

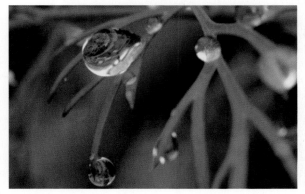

Figure 4.74 Getting in close to your water subjects can really create some interesting design and compositional possibilities.

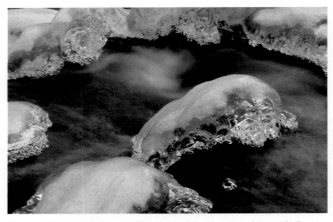

Figure 4.75 Don't limit yourself to the traditional water subjects. Challenge your photographic skills by try to capture scenes containing ice or steam.

direct lighting will produce bright hotspots and reflections. You can easily create this type of lighting setup in a studio, by moving the light or the subject or both, but working in the field is another proposition. Here the position of the light (the sun) and the subject is generally fixed. In these circumstances try shading the subject with a dark reflector (gobo) and changing your own position until the lighting is more appropriate. To make a subject such as a water droplet really stand out, light from behind and then try to position the subject so that it is against a dark subject in the background.

The essential kit for photographing water

Tripod – To ensure that you have the choice of using short or long exposure be cure to include a tripod (even a small one) in your kit bag. There is nothing worse than stumbling upon a free-flowing stream and not being able to emphasize the moment of the water with a long shutter speed.

Portable Flash – Though not essential for taking great water shots the addition of a flash to your equipment bundle will provide the added option of freezing airborne water droplets with the flash burst rather than a very fast shutter speed.

Splash proof housing or DIY camera-mac (plastic bag with holes cut in it) – I probably don't need to tell you that water and camera electronics are not the best of friends so make sure that your expensive equipment is well protected before entering a wet environment. This might mean that you use a simple plastic bag with a few well positioned holes cut in it to shield your camera from unexpected splashes or for the dedicated water photographer, it may well be worth investing in a water-proof or splash-proof housing.

Fold-up backgrounds – As we have seen, capturing the true transparent nature of water is enhanced when the liquid

is photographed against a dark background. But what if your environment doesn't contain a suitable backdrop? Simple, bring your own. A folded dark green or black cloth that can be draped in the background of the photograph is a quick solution to problem backdrops.

Polarizing filter – A simple polarizing filter fitted to the end of your lens can make a world of difference to the appearance of the water in your photo. Given the right position of the sun in the scene this filter can reduce and in some cases eliminate the glare reflecting from the surface of the water allowing you to see what lies beneath.

Neutral density (ND) filter – A neutral density filter is constructed of an uniform gray material and is used to reduce the amount of light entering the camera. This filter is particularly helpful if you want to use a long shutter speed but the brightness of the scene (and the minimum ISO setting available on the camera) will not allow you to select a suitable shutter speed. Adding a ND filter can increase the length of the shutter speed from 2 to 8 times depending on how dark the filter is.

Tackling self-set themes

A good way to extend your photography is to work to a particular topic or theme – something you have chosen, or set perhaps by a competition. This will challenge you to organize ideas and plan your approach, and actually having to carry out an assignment encourages you to solve technical problems, gaining experience and confidence.

Themes might place greatest emphasis on the subject itself (a person or thing) or on shapes or structures. Or again they may be concerned with underlying concepts, such as humour and emotions of various kinds.

Singles or series?

Your result might be a single picture, or a pair or sequence of photographs. One picture can sum up a simple concept, such as joy or sorrow, whereas taking two separate photographs offers opportunities for comparisons and contrasts when presented together. Sometimes it's helpful or even necessary to make features such as background, positioning in the frame and angle of view similar in both pictures to show up differences in your main subjects. A longer series of pictures gives scope to tell a story or explain a process, show changes of time and place, and thus develop a theme.

Subject-based themes

Several subject themes have been touched on in this part of the book, but there are many more, such as travel, natural history and still life, for you to choose from. Perhaps you decide to work to a portrait theme. Think of all the ways you can show an individual – at work, at home with their possessions, with family and friends, travelling, relaxing or practicing a hobby. You need patience and time to get to know your subject well, observing mannerisms and seeking out representative aspects of their life.

Another way of working is to shoot a collective portrait, say one picture of every family in a street or apartment block. Here you might show each at their own front door, keeping your viewpoint and lighting similar to provide continuity.

Structural themes

Here the project might center on movement or color, or shapes. You might build a set of pictures from 'found' subjects that all share a common color scheme but have many variations in content, scale and/or texture. One might be blue sky with clouds, another a group of blue-painted signs, a house with blue curtains or a close-up of blue flowers. Make sure each shot is a satisfying image within itself, as well as working as a part of the whole series.

To begin a project on the theme 'light', you could consider qualities such as brilliance, reflection, color, cast shadow and so on. Observe the effects of light on various surfaces under different atmospheric conditions. Next, work through your list, eliminating similarities and identifying six or so characteristics you want to show. Then find suitable subjects (don't overlook the macro world) and techniques to strongly communicate each aspect of the theme.

Emotive and narrative themes

Projects based on the dominant feelings a viewer reads out of your picture are arguably more difficult to plan and tackle. A sense of jubilation, or stress, implied menace, despair, loneliness or close friendship are all feelings that can form the basis of an interesting series. Your chosen approach might be factual and objective, or implied through the shape of a shadow or plant structure, or something colorful but quite abstract.

Alternatively, you may want to work in a more storytelling or narrative way. You could use your sequence of images to illustrate a poem, or cover a passage of time, or a journey from one place to another. A picture series like

(continued)

this needs visual variety as well as continuity if all the photographs are to work as individual pictures and also as part of a series. Start off with a strong general view as an establishing shot, then move in to concentrate on particular areas, including close-ups and lively (but not puzzling) viewpoints. The final photograph might bring the viewer full circle, e.g. the opening picture reshot at dusk.

1 Pick a letter of the alphabet and photograph five different found objects that look like the letter shape. Don't forget to use close-up as well as distant shots to add variety to your series.

2 Sum up your impressions of one of the following places in three or four pictures: (a) a graveyard; (b) the seashore; (c) a modern industrial park.

3 Try to illustrate the color red in three pictures without actually photographing any objects colored with the hue.

4 Make a short series of pictures of owners and pets to prove or disprove the theory that they grow to resemble one another.

5 Create a descriptive portrait of the character of a family member by photographing three images containing places and things that are important to the subject. Don't include the subject in any of the pictures.

6 Produce two or three animal 'head and shoulders' portraits of either: (a) a dog; (b) a tame rabbit or hamster; or (c) a cat. Try to convey character through showing what they do. Include the owner if relevant.

7 Photograph a series of valuable items to record them for insurance purposes. Include a ruler alongside for scale.

8 Using hands as an expression of emotion, produce three pictures, each conveying one of the following: anger; tenderness; tension; prayer.

9 Illustrate three of the following themes using a pair of pictures in each case: simple/complex; young/old; tall/short; hard/soft.

10 Make a documentary series of four pictures on either 'children at play', 'shopping' or 'a day off'.

5 Controlling Light

'Without light there would be no photography.' Such a statement seems almost so simple and obvious that voicing it sounds ridiculous, but sometimes we need to be reminded just how crucial light is to the creation of our images. When first picking up a camera we grow to understand that the quantity of light in our scenes has direct consequences on factors such as the selection of shutter speeds and apertures, but it is only further on in our photographic education that we discover that light also plays another role in the image-making process. It is a role of description. Taking lighting to this next step means that you not only become concerned with the amount of light in the scene but also with more descriptive characteristics. In this chapter we look at practical ways to light portraits and products and then see how we can apply these techniques outdoors, with flash and in the studio.

The basics of great lighting

There are three corner stones to great lighting – the quantity, quality and direction of the light. When shooting in the studio we have the luxury of being able to control all of these characteristics making it a great environment to learn more about your craft. Photographing outside is little trickier but good images use the same understanding of lighting when working here as they do in the studio.

There is no underestimating the importance of good lighting in the popular areas of portraiture and table top photography. After all it is the light itself that gives volume, texture and shape to your subjects. Just as a sculptor reveals the form of their subject by carving away pieces of stone from a shapeless block, so too the photographer reveals the form of their subjects by describing their surface and shape with skilful lighting control.

Quantity

So if there is no photography without light then one of the first tasks of the photographer is to ensure that he or she has enough light to enable good exposure. This is essentially a technical consideration, balancing the light level with aperture, shutter and ISO settings, but in the haste to provide enough light for subjects, many photographers forget that quantity is not an end in itself, but rather, just part of the equation. This approach often leads to images that are well exposed, sharp and clear, but are lacking a descriptive quality.

Figure 5.1 Good lighting both describes and illuminates the subject. Here the lighting adds to the drama of the portrait contrasting the girl's fair skin against the dark background and the direction of the main light adds volume and form to the subject.

Measuring light

In the days of old, you could always tell a serious photographer, as they were the one with a light meter dangling around their neck. Despite the accuracy of in-camera meters, these hand-held devices are still the studio pro's choice as they can accurately measure the light falling on a subject from both flash and continuous sources (tungsten, daylight, fluorescent). The readout provides a range of shutter and aperture combinations for a given ISO setting which can then be transferred to the camera. In addition, they are great for working out lighting ratios (the difference in brightness between light sources in the photo) helping to ensure shadows are not too dark, or highlights too bright to be recorded with detail.

If your budget doesn't stretch that far, then the camera's own light meter can be used to try using the 'shoot and review' approach. This involves capturing a series of test shots using different aperture/shutter/ISO settings and then assessing the results on the camera's LCD screen. Both the Histogram and Highlight Warning features in your camera should be used to help ensure good exposure and avoid clipping of highlight shadow details.

Quality

As we'll see throughout the rest of this chapter, it is often the quality of the light that makes a great image. So once you have ensured that there is enough light for a good exposure, you need to turn your attention towards controlling the characteristics of the light itself. You don't need to be satisfied with the light that you are first presented with; one of the key skills of a photographer is being able to modify and change the quality of the light falling on their subjects. This is true not just for studio work, but also when photographing outside.

You can change the quality of your light source falling on your subject with a range of light modifiers. Diffusion material stretched over a frame, soft box attachments or white photographic umbrellas will all soften the light where as silvered umbrellas, metal reflectors, bare bulbs or direct flash create direct, hard edged lighting. There are a range of companies that provide off the shelf, system based, attachments for their light heads, but many photographers also experiment with creating, and using, their own light modifiers. Material such as sail cloth can be stapled to a simple wooden frame to create a diffuser or tin foil adhered to a cardboard sheet for a directional reflector and large sheets of thin polystyrene foam make great white reflectors.

Direction

The direction of the light also plays a key descriptive role, providing a sense of shape, texture and volume to the subject. In simple terms lighting a subject from the front flattens the object and reduces the appearance of texture. Lighting from the side creates a sense of 3 dimensions in the photo. This sensation is underpinned by the introduction of highlights and shadows to the subject. Side lighting also emphasizes the subject's texture. Continuous light sources, or flash systems with an included modelling light, allow the photographer to preview the effects of changing the light's position. The monitor on the back of the camera also provides instant feed

back on the way that the light's direction (and quality) is describing the subject. In addition some newer model cameras have a LiveView option that allows you to preview the subject and its lighting before pushing the button.

Your lighting workflow

Keep these three key areas in mind when lighting your subjects. Start with a single light. Adjust the quality by adding a diffuser, bouncing off the surface of a white board or using attachments such as a soft box or umbrella. Change the height and position of the light in relation to your subject until the direction of the light best describes the texture and volume of the subject. Check the power settings or subject to light distance to ensure adequate light quantity for your selected aperture/shutter speed/ ISO combination.

Matching subjects with a specific light quality and direction is largely a matter of style and artistic direction, but over the years photographers have developed a set of specific lighting schemas (light set ups) for portraiture and table top work that provide a good starting point to your studio experiments. Over the next few pages I'll will introduce you to these tried and true approaches.

Figure 5.2 Sharp direct lighting from behind this @ symbol casts a hard edged shadow in the foreground of the photo. But this is not the only light in this image. If it was, we would see no detail in the shadow. There is also a soft shadow light falling on the whole composition lighting the top of the symbol and filling in the shadow area.

Lighting for people photographs

Like viewpoint and framing, there are no absolute 'rights' or 'wrongs' of organizing lighting. There are basic guidelines, but you must decide which subject features you want to emphasize or suppress and the general mood you need to set, and manipulate your lights accordingly. You can dramatize and dominate the subject matter with your lighting, or keep the light simple and subsidiary so that subject features alone make your shot.

Experiment until you can forecast and control how the final picture will look. Lighting control doesn't start and end with a studio environment and a set of studio lamps but rather also encompasses those times when you are photographing outdoors or using an on-camera flash system as your main light source. The approach should be the same in all these circumstances. The photographer works with the light available, sometimes modifying the quality and direction and other times adjusting the position of the subject to take advantage of a light source that cannot be moved or modified.

When working indoors remember what you learnt by observing natural lighting outdoors. Think of a spotlight as direct sunlight and diffused or reflected light like slightly hazy sun. The difference is that you can set their position instantly instead of waiting for different times of day for the sun to move. As you get more experienced, it becomes helpful to use more than one lighting unit at a time or to modify the main light source with reflectors or diffusers. Don't allow this to interfere with your main lighting, though, destroying its 'natural light' basis of causing only one set of shadows. In the studio a second lamp might, for example, separately illuminate the background behind a portrait or still life. This allows you to separate the subject

Figure 5.3 Adding another light to the set-up to illuminate the background provides separation between the dark hair of the model and what would be an equally dark background if left unlit.

from the background by making it lighter, or graduated in tone, or even colored (by filtering the light source). Alternatively, when working outdoors a well-positioned reflector can add much needed light into dark shadow areas of the portrait (see Figures 5.3 and 5.4).

Basic portrait lighting

One of the key factors to capturing good portraits is making sure that your lighting is up to the task. Good photographers understand and can control the quality of light within their pictures. It is up to you to start to train your eyes to see the differences in light quality and to predict the effect they will have on the way that your subjects are lit. The two main light qualities are:

1 **Direct, strong lighting**, which produces hard-edged, dark shadows and is often used to emphasize texture. In portraiture, this style suits subjects with big and bold personalities and strong facial features.
2 **Soft, diffused light** is more delicate, creates light shadows and is often used to minimize texture. This lighting is by far the most popular style of portrait lighting, as it softly caresses sitters rather than starkly defining them.

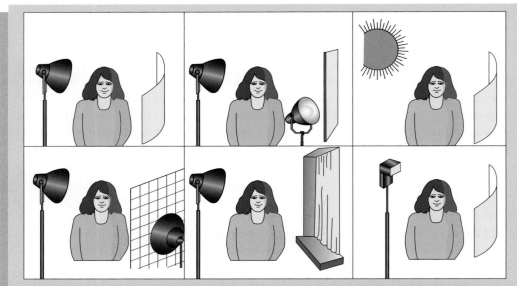

Figure 5.4 There are a range of ways to reduce the light contrast in the studio (and outdoors) without creating a second shadow.

Typical portrait lighting set-ups

Most photographers control the quality and the direction of the light used for their portraits. By manipulating these two factors they can produce radically different images of the same sitter. Don't think that these styles are only used in the studio with expensive flash kits; the same techniques can be used with affordable floodlights or when you are taking pictures with your portable flash gun, or even when shooting outside with the sun as the main light.

Photographers have their own favorite lighting set-ups that they use on a regular basis. Let's look at the most common approaches.

Front lighting

One of the most common styles of lighting is 'direct front'. This is especially true for those photographers whose cameras contain a built-in flash system and for those people who still remember the famous Kodak saying: 'Always shoot with the sun behind you.' Pictures illuminated in this way show sharp-edged shadows trailing behind the subject. The fact that the light is coming from the front also means that there will not be much texture in the subject's face.

For most portrait photographs, this style of lighting is neither flattering nor descriptive. You should only use it when you have no other options (see Figure 5.5).

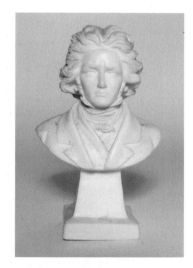

Figure 5.5 Front lighting.

Side-top lighting

Sometimes referred to as Rembrandt lighting, as it copies the way that the famous artist used to light the main figures in his paintings, with this set-up the light is positioned above and to one side of the subject. This provides both texture and form to the face, and is by far the most popular set-up used by portrait photographers (see Figure 5.6).

To get the position of the light just right, make sure that:

• there is a twinkle of light in the subject's eyes (called a 'catch light'); and

• there is a triangle of light on the side of the face that is opposite to the light source.

Figure 5.6 Side-top lighting.

'Okay,' I hear you say, 'this is all well and good in the studio with movable lights, but I don't have that luxury.' The trick is to use the principles of these lighting set-ups with any source that you have available.

If you are photographing outside, it will not be possible to move the sun to just the right position, so instead move the subject. If the sun is too high, then tilt the subject's head up a little, or wait until the sun moves lower in the sky before photographing.

It is important to teach yourself to see how the lighting in your environment is falling on your subject and then either modify the lighting to suit (e.g. move the study lamp on the side desk this way or that), or change the position of your subject to take advantage of the lighting that is available.

Figure 5.7 Lighting from above.

Lighting from above

Many a photographer, wanting to avoid the flat lighting that accompanies using their camera's flash straight on, simply flips the unit so that it faces skywards. The flash light then bounces off the ceiling and then onto the subject. The results do provide more texture in the face, but often the eyes are hidden in the dark shadows of the brows. Similar results regularly occur when photographing portraits outside when the sun is high. Top lighting is generally not used for portraiture for this reason (see Figure 5.7).

Instead of bouncing your light off the ceiling, try twisting it sidewards and reflecting it off a white wall. This will give you much better results that look and feel like soft window light. If you must shoot in the middle of the day with the sun above, try adding a little fill-flash to lighten the shadows around the eyes. Most modern cameras contain the option for this flash mode and, unlike the bad old days of manual flash calculations, the camera will generally balance the daylight and flash exposures as well.

Lighting from behind

Positioning your main light behind the subject can create particularly dramatic portraits and silhouettes, but in most cases the lack of detail in the subject's face can prove disappointing. By all means play with this lighting approach as it offers very real creative opportunities, but make sure that the positioning of the subject is such that the face doesn't become a big dark chasm (see Figure 5.8).

Figure 5.8 Lighting from behind.

Soft diffused light – Rembrandt style

In the previous lighting set-ups, I used a strong direct light source to make the shadow areas and direction of the light completely obvious. But this style of light is rarely used for contemporary portraiture. These days, soft or diffused light is much more popular (see Figure 5.9).

In this example, I positioned the soft light source to the left and above the subject – Rembrandt style. Notice that the triangle of light is still visible but the edges of the shadow areas are much softer.

Professionals use special attachments for their studio flashes, called 'soft boxes', to create this type of soft diffused lighting. Some even use semi-transparent white umbrellas in front of their flash heads. You can replicate the same effect by passing your main light through some diffusion material before it falls onto your subject. You can use drafting or tracing film, or even an offcut of white sail cloth (the sort used by sail makers to construct the sails for sailboards). This also works well when you are photographing outside with the sun as your light source. Just place the diffuser between the sun and your subject.

Alternatively, you can bounce your light off an angled white board, or piece of polystyrene foam, that is positioned top left of the subject. All of these techniques work particularly well at softening the light falling on your subject.

Figure 5.9 Soft diffused light.

Soft light with reflector

Sometimes a single light, even if it is softened, casts shadows on the subject that are too dark for our camera's sensors to penetrate. So most professionals add a reflector to the opposite side of the subject to lighten the shadows and reveal the details hidden by the lack of light. Reflectors can be made from many different materials, including polystyrene foam and white card, but remember to keep the surface white as any color present here will be added to your shadows (see Figure 5.10).

Reflectors are often used when making portraits in the environment to help ensure that dark shadows don't ruin a good picture.

In practice, with your main light positioned to ensure good texture and form for the face, slowly bring a reflector in from the opposite side. Watch as the shadows lighten. Be sure that, when framing the portrait, the reflector remains out of view. To make a more directional reflector, try adhering aluminum foil to a piece of card.

Lighting and movement

The lighting control you have in the studio can help with many of the experimental approaches to depicting movement, as discussed in Part 9. Figure movements during a long exposure, for example, can be turned into abstract patterns in accurately directed ways. For Figures 5.11 and 5.12, two dancers, in pale reflective clothing, posed some distance in

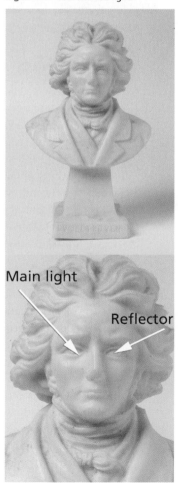

Figure 5.10 Soft light with reflector.

front of a black background. The lighting was two spotlights – positioned left and right at right angles to the camera viewpoint, and screened off from both the background and lens. Within the 'slot' of light so formed, one dancer stood completely still while the other moved to the music throughout a five-second exposure. Including a static element, like the still dancer, in your picture gives a counterpoint to all the action going on elsewhere.

Figures 5.11 and 5.12 Double side-lighting and a long exposure produced each of these expressionist dance images.

Lighting objects

Controlling the quality and direction of the light when capturing portrait photos is often the difference between producing an acceptable image and one that really stands out. The same can be said about lighting control when we are photographing objects. In fact, in some ways, good product photography is even more dependent on the lighting abilities of the photographer as he or she needs to adjust the set-up to suit the surface qualities of the object. It is not enough just to position the light and modify its quality, the photographer also needs to alter the way that the product is lit to ensure that the surface or textural qualities of the object are accentuated. Sound tricky? Well it is only really an extension of the lighting skills we started to develop in the last section. Remember the key to producing well-lit photos is learning to see how light describes your subjects first and then being able to modify the description when necessary.

The five studio shots and lighting set-ups in Figure 5.13 show how mixed changes of lighting can alter subject appearance, especially texture. The lighting illustration shows where the (single) light source was positioned for each version. In first image the spotlight was positioned at the rear of the stone slab, a little above lens height. Its direct light exaggerates texture but gives such contrast that the film both overexposes highlights and underexposes shadows. The second picture uses a reflector board close to the camera to return diffused light into the shadows. In photo 3 the spotlight is now to one side, changing the direction of the (harsh) shadows. With image 4 the spotlight was turned away from the leaf altogether, and illuminates a large white card. The result is diffused ('soft') light, still directed from the side but now free of sharp-edged shadows and even less contrasty than number 2. In the last photo (5) the spotlight is now positioned close to and directly above the camera, and used direct. Like flash on the camera, everything receives light but it is like a drawing without shading, suppressing texture and form.

Arguably, the second photo gives the best compromise between drama and detail, although as a beginner you will often be tempted by photo 1 because it looks good in the studio. Always remember that your eye can cope with greater contrast than film will successfully record.

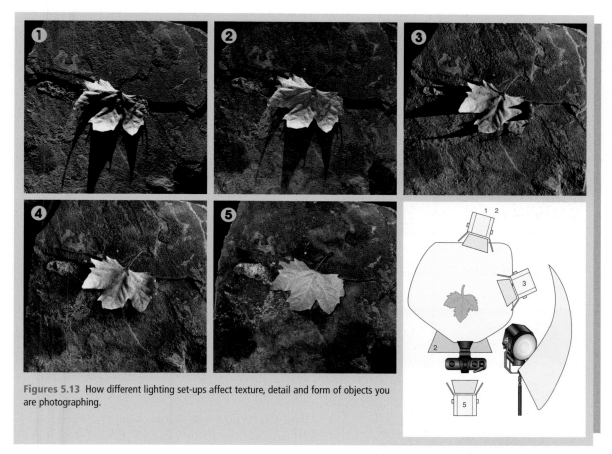

Figures 5.13 How different lighting set-ups affect texture, detail and form of objects you are photographing.

Lighting for different surfaces

Over the years, photographers have developed specific lighting set-ups that work well with different subject surfaces. These set-ups, sometimes called lighting 'schema', provide a good starting point when lighting a difficult subject in the studio.

Figure 5.14 The textural qualities of both the blocks themselves and the greater assemblage are emphasized by skimming strong directional light across the surface of the subject. In this way, the shadow provides the sense of texture, but be careful, if the shadow is too dark and not lightened with a reflector or a second weaker light, little or no detail will be seen here.

Texture

Lighting for texture is all about using strong directional light that skims across the surface of the object, producing shadows as it goes. To show texture you must create shadows, so move your light or your subject around until you see the texture become pronounced. Don't use soft or diffused light sources, even if this results in some dark featureless shadow areas. Instead, set up your main light and then use a reflector to help fill in the shadow regions. Remember the golden rule for texture is light from the side of the object (see Figure 5.14).

Figure 5.15 Tent lighting is the best approach to use for glossy or silver objects. The surface quality of these objects is only apparent when they are reflecting the white of the lit tent fabric.

Silverware or glossware

Highly reflective surfaces, such as chrome or highly polished, glossy paint, need to be treated quite differently to the textured surfaces above. Aiming a strong light directly at the surface will only result in a bright hot spot, with the rest of the object looking dull and dark. Professionals light these subjects by surrounding the object with a 'tent' of diffusion material that they then light through. The silver or gloss surface then reflects the white surface of the inside of the tent.

Though this sounds a little tricky, in practice a successful silver jewellery photograph can be taken by suspending a piece of white sailcloth over the top of the object and then passing the light through the diffuser. The camera is then positioned so that it is to the side of the diffuser and is not reflected in the jewellery surface (see Figure 5.15).

Glassware

Glass objects pose a similar problem to the previous surface types in that directing a light onto the surface produces a hot spot and doesn't show the translucency of the subject at all. To solve this problem, glassware should be lit from behind. Often, this involves a set-up where light is directed onto a lightly colored background and then photographing through the glass object to the lit surface behind.

Once you build up your confidence with lighting subjects with each of these techniques, stretch your skills by trying to light a subject that contains more

Figure 5.16 The transparency or translucency of a subject is shown in a photograph by lighting it from behind, but don't think that this is only achieved by directing the light onto the subject. Here the surface in and around the subject is lit, and then this illuminated area is photographed through the glasses.

than one surface type. For instance, a glass bottle with a silvered label would require you to light the bottle from behind and the label using a broad diffused light (tent) – see Figure 5.16.

Lighting for copying

Photographic copying means accurately recording two-dimensional subjects such as artwork, photo prints, montages and paste-ups. You can turn prints into slides, slides into prints, or color into black and white. The essential technique is to light as evenly as possible, and have the camera set up square-on. Drawings, pictures and clips from papers are best taped against black cardboard, attached to the wall and lit by two floodlights positioned about 30° to the surface. Keep each flood well back from the original to help ensure even illumination. Check lighting with a pencil (Figure 5.17) held at right angles to the original. The two shadows should be equally dark, the same length and together form one straight line.

To copy a slide, you can improvise by laying it horizontally on opal plastic, masked along all four edges with wide strips of black card. Illuminate the plastic from underneath using a floodlight (bounced off white card to avoid heat damage). Support the camera square-on and directly above, fitted with close-up extension tubes or bellows to allow a same-size image. Alternatively, use a slide copying attachment (Figure 5.18) added to an SLR fitted with tubes or bellows. The slide slips into the far end of the attachment, in front of a light diffuser.

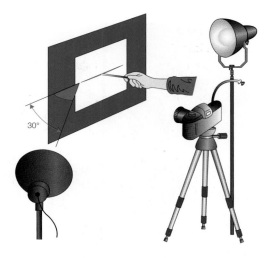

Figure 5.17 Set-up for copying paste-up photo prints, drawings and other flat work.

Figure 5.18 Slide copying. S, slide; D, light diffuser. Adjustable length tube fits on the front of the camera lens and extension ring.

Outside shooting

Most photographers think that it is only possible to control the lighting in a photo when you are working in a studio. But this isn't the case. Yes it is generally easier to control the lighting in a studio environment than when you are photographing outside, but understanding and being able to work with or even modify the light outside is no less important.

Portraits in the environment

When photographing people outside, always be aware of the direction and quality of the light and how it is interacting with your subjects. With most studio set-ups photographers start with a single light that defines the subject and then other lights or reflectors are added to complement

Figure 5.19 A natural environment with soft lighting from a cloudy sky is perfect for creating casual but intimate portraits.

this main or key light source. When capturing portraits outside the studio your approach should be the same. Think of the sun as the main or key light. You can't alter the sun's position so be prepared to move yourself or even your subject, if the sun is not quite in the right position. Professional photographers who regularly create environmental portraits are so aware of the position of the sun that they book portrait sessions based on time of day or even season. This way they can predict where the sun will be during the shooting session.

As for the quality of the light, don't forget that a portable white reflector directed at the subject or a little fill-flash can help to lighten the deep shadows caused by contrasty lighting. When you want a softer light source either diffuse the sunlight with white a white umbrella, move the subject so that they are in the shade of a building or wait until a cloud moves in front of the sun (see Figure 5.19). In tricky lighting conditions, shoot and review the image on the camera's LCD screen, paying attention to shadows and highlights. If need be, re-shoot, overriding the camera's settings using features like the exposure compensation control to attain a good exposure.

Figure 5.20 Nestled in an old wooden crate, these bunches of lavender evoke much of the atmosphere and indeed fragrance of Provence in summer, and as such, are a good reminder of a recent trip to the area.

Location product photography

One of the joys of travel is seeing new peoples, cultures, architecture, food and hand crafts, all in their native environment. Such travel provides the photographer with wonderful opportunities to record these items against the background ambience and color that only comes from an authentic context. It is not so hard to take snapshots of the goods on display in the local market but it is a little more difficult to photograph the same scene giving due consideration to the lighting guidelines we have been looking at here. The weather, the time of day and position of the market stalls in relation to shade-giving buildings will all play a role in the quality of light falling on your subjects. When photographing in public spaces like this, you will have little chance of being able to move the subject to adjust the direction of the light so that it is more sympathetic to its surface qualities. So instead you will need to be on the look out for situations where subject positioning, light direction and quality of light all happen to coincide. The task is more one of recognizing good lighting rather than creating it (see Figure 5.20).

Landscape

It seems like a statement of the obvious that 'Great landscape pictures are made by photographing great landscapes', but just as visually important as the location is the time of day that you photograph it. Studio photographers have the luxury of complete control over the quality and quantity of the light they use in their pictures, but landscape shooters are totally dependent on the weather and the sun for illuminating their subjects.

This doesn't mean that you are totally at the mercy of the gods though; the most important lighting control mechanism the landscape photographer possesses is time. Waiting just a few minutes can change the appearance of a scene dramatically. If the sun is too strong or direct, wait for a little cloud cover or even return to shoot the scene at dusk, at dawn or on an overcast day (see Figure 5.21).

Do your homework before arriving at the location so that you know where the sun will be at what time and then predict how it will light the scene. If need be, arrive and set up before sunrise to make sure that you catch the 20 or so minutes when the sun makes its way past the horizon. So select the time of day that you photograph carefully and don't be afraid to return to a location at a later time or date to ensure the best lighting.

3 minutes

Figure 5.21 Landscape photographers can't control the quality of the light in their chosen scenes but they can decide when to click the shutter button. The look and feel of the light in the scene can change dramatically over a period of just a few minutes.

Flash and its control

Flash is a very convenient way of providing enough light for photographing in low light situations. After all, most compact and many SLR cameras contain small flash lights built into the camera; its pulse of light is brief enough to prevent camera shake and freeze most subject movement, and it matches the color of daylight.

Unfortunately, this compact, handy light source has its shortcomings too. As explained below, in portraiture it is easy to get an effect called 'red eye' with every shot. Small, built-in flash units give harsh illumination slammed 'flat on' to your subject, resulting in ugly and very unnatural looking lighting effects. Subjects often show a dark, sharp-edged shadow line cast to one side of them onto background detail (see Figure 5.23).

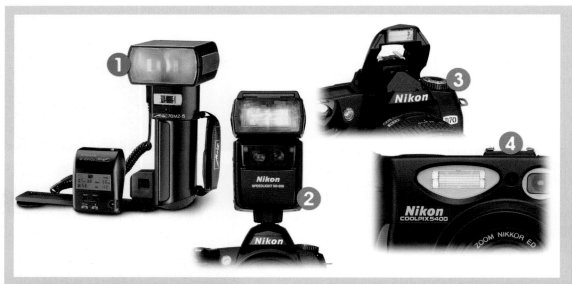

Figure 5.22 The flash lights for modern cameras come in a range of designs.

(1) Until recently, the most powerful models, generally used by professional press and wedding photographers, attached to the camera using an angled bracket. Positioning the flash to the side of the camera also had the advantage of minimizing the occurrence of red eye.

(2) Many cameras have a 'hot shoe' flash mount located on the top of the camera body. This connection is used to attach a portable flash unit.

(3) Less powerful than either of the two previous flash types, the pop-up flash units found on many SLR cameras are suitable for illuminating distances up to about 3 or 4 meters.

(4) Built-in 'twinkle' flashes, like those found in most compact cameras, are fine for close portraits and even some fill-flash work, but because of their proximity to the lens often suffer from red eye problems.

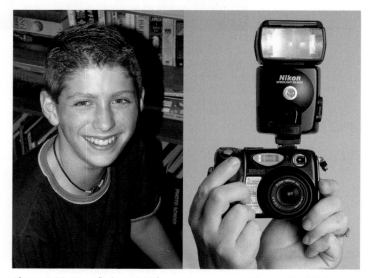

Figure 5.23 Direct flash, straight from your camera, provides very flat lighting with strong, hard-edged dark shadows.

Any reflective surface like gloss paint or glass, square-on to the camera, records as a flare spot (see Figure 5.24). Nearest parts of a scene receive more light than furthest parts, often destroying the normal sense of depth and distance. Finally, flash pictures have a uniformity of lighting – which tends to make one shot look much like every other.

Don't, however, let this put you off flash photography. Most of these defects can be avoided or minimized (particularly if you can use a separate, clip-on flash unit). Flash is really useful when natural light is excessively contrasty or

from the wrong direction, or impossibly dim for active subjects indoors. Just don't allow it to become the answer for all your indoor photography – especially if having a camera with a wide aperture lens loaded with fast film (or digital camera set to a high ISO value) allows you to work using existing light.

Cameras with built-in flash

With the exception of some single-use types, virtually all compact 35 mm, APS film and digital cameras today are designed with a small flash unit built in. The vast majority of SLR auto-focusing cameras are similarly equipped. Manual single lens reflexes more often have a flash shoe with electrical contacts ('hot shoe') on top of the camera body. This will accept one of a range of more powerful slip-on flashguns.

In both instances the flash unit takes a few seconds to charge up when switched on, and after each flash. Wiring in the camera synchronizes the flash of light to the camera shutter's open period when you take the picture. Some cameras automatically switch on the flash when the metering system detects dim lighting conditions; it is important, though, to be able to switch it off when you want to shoot by existing light.

Figure 5.24 Watch the background of the scenes you photograph with flash. Glass or gloss surfaces directly behind your subject will reflect the flash-light back into the camera lens, causing a brilliant 'hot spot' to appear in the photograph.

'Red eye'

When you look at someone's face the pupil in the center of each eye appears naturally black. In actual fact, the light-sensitive retina at the back of the eye is pink, but is too recessed and shaded to appear colored under normal lighting conditions. However, the flash that is built into a small camera body is only displaced an inch or so to one side of the lens. Like an optician's lamp used to closely examine eyes, the flash easily lights up that part of the retina normally seen as dark. The result is portraits showing 'red eye'.

Camera designers go to great lengths to minimize the defect – the flash source often slides out or hinges up (Figure 5.22) to locate it further from the lens. Another approach is to make the flash give one or more flickering 'pre-flashes' just before flashing at full power with the shutter. This is done to make the eyes of whoever you are photographing react by narrowing their pupil size, which in turn results in reducing the occurrence of red eye.

In addition to these techniques, you can help minimize red eye by angling the camera to avoid straight-on portraits. This may also avoid glare from any reflective surfaces square-on in the background. You may even be able to diffuse and so spread the light with a loop of tracing paper over the flash window. But the best approach of all, if your camera accepts an add-on flashgun, is to 'bounce' the light and avoid red eye altogether.

Using bounce flash

Instead of pointing the flash direct from the camera you will get far more natural, less problematic results by bouncing the light off some nearby white surface (Figures 5.25 and

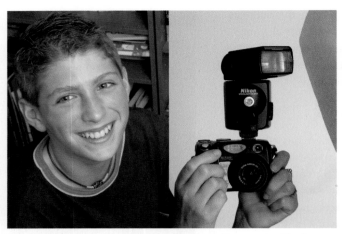

Figure 5.25 Bouncing your flash off a white card reflector to the side of your subject creates a similar effect to soft window light.

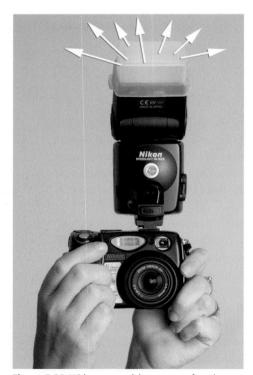

Figure 5.26 With some models you can soften the light using a flash attachment designed to spread the light coming from your flash. Some models are supplied with diffusion attachments designed for just this purpose, or you can purchase a diffuser from a third-party supplier.

5.26). This might be a ceiling or wall indoors, or even white card or plastic in a camera-attachable support, which is usable outside too. Most accessory flashguns can be tilted or swivelled so that you can point them upwards or sideways.

The bounced surface then effectively becomes the light source for the image, providing a soft and even light similar to that available on an overcast day. Using this type of flash set-up you avoid the worst aspects of direct flash and red eye. The less flat-on lighting gives you much better subject modelling and sense of form. And instead of light intensity falling away from front to back, most of the room is lit in an even and natural-looking way – from above.

Be careful, though, not to bounce the flash off a tinted ceiling or when surrounded by strongly colored walls. The overall color cast this gives is much less acceptable in a photograph than in real life. Also, ceiling-bounced flash should be directed at an area above the camera rather than above the subject. Otherwise, the subject receives too much top lighting, resulting in overshadowed eyes and a deep shadow below the chin.

Accessory flash units

Provided your camera has some form of electrical contacts for flash such as a hot shoe, you can mount a separate flashgun on top of the body. Here the flash head itself is sufficiently spaced from the lens to avoid red eye and it still fires when triggered by the shutter. There are three main types of small add-on flashguns (see Figure 5.27).

The simplest type does not tilt, has one fixed light output, and a table on the back shows the aperture to set for different flash-to-subject distances and ISO values. Though not used often these days, this type of flash is still available and is often coupled with manual SLR cameras.

The second kind is self-contained and semi-automatic. The ISO value and camera lens aperture you have set are also set on the flashgun. When the picture is taken, a sensor on the front of the unit measures how much light is

reflected off your subject and cuts ('quenches') the duration of flash. The head tilts for bouncing light, but you must always have the sensor facing your subject, not the ceiling.

Then there are 'dedicated' flash units which, when connected into an SLR or advanced compact metering circuit, pick up information on the ISO value that is set and use the camera's own metering system to measure and control flash power and duration.

It may be impossible to connect these styles of flash units with the most basic of compact cameras, namely those that don't contain a connection for external flash. However, it is worth experimenting with a self-contained 'slave' unit, which someone can hold for you, perhaps pointed at the ceiling. The slave has a light-detecting trigger that responds to your camera's built-in flash and instantaneously flashes at the same time. You can then use the external unit to provide bounced or diffused lighting of your main subject. With some units it is even possible to take the flash off the camera and use it to the side, providing very directional lighting (see Figure 5.28).

Exposure and flash

With simple compact cameras that allow no adjustments, the built-in flash gives sufficient light for recording a correct exposure at a fixed aperture (typically f5.6 for an ISO value of 100) and at one set distance (typically 2.1 m or 7 ft). A flash of this power is said to have a 'guide number' of 12 (f5.6 @ 2.1 m) – see Appendix K for guide number, aperture and distance chart. Anything in your picture much closer or further away will be over- or underexposed respectively. The same applies to the simplest add-on flash units with a fixed light output.

Most flash units that are built into entry-level compact cameras are like self-contained automatic flash units, as they contain a small light sensor pointing at your subject. The closer and lighter your main subject, and the faster the ISO value set, the briefer the duration of your flash will be. So for a really microsecond flash, which is able to show spraying water droplets as frozen 'lumps of ice', work close and load fast film or set your digital camera to a high ISO value.

All self-regulating flash units, whether built-in or used as an add-on, only maintain correct exposure over a range of flash-to-subject distances. At the basic level, the distance range is often between 1.5 and 3.5 m. The more advanced the system (e.g. dedicated units), the wider the range of distances over which it will adjust to maintain correct exposure. But

Figure 5.27 Add-on flashguns that connect via the camera's 'hot shoe' or cable. (1) Low-cost basic unit. (2) Semi-automatic with tilting head. (3, 4) More powerful dedicated types.

Figure 5.28 You can use your flash as a studio light replacement and can free the unit from its hot shoe base by using an extension cable. The cable maintains a link for all the flow of exposure and triggering information, whilst allowing the photographer to position the flash head away from the camera body.

Figure 5.29 Candid portraits taken outside, where there is little or no control over lighting conditions, can generally benefit from a little fill-flash provided by the camera's built-in flash unit. The flash lightens the shadows caused by the sun's strong and contrasty light.

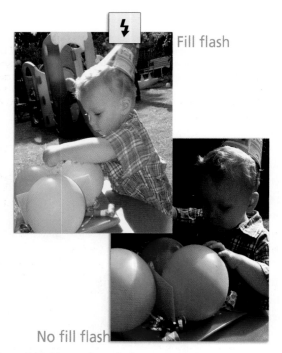

Fill flash

No fill flash

Figure 5.30 Most medium-priced cameras contain exposure systems that can balance the light available in the scene (ambient) with that being emitted from the flash. Some models even have controls that enable the strength of the flash's output to be varied to suit the scene.

don't expect to be able to light a cathedral interior with amateur flash equipment. The same goes for using an auto-flash camera in the audience at a pop concert. The power of these units is often so limited that it will probably just record people a few meters ahead of your position, with all the rest of the scene disappearing into a sea of black.

Switching on the flash on a camera with built-in flash automatically sets the shutter to a speed (typically 1/60 second) short enough to hand-hold the camera, but not too short to 'clip' the flash. When you add a flash unit to a manual SLR you may have to perform this function yourself and set the shutter speed to 'X' (the default flash sync speed) or any slower setting to synchronize properly for flash.

Fill-in flash

An excellent way of using flash on the camera is as auxiliary or 'fill-in' illumination for the existing lighting. When you shoot towards the light, as in Figures 5.29 and 5.30, a low-powered flash on the camera (built-in or clip-on) illuminates what would otherwise be dark shadows. Provided the flash is not overwhelming, the results look entirely natural – you have simply reduced excessive lighting contrast. An auto-focus compact or SLR camera that offers 'fill-flash' mode will make the necessary settings for this style of shooting for you.

Fill-in flash from the camera is also useful for room interiors, which may include a window and where the existing light alone leaves heavy black shadows. If possible, use a powerful flashgun in these circumstances and bounce the light off a suitable wall or surface not included in the picture. This will produce the most even fill-in effect for the scene.

'Open flash'

An interesting way to use a separate flashgun, without needing any extra equipment, is called

open flash technique. This technique involves working in a blacked out room, or outdoors at night. You set the camera up on a firm support such as a tripod and lock the shutter open on 'B'. Then, holding the flash unit freely detached from the camera but pointed at your subject, you press its flash test firing button. Having fired the flash once and allowed it to recharge, you can fire it several more times, each from different positions around the subject, before closing the shutter again. The result looks as though you have used several lights from different directions.

Open flash allows you to photograph the garden or part of your house as if floodlit. Calculate exposure from the guide number given for your flash. This is flash-to-subject distance times the lens f-number needed. If the guide number is 30 (meters) with the film you are using then set the lens to f8 and fire each flash from about 3.75 m (12 ft) away from its part of the subject. Plan out roughly where you should be for every flash, to light a different area. The total time the shutter remains open is not important provided there is little or no other lighting present.

Alternatively, if the flash unit you are using has a built-in sensor, then match ISO and f-stop values from the camera with those on the flash and then proceed to paint your subject with the flash light, allowing the unit to automatically govern its output.

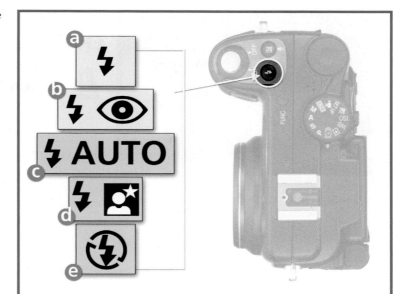

Flash modes explained

Your camera controls its flash system (either built-in or external) based on the selection you make from the flash modes available. The modes can be set using the button located on your camera body or, with some models, via the flash set-up menu in the camera's main settings. These modes also control the way that the flash interacts with your main exposure system. Typical modes include:

(a) **Anytime Flash** (fill flash) – With this setting selected the flash fires every time a picture is taken. Use this option for filling in shadows when photographing in bright sunlight.

(b) **Anytime Flash with Red Eye Reduction** – This option is designed to reduce the red eye problem you often see in photographs taken with compact cameras. In most models a series of small flashes are fired before the main exposure. This setting is good for use when shooting portraits.

(c) **Auto** – This option automatically fires the flash when it is dark or the light level is low. This setting is the best choice for most shooting circumstances.

(d) **Slow Shutter Flash** – This option means that you can combine a long shutter speed with the flash operation. It is best used for night portraits where the flash lights up the person and the long shutter is used to record the night or city lights.

(e) **Flash Cancel** – This option turns the flash off so that it will not fire in any circumstance.

Layout and lighting in the studio

Figure 5.31 Working in a studio gives you the opportunity to fine-tune lighting, zone of focus and compositional skills.

A photographic studio is the rather grand term for any room where you can clear enough space to take pictures. Working in a studio should offer you full control over subject, camera position, lights and background, and is without doubt the best place to learn the basics of lighting and composition. A studio allows you time to experiment, especially with portraits or still-life shots. You can keep essential bits and pieces on hand and leave things set up. This is a great help in allowing you to shoot, check results and, if necessary, retake the picture with improvements (see Figures 5.31 and 5.32).

Your 'studio' may simply be an empty spare bedroom, or better still a garage, outhouse or barn. It should be blacked out so that all lighting is under your control. In the studio shown in Figure 5.33, a large room has been cleared. Walls and ceiling are matt white and the floor gray, to avoid reflecting color onto every subject. White surfaces are also important for 'bouncing' light when required. The window has a removable blind and the glass behind is covered with tracing paper. If daylight is needed, the light coming through the window is therefore soft and diffused.

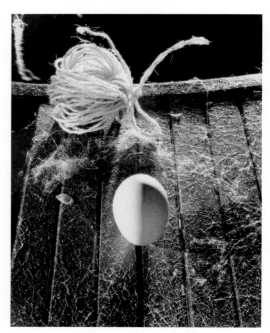

Figure 5.32 Working with light in the studio, you can make pictures from simple oddments.

To start, you don't need a lot of lighting units. A couple of basic photographic lamps are perfectly suitable. These come in two main kinds – spotlights and floodlights. They need to be mounted on height-adjustable floor stands and have tilting heads. The 'boom' stand is an ideal way to position a lamp high up to backlight a figure or illuminate the background (see Figure 5.34).

As an alternative, many top-of-camera flash units can now also be used off the camera. Two such flash guns, using either sync cords or wireless links, can be employed instead of the photographic lamps for most studio work. They have the advantage of being balanced for daylight film (or white balance setting) and the exposure of many models can be automatically calculated via special flash readings in the camera. The downside is that most of these portable, on-camera models do not contain any modelling lamps and so it is very difficult to predict the positioning and quality of the light that they are emitting. Digital shooters have an advantage in this respect, being able to shoot and assess the resultant

lighting via the LCD screen on the back of the camera. Changes can then be made to the lighting set-up before reshooting again.

As well as lighting, you will also need a stool for portraits and one or two reflector boards and diffusers. These can be made from white card and tracing paper stretched over a simple frame. Have a table to support small still-life subjects at a convenient height. You will also need lots of useful small items – sticky tape, string, blocks of wood to prop things up with, modelling clay, wire and drawing pins.

Essential studio equipment

Light sources - One of the joys of shooting in a studio is being able to control the lighting you use to sculpt your subjects. In years past having reliable and controllable studio lighting meant investing thousands of dollars on sophisticated pro systems, but thankfully, there are now several more affordable options available to the photo enthusiast that let you shoot like the professionals, but on a modest budget.

Lighting systems can be broken into five general categories – portable flash (top of camera), high intensity fluorescent, traditional tungsten, entry-level studio flash and good old daylight. Each category has its own advantages, challenges, and cost points, and selecting the avenue that best suits you, should be based on criteria such as the way you work, the subjects you like photographing and, of course, your budget. See Table 5.1.

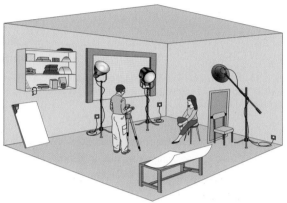

Figure 5.33 A room cleared to form a temporary studio. The table with curved card background is used for still lifes.

Light meter – Having enough light is only part of the equation. Matching the quantity of light with your camera settings, shutter, ISO and aperture, is also key. When shooting with daylight, or flash on camera, this task is controlled by the light meter in the camera. This is also the case with continuous light sources such as fluorescent, tungsten, and daylight, but short burst lighting, like studio flash, requires a different type of meter, generally a hand-held flash meter, to provide light level and shutter/aperture/ISO details. Hand-held meters also provide the ability to more easily gauge the light levels through out the scene, as well as determine the brightness ration provided by multiple light setups.

White balance system – Different light sources have different color temperatures. Thankfully the white balance system of most digital cameras is up to the task of neutralizing any color casts that result from these differences. For very tricky, mixed, lighting scenarios, use the custom white balance option. See Table 5.2.

Light modifiers – As you now know, the quality of light is one of the corner stones of photographic lighting and so any pieces of equipment that can be used to change the characteristics of a given light source are helpful. These can be as simple as a white reflective card to bounce your flash off, or a simple white translucent umbrella placed in front of the light to soften and diffuse. Depending on which lighting system you are using, most manufacturers have plenty of options available. Alternatively, with a little creative thinking you will probably

Figure 5.34 Commercially available tent set-ups like this one create even, diffused lighting that is suitable for glossy, reflective and silvered surfaces..

be able to cobble together some of your own modifiers. Just be careful when using attachments with hot light systems, such as tungsten, as many of the materials may be flammable if they come in contact with the lights.

Table top light cubes or tents – If you have a passion for table top photography and regularly use the soft diffused lighting recommended for shooting glassware, silverware or glossy subjects then maybe a dedicated lighting kit would be a good investment. Available from well know companies such as Lastolite or Calumet these set ups provide both diffusion of the light sources plus a seamless interior to control the reflections in the subject's surface. See Figure 5.34.

Top of camera flash modifiers – There is nothing handier than strapping your speed light to the top of your camera to light dark scenes, but the quality of the light emitted from the flash gun is not very suitable (read flattering) for most subjects. Thankfully there are several different softening attachments on the market that improve the softness of the flash light. Ranging from the tried and tested Stofen clip on diffuser caps, to the very popular Light Sphere and Whale tail from Gary Fong.

Light stands – As well as the light sources themselves, it is important to think carefully about the stands that support them. Make sure that the stand is capable of extending above the subject's head for portraits or can be positioned easily over the centre of a table top setup.

Background – Rolls of paper, or fabric, have long been used as a means of providing a clean neutral background for portraits or object photography. Some photographers, who are lucky enough to have a dedicated studio space, build a curved, painted background in preference to using a paper background.

Tripod – Though not necessary when working with top of camera, or studio flash (the short duration of the flash burst illuminates camera shake), a good tripod is essential when using continuous light sources as shutter speeds are generally longer. With table top set ups, where exact composition is important a lock down three-way tripod head should be used. Portrait shooters, on the other hand, will benefit from the flexibility of a quick-release ball head, which provides the option to work off tripod as well as flip from vertical to horizontal quickly.

A space to shoot – We might not all have a dedicated studio in which to shoot, but space to set up and move around is still an important factor when practicing your craft. If the lounge room stripped of furniture still doesn't provide enough space (or harmony at home) then why not get together with your fiends and hire the local community or church hall for a studio session. The extra hands to hold reflectors or move lights will always be welcome.

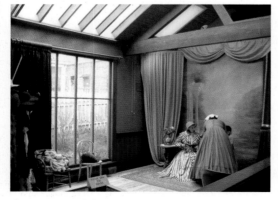

Figure 5.35 Daylight studios like this one located in an historical village harness the free energy of the sun as the primary light source for the scene.

Table 5.1 Studio light source options

	System cost	Advantages	Disadvantages	Associated requirements
Portable flash	Varies – Low to Medium depending on model features and power	• Can be used in the studio and on the move • In camera flash control very powerful • Some models are wirelessly linked • Variable output levels • Daylight balanced • More and more modifying accessories are becoming available all the time • Some models can be used in conjunction with pop-up flash to create a two light set-up	• Generally very direct and harsh • Some models not very powerful • Can be a little confusing to set up • Difficult to predict how the light will look as no modelling light is included • Smaller range of accessories than studio flash	• Softening attachments (e.g. Gary Fong's Whale Tail or Light Sphere) • Flash control system (in camera or via flash) • Filter attachments • Off camera leads or wireless control • Flash bracket for off camera usage
HI Fluorescent	Low	• Cheap for multi-head systems • Much cooler than tungsten • Continuous output makes previewing lighting effects very easy • Some models are daylight balanced • Most use the popular E27 connection (Edison screw) and therefore can be substituted in sockets generally used for photolamps	• Low wattage output when compared to tungsten • Single level output • Some systems require custom white balanced • High ISO necessary for lower wattage lighting	• Generally can be used in systems designed for photo lamps • Soft boxes, umbrellas and reflectors • High ISO settings • Light meter (in camera and hand held) • White balance control • Tripod • High ISO settings
Tungsten	Medium	• Tried and tested traditional system • Continuous output output makes preview lighting effect easy • Can be picked up second hand cheaply	• Generates large amounts of heat for the light output • Single level output • Requires tungsten white balance setting • Difficult to combine with daylight because of the different color temperature • Modifying accessories need to be heat resistant	• Reflectors, diffusers, gobos (black reflectors) • Light meter (in camera or hand held) • White balance • Tripod • High ISO settings
Entry Level Studio flash	High	• Controllable output level • Modelling light generally included to preview lighting effect • Professional level results possible • Daylight balanced • High power for low heat output • Low ISO settings possible	• Generally more expensive to buy into than other systems	• Reflectors, diffusers, gobos (black reflectors) • Light meter (in camera or hand held), • Soft boxes, umbrellas and reflectors
Daylight (via window or skylight. See Figure 5.35.)	Free	• Did I mention it's free? • Beautiful effects are possible with well controlled day light	• Not available on demand • Requires big, high windows • Intensity is fixed • Intensity and color temperature changes with the weather	• Reflectors, diffusers, gobos (black reflectors) • Light meter (in camera or hand held) • White balance • Tripod • High ISO settings

Matching the colour of the light to the sensor

Unless you only work in black and white, however, you must ensure that the light from all your lighting units matches in color. One-hundred-watt lamps, for example, give yellower (as well as dimmer) light than 500-watt lamps, and so are best avoided for color photography. Then, having matched up your illumination, you can fit a color correction filter (see Table 5.2) to suit the daylight film you are using. Digital shooters can switch the white balance setting to tungsten or, better still, use the custom option to match the color of the light precisely to the sensor.

Table 5.2 Camera filters and white balance settings for color-balancing studio lighting

Light source	Filter needed for daylight film	Filter needed for tungsten film	White balance setting on a digital camera
Flash	No filter	85B	Daylight
Warm white fluorescent tubes	Fluor. correction or 40 magenta	81EF	Fluorescent
500 W lamps (3200 K)	80A	No filter	Tungsten
100 W domestic lamps	Not recommended	82B	Custom or Preset

Controlling lighting

Exploring lighting, given the freedom offered by a studio, is interesting and creative – but be prepared to learn one step at a time. Firstly, if you are shooting in color, match up the color balance of your film with the color of your lighting as closely as possible. Table 5.2 shows the code number of the blue conversion filter needed over the camera lens with daylight color film (print or slide) using 500-watt lamps. A few color films, mostly slide, are balanced for artificial light and so need different filtering, or none at all. These films are often referred to as tungsten balanced films.

Start off with a still-life subject because it is easier to take your time experimenting with this than when shooting a portrait. Set up your camera on a tripod and compose the subject. You can

Figures 5.36 and 5.37 Lighting direction: Surface appearances change dramatically when you alter the position of the lamp.

then keep returning to check appearance through the camera viewfinder for every change of lighting, knowing that nothing else has altered.

Direction

Keep to one light source at first. The aim of most studio lighting is to give a fairly natural appearance as if lit by the sun. This means having one predominant source of light and shadows, positioned high rather than low down. Set up your light source (a spotlight, for example) somewhere above camera height and to one side of the subject. Adjust it to give the best lighting direction for showing up form, texture and shape – whatever you consider the most important features of your subject to stress. Figures 5.36 and 5.37 illustrate how simply changing direction picks out or flattens different parts of a three-dimensional subject.

Contrast

Be careful about contrast (the difference in brightness between lit and shadowed parts) at this point. Outdoors, in daylight, the sky always gives some illumination to shadows, but in an otherwise darkened studio direct light from a single lamp can leave very black shadows indeed. You may want to 'fill in' shadows with just enough illumination to record a little detail, using a large white card reflector as shown in Figure 5.38. This throws back very diffused light towards the subject and, since it does not produce a second set of clearly defined shadows, you still preserve that 'one light source', natural look.

Figure 5.38 Contrast control. A spotlight used alone (left) and with a large white card added (right). Shadows become paler, without additional shadows forming.

Recipes for success

It doesn't matter whether your passion is photographing people, capturing complex table top set-ups, or even documenting a much treasured stamp collection, having your own studio is a great way to master the skills needed to produce successful photos time and time again. Having the space to work unimpeded, the lighting and camera kit to hand and the time to experiment, all contribute a perfect learning environment, but the real key is being able to 'see'. To see the way that the subject is posed (or arranged), to see how the lights are describing the subject's surface and shape and to see how the whole photo is composed in the viewfinder. To this end, start to train your eye by examining successful studio photos and dissecting their composition, lighting setup and posing or arrangement designs.

To point you in the right direction, here I perform just such an examination on a three great studio images.

Background evenly lit by using large light sources such as soft boxes positioned on either side of the glass and directed towards opposite sides of the background.

Wine carefully directed using a flute or funnel out of shot

Both the wine glass and the camera are locked down so that they don't move, the camera on a studio tripod and the glass with clamp.

Several photos are taken checking the shape of the poured wine and resetting the glass after each exposure

Lights directed on the background rather than on the glass.

With a table top set up like this one it is very helpful to have an assistant to do the pouring while the photographer concentrates on the tripping the shutter

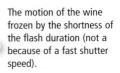

The motion of the wine frozen by the shortness of the flash duration (not a because of a fast shutter speed).

Broad soft lighting directed from above and just in front of the subject brings form to the face.

A small aperture number (f 5.6 or f4.0) is used to keep the sharpness in the photo on the subject only.

The background is shielded from too much stray light to ensure that it remains dark and contrasts the subject.

A fill light of less strength than the main, or a reflector, is used to fill in the shadows so that these areas don't become dark and detailess.

The brightness of the background is carefully controlled so that the model's black hair is still clearly separate.

Black background used to highlight the edges of the stamp and reduce shadows. Some photographers use velvet as a background material as it tends to record as matte black.

Remote cable release or self-timer is used to release the shutter to ensure that the camera remains steady during the exposure.

A copy lighting set up (two lights aimed on an angle from either side) is used to ensure that the stamp is evenly lit.

The back of the camera is positioned parallel to the stamp by placing a small mirror over the stamp and making sure the camera's reflection is in the center of the viewfinder. This ensures that the stamp is not distorted.

Macro lens is used to get in close enough fill the frame with a single stamp.

Camera is suspended over the center of the stamp using a tripod with a horizontal arm.

1 A great way to help educate your eye as to the way that both portraits and products are lit is to examine how the professionals do it. Select a few example images from product catalogues or the advertising section of the weekend newspapers and analyze how each of the photographs is taken. For clues of lighting set-ups, look for the direction and style of shadows falling from the main subjects, as well as the reflection of light sources in the eyes of the portrait sitters or off the surface of reflective subjects. Once you diagnose the schema used, try to recreate the look of the photograph using your own set-up.

2 Photograph two portraits of a willing friend or relative using two completely different lighting set-ups. Create one with harsh direct lighting that has strong, hard-edged shadows and then use soft, well-diffused light with shadows that are almost totally filled in (with a broad white reflector) for the other.

3 Find a collector of dolls, toy soldiers, unusual teapots, stamps or something similar in your local area. Offer to make a record of some of the pieces in their collection and then go on to use the opportunity to practice your lighting and still-life photography skills.

4 Make a photographic copy of a set of montaged prints created with one of the techniques in Part 9 of this book. Ensure that the montage is evenly lit and that the camera is positioned so that it is 'straight on' to the original. Use the resultant image to make a single flat print of the picture.

5 Shoot separately pieces of glassware, silverware and a highly textured object, changing the lighting set-ups to suit each subject as you go. Once you have mastered each of these typical schemas, try photographing a subject that contains two, or more, of these surface types in combination.

JRE

PROCESS

Film
era

Process
negatives

Process
slides

nner
film
print
inals

nner
3D
inals

gital
era

Convert
Raw files

bile

6 Photographic Workflow

Demystifying the photographic process

A few short years ago life seemed so simple – photographically speaking that is. We captured our images on film. The film was then processed and we either projected the results onto a screen or created prints to adorn our walls. The photographic workflow – called the photographic process back then – was familiar and for most of us it seemed uncomplicated. But times change and the image-making world has been turned upside down with the introduction of digital photography. Now when we talk about the photographic workflow we have more choices at more points in the process than ever before. This section of the book summarizes the various ways that you can:

- capture,
- process,
- edit and enhance,
- produce and
- share your imagery.

It is positioned before major chapters that deal with traditional film-based production and the new digital workflow so that you have a framework for making decisions about the way that you will choose to work.

Options for capture

When it comes to decisions about how to capture their photos many photographers wrongly believe that they only have two choices – film or digital cameras. It is true that at the moment most image makers choose either an SLR or compact camera as their primary capture device and that now digital cameras vastly outsell their film counterparts. But these aren't the only options.

It may surprise you to know that this year and for the first time ever the biggest camera manufacturer in the world is predicted to be Nokia. They will produce more cameras, as built-in technology for their mobile phones, than any of the big name camera manufacturers. Now as little as a year ago, I would have been reluctant to even mention camera-phones as part of this discussion but the features and image quality of the photos produced by these multi-purpose devices is increasing all the time. There are now phones which incorporate 7 megapixel cameras complete with optical zoom lenses, sophisticated auto-focus

Figure 6.1 With the increasing sophistication of mobile phone cameras these multi-function devices are now capable of producing very good photographs.

Figure 6.2 Digital video cameras are also capable of capturing still photos of good quality.

systems and built-in flash. In many cases the camera options are better than many entry-level digital compacts (see Figure 6.1).

Alongside the rise in popularity of cameras phones, digital video cameras are also crossing over into the territory usually reserved for serious still photographic equipment. Many of the new High Definition models are capable of producing good quality photographs from their still-frame-capture features. Though not yet at resolutions to rival the highest level cameras, the digital photos produced from these video units are still very usable (see Figure 6.2).

As we have already seen in early chapters a scanner also provides a good way to create digital photographs. This is especially true if you have a substantial investment in film-based equipment. You can continue to shoot with film and then either use a film or print scanner to convert the resultant images into digital form. Flatbed or print scanners can also be used as a simple but high-resolution camera suitable for capturing small three-dimensional objects. In fact it has been known for photographers to take their scanners off their desks and into the field (attached to laptops of course) in pursuit of high-resolution files of ground cover, rock surfaces and tree bark (see opposite page).

Figure 6.3 Most digital photos are ready for editing or enhancing straight out of the camera but those captured and stored in the RAW file format need converting to a more standard format before being passed to the editing program. Both Photoshop and Photoshop Elements contain the Adobe Camera RAW utility (above) designed for just such a conversion. See Chapter 7 for more details on converting RAW files.

Processing your photos

The type of capture you decide to use will determine how the image is processed. If you are working with a film-based workflow then the next step is to process the captured images to produce either negatives or slides (sometimes called transparencies). You can find more details about film processing in the appendix.

In contrast, most digital captures do not require any intermediate processing before the images can be edited. The exception to this rule is those photographers who are using the RAW format. Typically these images need to be processed or converted from their RAW state to a file format that can be easily edited and enhanced in a standard imaging program such as Photoshop or Photoshop Elements. There are, of course, imaging programs designed specifically for working with RAW files such as Photoshop Lightroom and Aperture, but most photographers still move their photos to an editing program, at some stage, for further processing (see Figure 6.3).

Using your scanner as a camera

As well as a device that can convert prints into digital photographs your scanner can be used as a giant camera that can capture small objects with amazing clarity. You can extend the use of your scanner by employing its imaging skills as a way to photograph small stationary objects.

Simply place the object carefully on the glass pattern, closing the lid so that you don't crush or move the subject, and scan away. More adventurous readers may even want to construct a small white foam box to place over the top of their subjects so that the scanner's light will be reflected from behind as from the front. You subject matter is only limited by your imagination (and what you can safely place on the scanning surface).

Step 1: Protect the scanner

Keep in mind when selecting suitable subjects for this task that scratches and marks on the scanning area will ensure problems when capturing print later, so pick objects that won't damage the surface. If in doubt place a clear piece of plastic over the scanner's glass before proceeding.

Step 2: Position the objects

With the scanner lid open position the object on the scanner's glass platen. Use a small piece of fishing line secured to the foam box to suspend any parts of the object that you don't want flat on the glass surface. Carefully lower the light box over the subject.

Step 3: Make the scan

Turn the scanner on and then the computer. Start the scanner software program. If you want the image to appear in the editing software then start the TWAIN driver from inside the editing program. For instance with Photoshop Elements, select the scanner from the list under the File>Import menu.

Creating a light box for your scanner

Placing a small white box over the subject you are scanning will help even out the light falling on the object. The simplest way to construct such a box is with several sheets of thin, light polystyrene foam. This material can be purchased in sheets from good hardware stores or if you are lucky you may already have some that was originally used as packaging, lying around the house.

1. Cut the foam into five pieces, one for the box bottom and four pieces for the sides. The bottom should be the same size as the scanning area of your machine. The sides should be the length and width of the bottom and about 3–4 cm deep. Using PVC white glue and pins for temporary support assemble the box and leave to dry.

2. To use, open your scanner lid, position your subject on the glass plate and place the light box over the subject. Scan as usual.

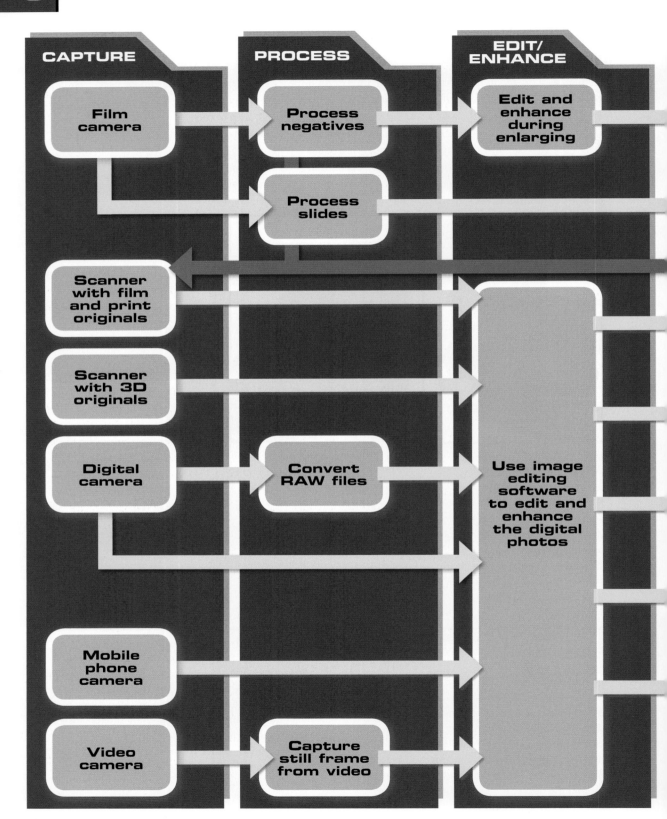

CAPTURE

PROCESS

EDIT/ENHANCE

Film camera

Process negatives

Edit and enhance during enlarging

Process slides

Scanner with film and print originals

Scanner with 3D originals

Digital camera

Convert RAW files

Use image editing software to edit and enhance the digital photos

Mobile phone camera

Video camera

Capture still frame from video

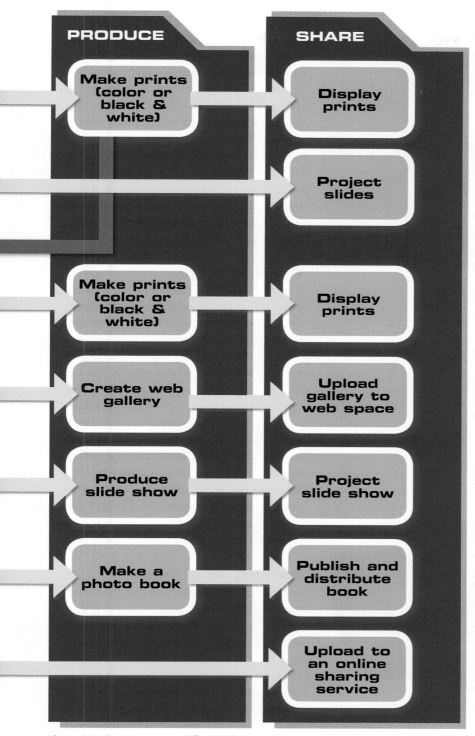

PRODUCE

- Make prints (color or black & white)
- Make prints (color or black & white)
- Create web gallery
- Produce slide show
- Make a photo book

SHARE

- Display prints
- Project slides
- Display prints
- Upload gallery to web space
- Project slide show
- Publish and distribute book
- Upload to an online sharing service

Figure 6.4 There are now many different pathways that can be used to capture, manipulate and produce your photographs. Whilst at the moment most image makers opt for a digital SLR or compact camera the increasing popularity of camera-phones will soon mean that these devices may become the primary way that photographers document their world.

Many digital video cameras have a still image function which captures single frames directly to a memory card in much the same way as a normal still camera, but for those models that don't have this feature it is still possible to pull individual frames from the movie footage using still-frame-capture utilities. Such features are available in general video editing packages. See Part 7 for further details on processing digital files.

Editing and enhancing

Once the captured image is in a usable form (negative, slide or digital file) the next step is to edit or enhance the photo.

For film users, this occurs as part of the production phase as the photographer coaxes the best possible print out of his or her negatives. Enhancement techniques such as dodging and burning, adjusting contrast and retouching the final print are all part of this process. See the appendix for more details on editing and enhancing in a film-based workflow.

Digital shooters, as well as those film photographers who scan their negatives or prints, have much more

Figure 6.5 The features and tools in software such as Photoshop and Photoshop Elements (above) are capable of handling all manner of editing and enhancement changes. They provide a level of control that is far more sophisticated, repeatable and powerful than what was ever possible in a film-based workflow.

control over their images in this editing and enhancement phase. This is largely thanks to the host of tools, features and commands available in the current crop of image editing software. In this phase of the workflow the digital photograph can be enhanced and edited in many ways, including changes to color, brightness, contrast and sharpness (see Figure 6.5). In addition it is also possible to retouch, montage several photos together, and add text and special effects to the photo. See Part 7 for more details on how to edit and enhance your digital files.

Producing your pictures

Even these days the most precious of pictures generally end up as prints (see Figure 6.6). This is true despite their starting points being film or digital. Sometimes the prints are kept in an album, on other occasions they are hung on a wall, or they may just be simply passed from friend to friend, but gradually other production outcomes are becoming more popular. Now you can just as easily produce a web gallery, photo book or multimedia slide show as output a bunch of 6 × 4 inch prints. Unfortunately for film users the range of possible outcomes is more limited than for those who are using a digital workflow. On the whole the same software that is used for editing and enhancing digital photos also contains the ability to output pictures in a range of different forms. The latest version of Photoshop Elements, for instance, allows photographers to produce photo books, slide shows, simple animations, web galleries, greeting cards, panoramas, individual prints, picture packages (prints of different sizes), contact sheets, CD jackets and labels, and photo calendars. See Parts 7 and 10 for more details on outputting your photos in various forms.

Figure 6.6 The modern desktop printer is more than capable of producing high quality photographic prints. Some models contain up to eight different ink colors and are capable of producing cast-free black and white pictures as well as vibrant color prints.

Sharing your imagery

For many photographers having their images seen is one of the key reasons they capture pictures in the first place. With so many ways of producing your photos there are now a host of different ways of sharing your images. Modern image makers are no longer limited by distance or geographic borders. With the ability to easily produce web galleries, or attach photos to e-mails, the whole world is truly a smaller place. See Part 10 for extra ideas for sharing your photographs.

7 Digital Processing and Printing

In the previous sections we looked at how to successfully create your own digital pictures (with camera or scanner), so let's now take a deeper look at how to process, edit, enhance, and produce and share these images.

Introducing the digital photography tools

The image editing program

An image editing application is a computer program that can be loaded onto your machine and then used to change and enhance your digital pictures. There are many different programs available for installation on your computer. Some are used for word processing, chart creation or working out the family budget, but it is those that are specifically designed for manipulating pixels and fixing up digital photographs that we will look at here.

A lot of image retouching programs combine features that can be used for everything from web design, manipulating photographs, converting your RAW files, creating posters and flyers for your business to making titles for your home movies. Such software can range in price and functionality (see Figure 7.1). So which program is a good choice for you?

Figure 7.1 There are many different software packages on the market that are designed to edit and enhance your pictures.

Simply considered, image retouching/manipulation software can be placed in three application levels: enthusiast, semi-pro and professional. Enthusiast programs are generally easier to use but at times limited, whilst professional packages are designed for sophisticated image retouching and manipulation in a professional working environment. For most of us, however, it's the 'semi-professional' packages in the mid-price range that give the best value, performance and room for growth.

Entry-level applications

At the base level, you can get your hands on simple image editing software for free (see Figure 7.2). Both the Windows and Macintosh platforms come with basic, though comparatively limited, photo tweaking capabilities and more and more web-based editors are now available.

As you may already know, desktop scanners and cameras often come bundled with several different application programs, one of which is always a simple image editing package. Most of these 'free' inclusions are very good and though they may not fulfil all your imaging needs, they

What retouching software can do for photos

- Improve/change the color, contrast, brightness, hue and saturation (intensity).

- Change color images to black and white.

- Change black and white to duotone (two colors), tri-tone (three colors) or quad tone (four colors).

- Change mono (black and white) to color using hand coloring tools.

- Remove dust specks, scratches and other damage.

- Invisibly remove parts of an image.

- Repair damaged sections and reduce the effects of ageing in old photos.

- Apply effects to the whole picture or just parts of it.

- Alter images to create stunning artworks.

- Add 2D or 2D text effects.

- Include your images in calendars, cards, report covers, school projects, business cards, letterheads, invitations and more.

- Save to different file formats suitable for web, print and desktop publishing.

- Convert photos into a web page complete with links and animated effects.

- Create special web page buttons and animations.

- Create index or contact sheets.

- Convert your pictures to different color spaces, e.g. CMYK, LAB color, RGB and Grayscale.

- Add artistic effects.

Figure 7.2 Entry-level programs like Google's Picasa use a simple, easy to follow interface designed to get users editing their pictures quickly.

are a good place to start. For instance, Adobe's Photoshop Album is a program that is often included.

Besides purely edit-based programs, you will also see a range of products targeting the younger digital imager: programs for morphing one photo into another and liquid paint programs used for creating cool effects. These are tremendous fun but limited in their scope. No detailed restoration or retouching is possible with these!

Semi-professional programs (see Figure 7.3)

In the mid-range category, Adobe Photoshop Elements is definitely a favorite, being essentially a cut-down version of Photoshop, the world-class standard in image retouching programs. Designed to compete directly with the likes of Corel's Paintshop Pro and Ulead's PhotoImpact, Adobe's mid-range package gives desktop photographers top quality image editing tools that can be used for preparing pictures for printing or web work.

Tools like the panoramic stitching option, called Photomerge, and the File Browser via the Organizer are favorite features. The color management and text and shape tools are the same robust technology that drives Photoshop itself, but Adobe has cleverly simplified the learning process by providing a range of levels of editing including step-by-step interactive guided edits for common image manipulation tasks. These, coupled with other helpful features like Shadow/Highlights, Adjust Color for Skin Tones and the Red Eye Brush tool, make this package a digital photographer's delight.

Figure 7.3 Semi-professional packages, like Photoshop Elements, give high-quality results with slightly reduced feature sets and an easier to use interface than the professional programs.

The mid-range price category (US $60–200) has seen the greatest improvements, often producing results as professional as something created with software costing US $500 or more.

Professional programs (see Figure 7.4)

The top end of town gives you everything that a mid-range program can provide *plus* sophisticated productivity enhancing features with complete editablilty. Programs like Photoshop are designed for total integration with other Adobe products (InDesign, Illustrator, Flash and Dreamweaver). An enthusiast will find it hard to justify spending much more on a program that's unlikely to produce any better inkjet print results than programs like PaintShop Pro, Adobe Photoshop Elements or Ulead PhotoImpact.

Figure 7.4 For the absolute best quality and greatest control over your pixels, you can't better the industry leader Adobe Photoshop.

What you get for your money

Entry level

- Support for a limited number of file formats.
- Basic tool and feature set.
- Limited file saving options.
- Some preset special effects or filters.
- Plenty of template-based activities, such as magazine covers, calendars and cards.

Semi-professional

- Wide range of file formats supported.
- The use of separate image layers.
- Reasonably unlimited file saving options.
- Wide range of special effects filters.
- Support for third-party plug-in programs to add extra features to the software.
- Inclusion of web-based design features, including image slicing, image optimization and animation.
- Drag and drop web page creation.

Professional

- Multiple file format support.
- Integration with other programs.
- Fully editable layers.
- Fully editable paths.
- Combination of scalable vector and bitmap graphics.
- Sophisticated special effects filters.
- Complex web design features.
- Wide range of editable pro paint and drawing tools.
- Wide range of darkroom manipulation tools.
- Wide range of specialist image adjustment features.
- Support for third-party plug-in programs to add extra features to the software.

The differences between high-end programs and entry-level products are really noticeable in a high turnover production business, especially in the prepress or publishing environment. The array of functions and the level of editability of the files are something that cheaper programs just don't provide in any depth.

Parts of image editing programs

Most editing programs contain a look and feel that is very familiar and pretty much the same from one program to the next. This remains true even if the packages are created by different manufacturers.

The interface is the way that the software package communicates with the user. Each program has its own style, but the majority contain a workspace, a set of tools laid out in a toolbar and some menus. You might also encounter some other smaller windows around the edge of the screen. Commonly called dialog boxes and palettes, these windows give you extra details and controls for tools that you are using (see Figure 7.5).

Welcome screen

Menu bar – contains features grouped in menu and sub-menus

Options bar – displays the options for the currently selected tool

Task modes – click to access the new task modes

Go to Organizer

Full, Quick and **Guided Edit** buttons for switching workspaces

Figure 7.5
The program's interface is the gateway to the editing of your photographs.

Tool bar – displays icons of the tools available; can also be displayed in two-column view

Project Bin – for easily switching to the active document from those open in the Editor workspace and displaying files selected in the Organizer or Albums.

Image window – displays the open picture in Elements; can be maximized, minimized and cancelled using the corner buttons

Task pane – for storing panel options, palettes, similar to the Palette Well/Bin in previous versions

Programs have become so complex that sometimes there are so many different boxes, menus and tools on screen that it is difficult to see your picture. Photographers solve this problem by treating themselves to bigger screens or by using two linked screens – one for tools and dialogs, and one for images. Most of us don't have this luxury, so it's important that, right from the start, you arrange the parts of the screen in a way that provides you with the best view of what is important – your image. Get into the habit of being tidy.

Know your tools

Over the years, the tools in most image editing packages have been distilled to a common set of similar icons that perform in very similar ways. The tools themselves can be divided up into several groups, depending on their general function.

Drawing tools (see Figure 7.6)

Designed to allow the user to draw lines or areas of color onto the screen, these tools are mostly used by the digital photographer to add to existing images. Those readers who are more artistically gifted will be able to use this group to generate masterpieces in their own right from blank screens.

Most software packages include basic brush, eraser, pen, line, spray paint and paint bucket tools. The tool draws with colors selected and categorized as either foreground or background.

Paint Bucket Pencil Gradient Brush Impressionist Brush

Color Replacement Eraser Magic Eraser Background Eraser Custom Shape

Ellipse Rectangle Rounded Rectangle Polygon Line

Figure 7.6 Drawing tools.

Selecting tools (see Figure 7.7)

When starting out, most new users apply functions like filters and contrast control to the whole of the image area. By using one, or more, of the selection tools, it is also possible to isolate part of the image and restrict the effect of such changes to this area only.

Used in this way, the three major selection tools – lasso, magic wand and marquee – are some of the most important tools in any program. Good control of the various selection methods in a program is the basis for many digital photography production techniques.

Rectangle Marquee Elliptical Marquee Lasso Polygonal Lasso Magnetic Lasso

Magic Wand Quick Selection Selection Brush

Figure 7.7 Selecting tools.

Text tools (see Figure 7.8)

Adding and controlling the look of text within an image is becoming more important than ever. The text handling within all the major software packages has become increasingly sophisticated with each new release of the product. Effects that were only possible in text layout programs are now integral parts of the best packages.

Type tool Vertical Type Type Mask Vertical Type Mask

Figure 7.8 Text tools.

Viewing tools (see Figure 7.9)

This group includes the now infamous magnifying glass for zooming in and out of an image and the move tool used for shifting the view of an enlarged picture.

Hand Zoom

Figure 7.9 Viewing tools.

Others (see Figure 7.10)

There remains a small group of specialist tools that don't fit into the categories above. Most of them are specifically related to digital photography. In packages like Photoshop Elements they include a 'Red Eye Remover' tool specially designed to eliminate those evil-eyed images that plague compact camera users. Photoshop, on the other hand, supplies both 'dodging' and 'burning-in' tools. Most packages also include a variety of tools for repairing or retouching work. The most well known of these is the Clone Stamp or Rubber Stamp tool but Photoshop and Elements also include Healing brushes.

Figure 7.10 Other tools.

Red Eye Sharpen Blur Smudge Sponge

Burn Dodge Clone Stamp Pattern Stamp Cookie Cutter

Crop Straighten Eyedropper Spot Healing Healing

Making a menu selection (see Figure 7.11)

Features not activated via a tool can be found grouped under headings in the menu bar. Headings such as File, Edit, View and Help are common to most programs, but picture editing packages also display choices such as Image, Layer, Select and Filter. Navigating your way around the many choices and remembering where certain options are found takes practice, but after a little while finding your favorite features will become almost automatic.

When writing about how to select a particular option in a menu, authors often use a style of menu shorthand. For instance, 'Image > Image Size' means select the 'Image Size' option, which can be found under the 'Image' menu.

Figure 7.11 As well as the standard menus found in most programs image editing applications also contain specialist menus that list features use for modifying your photos.

Transferring pictures from the camera to computer

There are several different ways to transfer or download your photos from camera to computer. Some photographers love to connect their cameras directly to the computer, others who use multiple memory cards employ a dedicated card reader to transfer their files.

Camera to computer

When connecting your camera to the computer it is important to ensure that any drivers that are required to recognize the camera are installed before plugging in the cables. These little pieces of software are generally installed at the same time that you load the utility programs that accompanied the camera. If you haven't yet installed any of these applications then you may need to do this first before the computer will recognize and be able to communicate with the camera. During the installation process follow any on-screen instructions and, if necessary, reboot the computer to initialize the new software.

Once the drivers are correctly installed you may also need to change the basic communications set-up on the camera before connecting the unit. This need is largely based on the operating system (and version) that you are using. Typically you will have a choice between connecting your camera as a mass storage device (the most common option) or via PTP (Picture Transfer Protocol).

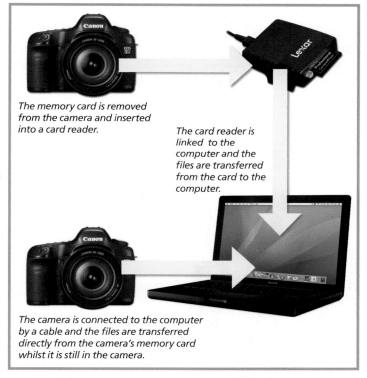

The memory card is removed from the camera and inserted into a card reader.

The card reader is linked to the computer and the files are transferred from the card to the computer.

The camera is connected to the computer by a cable and the files are transferred directly from the camera's memory card whilst it is still in the camera.

Figure 7.12 There are two main ways to transfer your files from camera to computer – via a card reader (top) or directly by connecting the camera to the computer (bottom).

Check with your camera documentation which works best for your set-up and then use the mode options in the camera's set-up menu to switch to the transfer system that you need.

The next step is to connect the camera to the computer via the USB/Firewire cable. Make sure that your camera is switched off, and the computer on, when plugging in the cables. For the best connection and the least chance of trouble it is also a good idea to connect the camera directly to a computer USB/Firewire port rather than an intermediary hub.

Now switch the camera on. Some models have a special PC or connect-to-computer mode – if yours is one of these then change the camera settings to the PC connection mode. Most cameras no longer require this change, but check with your camera manual just in case. If the

Figure 7.13 After installing the drivers that are supplied with your camera, your computer will automatically recognize the camera when you connect it.

Figure 7.14 Many modern card readers can be used with multiple card types, making them a good solution if you have several cameras in the household or office.

drivers are installed correctly the computer should report that the camera has been found and the connection is now active and a connection symbol (such as PC) will be displayed on the camera (see Figure 7.13). If the computer can't find the camera try reinstalling the drivers and, if all else fails, consult the troubleshooting section in the manual. To ensure a continuous connection use newly charged batteries or an AC adaptor.

Card reader to computer

Like attaching a camera, some card readers need to be installed before being used. This process involves copying a set of drivers to your machine that will allow the computer to communicate with the device. Other readers do not require extra drivers to function and simply plugging these devices into a free USB or Firewire port is all that is needed for them to be ready to use (see Figure 7.14).

After installing the reader, inserting a memory card into the device registers the card as a new removable disk or volume. Depending on the imaging software that you have installed on your computer, this action may also start a download manager or utility designed to aid with the task of moving your photo files from the card to hard drive.

Failing this, Windows users will be presented with a Removable Disk pop-up window containing a range of choices for further action. One of the options is 'Copy pictures to a folder on my computer'. Choosing this entry will open the Microsoft Scanner and Camera Wizard which acts as a default download manager for transferring non-RAW-based picture files. If your card contains RAW files then some versions of the wizard will report that there are no photos present on the card. This situation will change as the Windows software becomes more RAW-aware, but for the moment the solution is to open folder to view files and manually copy the pictures into a new folder on your hard drive.

Figure 7.15 Make sure that your camera of card reader is disconnected properly from your computer using the preferred method for Macintosh or Windows systems.

Before disconnecting

Before turning off the camera, disconnecting the cable to camera/card reader, or removing a memory card from the reader, make sure that any transfer of information or images is complete.

Mac users should then drag the camera/card volume from the desktop to the trash icon or select the volume icon and press the eject button.

Windows users should click the Safely Remove Hardware icon in the system tray (found at the bottom right of the screen) and select Safely Remove Mass Storage Device from the pop-up menu that appears.

Cards inserted into a Macintosh connected reader will appear as a new volume on the computer's desktop. Users can then copy or move the picture files from this volume to a new folder on their hard drive.

The important last step on both Macintosh and Windows platforms is to ensure that the card or camera is correctly disconnected from the system. Macintosh users will need to drag the volume to the Wastebasket or Eject icon, whereas Windows users can use the Safely Remove Mass Storage Device feature accessed via a button in the Taskbar (bottom right of the screen) (see Figure 7.15).

Fast Cards means Fast Downloads

It seems to be stating the obvious to say that the faster your memory card, the less time it will take to download your files, but photographers who regularly take hundreds of photos, will gain real benefits from investing in the fastest cards they can afford. As sensor resolution increases, so too does the size of the capture files. A typical shoot can now amass gigabytes of photos prompting the need for efficient and speedy downloading.

The latest incarnation of fast memory cards require equally fast card readers in order to take advantage of the increased speed. In the case of the UDMA cards from Lexar that are capable of 300× download speeds, the fast transfer performance is only possible when using the matched card reader and a Firewire 800 connection. Firewire 800 is the fastest of all the plugable connections and is necessary if the upper limit of the card/reader combination download speed is to be reached and, more importantly, sustained.

For Macintosh users working on a recently released model, the Firewire 800 connection is not a problem as these computer models include at least one port of the faster interface as standard. Windows users on the other hand will have a more difficult task tracking down an off the shelf computer that features Firewire 800. Instead most users will need to add the functionality to an existing system via an upgrade card.

Figure 7.16 Flash memory companies are always producing new products that make the process of downloading files faster than what was possible with the previous generation of cards. Lexar's latest offering boasts 300× speed which dramatically decreases the time taken to download large numbers of files.

In the demonstration, above, the same folder of photos (1Gb in size) was downloaded from both a 133× (lower) and the new 300× card (upper). The UDMA card was noticeably faster, completing the task minutes ahead of the older style flash card and reader.

The essentials – Card speeds

When shooting large numbers of RAW files it is worth investing in memory cards of at least 1 Gb or 2 Gb capacity, preferably with some sort of accelerated read/write speed. In case you're wondering what that 300×, 133× or 60× label means, card performance is based on a benchmark of megabytes per second of read/write rate. Using a starting point of 3 Mb/sec equalling a 20× memory card read/write rate, typical rates will be:

9 Mb/sec = 60×	10 Mb/sec = 66×
20 Mb/sec = 133×	45 Mb/sec = 300×

For example, a 120× 2 Gb SD card has a read rate of 21 Mb/sec and a write rate of 18 Mb/sec. Such read/write speeds will provide not only fast storage of large image files to card, they will also facilitate quick viewing of images and faster transfer rates during downloading than, say, a 60× card. The Lexar Professional UDMA card range with Write Acceleration provides a staggering 300× read/write speed which is currently one of the fastest on the market. Many photographers prefer to use two 2 Gb cards instead of one 4 Gb card. If you are creating huge files from a 22 Mp camera then 4 Gb or even 8 Gb will be attractive.

RAW Enabling Windows Vista

One of the difficulties when working with RAW files is that sometimes the computer's operating system is unable to display thumbnails of the images when viewing the contents of folders or directories.

When using Windows XP it was necessary to install Microsoft's Raw Image Thumbnailer and Viewer utility before the operating system was able to recognise, and display, RAW files. The system was slow and most users reverted to employing Bridge as the main way they viewed their files.

Now Windows users are migrating to the Vista operating system. Recognising that RAW files are a key component of the photographer's workflow, Microsoft has taken a different approach to the problem in its latest operating system offering. In creating a more 'RAW aware' operating system, Microsoft has made use of a structure where the various camera manufacturers supply their own CODECs (Compression Decompression drivers) to be used with their particular type of RAW files inside Vista. With this approach the user has to install the CODEC for the camera that he or she uses before they are able to view their images in the system folders or directories.

Though a little troublesome to start with, as you need to install codecs for all the cameras you use or have used in the past, this approach will hopefully future proof the operating system's support for RAW files. It is a simple matter in the future to support the latest camera, or RAW file type, by installing the latest CODEC from the manufacturer.

Use the following steps as a guide for RAW enabling your own Windows Vista machine.

01 Locate the CODEC
Start by searching the internet, or your camera manufacturer's support site, for the specific Vista CODEC that supports your RAW files. Once located, download, and in some cases, extract, or decompress, the files to your desktop ready for installation.

02 Follow the manufacturer's install instructions
Next follow the install instructions. Here I am installing the Nikon Raw CODEC for Vista. As part of the process, the user is required to input location and language selections.

03 Reboot the computer (if necessary)
As the CODEC forms part of the file processing functions of the operating system it may be necessary to reboot (turn off and turn back on again) your computer after installing the software.

04 **Test the install**
After rebooting check to see that the CODEC is functioning correctly by displaying an Icon View of an image folder that you know contains RAW files. You should see a series of thumbnails representing your image files.

Camera and card reader connections

The connection that links the camera/card reader and computer is used to transfer the picture data between the two machines. Because digital photographs are made up of vast amounts of information this connection needs to be very fast. Over the years several different connection types have developed, each with their own merits. It is important to check that your computer has the same connection as the camera/card reader before finalizing any purchase.

USB

Firewire

CONNECTION TYPE:	MERITS:	SPEED RATING:
USB 1.0	• No need to turn computer off to connect (hot swappable) • Can link many devices • Standard on most computers • Can be added to older machines using an additional card	Fast (1.5 Mbytes per sec)
USB 2.0	• Hot swappable • Can link many devices • Standard on most models • Can be added to older machines using an additional card • Backwards compatible to USB 1.0	Extremely fast (60 Mbytes per sec)
Firewire	• Hot swappable • Can link many devices • Becoming a standard on Windows machines, especially laptops • Can be added using an additional card • Standard on Macintosh machines	Extremely fast (50 Mbytes per sec)
Firewire 800	• Hot swappable • Can link many devices • Can be added using an additional card • Not yet standard but some new machines feature the connection	Fastest connection available (100 Mbytes per sec)

Camera-specific download

Most digital cameras now ship with a host of utilities designed to make the life of the photographer much easier. As part of this software pack the camera manufacturers generally include an automated download utility designed to aid the transfer of files from camera or card reader to computer. These camera-specific download managers are clever enough to know when a camera or card reader is connected to the computer and will generally display a connection dialog when the camera is first attached or a memory card inserted into the reader.

Figure 7.17 Some camera manufacturers supply specialist download software with their cameras. Nikon Transfer, pictured above, is an example of this type of software. These small utilities handle the job of transferring photos from camera or memory card to the computer.

For instance, Nikon owners have the option to use the Nikon Transfer manager, a small pop-up utility that automates the moving of files from card/camera to hard drive. See Figure 7.17. The manager is installed along with camera drivers, photo browser and basic RAW conversion software when you load the software on the disk that accompanies your camera. Generally this type of software provides settings for choosing destination directories, renaming files on the fly, adding in copyright information and determining if the files are deleted from the camera or card after transfer.

Software-specific download

Some photographers choose not to rely on the download options available with their camera-based software or the manual copy route provided by the operating system. Instead they manage the download component of their workflow with the main imaging software package. Here we look at routes for transferring your photos with both Photoshop Elements and Photoshop.

Photoshop Elements and the Adobe Photo Downloader (APD)

After attaching the camera, or inserting a memory card into the reader, you will see the Adobe Photo Downloader dialog. This utility is designed specifically for managing the download process and contains the option of either a Standard or Advanced dialog. The Standard option offers the simplest method of transferring your files and the Advanced option provides more settings the user can customize (see Figure 7.18).

APD – Standard mode

After finding and selecting the source of the pictures (the card reader or camera) via the drop-down menu at the top of the dialog, you will then see a thumbnail of the first file stored on the camera or memory card. By default all pictures on the card will be selected ready for downloading and cataloging.

Next set the Import Settings. Browse for the folder where you want the photographs to be stored and if you want to use a subfolder select the way that this folder will be named from the Create Subfolder drop-down menu. To help with finding your pictures later it may be helpful to add a meaningful name, not the labels that are attached by the camera, to the beginning of each of the images. You can do this by selecting an option from the Rename File drop-down menu and adding any custom text if needed. It is at this point that you can choose what action Elements will take after downloading the files via the Delete Options menu.

It is a good idea to choose the Verify and Delete option as this makes sure that your valuable pictures have been downloaded successfully before they are removed from the card. Clicking the Get Photos will transfer your pictures to your hard drive – you can then catalog the pictures in the Organizer workspace. For more choices during the download process you will need to switch to the Advanced mode.

Figure 7.18 To download the pictures from your camera's memory card whilst in Photoshop Elements Organizer workspace:
(1) select Get Photos > From Camera or Card Reader.
(2) locate the card reader in the drop-down menu.
(3) browse for the folder to store the pictures.
(4) elect to Rename or Auto Fix Red Eye, and then
(5) click the Get Photos button.

The Adobe Photo Downloader software also provides an auto-start option (right) that allows the user to select the feature from a pop-up window when a memory card (in reader) or camera is attached to the computer.

Windows Vista users may also see the operating system's AutoPlay dialog when inserting a card or connecting a camera. To use Adobe Photo Downloader simply select the Organize and Edit option from the list of available choices.

APD – Advanced mode

Selecting the Advanced Dialog button at the bottom left of the Standard mode window will display a larger Photo Downloader dialog with more options and a preview area showing a complete set of preview thumbnails of the photos stored on the camera or memory card. If for some reason you do not want to download all the images, then you will need to deselect the files to remain by unchecking the tick box at the bottom right-hand of the thumbnail.

Note: The only way to delete files using the utility is to select them in the dialog. This means they have to be downloaded and added to the catalog (even if they are already there from a previous download) before they can be deleted.

The Advanced version of the Photo Downloader contains the same Location for saving transferred files, Rename and Delete after importing options that are in the Standard dialog. In addition, this mode contains the following options:

- **Automatically Fix Red Eyes** – This feature searches for and corrects any red eye effects in photos taken with flash.
- **Automatically Suggest Photo Stacks** – Select this option to get the downloader utility to display groups of photos that are similar in either content or time taken. The user can then opt to convert these groups into image stacks or keep them as individual thumbnails in the Organizer.
- **Make 'Group Custom Name' as a Tag** – To aid with finding your pictures once they become part of the larger collection of images in your Elements' catalog, you can group tag the photos as you download them. Adding tags is the Elements equivalent of including searchable keywords with your pictures. The tag name used is the same as the title added in the Rename section of the Photo Downloader utility.
- **Apply Metadata (Author and Copyright)** – With this option you can add both author name and copyright details to the metadata that is stored with the photo. Metadata, or EXIF data as it is sometimes called, is saved as part of the file and can be displayed at any time with the File Info (Editor) or Properties (Organizer) options in Elements or with a similar feature in other imaging programs.

Automatic downloads

Both the Standard and Advanced dialogs contain the option to use automatic downloading the next time a camera or card reader is attached to the computer. The settings used for the auto download, as well as default values for features in the Advanced mode of the Photo Downloader, can be adjusted in the Organizer: Edit > Preferences > Camera or Card Reader dialog (see Figure 7.19).

Figure 7.19 The default settings for the Adobe Photo Downloader are located in the Camera or Card Reader section of the Edit > Preferences option in the Organizer workspace. This is also the place for adjusting the options for the Automatic Download feature as well.

Photoshop and Bridge

Photoshop users now also have the option of transferring their images with the Adobe Photo Downloader. But the transfer utility needs to be started from inside of the Bridge program (which ships with Photoshop). Bridge is essentially a browser program and in the latest release contains a version of the Adobe Photo Downloader that we have just seen in action. If required Photoshop users can also employ other methods for transferring photos to their computer. These include the options outlined earlier such as:

* a manual method of transferring files using the computer's operating system or
* a camera-specific download manager such as the Nikon Transfer utility.

Once the files have been downloaded they can be managed and sorted using the features in Bridge.

Processing the picture file

As we have already seen, selecting the file format you choose to store your captured photos in camera has implications for how the picture document is handled. Photos saved in the JPEG or TIFF formats can be edited or enhanced as soon as they are transferred from the camera or memory card, whereas those images stored in the RAW file format need to be processed or converted first before they can be manipulated (see Figure 7.20).

The conversion task can be handled by software supplied by your camera manufacturer, with features that are built into your image editing program or via dedicated utilities designed specifically for the task. Both Photoshop and Photoshop Elements contain Adobe's own RAW conversion software called Adobe Camera RAW (ACR) and, for most photographers, it will be this utility that will handle their RAW file processing. Despite being based on the same core design, the version of Adobe Camera RAW that appears in Photoshop Elements is slightly different, with a smaller feature set, than Photoshop's version. Use the following step-by-step guide to help you convert your RAW files.

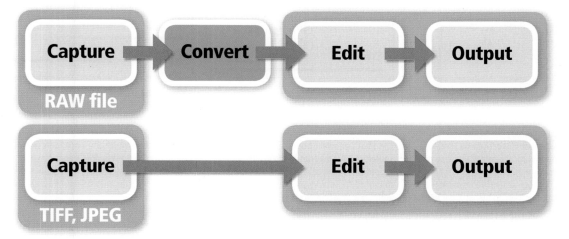

Figure 7.20 Photos captured and saved in JPEG or TIFF formats need no further processing before they can be edited or enhanced in software such as Photoshop or Photoshop Elements. In contrast, most RAW files need to be converted to another format before they can be manipulated.

RAW conversion using Adobe Camera RAW (ACR)

Use the following workflow when converting your RAW photos with ACR in Photoshop Elements. The same utility is also used in conjunction with Photoshop and Bridge.

Step 1: Opening the RAW file

Once you have downloaded your RAW files from camera to computer you can start the task of processing. Keep in mind that in its present state the RAW file is not in the full color RGB format that we are used to, so the first part of all processing is to open the picture into Adobe Camera Raw. Selecting File > Open from inside Elements will automatically display the photo in this.

Step 2: Starting with the Organizer

Starting in the PhotoBrowser or Organizer workspace simply right-click on the thumbnail of the RAW file and select the Full Edit option from the pop-up menu to transfer the file to the Elements version of ACR in the Editor workspace.

Step 3: Rotate Right (90 CW) or Left (90 CCW)

Once the raw photo is open in ACR you can rotate the image using either of the two Rotate buttons at the top of the dialog. If you are the lucky owner of a recent camera model then chances are the picture will automatically rotate to its correct orientation. This is thanks to a small piece of metadata supplied by the camera and stored in the picture file that indicates which way is up.

Step 4: Crop and Straighten

The Straighten tool can automatically rotate a picture taken with the horizon slightly crooked. Simply drag the tool along the line in the image that is meant to be level and ACR will automatically rotate and crop the photo to realign the horizon.

Use the Crop tool to remove unwanted areas around your photo or to reshape the format of the image to fit a specific paper type. The tool can be click-dragged around the area you want to keep or a specific cropping format can be selected from the drop-down menu accessed via the small downward facing arrow in the bottom right of the Tool button.

Step 5: Preset changes

When it comes to the White Balance options applied to your photo you can opt to stay with the settings used at the time of shooting ('As Shot') or select from a range of light source-specific settings in the White Balance drop-down menu of ACR. For best results, try to match the setting used with the type of lighting that was present in the scene at the time of capture. Or choose the Auto option from the drop-down White Balance menu to get ACR to determine a setting based on the individual image currently displayed.

Step 6: Manual adjustments

If none of the preset White Balance options perfectly matches the lighting in your photo then you will need to fine-tune your results with the Temperature and Tint sliders (located just below the Presets drop-down menu). The Temperature slider settings equate to the color of light in degrees Kelvin – so daylight will be 5500 and tungsten light 3200. It is a blue to yellow scale, so moving the slider to the left will make the image cooler (more blue) and to the right warmer (more yellow). In contrast the Tint slider is a green to magenta scale. Moving the slider left will add more green to the image and to the right more magenta.

Step 7: The White Balance tool

Another quick way to balance the light in your picture is to choose the White Balance tool and then click on a part of the picture that is meant to be neutral gray or white. ACR will automatically set the Temperature and Tint sliders so that this picture part becomes a neutral gray and in the process the rest of the image will be balanced. For best results when selecting lighter tones with the tool ensure that the area contains detail and is not a blown or specular highlight.

Step 8: Setting the highlights

To start modifying the tones, adjust the brightness with the Exposure slider. Moving the slider to the right lightens the photo and to the left darkens it. The settings for the slider are in f-stop increments, with a +1.00 setting being equivalent to increasing exposure by 1 f-stop. Use this slider to set the white tones. Your aim is to lighten the highlights in the photo without clipping them (converting the pixels to pure white). To do this, hold down the Alt/Option whilst moving the slider. This action previews the photo with the pixels being clipped against a black background. Move the slider back and forth until no clipped pixels appear but the highlights are as white as possible.

Step 9: Adjusting the shadows

The Blacks slider performs a similar function with the shadow areas of the image. Again the aim is to darken these tones but not to convert (or clip) delicate details to pure black. Just as with the Exposure slider, the Alt/Option key can be pressed whilst making Blacks adjustments to preview the pixels being clipped. Alternatively the Shadow and Highlights Clipping Warning features can be used to provide instant clipping feedback on the preview image. Shadow pixels that are being clipped are displayed in blue and clipped highlight tones in red.

Step 10: Brightness changes

The next control, moving from top to bottom of the ACR dialog, is the Brightness slider. At first the changes you make with this feature may appear to be very similar to the Exposure slider but there is an important difference. Rather than adjusting all pixels the same amount the feature makes major changes in the midtone areas and smaller jumps in the highlights. In so doing the Brightness slider is less likely to clip the highlights (or shadows), as the feature compresses the highlights as it lightens the photo. This is why it is important to set white and black points first with the Exposure and Shadows sliders before fine-tuning the image with the Brightness control.

Step 11: Recovering Highlights and Shadow detail

If the highlights are still being clipped then use the Recovery slider to recreate detail in the problem area. Likewise, if the shadows areas are too dark then drag the Fill Light slider to the right to lighten these tones in the photo. Be careful with overapplication of either of these controls as it can make the image look low in contrast.

Step 12: Increasing/decreasing contrast

The last tonal control in the dialog, and the last to be applied to the photo, is the Contrast slider. The feature concentrates on the midtones in the photo with movements of the slider to the right increasing the midtone contrast and to the left producing a lower contrast image. Like the Brightness slider, Contrast changes are best applied after setting the white and black points of the image with the Exposure and Contrast sliders.

Step 13: Local Contrast Control

The Clarity slider is used to alter the local contrast or the contrast of details within the photo. It works well with photos that have been photographed with diffused light or on a cloudy day. Use Clarity and Contrast sliders together.

Step 14: Saturation control

The strength or vibrancy of the colors in the photo can be adjusted using the Saturation slider. Moving the slider to the right increases saturation, with a value of +100 being a doubling of the color strength found at a setting of 0. Saturation can be reduced by moving the slider to the left, with a value of −100 producing a monochrome image. Some photographers use this option as a quick way to convert their photos to black and white but most prefer to make this change in Photoshop Elements proper, where more control can be gained over the conversion process.

Step 15: Vibrance Adjustment

Unlike the Saturation slider which increases the strength of all colors in the photo irrespective of their strength in the first place, Vibrance targets its changes to just those colors that are desaturated. As well as targeting only pastel like colors, the Vibrance slider tends to protect skin tones when making changes to the saturation of colors in the photo. For these reasons you should use this control to boost color strength with less risk of posterized results or overly saturated skin tones.

Step 15: To sharpen or not to sharpen

The latest version of ACR contains four separate sharpening controls. Use the Amount slider to determine the overall strength of the sharpening effect. The Radius is used to control the number of pixels from an edge that will be changed in the sharpening process.

Step 16: Targeting sharpening

The Detail and Masking sliders are both designed to help target the sharpening at the parts of the image that most need it (edges) and restrict the sharpening effects from being applied to areas that don't (skin tone and smooth graded areas). Moving the Detail slider to the right increases the local contrast surrounding edge areas. The Masking control interactively applies a edge locating mask to the sharpening process. A setting of 0 applies no mask and moving the slider to the right gradually isolates the edges until at a setting of 100 sharpening is only being applied to contrasty or dominant edges in the picture.

Step 16: Reducing noise

ACR contains two different noise reduction controls. The Luminance Smoothing slider is designed to reduce the appearance of grayscale noise in a photo. This is particularly useful for improving the look of images that appear grainy. The second type of noise is the random colored pixels that typically appear in photos taken with a high ISO setting or a long shutter speed. This is generally referred to as chroma noise and is reduced using the Color Noise Reduction slider in ACR. The noise reduction effect of both features is increased as the sliders are moved to the right.

Step 17: Controlling output options

The section below the main preview window in ACR contains the output options settings. Here you can adjust the color depth (8 or 16 bits per channel) of the processed file. Earlier versions of Photoshop Elements were unable to handle 16 bits per channel images but the latest releases have contained the ability to read, open, save and make a few changes to these high color files.

Step 19: Saving the processed RAW file

Users have the ability to save converted RAW files from inside the ACR dialog via the Save button. This action opens the Save Options dialog which contains settings for inputting the file name as well as file type-specific characteristics such as compression. Use the Save option over the Open command if you want to process photos quickly without bringing them into the Editing space.

Pro's tip: Holding down the Alt/Option key whilst clicking the Save button allows you to store the file (with the raw processing settings applied) without actually going through the Save Options dialog.

Step 18: Opening the processed file

The most basic option is to process the RAW file according to the settings selected in the ACR dialog and then open the picture into the Editor workspace of Photoshop Elements. To do this simply select the OK button. Select this route if you intend to edit or enhance the image beyond the changes made during the conversion.

Step 20: Applying the RAW conversion settings

There is also an option for applying the current settings to the RAW photo without opening the picture. By Alt-clicking the OK button (holding down the Alt key changes the button to the Update button) you can apply the changes to the original file and close the ACR dialog in one step.

The great thing about working this way is that the settings are applied to the file losslessly. No changes are made to the underlying pixels, only to the instructions that are used to process the raw file.

When next the file is opened, the applied settings will show up in the ACR dialog ready for fine-tuning, or even changing completely.

ACR Differences between Photoshop and Photoshop Elements

The Adobe Camera RAW utility is available in both Photoshop Elements and Photoshop (and Bridge) but the same functionality and controls are not common to the feature as it appears in each program. The Photoshop Elements version contains a reduced feature set but not one that overly restricts the user's ability to make high-quality conversions.

The following features and controls are common to both Photoshop/Bridge and Photoshop Elements:

White Balance presets, Temperature, Tint, Exposure, Shadows, Brightness, Contrast, Clarity, Auto checkboxes for tonal controls, Vibrance, Saturation, Sharpness, Luminance Smoothing, Color Noise Reduction, Rotate Left, Rotate Right, Shadow and Highlights Clipping Warnings, Preview checkbox, Color Histogram, RGB readout, Zoom tool, Hand tool, White Balance tool, Color Depth, Advanced Sharpening options, Open processed file, Apply conversion settings without opening.

These options are only available in ACR for Photoshop/Bridge:

Tone Curve, Convert to gray, Hue, Saturation and Luminance, Split Toning, Chromatic Aberration, Vignetting, Curves, Calibration controls, Color Sampler tool, Color Space, Image size, Image resolution, Save settings, Save processed file direct from ACR and Develop Presets.

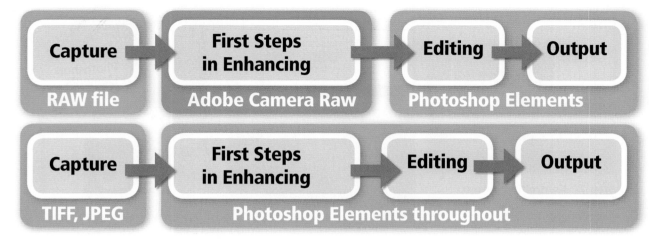

Figure 7.21 The capture format you pick determines where the first enhancement steps will be performed. RAW shooters will initially adjust their images in Adobe Camera Raw before moving the processed file to Photoshop or Photoshop Elements for further editing and output (see upper workflow diagram). When capturing in TIFF or JPEG file formats the first processing steps are carried out inside the image editing program itself (see lower workflow diagram).

First steps in enhancing

If you choose to use a non-RAW capture format, such as JPEG or TIFF, then the enhancement steps applied to RAW files via utilities like Adobe Camera Raw will need to be undertaken in an image editing program such as Photoshop Elements. See Figure 7.21. To start your introduction to non-RAW based image processing, we will duplicate the adjustments that I demonstrated in the last section on RAW files, in Photoshop Elements. The following basic steps those that most photographers perform after each shooting session:

1 Starting the process.
2 Changing the picture's orientation.
3 Cropping and straightening.
4 Spreading the image tones.
5 Removing unwanted casts.
6 Applying a little sharpening.
7 Saving the picture.

These basic alterations take a standard picture captured by a camera, or scanner, and tweak the pixels so that the resultant photograph is cast free, sharp and displays a good spread of tones.

No matter what image editing program you are using, the tools and features designed to perform these steps are often those first learned. Here the steps are demonstrated using Photoshop Elements, but these basic steps can be performed with any of the main image editing programs currently available on the market. A summary of the tools and menu options needed to perform these steps in Photoshop is also included at the end of each section. A trial version of Photoshop Elements and Photoshop can be obtained by downloading the 30-day demo from the www.adobe.com website.

Figure 7.22 Start the process from the Photoshop Elements' Welcome screen.

Step 1. Starting the process

When opening Photoshop Elements for the first time, the user is confronted with the Quick Start or Welcome screen, see Figure 7.22, containing several options. You can select between a range of workspaces using the options in this screen. To download and import photos from your camera or card reader select the Organize option. To make fast general changes with the added benefit of before and after preview screens or for more sophisticated and complex editing and enhancement tasks click on the Edit button. The final options, Create and Share, are used to start the production of a range of photo projects. These include creating slideshows, web galleries, photo books or collages and emailing images to friends and relatives.

Most photographers start in the Organize option which takes you directly to the Organizer workspace. Here you will see a series of thumbnails of the photos in your collection. If you have transferred your pictures using the Adobe Photo Downloader then they will already be cataloged and included in the display. If you are yet to add your photos, then choose one of the options in the File > Get Photos and Videos menu. Selecting From Camera or Card Reader will display the Adobe Photo Downloader dialog, which can be used to automate the transfer process. If the pictures have been transferred with another utility then select File > Get Photos and Videos > From Files or Folders.

After cataloging the next step is to open a photo into an editing workspace. To do this right-click on a thumbnail displayed in the Organizer and then select Full Edit from the pop-up menu. The picture will then open in the Editor workspace.

This step in Photoshop:
To browse for a picture: *File > Browse*
To open a picture from a folder: *File > Open*
To import an image from a connected camera: *File > Import*
To use the Adobe Photo Downloader: *In Bridge choose File > Get Photos from Camera*

Figure 7.23 Changing a picture's orientation.

Step 2. Changing a picture's orientation

Turning your camera to shoot images in portrait mode will generally produce pictures that need to be rotated to vertical after importing. Elements provides a series of dedicated Rotate options under the Image menu designed for this purpose. Here the picture can be turned to the right or left in 90° increments or to custom angles, using the Canvas Custom feature. See Figure 7.23.

There is even an option to rotate the whole picture 180° for those readers who, like me, regularly place prints into their scanners upside down.

This step in Photoshop:
To rotate a picture: Image > Rotate Canvas > Select an option

Step 3. Cropping and straightening

Most editing programs provide tools that enable the user to crop the size and shape of their images. Elements provides two such methods. The first is to select the Rectangular Marquee tool and draw a selection on the image the size and shape of the required crop. Next choose Image > Crop from the menu bar. The area outside of the marquee is removed and the area inside becomes the new image.

Figure 7.24 Cropping and straightening.

The second method uses the dedicated Crop tool that is also located in the toolbox. Just as with the Marquee tool, a rectangle is drawn around the section of the image that you want to retain. The selection area can be resized at any time by clicking and dragging any of the handles positioned in the corners of the box. To crop the image, click the Commit button (green tick) at the bottom of the Crop marquee or double-click inside the selected area. See Figure 7.24. An added benefit of using the Crop tool is the ability to rotate the selection by clicking and dragging the mouse when it is positioned outside the box. To complete the crop, click the Commit button, but this time the image is also straightened based on the amount that the selection area was rotated.

As well as this manual method, Elements provides an automatic technique for cropping and straightening crooked scans. The bottom two options in the Rotate menu, Straighten Image and Straighten and Crop Image, are specifically designed for this purpose.

This step in Photoshop:
To crop a picture: use the Crop tool or Rectangular Marquee tool in the same way as detailed in the Photoshop Elements steps above

Figure 7.25 Spreading your image tones using the automatic options contained in the Enhance menu of Photoshop Elements.

Figure 7.26 Adjust the brightness and contrast of your photos manually using features such as Levels or Brightness/Contrast.

Step 4. Spreading your image tones

When photographers produce their own traditional monochrome prints, they aim to spread the image tones between maximum black and white; so too should the digital image maker ensure that their pixels are spread across the whole of the possible tonal range. In a full color 24-bit image, this means that the tonal values should extend from 0 (black) to 255 (white).

Elements provides both manual and automatic techniques for adjusting tones. The Auto Contrast and Auto Levels options are both positioned under the Enhance menu. See Figure 7.25. Both features will spread the tones of your image automatically, the difference being that the Auto Levels function adjusts the tones of each of the color channels individually, whereas the Auto Contrast command ignores differences between the spread of the Red, Green and Blue components and just concentrates on adjusting the overall contrast.

If your image has a dominant cast, then using Auto Levels can sometimes neutralize this problem. The results can be unpredictable, though, so if after using the feature the colors in your image are still a little wayward, undo the changes using the Edit > Undo command and use the Auto Contrast feature instead. This feature concentrates on tones and ignores colors.

If you want a little more control over the placement of your pixel tones, then Adobe has also included the same slider-based Contrast/Brightness and Levels features used in Photoshop in their entry-level software. Both these features, Levels in particular, take back the control for the adjustment from the program and place it squarely in the hands of the user. See Figure 7.26.

This step in Photoshop:
To automatically adjust the contrast only in a picture: Image > Adjustments > Auto Contrast
To automatically adjust the contrast and color in a picture: Image > Adjustments > Auto Levels
Manual adjustment of contrast and brightness: Image > Adjustments > Brightness/Contrast or Image > Adjustments > Levels

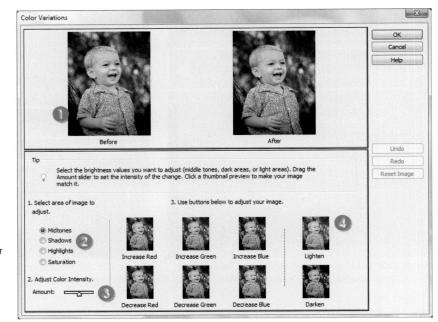

Figure 7.27 The Color Variations feature can be used to help rid your pictures of unwanted color casts.
1. Before and after thumbnails
2. Tonal range selection
3. Amount slider
4. Thumbnail adjustments

Step 5. Ridding your pictures of unwanted color casts

Despite the quality of modern digital cameras' white balance systems, images shot under mixed lighting conditions often contain strange color casts. The regularity of this problem led Adobe to include the specialized Color Cast tool (Enhance > Adjust Color > Color Cast) in Elements. Simply click the eyedropper on a section of your image that is meant to be gray (an area that contains equal amounts of red, green and blue values) and the program will adjust all the colors accordingly.

This process is very easy and accurate – if you have a gray section in your picture, that is. For those pictures without the convenience of this reference, the Variations feature (Enhance > Adjust Color > Color Variations) provides a visual 'ring-around' guide to cast removal. See Figure 7.27. The feature is divided into four parts. The top of the dialog (1) contains two thumbnails that represent how your image looked before changes and its appearance after. The radio buttons in the middle-left section (2) allow the user to select the parts of the image they wish to alter. In this way, highlights, midtones and shadows can all be adjusted independently. The 'Amount' slider (3) in the bottom left controls the strength of the color changes.

The final part, bottom left (4), is taken up with six color and two brightness preview images. These represent how your picture will look with specific colors added or when the picture is brightened or darkened. Clicking on any of these thumbnails will change the 'after' picture by adding the color chosen. To add a color to your image, click on a suitably colored thumbnail. To remove a color, click on its opposite.

This step in Photoshop:
To automatically adjust the color in a picture: Image > Adjustments > Auto Color
To adjust the color in a picture using preview thumbnails: Image > Adjustment > Variations

Step 6. Applying some sharpening

The nature of the capture or scan process means that most digital images can profit from a little careful sharpening. I say careful, because the overuse of this tool can cause image errors, or artifacts, that are very difficult to remove. Elements provides several sharpening choices including both manual and automatic options.

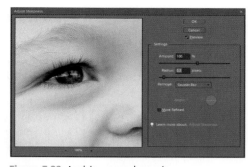

Figure 7.28 Applying some sharpening.

The Auto Sharpen feature found in the Enhance menu provides automatic techniques for improving the clarity of your images. The effect is achieved by altering the contrast of adjacent pixels and pixel groups. The Auto Sharpen feature applies a set amount of sharpening and provides no way for the user to adjust the effect.

In contrast Elements also contains two manual sharpening control options. The Unsharp Mask and Adjust Sharpness filters provide the user with manual control over which pixels will be changed and how strong the effect will be. The key to using these features is to make sure that the changes made by the filter are previewed in both the thumbnail and full image at 100 per cent magnification. This will help to ensure that your pictures will not be noticeably over-sharpened.

This step in Photoshop:
To automatically adjust the sharpness: Filter > Sharpen > Sharpen or Sharpen More or Sharpen Edges
To manually adjust sharpness: Filter > Sharpen > Smart Sharpen or Unsharp Mask

Step 7. Saving your images

The final step in the process is to save all your hard work. The format you choose to save in determines a lot of the functionality of the file. If you are unsure of your needs, always use the native PSD or Photoshop format. These files maintain layers and features like editable text and saved selections and do not use any compression (keeping all the quality that was originally contained in your picture). If you are not using Photoshop or Elements and still want to maintain the best quality in your pictures, then you can also use the TIF or Tagged Image File Format, but this option has less features than the Photoshop format. JPEG and GIF files should only be used for web work or when you need to squeeze your files down to the smallest size possible. Both these formats lose image quality in the reduction process, so keep a PSD or TIF version as a quality backup.

Figure 7.29 Saving your images.

To save your work, select File > Save As, entering the file name and selecting the file format you desire before pressing OK.

This step in Photoshop:
To save pictures in a given format: you can use the same File > Save As option in Photoshop that was available in Photoshop Elements

Editing techniques

Now let's throw a few more techniques into the editing arena for good measure. More than enhancing existing detail, these techniques are designed to change the information in your pictures and so are usually considered editing techniques.

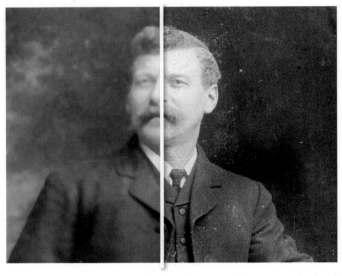

Figure 7.30 Too much Dust and Scratches filtering can destroy image detail and make the picture blurry. Before (right) and after (left) Dust and Scratches filter application.

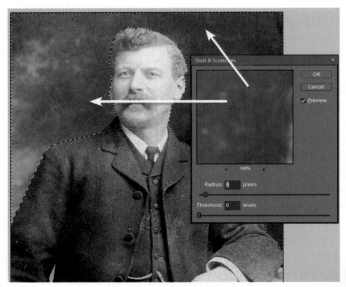

Figure 7.31 Select an area of the image that doesn't have a lot of detail first and then apply the Dust and Scratches filter using the Radius first and then the Threshold slider.

Dust and Scratches filter

It seems that no matter how careful I am, my scanned images always contain a few dust marks. The Dust and Scratches filter in Photoshop and Photoshop Elements helps to eliminate these annoying spots by blending or blurring the surrounding pixels to cover the defect. The settings you choose for this filter are critical if you are to maintain image sharpness whilst removing small marks. Too much filtering and your image will appear blurred, too little and the marks will remain (see Figure 7.30).

To find settings that provide a good balance, try adjusting the threshold setting to zero first. Next use the preview box in the filter dialog to highlight a mark that you want to remove. Use the zoom controls to enlarge the view of the defect. Now drag the Radius slider to the right. Find, and set, the lowest radius value where the mark is removed. Next increase the threshold value gradually until the texture of the image is restored and the defect is still removed (see Figure 7.31).

Generally, I only use this filter on the picture parts where there is little detail such as the background in the example. I select this area first and then apply the filter. This action successfully removes dust from smoothly graded areas such as skies without losing details in the important parts of the picture.

This feature in Photoshop:
Photoshop also contains the Dust and Scratches filter.

Clone Stamp

In some instances, the values needed for the Dust and Scratches filter to erase or disguise picture faults are so high that it makes the whole image too blurry for use. In these cases, it is better to use a tool that works with the problem area specifically rather than the whole picture surface.

The Clone Stamp tool (sometimes called the Rubber Stamp tool) samples an area of the image and then paints with the texture, color and tone of this copy onto another part of the picture. This process makes it a great tool to use for removing scratches or repairing tears or creases in a photograph. Backgrounds can be sampled and then painted over dust or scratch marks, and whole areas of a picture can be rebuilt or reconstructed using the information contained in other parts of the image (see Figure 7.32).

Using the Clone Stamp tool is a two-part process. The first step is to select the area that you are going to use as a sample by Alt-clicking (Windows) or Option-clicking (Macintosh) the area (see Figure 7.33). Now move the cursor to where you want to paint and click and drag to start the process (see Figure 7.34).

The size and style of the sampled area are based on the current brush and the opacity setting controls the transparency of the painted section.

This feature in Photoshop:
Photoshop also contains the Clone Stamp tool.

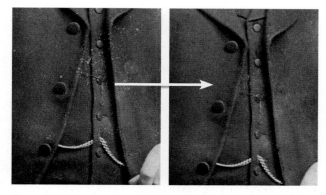

Figure 7.32 The Clone Stamp tool is perfect for retouching the marks that the Dust and Scratches filter cannot erase. Before (left) and after (right) applying the Clone Stamp tool to the dust spots on the jacket.

To sample

Figure 7.33 Alt + click (Windows) or Option + click (Mac) to mark the area to be sampled.

Sample point Retouching area

Figure 7.34 Move the cursor over the mark and click to paint over with the sampled texture.

Before | After

Figure 7.35 The Healing Brush, which can be found in more recent versions of Photoshop, is an advanced retouching tool that works in the same basic 'sample and paint' way as the Clone Stamp tool. The difference is that the Healing Brush merges the newly painted area into the pixels that surround the mark, creating a more seamless repair.

Locate the area to be healed | ALT + Click to set sample point | Click and Drag to heal

Figure 7.36 Use this three-step approach to retouch using the Healing Brush.

Using the Healing Brush

Designed to work in a similar way to the Clone tool, the user selects the area to be sampled before painting. This Photoshop-only tool achieves great results by merging background and source area details as you paint. Just as with the Clone Stamp tool, the size and edged hardness of the current brush determines the characteristics of the Healing tool tip (see Figure 7.35).

To use the Healing Brush, the first step is to locate the areas of the image that need to be retouched. Next, hold down the Alt key and click on the area that will be used as a sample for the brush. Notice that the cursor changes to cross-hairs to indicate the sample area (see Figure 7.36).

Now move the cursor to the area that needs retouching and click and drag the mouse to 'paint' over the problem picture part. After you release the mouse button, Photoshop merges the newly painted section with the image beneath.

Spot Healing Brush

In recognition of just how tricky it can be to get seamless dust removal with the Clone Stamp tool, Adobe decided to include the Spot Healing Brush in Elements. After selecting the tool you adjust the size of the brush tip using the options in the tool's option bar and then click on the dust spots and small marks in your pictures. The Spot Healing Brush uses the texture that surrounds the mark as a guide to how the program should 'paint over' the area. In this way, Elements tries to match color, texture and tone whilst eliminating the dust mark. The results are terrific and this tool should be the one that you reach for first when there is a piece of dust or a hair mark to remove from your photographs.

This feature in Photoshop:
Photoshop contains both the Spot Healing and Healing Brushes.

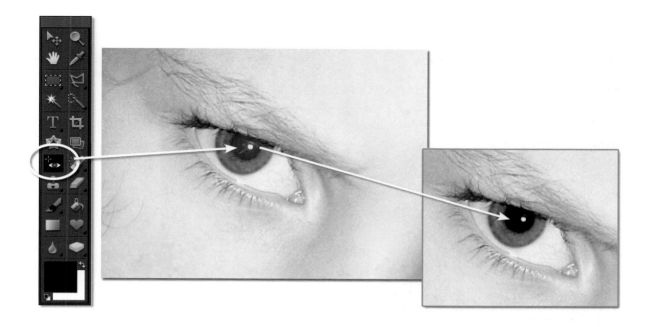

Red eye removal

The dreaded red eye appears all too frequently with images shot using the built-in flash on compact digital cameras. The flash is too close to the lens and the light reflects back from the inside of the subject's pupil, giving the tell-tale red glow. Red eye removal features can be found in most digital photography software and usually consist of a brush tool that replaces the red color with a hue that is more natural.

Photoshop Elements contains a specialist tool to help retouch these problems in our pictures. Called the Red Eye Removal tool, it changes crimson color in the center of the eye for a more natural-looking black (see Figure 7.37). To correct the problem is a simple process that involves selecting the tool and then clicking on the red section of the eye. Elements locates the red color and quickly converts it to a more natural dark gray. The tool's options bar provides settings to adjust the pupil's size and the amount that it is darkened. Try the default settings first and if the results are not quite perfect, undo the changes and adjust the option's settings before reapplying the tool.

Figure 7.37 The Photoshop Elements' Red Eye Removal tool is designed to eliminate the 'devil-like' eyes that result from using the inbuilt flash of some digital cameras.

This feature in Photoshop:

Photoshop also contains a version of this feature called the Red Eye tool. You can find it nestled in the fly-out menu (to display, click and hold the mouse pointer over the small triangle in the bottom-right corner of the tool icon in the toolbox) of the Spot Heaing Brush, Healing Brush and Patch tools. The Photoshop version works in the same way as the Elements tool detailed here.

After Before

Figure 7.38
The dodging and burning-in tools can be used to selectively lighten or darken areas of your pictures.

The Dodge and Burn-in tools

Over the years, the people at Adobe have borrowed many traditional darkroom terms and ideas for use in their Photoshop and Photoshop Elements image editing packages. I guess part of the reasoning is that it will be easier for us to understand just how a feature works (and what we should use it for) if we have a historical example to go by.

The Photoshop Elements dodging and burning-in tools have roots in traditional darkroom techniques that enabled photographers to selectively darken and lighten sections of their pictures. These techniques involve shielding the print from light ('dodging') during exposure or adding extra light ('burning in') after the initial overall exposure. In this way, and unlike brightness changes, which alter the tones across the whole picture, burning-in and dodging techniques are used to darken or lighten just a portion of the picture (see Figure 7.38).

The digital versions of the technique use brush-shaped tools that are dragged over the picture area to be changed. The pixels beneath the dragged brush are either lightened or darkened according to the Exposure value selected and how many times the area is brushed. By selecting different Range options in the tool's options bar, the tonal changes can be limited to either highlights, shadows or midtones.

Figure 7.39 Photoshop Elements (top) and Photoshop (bottom) both contain the same set of Dodge and Burn tools.

This feature in Photoshop:
The same tools are available in both Photoshop and Photoshop Elements. See Figure 7.39.

Dodging and burning in practice

1 With an image open and a dodging tool selected, adjust the Brush, size, target tonal Range and Exposure values in the options bar. To start with, use a small, soft-edged brush, select midtones and ensure that the exposure is around 20 percent (see Figure 7.40).

2 For dark areas of the image, select the dodging tool and, using a series of overlapping brush strokes, click and drag over the area to lighten it. If the lightening effect is too great, Edit > Undo the changes and select a lower exposure value (see Figure 7.41).
Note: to apply these changes non-destructively duplicate the image layer first.

3 For lighter parts, switch to the burning-in tool and brush the whole area except the steps (see Figure 7.42).

4 In some cases the act of lightening or darkening specific picture parts may cause the color in the altered areas to become more saturated or vibrant. If this occurs use the Sponge tool (which is grouped with the Dodge and Burn tools) set to desaturate, to reduce the strength of the color.

Figure 7.40 Setting the values for the dodging tool.

Figure 7.41 The dodging tool in practice, lightening darker areas of the photo.

Figure 7.42 The burning-in tool in practice.

Before

After

Figure 7.43 Digital filters can be used to dramatically alter the way that your pictures appear. In this example, a filter is used to change a color photograph into a 'look-alike' pen and ink drawing.

Filter preview

Figure 7.44 Most filters are supplied with a preview and settings dialog that allows the user to view changes before committing them to the full image. (1) Filter preview thumbnail. (2) Filter controls.

Applying a filter to your image

Using a filter to change the way that your picture looks should not be a completely new technique to readers, as we have already looked at a sharpening technique that used the Unsharp Mask filter to crispen our pictures. Here we will look at filters more generally and also find out how we can filter only a part of the picture, leaving the rest unchanged (see Figure 7.43).

The filters in Adobe Photoshop Elements and Photoshop can be found grouped under a series of sub-headings based on their main effect or feature in the Filter menu. Selecting a filter will apply the effect to the current layer or selection. Some filters display a dialog that allows the user to change specific settings and preview the filtered image before applying the effect to the whole of the picture (see Figure 7.44). This can be a great time saver, as filtering a large file can take several minutes. If the preview option is not available then, as an alternative, make a partial selection of the image using the Marquee tool first and use this to test the filter. Remember, filter changes can be reversed by using the Undo feature, but not once the changes have been saved to the file.

The number and type of filters available can make selecting which to use a difficult process. To help with this decision, both Photoshop and Photoshop Elements contain a Filter Gallery feature that displays thumbnail versions of different filter effects. Designed to allow the user to apply several different filters to a single image, it can also be used to apply the same filter several different times. The dialog consists of a preview area, a collection of filters that can be used with

Figure 7.45 Features like the Filter Gallery in Photoshop Elements give users a good idea of the types of changes that a filter will make to an image whilst providing the ability to view and add multiple filtering effects to a photo in a single action.

the feature, a settings area with sliders to control the filter effect and a list of filters that are currently being applied to the picture (see Figure 7.45).

Multiple filters are applied to a picture by selecting the filter, adjusting the settings to suit the image and then clicking the New effect layer button at the bottom of the dialog. Filters are arranged in the sequence they are applied. Applied filters can be moved to a different spot in the sequence by click-dragging them up or down the stack. Click the eye icon to hide the effect of the selected filter from preview. Filters can be deleted from the list by selecting them first and then clicking the dustbin icon at the bottom of the dialog.

Figure 7.46 Filters in action

Filters in action

1 Check to see that you have selected the layer that you wish to filter (see Figure 7.46).
2 Select Filter > Filter Gallery and then select or click on the filter to display the preview dialog or to apply. Adjust settings in the preview dialog (if available for the particular filter chosen). Click Apply to finish (see Figure 7.47).

Figure 7.47 Filters in action.

Restricting your filtering

You can restrict your filtering to just a single part of the picture by isolating this area with a selection tool first before applying a filter. Choose a selection tool, such as the Rectangular Marquee tool, draw a selection of part of the picture, and then choose and apply the filter of your choice. Notice that only the area that was defined by the selection has been changed (see Figure 7.48).

Figure 7.48 By selecting a portion of your picture first before filtering, you can restrict the area where the effect is applied.

Introduction to layers

It doesn't take new digital photographers much time before they want to do more with their pictures than simply download and print them. Before you know it, they are adding text to their photographs, combining several images together and even adding fancy borders to their pictures. In some image editing packages, these sorts of activities are performed directly on the picture, which means making corrections, or slight modifications of these changes at a later date, difficult, if not almost impossible.

The leading programs, such as Photoshop and Photoshop Elements, use a better approach to image editing by providing a layer system to their files. The system enables users to separate individual components of a picture onto different layers. Each layer can be moved and edited independently. This is a big advantage compared to programs that treat the picture as a flat file, where any changes become a permanent part of the picture (see Figure 7.49).

Though each program handles this system differently, all provide a palette that you can use to view each of the layers and their content. The layers are positioned one above each other in a stack and the picture you see in the work area is a preview of the image with all layers combined (see Figures 7.50 and 7.51).

Figure 7.49 Image parts, text and editing functions can all be separated and saved as individual layers that can be moved and edited independently.

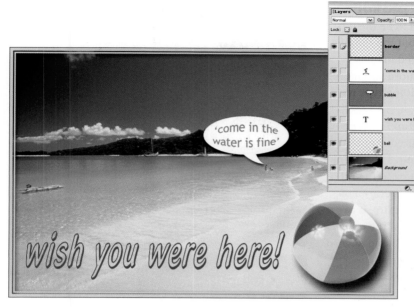

Figure 7.50 The layers that are used to construct an image can be viewed in two ways with Photoshop or Photoshop Elements. The main image window provides a preview of what the picture looks like with all the layers combined and the Layers palette shows each of the layers separated in a layer stack.

Layered pictures are only possible with file formats that support the feature. The Photoshop or PSD format supports layers and so should be used as your primary method of storing your digital pictures. Formats like JPEG and GIF don't support layers.

Getting to know how layers work in your favorite program will help you create more exciting and dynamic images in less time.

Photoshop: *Very similar filters are available in both Photoshop and Photoshop Elements.*

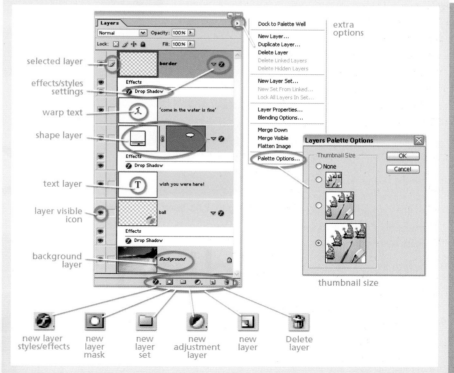

Figure 7.51 Most layer functions and features can be accessed via buttons and menus in the Layers palette. These features can also be activated from the Layers option in the menu bar.

Adding text to your pictures

Combining text and pictures used to be the job of a graphic designer or printer, but the simple text functions that are now included in image retouching programs mean that more and more people are trying their hand at adding type to pictures (see Figure 7.52).

Photoshop as well as Photoshop Elements provide the ability to input type directly onto the canvas rather than via a type dialog. This means that you can see and adjust your text to fit and suit the image beneath. As the text is stored on a separate layer to the rest of the picture, it can be moved and altered independent of the other image parts. Just like when you are using a word processing program, changes of size, shape and style can be made at any stage by selecting the text and applying the alterations.

Photoshop:
The text options in Photoshop and Elements are very similar.

Figure 7.52 Current image editing programs like Elements have a range of custom text features that not only allow you to add text to your pictures, but also control the way that the text looks.

Text in action

1 Select the Type tool from the toolbox. There are two different versions to choose from – one produces horizontal type and the other vertical. Click on the picture surface at the point where you want the type to start. At this point, you can also choose the type style, font, color and size in the options bar (see Figure 7.53).

2 Enter the text using the keyboard. To begin a new line, press the Enter key. Click the OK button (shaped like a tick) in the options bar to complete the process (see Figure 7.54).

3 To add to the text later, select the Type tool, click next to the existing characters and continue typing (see Figure 7.55).

4 To change the font, style, color or size of the type, select the text and input the altered values in the options bar. To add fancy 3D styles and textures to the type, make sure the type layer is selected and then choose one of the Layer Styles options (see Figure 7.56).

Figure 7.53 Select text Type tool.

Figure 7.54 Add text to canvas.

Figure 7.55 Reselect text to add more.

Figure 7.56 Add style to text.

Printing your digital files

I t is one thing to be able to take great pictures with your digital camera and quite another to then produce fantastic photographic prints. With film-based photography, many photographers passed on the responsibility of making a print to their local photo store. In contrast, with the advance of the digital age the center of much digital print production sits squarely on the desk in the form of a tabletop printer.

The quality of the output from these devices continues to improve, as does the archival life of the prints they produce, but the first choice for many shooters for printing is still the local photo-lab. Here, too, times are changing. Not only can they make prints from negatives, but also from digital camera cards and CD-ROMs.

The decision about whether you print your own, or have your pictures printed for you, is generally a personal one, based on ease and comfort as much as anything. A summary of the current state of play is given in Table 7.1.

If you opt to make your own prints, there are several different printer technologies that can turn your digital pictures into photographs. The most popular, at the moment, is the *inkjet* (or bubble jet) printer, followed by *dye sublimation* and *laser* machines.

Table 7.1 Summary of the features of different methods of printing

	'Do It Yourself' desktop printing	Photo-lab printing
Set-up cost	Initial purchase of printer US $100–400	Nil
Cost per print	Moderate	Small
Ease	You will need a little instruction to get started	Very easy to use
Quality	Good	Good
Archival life	Good for some models, average for others	Good
Ability to change results to suit your own taste or ideas	Almost unlimited options to make user changes to how the print looks	Limited options or none
Convenience	Print whenever you want	Limited to shop hours, unless lab has online options

The inkjet printer

Starting at a price of around US $50, the inkjet printer provides the cheapest way to enter the world of desktop printing. The ability of an inkjet printer to produce great photographs is based on the production of a combination of fineness of detail and seamless graduation of the color and tone. The machines contain a series of cartridges filled with liquid ink. The ink is forced through a set of tiny print nozzles using either heat or pressure. Different manufacturers have slightly different systems, but all are capable of producing very small droplets of ink (some are four times smaller than the diameter of a human hair!). The printer head moves back and forth

across the paper laying down color, whilst the roller mechanism gradually feeds the print through the machine. Newer models have multiple sets of nozzles that operate in both directions (bidirectional) to give faster print speeds (see Figure 7.57).

The most sophisticated printers from manufacturers like Canon, Epson and Hewlett Packard also have the ability to produce ink droplets that vary in size. This feature helps create the fine detail in photographic prints.

Most photographic quality printers have very high resolution, approaching 6000 dots per inch, which equates to pictures being created with very small ink droplets, and six, seven or even eight different ink colors, enabling these machines to produce the highest quality prints. These printers are often more expensive than standard models, but serious photographers will value the extra quality they are capable of (see Figure 7.58).

Printers optimized for business applications are often capable of producing prints faster than the photographic models. They usually only have three colors and black, and so do not produce photographic images with as much subtlety in tonal change as the special photo models.

One of the real advantages of inkjet printing technologies for digital photography is the choice of papers available for printing. Different surfaces (gloss, semi-gloss, matte, iron-on transfer, metallic, magnetic and even plastic), textures (smooth, watercolor and canvas), thickness (from 80 to 300 gsm) and sizes (A4, A3, 10 in × 8 in, 6 in × 4 in, panorama and even roll) can all be fed through the printer. This is not the case with laser, where the choice is limited in surface and thickness, or dye sublimation, where only the specialized paper supplied with the colored ribbons can be used (see Figure 7.59).

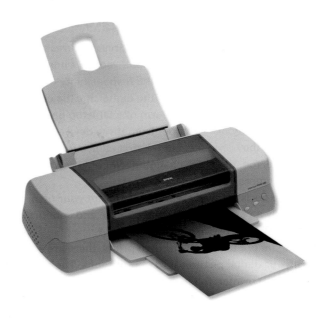

Figure 7.57 Standard inkjet printers use a four-color system containing cyan, magenta, yellow and black to produce color pictures.

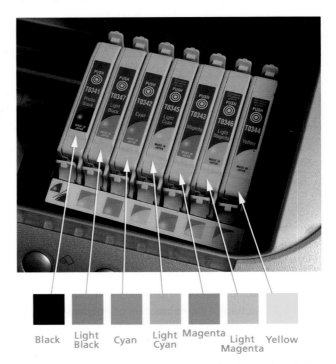

Black Light Black Cyan Light Cyan Magenta Light Magenta Yellow

Figure 7.58 Inkjet printers designed especially for photographic printing often contain five or more colors plus black, and some models can even print up to A3+ (bigger than A3).

Figure 7.59 One advantage of creating your photographs with an inkjet machine is the large range of paper stocks available to print on.

Before you start to print

Make sure that your printer is turned on and then with an image editing program open your photograph ready for printing. Select the Print option from the File menu (generally File > Print). This will open up a general print dialog which contains settings for print layout, printer selection and print size. With Windows-based machines choosing the Page Setup option will display another dialog with specific printer settings. The Printer button shows the machine's control panel, often called the printer driver dialog. It is here that you will need to check that the name of the printer is correctly listed in the Name box. If not, select the correct printer from the drop-down menu. Click on the properties button and choose the 'Main Tab'. Select the media type that matches your paper, the 'Color' option for photographic images and 'Automatic and Quality' settings in the mode section. These options automatically select the highest quality print settings for the paper type you are using. Click OK. Now with your printer set for the paper, quality and type of print you require, let's output the first image.

Note: Many of the specific dialogs and controls involved in printing from both Photoshop and Photoshop Elements are determined by the operating system (OSX or Windows) and the printer model and make you have installed so they may differ from those illustrated here. The key features and controls should be similar, they just might be presented differently.

Making your first digital print

With an image open in Photoshop or Photoshop Elements, open the Print preview dialog (File > Print). Check the thumbnail to ensure that the whole of the picture is located within the paper boundaries. To change the paper's size or orientation, select the Page Setup and Printer Properties options. Whilst here, check the printer output settings are still set to the type of paper being used. Work your way back to the Print Preview dialog by clicking the OK buttons (see Figure 7.60).

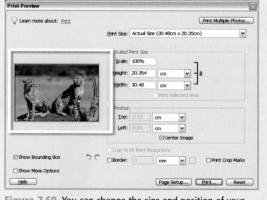

Figure 7.60 You can change the size and position of your image on its paper background via the Print preview dialog.

To alter the position or size of the picture on the page, deselect both Scale to Fit Media and Center Image options, and then select the Show Bounding Box feature. Change the image size by clicking and dragging the handles at the edge and corners of the image. Move the picture to a different position on the page by clicking on the picture surface and dragging the whole image to a different area (see Figure 7.61). To print, select the Print button and then the OK button.

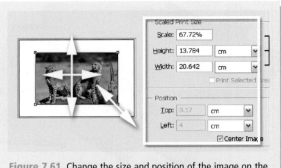

Figure 7.61 Change the size and position of the image on the page with the Print Preview dialog.

Printing in action

1 Select Print preview (File > Print or File > Print with Preview) and click the Page Setup button. Check the Printer Properties options are set to the paper type, page size and orientation, and print quality options that you require. Click OK to exit these dialogs and return to the Print Preview dialog (Figure 7.62).

2 At this stage you can choose to allow Photoshop or Elements to automatically center the image on the page (tick the Center Image box) and enlarge or reduce the picture so that it fits the page size selected (tick the Scale to Fit Media box) – see Figure 7.63.

3 Alternatively, you can adjust the position of the picture and its size manually by deselecting these options and ticking the 'Show Bounding Box' feature. To move the image, click inside the picture and drag to a new position. To change its size, click and drag one of the handles located at the corners of the bounding box. With all the settings complete, click Print to output your image (Figure 7.64).

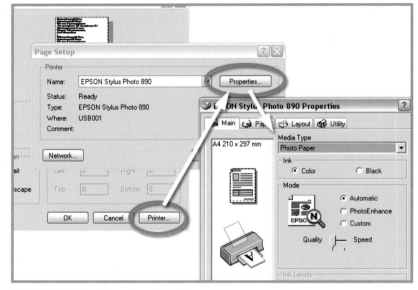

Figure 7.62 Display the print preview dialog.

Figure 7.63 Adjust image size and placement

Figure 7.64 Manually fine tune.

Producing a digital contact sheet

Digital photographers are not afraid to shoot as much as they like because they know that they will only have to pay for the production of the very best of the images they take. Navigating through all the images can be quite difficult and many shooters still prefer to edit their photographs as prints rather than on screen. The people at Adobe must have understood this situation when they developed the Contact Print feature for Photoshop and Elements. With one simple command, the imaging program creates a series of small thumbnail versions of all the images in a directory or folder. These small pictures are then arranged on pages and labelled with their file names. From there, it is an easy task to print a series of contact sheets that can be kept as a permanent record of the folder's images. The job of selecting the best pictures to manipulate and print can then be made with hard copies of your images without having to spend the time and money to output every image to be considered (see Figure 7.65).

The options contained within the Contact Sheet dialog allow the user to select the size and the number of thumbnails that will be placed on this page.

Figure 7.65 The Contact Sheet feature creates thumbnail versions of all the selected images (Photoshop Elements) or those located in a specific directory (Photoshop).

Contact sheets in action

1 In Elements select File > Print after multi-selecting the photos to include from the Organizer. Photoshop users should choose File > Automate > Contact Sheet and then use the Browse button to pick the folder or directory containing the images to be placed on the contact sheet (Figure 7.66).

2 In Photoshop – In the *Document* area, input the values for width, height, resolution and mode of the finished contact sheet. In the *Thumbnails* section, select the Place or sequence used to layout the images, as well as the number of columns and rows of thumbnails per page.
With Elements – Choose Contact Sheet as the Type of Print and choose the number of columns in the Layout settings (pictured). If you selected more images than can fit on one page, Elements or Photoshop will automatically make new pages to accommodate the other thumbnails (Figure 7.67).

3 In the final section you can elect to place a file name, printed as a caption, under each image. The size and font family used for the captions can also be chosen here. Click OK to make the contact sheet (Photoshop) or Print in Elements (Figure 7.68).

Figure 7.66 Choose the Print option.

Figure 7.67 Select the contact sheet entry.

Figure 7.68 Pick layout options.

Experimental and Constructed Images

Don't become too fixed in your ideas about what makes a technically good photograph. Successful pictures don't necessarily have to be blur-free, full of detail and an accurate record of what was in front of your camera. In fact, sometimes what at first seemed like an error can produce the sort of image that sums up an event or expresses a subject better than a completely controlled photograph that produces a predictable result. Happy accidents or the unexpected result mean that you can then explore this approach further, allowing you another chance to expand your picture-making skills. It's also great fun.

Few of the techniques in this part call for equipment beyond a camera offering a 'B' setting shutter (long exposure), or a couple of small attachments such as lens filters. On the other hand, they are all suggestions for experiments, so you must be prepared to waste film on a trial-and-error basis. Or if you are a digital shooter, expect to shoot many images in order to obtain a couple that are usable.

Don't let this idea worry you, as even professionals expect to shoot many frames for one good result. This is often called the 'shooting ratio'. Areas like wildlife photography and sports journalism typically have high numbers of wasted photographs for every one or two acceptable pictures. For your experiments take a range of versions of your subject, making notes of the settings used. This way you can match the results with the techniques used to produce them. You can then, if necessary, make further experimental shots based on your best results.

Remember too that even after the shooting and processing stages there is still plenty you can do to alter and reconstruct pictures. This can be done by joining prints, combining slides, and hand-coloring black and white prints. A wider range of manipulative possibilities opens up if you are working with digital photographs using some of the special effects features of one of the many image editing software packages on the market.

Letting the image move

The painter Paul Klee once said that 'a line is a dot that has gone for a walk'. In photography, as soon as you allow the image to move, while it is exposing every dot, the highlights of the picture are drawn onto the photograph as a line. This image movement might be the result of shifting your camera during a long exposure, in which case the subject remains static and fixed and the camera moves (see Figure 8.1). Alternatively, the camera might remain still and the subject move. Or thirdly, interesting pictures can result when both the camera and subject are on the move, as in Figure 8.2.

We are all used to experiencing blur as a symbol of movement, from close objects rushing past the car window, to the streaks drawn behind characters in comic strips. A photograph can exaggerate speed by showing the subject with lengthy blur trails, created by allowing considerable image movement during a long exposure time. Your subject can appear to have bumpy or smooth motion too, according to the shape of the lines – something you can control by jerking or gliding

Figure 8.1 Not on fire – the camera was just shifted part way through exposure.

the camera with its shutter open. In extreme instances (Figure 8.2, for example), the nature of the subject gets lost and what you create is an abstract pattern of color and light.

General technique

The best way to start experimenting is to shoot at night, picking scenes containing plenty of pinpoints of different colored light. Street lights, illuminated signs, decorative lamps on buildings or at the seaside, and moving traffic during the rush hour are all good raw material. Try to pick a clear night with an intensely black sky. You will need a camera allowing timed exposures up to several seconds and/or a 'B' setting. A tripod and a cable or remote shutter release are also essential. If your camera doesn't have the option for a cable release, try activating the self-timer option before the long exposure. This will give the camera time to stop moving before the shutter opens.

Figure 8.2 An abstract picture created from small lamps in a multi-colored sign. The camera was kept moving for 8 seconds.

Set a low ISO value (digital cameras) or load slow film and then select a small lens aperture. If your camera offers aperture priority, then choosing this mode should result in the slowest possible shutter setting without overexposing. If you have a manual camera, try exposures around 10 seconds at f16 for ISO 100 film or setting, or be guided by what was used for pictures on these pages.

Be careful, though, as some cameras do not measure exposure when set to 'B' – in which case, open the lens aperture fully until your camera indicates a timed exposure, then return the lens setting to f16 and double the time for each change of f-number as you go. For example, if opening the lens to f2 makes the meter respond with 1/8 second, then at f16 you should give 8 seconds held open on 'B'.

Static subject, camera moved

One simple way of creating 'drawn' light patterns is to move around the street at night with your camera with the shutter open. In Figure 8.2, eight small groups of different colored bulbs in a sign were focused small in the frame. Then, as soon as the shutter was locked open, the camera was panned upwards and downwards, swaying side to side to form the tangle of shapes.

Interesting results happen with a lit subject at night when you give part of a (long) exposure with the camera first still and then moving. The 'still' part of the exposure records the general shape of your subject, avoiding total abstraction, and the moving part shifts all the highlights. In Figure 8.1, for example, the camera was loosely attached to a tripod. It was held firm for the first half of a 3-second exposure at f22, and then panned left at 45° throughout the final 1.5 seconds.

Static camera, subject moved

With night subjects like fairgrounds or busy highways, long exposures with the camera kept absolutely still can record static parts of a scene clearly but elongate bright moving subjects into streaking light trails. The nearer a particular light (or the slower its movement) the wider its trail will appear. Figures 8.3 and 8.4 show how two 5-second exposure pictures shot a minute or so apart record different patterns traced out by a fairground ride. Dusk shots of city lights combined with the remainder of the daylight can combine both the movement and color, as shown in Figure 8.5.

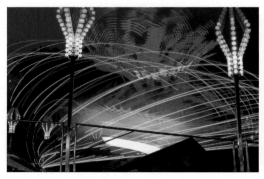 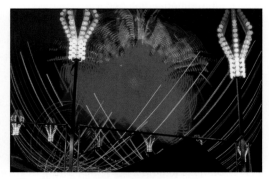

Figures 8.3 and 8.4 A fairground ride acts as a frantic drawing machine. Always try to include static elements too.

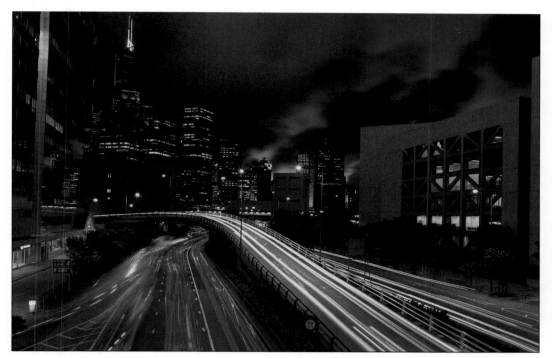

Figure 8.5 The long exposure needed to capture the falling light of dusk, combined with the movement of the traffic, creates streaking light trails against the city sky.

This 'drawing with light' can be developed further into 'writing with light' provided you have a steady hand. You will need to work outdoors at night or in a darkened room with a black background. Secure the camera to a tripod and mark out, on the ground, the left- and right-hand limits of your picture area. Your 'performance' must not exceed these extremes. Focus on something such as a newspaper, illuminated by a hand torch, held midway between the markers. Set the shutter for 'B' or an exposure of several seconds.

To produce the example in Figure 8.6, someone wearing dark clothes stood between the markers, facing the camera. Keeping on the move, they 'wrote' in the air with a lighted sparkler firework whilst the shutter remained open. A small, handbag-type torch makes a good light pen too, provided you keep it pointed towards the camera as you write. Torches with built-in color filters allow the lines to change color, or you can organize someone to use a series of filters over the camera lens.

Figure 8.6 Writing in the air with a sparkler in the dark. Image courtesy of Frank Thurston.

Exposure varies according to the strength of light and speed of drawing. Test at about f16 for a total writing time of 10 seconds (ISO 100 setting or film). Write at a consistent speed – slower lines thicken through overexposure, fast lines record thin. Words and numbers will appear the wrong way round to the camera, so you should have the negative printed, or slide projected, through the back of the film (unless you can write backwards).

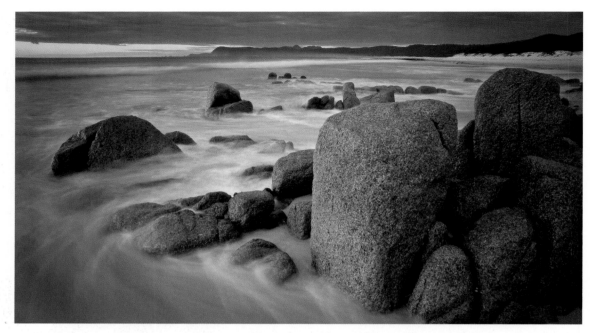

Figure 8.7 Long exposures in daylight are possible when a neutral density filter is attached to the lens. These dark filters reduce the amount of light entering the camera so that slow shutter speeds can be used during daylight conditions. Here a 2 second exposure was used with a ND8 filter and the aperture set at f22.0.

Polarizing filter ND 400 filter

Figure 8.8 The ND400 filter from Hoya cuts out and incredible 9 f-stops of light from entering the camera. This means that it is possible to use much longer shutter speeds even when shooting in daylight.

For more details about filters and other lens attachments go to page 242.

What about the circumstance where you want to capture blurred movement with a long shutter speed but there is so much light around that even using a very small aperture (large f-stop number) results in a shutter speed that is too fast? Well the first thing you can do is change the ISO sensitivity of the camera to its lowest setting (film users try using a low ISO film stock). By definition the lower sensitivity means longer exposure times.

If this still doesn't work then you will need to resort to an old landscape photographers' trick of adding a dark neutral density (ND) filter to your lens. These filters reduce the amount of light entering the camera without making a change to the color of the scene (hence the term 'neutral'). Filter manufacturers produce different versions depending on the amount of light you want to cut out.

For true blurred motion effects in daylight you will ned to use the darkest filter available (see Figure 8.7). Typically these filters can cut out as must as 8 full f-stops of light, so a tripod is essential, as is pre-focusing before attaching the filter to your lens. See Figure 8.8.

Figure 8.9 Technique for camera panning. Follow the subject with a smooth camera movement. Fire the shutter halfway through.

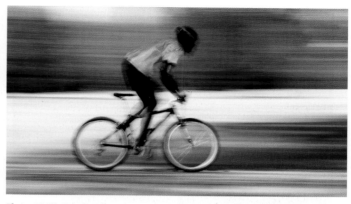

Figure 8.10 Panning the camera whilst photographing this cyclist produces a very characteristic photograph that is full of blurry movement but still retains enough detail that we can recognize the subject matter.

Moving camera and moving subject

If you pan the camera whilst photographing a fast-moving subject, you can capture the subject as sharp against a blurred background. This technique is often used by motor sports photographers to isolate cars or bikes against distracting backgrounds. Panning is best attempted at a shutter speed of about 1/30 second, and is therefore within the capabilities of even quite simple cameras. As Figure 8.9 shows, the technique is that you hand-hold the camera, pivoting your body so that its movement is in a smooth sweep, then release the shutter halfway through the pan. If your camera has automatic exposure options, set these to shutter priority mode so that you can control the shutter speed (see Figure 8.10).

Static subject, static camera

Zooming is a way of making the image move and blur during exposure, while both your subject and the camera itself are completely stationary. You need a camera with a zoom lens, low ISO setting (or slow film) and a subject sufficiently dimly lit to need an exposure time of at least 3 seconds. Then, from beginning to end of the exposure time, you smoothly zoom the lens through its full focal length range. Figure 8.11 depicts a scene looking down on the lights of New York from the Empire State Building. The picture was shot in this way using the zoom-in technique.

Whether you zoom from wide to long or the reverse makes little difference, but check out both ends of the range

Figure 8.11 City at night. The camera's lens was steadily zoomed during a 3-second exposure. The 'Christmas tree' shape resulted from a group of buildings more brightly lit than the rest, and imaged center frame.

Figure 8.12 Star tracks recorded at night during a 90-minute exposure.

before shooting. Digital shooters can practice smooth lens handling and can preview the amount of blur in each photograph, adjusting settings and zoom speed for different effects. For all zoom-motion work, a firm tripod is essential. Since all blur lines radiate from the precise center of the frame, it is this 'bull's-eye' part of the scene that should contain a point of focus.

Star tracks

Stars in the night sky look quite static, but only because they move too slowly for us to notice. The sky in Figure 8.12 was exposed for 90 minutes at f16 on a setting of ISO 125. The camera was left on its tripod, pointing generally towards the pole star (around which all other stars appear to rotate). Pick a clear moonless night, and shoot somewhere well clear of light-polluting roads and towns. Open country or a coastal area is ideal. Be sure to include some landmark, such as the tree shown here, to counterpoint the star tracks. If you are using a digital camera make sure that you are careful not to place a light source in the frame, as the extended exposure can cause permanent damage to the image sensor.

Exploring reflections

Some unusual and experimental pictures are possible without special know-how or any out-of-the-ordinary gear. They involve straightforward photography of what you can see in front of the camera, but by careful choice of viewpoint and framing you can create a picture with strange optical appearances. Results include distorted shapes, images with detail broken up in unfamiliar ways and combinations of two or more separate picture elements that form dream-like effects. All of these types of picture are based on photographing something either reflected or refracted. Everyday reflective surfaces include still water, glass windows and mirrors. Refraction alters the way things look when your subject is observed through things like patterned glass or clear or disturbed liquid.

Using water

Pictures like Figure 8.13 are best shot looking down into the clear water of a swimming pool, preferably outdoors, where light is plentiful. Using the long focus extreme of a zoom lens helps to fill up the frame. The appearance of this underwater swimmer changes every second due to the swirl of water altering refraction effects and the swimmer's movements, so it is best to work at 1/250 second or faster (using shutter priority mode on an AE camera) and pick the right moment carefully. Auto-focus is helpful here, provided it does not accidentally pick up on the pool's floor pattern some distance below the subject.

Figure 8.13 Distorted appearance due to reflection of light from the water surface.

Still water creates an almost mirror surface. By including only the far bank and sky reflected in a river and presenting this upside down (Figure 8.14), an impressionistic landscape image is formed. Remember that the reflection itself requires a lens focus setting different from the much nearer reflective surface. In a shot like this, focusing on the tree's reflection and then setting a small lens aperture would have brought detail on the surface of the water into focus too. Specks of floating flotsam would break the dreamy illusion. This picture was therefore exposed at f2.8, taking great care to (manually) focus so that only tree and clouds were included within the depth of field.

Using glass

Large glass-fronted buildings, including shops, are good locations for mixing one element (behind the glass) with another (reflected from its surface). Lighting is important here. People passing in the street may be sunlit and so dominate over figures inside the building. But later in the day, the balance reverses as internal lighting comes on behind the glass.

Often, reflected images like this include things happening on three different planes.

Figure 8.14 Reflection of the far bank in the smooth surface of a river. The result was turned upside down to make this picture.

Figure 8.15 Intentionally capturing the reflections from a glass or shiny surface gives you the ability to combine both the two different scenes together. Here a slogan painted onto a shop window is combined with the reflection of the New York city street.

People might be sitting directly behind the window inside the building; others may be a reflection off the glass surface of action outside; and finally there may be those subjects directly included in the viewfinder (not reflected at all). Working with effectively three images like this allows you to make use of interesting mixtures of scale, and can fill up a frame of what would be sparsely occupied scenes if shot individually.

Figure 8.15 mixes an advertising slogan in a New York city window with the reflection of people and traffic in a typical street. The lonely scene seems to give life to the consequences of living your life as the slogan suggests.

Similar possibilities apply to mirrors hung on walls or buildings clad with mirror-finished surfaces – these all allow you to relate two or more quite separate elements together in the same picture. Remember to set a small aperture (large DOF) if reality and reflections are all to appear sharp. You will probably have to set focus (manually) for somewhere between the two and, to prevent you and your camera appearing in the picture, shoot at a slight angle to the reflective surface. Where a square-on view is essential, use a long focal length lens. This will mean that you can shoot from well back from the surface and so appear as a small reflection in the final scene.

Using lens attachments

Another way of experimenting with the appearance of subjects is to fit a special effects attachment or filter over the front of your camera lens. This has the advantage that you can create strange results – repeat patterning, abstractions, offbeat coloring – from almost any scene, rather than work with long exposures or reflective surfaces. Some attachments optically soften or diffuse detail or split up the image whilst others, such as colored filters, tint all, or part, of your picture.

Typically, a lens attachment is a circular or square piece of optical plastic sufficiently large enough to cover the lens. Circular types may screw into a thread on the lens rim or, for cameras without this option, they fit via a clip-on holder. Failing this, you can also just hold the filter over the lens. For most types, it is important to be able to rotate the attachment freely because this is the way you alter how it interacts with the image. This means that you can alter the effect for each particular shot. Using an SLR camera will allow you to forecast exactly the effect produced. Digital users can shoot and then review the picture. When using a compact camera, first look directly at the subject through the attachment by eye, turning it to find the best effect, and then transfer it without further rotation to the camera's lens.

Special effects attachments

Some optical attachments are made of clear plastic with faceted surfaces to give a multiple image of your subject. This way, you can repeat whatever is composed in the center of the frame into three or more separated but overlapping images, like Figure 8.16. Some filters work by having a parallel fluted pattern, which turns one narrow strip of the image into a row of repeats. Strips may run vertically (Figure 8.17) or at any angle you choose to rotate the attachment. When you are making multiple image shots, pick a subject with a strong, simple shape and plenty of plain background.

Figure 8.16 A single lamp-post against white sky, turned into overlapping shapes by a three-faceted prism lens attachment.

Figure 8.17 A reeded glass attachment, fluting set vertically here, repeats a single portrait profile.

Figure 8.18 Many of the 'front of camera' filters previously used to create visual effects in photographs have been replaced by digital versions, which are applied to the images back at the desktop. Here a Glass filter is added to a picture, producing a similar effect as if the original picture was photographed through a piece of rippled glass.

Another attachment, known as a starburst and made of etched or moulded clear plastic (Figure 8.19), spreads bright highlights in a scene into star-like patches with radiating 'spokes'. Much used in the 1970s and 1980s, the starburst filter was seen as a good way to glamorize shots that contained brilliant but well-separated pinpoint highlights – for example, direct sunlight sparkling on water, disco spotlights and tight groups of lamps in dark interiors or at night.

As you rotate the attachment spokes rotate, so you can position them at the most interesting angle. Results from a softly lit scene, however, are disappointing, as the starburst just gives flat, slightly diffused results.

Almost all optical-effect attachments alter the image according to lens focal length and the aperture you set. An SLR camera with aperture preview button is the best way to make an exact check of image appearance at the f-number you will be using. There are dozens of different effects attachments made. They include types which just give soft focus around the edges of the picture. Others are bifocals containing a portion of close-up lens you can rotate to coincide with some small close object so it appears sharp when the camera's main lens is focused on a more distant part

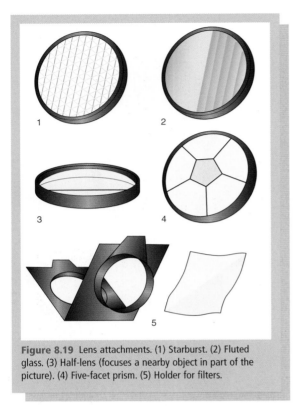

Figure 8.19 Lens attachments. (1) Starburst. (2) Fluted glass. (3) Half-lens (focuses a nearby object in part of the picture). (4) Five-facet prism. (5) Holder for filters.

of the background scene. This way, a foreground flower may record with as much detail as a landscape filling the other half of a shot.

Though all of these special effects filters are still readily available, much of their popularity has waned with the advances of digital photography. Many of the effects that were once only available as attachments for the camera lens can now be reproduced digitally via any good image editing package. Software packages like Adobe Photoshop and Photoshop Elements contain many of these styles of effects filters for you to experiment with (see Figure 8.20).

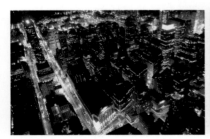
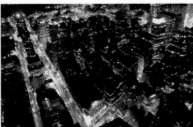
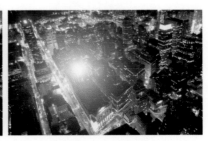

Original After Glass filter After Lens Flare filter

Figure 8.20 Hundreds of different digital filters can be found supplied as part of your favorite image editing package, such as Photoshop or Photoshop Elements. Some of these replicate existing traditional filter effects and others provide changes that have only become available with the advent of digital photography.

Filters

'Filters' are so called because they remove some of the light that would enter the lens:

- **Neutral density** – A simple gray 'neutral density' (ND) filter just dims the whole image, useful for avoiding overexposure when you have fast film loaded but want to use a slow shutter speed or set a wide lens aperture.

- **Polarizing filter** – A polarizing filter offers this same advantage but, like Polaroid sunglasses, also subdues reflections at some angles from surfaces such as glass or water. The filter is also used to darken areas of blue sky at right angles to the direction of sunlight.

- **Light-colored and gradient filters** – A pale-colored filter will 'warm up' or 'cool down' the general mood of a scene. Both these and ND filters are available as 'graduates' – meaning their color or tone fades off in the lower half of the filter to tint or darken just sky and clouds in a landscape.

- **Filters for black and white** – Stronger, overall color filters have a special role in black and white photography, allowing you to alter how a particular subject color translates into a darker or paler gray tone. The rule here is that a filter lightens the appearance of colors closest to itself and darkens opposite or 'complementary' colors. An orange or red filter, for example, darkens blue sky, so that white clouds in a landscape record more clearly (see Figure 8.21).

Figure 8.21 Darkening blue sky. (Left) No filter. (Right) Orange filter.

- **Color-correcting filters** – In color photography, especially when using film, you may want to use a strong overall color filter to compensate for a fluorescent or other artificial light source when using daylight balanced film – instead of hoping the lab can do corrections in printing. Some special effects color filters, 'tobacco' hue for example, are made as graduates to tint as well as darken the sky area alone. They produce results suggesting dusk or dawn.

- **Multi-color filters** – 'Dual color' filters are split into contrasting halves. Often, good results depend on you composing a picture with the horizon in a straight line, located about halfway across the frame. The smaller your lens aperture, the more abrupt the division between the two colors appears.

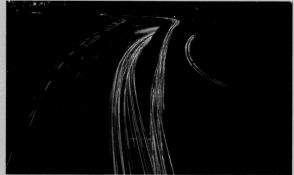

Figure 8.22 Traffic at night. Changing colors were created by a series of strongly tinted filters passed across the lens.

Most filters call for an increase in exposure. This is automatically taken into account, though, if you are using a camera that reads the light through the lens and therefore the filter as well. If this isn't the case, you should override the suggested exposure by the maker's rating on the filter.

There are no set ways of using most lens attachments, so experimenting is always worthwhile. For example, deep color filters intended for black and white work can produce strong effects in color photography. Try jazzing up the light trails from a moving camera or

moving traffic at night by holding a filter over the lens during part of a long exposure. For Figure 8.22, red, green and blue squares of filter were taped edge to edge to form one long continuous strip. Then, throughout a 30-second exposure of distant highway traffic, the strip was kept moving its full length several times across the lens.

The LensBaby attachment

The style of low tech images created with toy plastic cameras has become very fashionable in recent years. As all of these cameras are film based, does this mean that digital shooters are unable to recreate the dreamy and somewhat mysterious photos that are captured by these cameras? The answer is a definite no! The LensBaby system, like the toy cameras whose effects it simulates, is simple. The lens is attached to the camera via a flexible accordion type mount. See Figure 8.23. General focus, as well as positioning of the lens' sweet spot (area of sharpest focus), is controlled by pushing, pulling and squeezing the mount. This finger tip control is a little difficult to get the hang of at first, but once you have played for a while this method of focusing becomes a lot easier. Some camera models have a focus assist feature built-in to the viewfinder and these can be used to help ensure that important picture parts are sharp. The latest model is supplied with movement locks and and a fine tune focusing system which makes predictable focusing much easier.

No electronic connections are made between camera and lens so exposure control is strictly a manual affair. Aperture selection is made by placing one of a series of four iris discs in the front of the lens. The discs are held in place magnetically and a special tool is supplied to make the changing process easier.

My general approach with each subject is to find focus first, and then start to push and pull the lens sideways or up or down, to position the sweet spot in the frame.

Slight changes in the position of the lens can produce dramatically different results and I found myself shooting multiple images of the same subject, using various settings, until I found the look I wanted. Thank goodness I'm not paying for film any more!

Figure 8.23 The LensBaby is an attachment where focusing is controlled by pushing and pulling the mount. The look of pictures vary greatly, according to how the lens was positioned at capture time.

The guide to controlling LensBaby effects

Front focus The simplest way to focus an object close to the camera is to not touch the lens and move the camera back and forth until the subject is sharp.

Back focus To focus on subjects further away from the camera, pull the lens towards the camera until the subject appears sharp in the viewfinder.

Left focus Focusing on a subject in the left of the scene requires you to twist the lens to the left.

Right focus Moving the focus to the right needs the opposite action, pulling the front right of the lens towards the camera.

Top focus To push the focus to the top of the frame bend the lens upwards.

Bottom focus Bending the lens downwards moves the focus to the bottom of the frame.

Combining pictures

Photography allows you to combine records of separate scenes or subjects taken at quite different moments in time, place and scale into one picture. This fact gives you the freedom to construct images that never existed in reality. Results can be bold and eye-catching, like a poster, or haunting and strange, often making a statement in a visually more convincing way than something that is drawn or painted. Constructed images may differ radically from normal vision – or at first glance look normal but contain an odd and disturbing feature, like Figure 8.30.

As far as equipment is concerned, you will need a tripod and a cable release. Some techniques call for access to a slide projector and a filter; for others, you will need to use a camera that has a 'B' setting.

One way of combining images is by projecting a slide onto a subject, which is then photographed. Another is to sandwich two slides together, or make two exposures on the same frame of film. Other methods include the basic cutting and sticking together of photographic prints, or the popular (and some say easiest) method of using a computer and image editing software to cut and paste picture elements together.

Combining by projection

Using a projector, you can make a slide (or negative) image appear on the surface of any suitable light-toned object; the scene can then be photographed, with the result being recorded exactly as it appears to the eye. Work in a blacked-out room and if you are using daylight film add a bluish 80A filter on the camera to correct for the orangey light from the projector. In Figure 8.24, a slide of brickwork is projected onto a hand. By using a distant, black background, no brickwork appears elsewhere (see Figure 8.25). Your image-receiving surface could be flat or curved – one or more eggs perhaps, paper cups, wooden blocks or any object painted matt white especially for the purpose. Be careful not to make the result too complicated, though – if the image you project has a strong pattern then pick a receiving object that is simple in shape.

Strips of black card held about halfway between projector and receiving surface will restrict the image to where you want it to appear. Other lighting is needed to just suggest surroundings and the forms of your still-life objects, provided you keep the light off the projected image. Keep in mind that the fill light can't be too strong, otherwise it will obscure the projected image.

Figure 8.24 Color slide projected onto an actual hand.

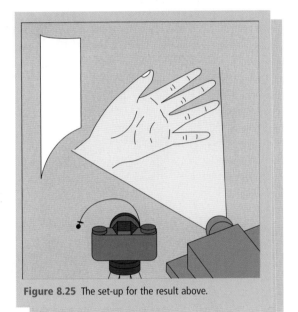

Figure 8.25 The set-up for the result above.

Combining by sandwiching

'Sandwiching' simply means placing two slide film images together in face-to-face contact within the same (glass) mount. Details of one appear in the lighter parts of the other. You can then project your result, or send it for a print or scan the picture ready for use on the computer.

Be careful that the relative size of each image, as well as its positioning in the frame, suits the other slide. You don't have the same flexibility to adjust size here as you do when projecting a slide onto an object. Another point to watch is that each slide should be slightly pale – overexposed by about one stop – otherwise your sandwich will be too dark. It is worth keeping a selection of reject slides for this possible purpose.

Quite often, one existing slide suggests another that needs taking to complete an idea. In this way, you can also ensure that size, lighting and subject placing are tailored convincingly. The sandwiched picture (Figure 8.27), for example, started as an experimental night shot of a distant town, the camera being tilted downward and wiggled for the second half of a 4-second exposure. The result seemed to suggest chaos and stress. Then another slide was planned and shot of a man with his hands to his head and silhouetted in front of white sky (Figure 8.26). This silhouette was slightly overexposed, so that when sandwiched it was not impenetrably black and some of the light trails could be seen 'penetrating' his head.

The seaside is an ideal location for shooting several picture components because of the large plain background offered by ocean and sky. Figure 8.28 is a sandwich combining two 'throwaway' slides. One is a shot of the seashore with a blank, overcast sky. The other contains only blue sky and clouds, but sandwiching this film upside down creates a slightly unsettling, surreal effect.

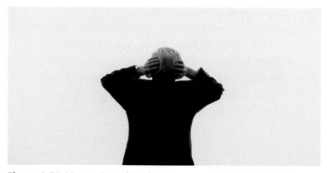

Figure 8.26 Man against white sky – a component of the picture below.

Figure 8.27 'Chaos and stress'. Sandwich of the slide above and camera-moved street lights.

Figure 8.28 Surrealism at the seaside – via sandwiched slides. Notice the clouds are upside down.

Bear in mind that results similar to the combining of two pictures by sandwiching are now possible by digital means, using cloning or 'layering' software. Sizing and subject orientation problems are less of an issue when digital is used for composition, as this technology allows for the separate resizing and positioning of each image part.

Multiple exposures

Another way of mixing images together, involving only your camera, is to make several exposures onto one frame of film. When sandwiching slides, the details of one picture appear most strongly in the light parts of the other, but multiple exposures work the opposite way, one picture showing up most in the dark areas of the other (see Figure 8.29). Keep this idea in mind when you plan out your picture.

Making two or more exposures is easiest if your camera has a multiple exposure button. This disengages the wind-on mechanism so that the film stays still and only the shutter resets after each exposure. Multiple exposure controls are provided on a number of compact and SLR cameras. On the other hand, any camera with a 'B' shutter setting can be used for this work provided it accepts a cable release, preferably with a locking screw. You will need to work with slow film, probably indoors, in order to make a time exposure necessary. A tripod is essential. Both Figures 8.29 and 8.30 were taken with a SLR camera set to manual, with the shutter set at 'B'.

For the picture in Figure 8.29 the girl sat in the chair for half the exposure, then got up (taking care not to shift the chair itself) so that the second half recorded it empty. Working indoors with dim light from a window and at smallest aperture, f16, the exposure required was 4 seconds. So, with the girl in place and keeping very still, the shutter was held open on 'B' for 2 seconds. Then, keeping the cable release pressed and locked, the lens was covered with a black card while the girl left. Next, it was uncovered again for a further 2 seconds before the shutter was finally closed.

Figure 8.29 Double exposure – is she there or not?

Figure 8.30 Man looking both ways, achieved by lighting change and double exposure.

Figure 8.31 The wild wood. Three exposures on one frame of film. Image courtesy of Amanda Currey.

It is important to plan pictures like this in terms of where 'lights' and 'darks' will overlap. In Figure 8.29, the girl wore a plain dark dress and the chair was chosen for its lighter tones and patterned design, which would therefore 'expose through' her clothing. The cardigan, face and hands had the opposite effect – dominating over the shadowy part of the room behind.

The man looking two ways at once (Figure 8.30) is also the result of two superimposed exposures. If you cover up vertically half of the picture at a time you will see that, between exposures, he has simply moved his eyes. For the first exposure only, the left half of his face was illuminated (while he looked that way), then that light was switched out and another, illuminating the right half, was switched on instead.

For this technique you need a darkened room, or work outdoors at night. Have two lamps you can control from the camera, set up well to the left and right, or use a flashgun you fire manually on its 'open flash' button, holding it first at arm's length to the left and then to the right. Only half of the face must be seen at a time, leaving the other totally shadowed. Give the full measured exposure to each half of your picture, since quite different parts of the head are illuminated at a time.

In Figure 8.31, the exposure needed was 1/60 second at f11. To achieve this effect, the shutter was fired three times at this setting onto the same frame of film, rotating the camera a few degrees about a horizontal axis between each one.

Combining images digitally

Using a computer of sufficient power, your photographic images can be combined and manipulated on screen. In only a few minutes it is possible to digitally combine two separate images to create a new constructed photograph. In Figure 8.32, the artichoke has been cut and pasted onto the shaven head and then blended into the skin of the skull. To add extra realism, the toning on the artichoke was altered to fit with the lighting of the head and shoulders photograph.

The digital montage process is handled by an image editing program such as Photoshop or Photoshop Elements. With this software two or more images can be slid as 'layers', one on top of the other, to superimpose wholly, or in part, with great precision (see Figure 8.33). Tools like the 'eraser' can then be used to remove sections of the upper image to reveal the detail from beneath. Using the selection tools, you can combine the main subject in one shot with the background of another. Any chosen elements in a picture can be multi-cloned, changed in size or color, reversed in tones or switched left to right, then returned to the shot. In fact, it's tempting to overdo these and many other image-distorting controls just for their novelty value.

As we have already seen in Part 7 these types of image editing programs also have great usefulness for improving and 'fine-tuning' photographic results in more subtle

Figure 8.32 Many of the traditional techniques used to combine different images have been superseded by digital photography techniques. Here an artichoke is combined digitally with a portrait to create a new photograph. Such a task would take an experienced photographer about half an hour to complete. Producing the same image traditionally (non-digitally) would take considerably longer.

ways. Retouching out any spots, disguising joins or removing obtrusive items from backgrounds is made easy by enlarging the image on screen and working on it pixel by pixel. Done well, changes are almost imperceptible and the results are easily accepted as straight and natural pictures.

Figure 8.33 Montaging separate images digitally is made easier because a single photographic document can contain multiple layers, each with different content. In the example, the artichoke, head and white background are all stored on separate layers, but are seen as one complete picture in the final photograph.

Creative digital

Working digitally has not only changed the way that we capture, process and edit our photos, but it has also opened up a whole new world of creative possibilities for the photographer as well. Manipulation tasks that a few years ago would have been impossible for the average user are now well within the grasp of image makers with a computer and a good imaging program. The following techniques will provide you with a idea of what is possible when working creatively with digital files.

Convert to black and white

When film was king, photographers had to make a conscious decision to capture in color or in black and white as deciding one way or the other determined the film stock that was loaded in the camera. Once the decision was made there was generally no turning back. In the digital era things are a little more flexible. Some cameras do contain a black and white mode but I would always recommend capturing in color and then converting back at the desktop where you have more control over the process. Though at first glance changing a color picture to grayscale may seem a simple one-step task, many conversions lack the contrast and drama of the color original. Here we look at several different methods for the task, providing you more creative choice when converting to gray.

Figure 8.34 The trick to good conversions from color to grayscale is ensuring that the hues in the original picture are translated into distinct tones. For this reason no one conversion process will be suitable for all pictures. Whichever technique you use, make sure that the color contrast present in the original (top) is translated into monochrome contrast in the result (bottom).

Change to Grayscale mode

A change of color mode is the simplest way to get rid of the color components of your picture. Be aware though that this technique changes the basic structure of the photo from three channels (red, green and blue) to a single channel (grayscale).

In Photoshop:
Use the Image > Mode command.

Step 1: Change color mode
Select the Grayscale option from the Mode section of the Image menu.

Step 2: Confirm changes
Click OK to the 'Discard color information?' question.

Desaturate the picture

If your aim is to add some color back to the black and white picture after the grayscale conversion, then you will need to use a technique that retains the basic red, green, blue structure. Both Photoshop and Photoshop Elements contain single-step features to handle this process.

Desaturate the photo
Select Enhance > Adjust Color > Remove Color.

In Photoshop:
Use the Image > Adjustments > Desaturate command.

Russell Brown's multi-layer technique

For those readers who want a little more control over the way that specific colors are converted to gray then this technique by Adobe's Russell Brown provides more flexibility than the options we have looked at so far. Russell cleverly uses two Adjustment layers to make the changes, which means that the technique is also 'non-destructive' as it never changes the original pixels in the backgound layer.

Step 1: Make first Hue/Saturation Adjustment layer
Make a new Hue/Saturation layer above your background. Don't make any changes to the default settings for this layer. Set the mode of the Adjustment layer to Color. Label this layer 'Filter'.

In Photoshop:
Use the same steps detailed here to create the multi-layer conversion using Hue/Saturation Adjustment layers.

Step 2: Create a second layer

Make a second Hue/Saturation Adjustment layer above the Filter layer and alter the settings so Saturation is -100. Call this layer 'Black and White Film'. The monochrome image now on screen is the standard result we would expect if we just desaturated the colored original.

Step 3: Adjust the conversion

Next double-click on the layer thumbnail in the Filter layer and move the Hue slider. This changes the way that the color values are translated to black and white. Similarly if you move the Saturation slider you can emphasize particular parts of the image.

Step 4: Fine-tune the colors

For more precise control of the separation of tones you can restrict your changes to a single color group (red, blue, green, cyan, magenta), by selecting it from the drop-down menu before manipulating the Hue and Saturation controls.

Custom grayscale conversions in Photoshop Elements and Photoshop

From version 5.0 Photoshop Elements has contained a custom Convert to Black and White feature (left) that lets you select from a range of conversion styles and then customize the grayscale mapping by adjusting how each color is converted. Photoshop users can get similar results using the Channel Mixer feature (right) with the Monochrome option selected. Just make sure that the total of each of the channel settings equals 100%. This will ensure that the brightness of the photo remains consistent through the conversion.

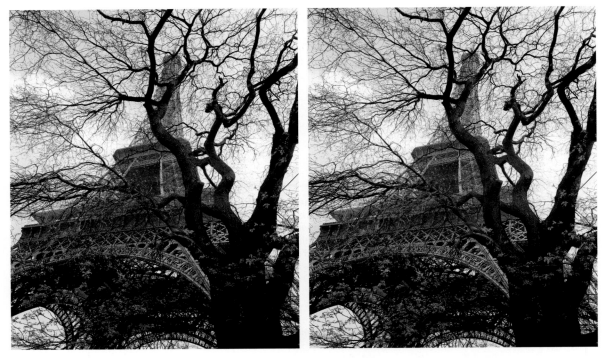

Figure 8.35 Many darkroom photographers wanting to make their images stand out from the crowd employed toning processes to alter the color of their black and white prints. As with many darkroom processes the look and feel of toned prints can be simulated digitally. Original black and white photo (left) and the same picture after digital sepia toning (right).

Toning photos

Normally associated with old or historic images, sepia or brown-toned photos have a unique appearance. Traditionally these pictures are created by taking the finished black and white print and passing it through one (or more) extra chemical processing steps. The result is an image where the gray tones are replaced by other colors such as the brown typically seen in sepia-toned photos.

As the black and white prints that exit our desktop printers are not based on silver it is not possible to alter their appearance using these chemical processes. Instead digital toning occurs before printing as a part of the enhancement process. Using the color control features that can be found in most image editing packages, digital photographers can easily replicate the results of these old processes. In addition, it is also possible to create sophisticated split-toning with more control than was ever possible in the darkroom. Here I explain several different approaches to toning your digital photos.

Simple single color changes

The simplest and fastest way to add color is to use the Hue/Saturation control (Enhance > Adjust > Color > Hue/Saturation). This can be applied directly to the whole image or as an Adjustment layer (Layer > New Adjustment Layer > Hue Saturation). To change the feature into a toning tool click the Colorize option in the bottom right of the box. The picture will switch to a single color

monochrome (one color plus white and black). The Hue slider now controls the color of your tone.

The sepia look in the example is a value of 30 on the Hue slider (see Figure 8.35). The Saturation slider varies the strength of the color. The Saturation value used in the example was 25. The Lightness slider adjusts the brightness of the image but changes of this nature should be left for the Levels feature.

The predictability of this digital toning system means that you can achieve the same tint in each image for a whole series of pictures. The recipes for regularly used tones, or favorite colors, can easily be noted down for later use or if toning using an Adjustment layer then the layer can be dragged from one image to another.

Step 1: Use Hue/Saturation
Select the Hue/Saturation control from the Enhance menu. For grayscale images change the mode to RGB color first (Image > Mode > RGB Color).

Step 2: Select Colorize
Place a tick in the Colorize and Preview checkboxes.

Step 3: Fine-tune the tint
Adjust the Hue slider to change tint color and the Saturation slider to change tint strength. You can also use a Hue/Saturation Adjustment layer for a non-destructive toning process.

In Photoshop:
As Photoshop contains the Hue/Saturation feature you can use the same steps detailed here to create a simple toned print effect.

Two or more colors creating a split-tone effect

Once you have mastered the art of digitally toning your pictures it is time to spread your 'tinting' wings a little. One of my favorite after-printing effects back in my darkroom days was split toning. This process involved passing a completed black and white print through two differently colored and separate toning baths. This resulted in the print containing a mixture of two different tints.

For example, when an image is split toned with sepia first and then blue toner the resultant picture has warm (brown) highlights and midtones, and cool (blue) shadows. Getting the right toning balance between the two solutions was difficult and then trying to repeat the process

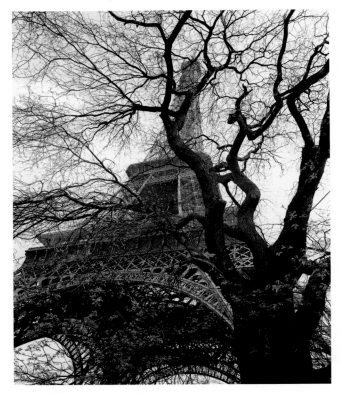

Figure 8.36 Split toning is when a different color or tint is added to high-lights and shadows of the print. Here the highlight areas have been toned reddy-brown and the shadow parts of the picture, blue.

uniformly over a series of images was even harder. Thankfully I can replicate the results of split toning in my digital picture with a lot less trouble and a lot more predictability.

Again the digital version of the process revolves around a tool that is common to both Photoshop Elements and Photoshop. Called the Color Variations feature (Variations in Photoshop), it is most commonly used for removing color casts from photos taken under mixed light sources. Color Variations is very helpful with these color correction tasks as the feature has the ability to isolate its color changes to specific tonal areas – highlights, midtone and shadows – and it is precisely this ability that we can use to create a split toning effect.

Using the feature the color or tint of highlights, midtones and shadows of grayscale photos (that have been stored in the RGB Color mode) can be individually adjusted. Replicating the sepia/blue split tone I produced in the darkroom is a simple matter of selecting the highlight tones and adding brown tint, and then selecting the shadow areas and altering these to blue. See Figure 8.36.

Step 1: Tint the highlights
Start by ensuring that the monochrome photo is in RGB Color mode. If not, change the mode using the options under the Image > Mode menu. Next select the Color Variations feature from the Enhance > Adjust Color menu. Select the Highlights setting and then click on the Increase Red and Decrease Blue thumbnail.

Step 2: Color the shadows
Now to the shadows. Without closing the Color Variations dialog, select the Shadows setting and click on the Increase Blue thumbnail. Alter the Amount slider to increase or decrease the degree of change made with each thumbnail click.

In Photoshop:
As well as using Image > Adjustments > Variations, Photoshop users can also apply the Color Balance Adjustment layer feature to split tone their photos non-destructively.

Selective toning

As well as controlling which group of tones is tinted it is also possible to restrict the effect to just a selected area of the photograph. Using the selection tools in Photoshop or Elements you can outline a portion of the photo and then apply the toning to just this area. If the color change is added to the picture using a Hue/Saturation Adjustment layer then a special mask (the size and shape of your selection) is added to this layer to restrict the effect of the layer. See Figure 8.37.

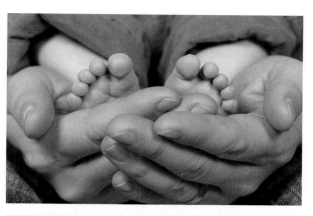

In Photoshop:
The main selection tools are the same in Photoshop as they are in Photoshop Elements. The Hue/Saturation feature is also contained in both packages.

Figure 8.37 To restrict the toning action to a specific area of the photo start by selecting a picture portion with one of the selection tools (Lasso, Marquee, Magic Wand, etc.) and then use the Hue/Saturation control to apply the tinting. Before selective tinting (top) and after (bottom).

Step 1: Select area to be toned
Start by using one of the selection tools (Lasso, Magic Wand, Marquee, Quick Selection, Selection Brush – Elements only) to isolate the picture part to be toned.

Step 2: Feather the selection
Next, feather the selection (Select > Feather) with a 1 pixel setting to soften the edge of the selection and make the border between toned and untoned areas less sharp.

Step 3: Apply the tinting
With the selection still active, choose the Hue/Saturation command from the Enhance > Adjust Color menu. Select the Colorize setting and adjust the Hue and Saturation sliders.

Hand coloring – the digital way

Before the days of color photography, studio photographers employed artists to paint washes of color onto their black and white prints to simulate the hues of the photographed scene. The previous few techniques looked at how to tint black and white photographs but, in this technique, we will reproduce the effect of hand coloring by using the Brush tool to apply a color tint to a photograph.

This sounds simple except that if you just select a color and then paint onto the picture the color will obscure the picture details beneath. Adjusting the opacity of the paint doesn't solve the problem so, instead, to ensure that the detail from the image shows through the coloring we must modify the way the hue is added. By switching the Brush mode (this is similar to the Layers blend mode options) from its Normal setting to a specialized Color setting the paint starts to act more like traditional watercolor paint. When the hue is applied the detail is changed in proportion to the tone beneath. Dark areas are changed to a deep version of the selected color and lighter areas are delicately tinted. See Figure 8.38.

To start it will be easier to apply the color directly to the image layer, but as you become more confident with the technique and want a little more control, try creating a new layer for each color in the document. Change the Blend Mode of the layer to Color and switch the Brush mode back to Normal. Now select a layer and choose a paint color and start to color the photo.

Figure 8.38 With digital hand coloring you can add back vibrant hues to black and white images. Original black and white photo (left) and after hand coloring of flower and stem (right).

Step 1: Check the Color mode

With your image open in Elements check to see what Color mode the picture is stored in. Do this by selecting Image > Mode and then locate which setting the tick is next to. For most black and white photographs the picture will be in Grayscale mode. If this is the case change it to RGB Color (Image > Mode > RGB Color). If you are starting with a color photo use the Desaturate (Photoshop) or Remove Color (Photoshop Elements) commands to convert the picture to monochrome but keep it in the RGB Color mode.

Step 2: Start painting

Now double-click on the foreground color swatch in the toolbox and select a color appropriate for your picture. Next select the Paint Brush tool from the toolbox and adjust its size and edge softness using the settings in the options bar. In order for the brush to just color the picture (keeping the details from beneath) the tool must be in the Color mode. To make the change click on the Mode drop-down menu in the options bar and select the Color option towards the bottom of the list.

Step 3: Using layers

For more control create a new layer (Layer > New Layer) for each color and change the Blend Mode of the layer to Color. Switch the Brush mode back to normal and proceed to paint the colors onto each individual layer. Use the Opacity control for each layer to adjust the strength of the colors.

In Photoshop:
Photoshop includes all the tools and features detailed in this technique.

Color and black and white together

So far in this section we have looked at a range of creative techniques that have their roots in effects that were possible with traditional photography. Now we will examine some options that are digital only.

Contemporary photographers now have the option to include both black and white and color picture parts in the same photo. Using the selection and grayscale conversion techniques detailed in the previous sections it is a comparatively simple step to create just such a hybrid photo. See Figure 8.39.

Commence the process with a full color photo. Next you will need to use one of the selection tools (Lasso, Magic Wand, Marquee) to isolate the picture part that you want to remain in color. To ensure

Figure 8.39 Starting with a color photo it is possible to convert just a section of the image to monochrome, producing a result where black and white and color can coexist in a single picture.

a smooth transition between colored and grayscale image areas the selection is then feathered (Select > Feather). Changing to grayscale at this point would convert the area that you want to remain in color so the selection must be flipped to include all but these portions of the photo. This is easily achieved using the Select > Invert option. With the selection you can now use a Hue/Saturation Adjustment layer to convert the rest of the picture to gray.

Step 1: Select color area

Start by selecting the areas of the picture that are to remain in color. Depending on the complexity this task may require you to use several different selection tools and to add to (hold down the Shift key) or take away from (hold down the Alt key) your selection as you go. Be careful with this part of the process as the quality of the selection will determine the quality of the result overall.

Step 2: Feather the selection

Whenever you are making changes to your photos through pre-made selections it is worth applying a small feather to the selection edge first. Here I used a radius of 1 pixel to help smooth the transition between colored and non-colored or black and white areas. The Feather is located under the Select menu or accessed via the Refine Edge feature.

Step 3: Invert the selection

At this point you should have a feathered selection around the areas that you want to remain in color. In order to change the rest of the picture to black and white we need to switch the selection from its current position to the rest of the image. We do this by inverting the selection (Select > Inverse).

Step 4: Convert to gray

With the selection still active, create a new Hue/Saturation Adjustment layer (Layer > New Adjustment Layer > Hue/ Saturation) above the background. When the dialog opens drag the Saturation slider all the way to the left to remove the color from the selected area.

Step 5: Non-destructive changes

Adding an Adjustment layer whilst a selection is active automatically creates a mask through which the changes are applied. This is a preferred way to work as the original picture remains untouched at the bottom of the layer stack.

In Photoshop:
The selection tools and selection menu options such as Inverse and Feather are all present in Photoshop. Creating masks from selections with Adjustment layers also works in the same way as the Photoshop Elements steps detailed above.

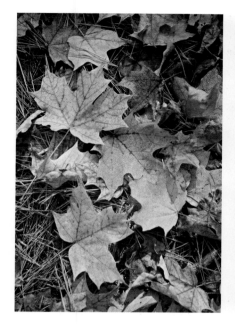
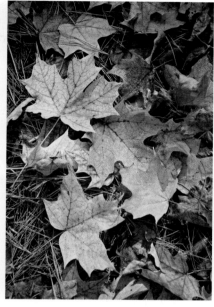

Figure 8.40 Add emphasis to your photos by selectively increasing and decreasing saturation in specific parts of the picture. Original photo (left) and the same picture with increased saturation in the leaves and decreased saturation everywhere else (right).

Using color for emphasis

Using a similar technique, involving a feathered selection and the Hue/Saturation control, you can also partially saturate and desaturate portions of a picture and in so doing draw the viewer's attention to this image part.

Start by selecting the picture parts that you want to emphasize and then increase the saturation of these areas by applying a Hue/Saturation Adjustment layer change. Then inverse the selection and apply a second Hue/Saturation Adjustment layer, this time reducing the saturation of the rest of the photo. Remember with this technique it is not about creating a monochrome versus color contrast. Instead you want to subtly increase the vibrancy of the color in one area whilst decreasing it in another. See Figure 8.40.

Step 1: Increase saturation
Select the picture area for increased saturation. Feather the selection and then with the selection active, add a Hue/Saturation Adjustment layer. Drag the saturation slider to the right to increase the vibrancy of the selected areas. Click Okay to close the dialog and apply the setting.

Step 2: Decrease saturation
Hold down the Control key and click on the mask thumbnail in the Hue/Saturation layer to reload the selection. Next choose Select > Inverse and add a new Hue/Saturation Adjustment layer. Drag the Saturation slider to the left to decrease the vibrancy of the rest of the photo. Click Okay to apply the changes.

In Photoshop:
Hue/Saturation Adjustment layers, selection tools and the Feather command are all standard features in Photoshop.

Figure 8.41 Darkening the corners of a print to keep the viewer's attention on the subject is a technique that has been popular with photographers for many years. The technique is called vignetting. In this example an oval selection was used as the basis of the vignette. The original photo (left) and how it appears after the corners have been darkened (right).

Creating a digital vignette

Vignetting, or the darkening of the edges of the print to concentrate the viewer's attention on the main subject, is not a new technique but it is an effective one. Creating a vignette traditionally meant adding extra light to the edges of the photo after the main exposure was completed. In the digital world similar results can be obtained by creating a feathered oval selection of the subject, inverting the selection and then darkening the selected areas with a Levels Adjustment layer. See Figure 8.41.

Step 1: Create feathered selection
Use the Elliptical Marquee tool to draw an oval selection over the area of the image that is to remain the same brightness. Feather the selection with a large pixel value to ensure a very soft blend once the effect has been applied. Inverse the selection so that only the edges of the photo are selected.

Step 2: Darken corners
With the selection still active add a Levels Adjustment layer above the background. Drag the midpoint input slider to the right to darken the selected areas. To darken white highlights more dramatically you can also drag the white output slider towards the center of the histogram.

In Photoshop:
Use the steps above along with the Elliptical Marquee tool, Feather and Inverse commands and the Levels Adjustment layer to create a same effect in Photoshop.

Adding texture

Texture is a traditional photographic visual element that is often overlooked when working digitally. All but the highest quality professional films have visible grain when they are printed. This is especially true when the print size goes beyond the standard 6 × 4 inches. In fact we are so familiar with the idea that grain is part of the photographic process that putting a little texture into an otherwise grainless digital picture can lend a traditional 'look and feel' to the image. Many photographers add a little texture to their pictures as part of their regular image editing process. Some go beyond this and produce photographs with huge clumps of grain that resemble the results often seen with prints made from old-style high ISO films.

The simplest method for adding texture to your picture is to use the Add Noise filter (Filter > Noise > Add Noise). The feature is provided with a preview dialog which allows you to alter the 'Amount' of noise that is added to the photograph, the style of noise – Gaussian or Uniform – and whether the noise is random colored pixels or just monochrome. See Figure 8.42. As with most filters it is important to use this feature carefully as once the filter is applied and the file saved you will not be able to undo its effects. For this reason, it pays to make a duplicate file of your picture which you can texturize without risk of destroying the original image.

Figure 8.42 Filters like Add Noise or Grain simulate the look of high ISO films. The original photo (top) and after the Add Noise filter has been applied (bottom).

Step 1: View at 100%
Zoom in so that the picture is at least at 100% view. Select the Add Noise filter from the Filter menu.

Step 2: Add texture
Adjust the Amount slider to change the strength of the effect and pick the noise type and color.

In Photoshop:
Photoshop contains both the Add Noise and Grain filters.

Figure 8.43 With slice and reassembly you can redesign any building.

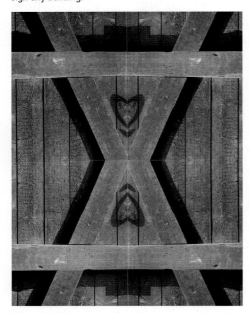

Figure 8.44 Four prints from the same negative make up a pattern montage.

Print manipulation

Even with the advent of digital photography, there is still plenty of scope for physically experimenting with images after you get your prints back from the processing lab. If you are good at handwork and have an eye for design, there are various possibilities of montage – pictures constructed from different paper prints arranged so that they join, overlap or blend with each other. Your aim may be simply an original form of pattern and decoration, or the assembly of a panorama otherwise impossible to shoot 'straight' without special equipment. You can construct a picture of a crowd of people or a fantastic landscape, create a caricature or a visual pun.

Similarly, the hand coloring of monochrome photographic prints opens up possibilities of color pictures in which every individual hue is under your control. Realistic or bizarre, colored in full or limited to just a suggestion here and there, you have a free hand. Watercolors, retouching inks and translucent oil paints can all be applied to the surface of black and white prints to give a hand-colored effect. Despite its heritage as a way to record color in a picture before color films were invented, this technique is best used for interpretive effect.

Assembled, montaged or colored, once your handworked print is complete you can copy it – either using your camera or through a high-quality photocopying machine or scanner. Results will then be free of joins or irregular surface finish.

Montaging

Like slide sandwiching and multiple exposure work, a print montage can combine elements or events that did not in fact occur together in real life. One person with eyes shut in a group can be pasted over with a cut-out print from another negative that is bad of everyone else. A strong foreground lead-in to a landscape can be combined with a distant main subject, when they were really hundreds of miles apart and shot on different days.

Again, most of these forms of manipulation are now handled digitally, but there is still plenty of scope for those who prefer to work in a more handcrafted manner.

Another form of reconstruction is to carefully dissect a single print into a regular pattern of slices, concentric discs, squares, etc., and then reassemble them in some different way, like the church architecture shown in Figure 8.43. In Figure

8.44, four prints have been butt-mounted to create one pattern. Look at the bottom left-hand quarter only and you will find that the subject is simply the inside of a shed door, including the shadow of the handle. It was constructed using two normal prints and two printed through the back of the negative.

The landscape (Figure 8.45) shows a more subtle form of repeat patterning – two butt-joined prints, one enlarged through the back of a negative and one from another negative, straight. Notice that having the dog on only one half breaks up the symmetry of the final result, making you wonder if the scene is real or constructed. Pictures like this need to be planned out before they are shot. If possible, make them pose a question or express some point of view. Figure 8.46, for example, says something about the fact that we work with hard edges to our pictures, unlike scenes observed by eye. A print of the man was pasted onto a seascape print and the shadow by his feet painted in with watercolor.

Hand coloring

Hand-tinting monochrome prints allows you to choose to leave some parts uncolored and suppressed, with others picked out strongly like the girl's eyes in Figure 8.47, irrespective of original appearance. Have your print made on fiber-based paper (if possible, make the print yourself and sepia tone it). The print should be fairly pale because underlying dark tones desaturate your colors. Choose paper which is matt, not glossy – the latter's extra gelatin top coat often gives uneven results. Remember too that big prints take longer to color than small ones. Begin with a size you know you can finish in one session.

Figure 8.45 Constructed landscape.

Figure 8.46 Montage (courtesy Graham Smith).

Work with either transparent photographic dyes or ordinary watercolors. Dyes give stronger hues and you can build them up by repeated application, but unlike watercolors they are hard to blend and mistakes cannot be washed off. (A dye remover pen will erase small color areas.) Start off by slightly damping your whole print surface to swell the gelatin, and firmly attach it on all four sides to hardboard with gummed brown tape. Work on the largest areas first, with a color wash on cotton wool. Then color in smaller parts using a brush, size 0–4, or a hand-coloring dye pen. Explore local coloring by computer too.

Panoramas

A panorama can consist of two, three or more prints joined up to form one uninterrupted picture. This is a very successful way of showing an architectural interior or a landscape when you do not have a sufficiently wide-angle lens. Building up a panorama also gives you an impressively large image from what were only quite small images (see Figure 8.48).

For the most accurate-looking result you must work carefully at the shooting stage. Expose each picture for a panorama from exactly the same spot. Pick a viewpoint giving some kind of start and finish to your vista – perhaps trees at one end and a building at the other. Avoid showing objects close to you in the foreground and shoot with a normal or long focal length lens – otherwise it will be difficult to join up both the near and the far details in the prints. In any case, try to overlap the contents of each frame by at least 30 per cent so you need only use the central zone of each shot.

Expose your series of pictures as quickly as possible in case figure movements or fluctuating lighting conditions upset your results. A camera with motor drive will allow you to keep your eye to the viewfinder. If the panorama features a prominent continuous line, such as the horizon, keep your

Figure 8.47 A hand-tinted black and white sepia-toned enlargement. A set of photo-coloring dyes is needed for this. Image courtesy of Sue Wilkes.

Figure 8.48 Panoramas are a quick, cheap way of making a big picture of a scene you cannot get in completely with one shot.

camera dead level. Pointing the camera slightly upwards or downwards results in prints that only join up to show this line curved (Figure 8.49).

Auto-exposure cameras will change the exposure settings according to the different subjects entering the frame of the various source images. If this happens, then individual photographs then show continuous elements like sky as too dark or light, and they will not match up. So ensure that exposure remains unchanged by keeping to one manual setting or applying AE exposure lock. This same advice should be applied to the focus and zoom settings as well. Lock these both at the beginning of the shot sequence to avoid changes during the series of images.

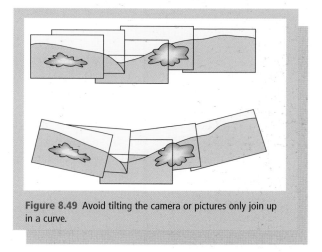

Figure 8.49 Avoid tilting the camera or pictures only join up in a curve.

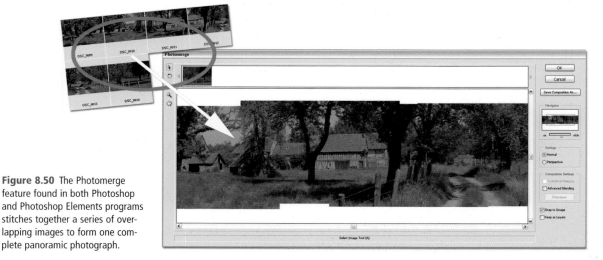

Figure 8.50 The Photomerge feature found in both Photoshop and Photoshop Elements programs stitches together a series of overlapping images to form one complete panoramic photograph.

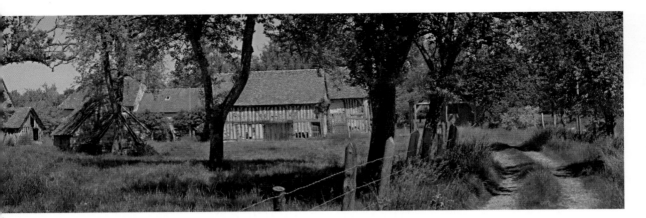

Figure 8.51 Photomerge, like other stitching software, matches and seamlessly blends the edges of adjacent images to form the final wide vista composition.

For digital shooters, make sure that the white balance option is set to the dominant light source in the scene, such as 'Daylight'. Leaving this option on 'Auto' can cause changes in color from one photograph to the next as the camera tries to eliminate color casts from a range of different subject-filled scenes.

Finally, if you are working with film and prints you can lay out your panorama images so that, when they overlap, details and tone values join up as imperceptibly as possible. Next, tack them down onto card with masking tape. Then, with a sharp blade, cut through each print overlap – either in a straight line or following the shape of some vertical feature. Discard the cut-off pieces and either tape together or butt-mount the component parts of your panorama. If necessary, trim or mask off the top and bottom as straight lines.

Those readers who have shot their source images digitally can use a stitching program to blend the edges of their photographs together. Image editing software like Photoshop Elements, as well as Photoshop itself, now contain a dedicated stitching feature, called Photomerge, built into the main program. Photomerge imports, sequences and positions the source images automatically, producing a stitched panorama. For problem picture sequences where adjacent images don't quite match up, the user is able to fine-tune these blending areas with a series of manual controls. The end result is a new picture file that is compiled of all the stitched source files (see Figures 8.50 and 8.51).

Producing digital panoramas

After successfully capturing the necessary source pictures let's set about stitching them together to form a panorama. In the latest version of Photoshop Elements the panorama option of Photomerge includes several auto modes as well as the manual (called Interactive) method for stitching photos. After selecting the Photomerge Panorama option from inside the Editor workspace you are presented with a dialog that not only contains Browse/Open and Remove options, which prompt the user to nominate the picture files that will be used to make up the panorama, but also a list of stitching approaches (on the left of the dialog). See Figures 8.52 and 8.53.

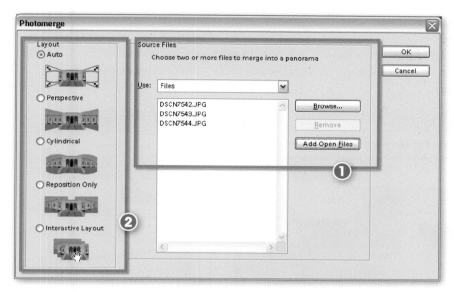

Figure 8.52 As well as the source files list (1) the Photomerge dialog includes five different Layout modes (2). The first four stitch the source images automatically and the fifth option transfers the pictures to the Photomerge workspace where the pictures can be manually placed.

Photomerge stitching modes

The five different Photomerge Panorama Stitching and Blending or Layout options in Photoshop Elements are:

Auto – aligns and blends source files automatically.

Perspective – deforms source files according to the perspective of the scene. This is a good option for panoramas containing 2 – 3 source files.

Cylindrical – designed for panoramas that cover a wide angle of view. This option automatically maps the results back to a cylindrical format rather than the bow tie shape that is typical of the Perspective option.

Reposition Only – aligns the source files without distorting the pictures.

Interactive Layout – transfers the files to the Photomerge workspace (which was the only option available in previous releases of Elements) where individual source pictures can be manually adjusted within the Photomerge composition. This is the only non-auto option.

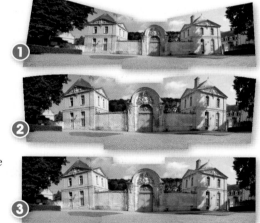

Figure 8.53 The auto Layout options in the Photomerge dialog use different approaches when producing the final panoramic photo. (1) Auto and Perspective. (2) Cylindrical. (3) Reposition Only.

In most circumstances one of the auto options will easily position and stitch your pictures, but there will be occasions where one or more images will not stitch correctly. In these circumstances use the Interactive Layout option. This displays the Photomerge workspace (see Figure 8.53) where individual pieces of the panorama can be moved or rotated using the tools from the toolbar on the left-hand side of the dialog. Reposition Only and Perspective options are set using the controls on the right. Photoshop or Photoshop Elements constructs the panorama when the OK button is clicked.

The auto workflow

If you have selected one of the auto Layout options then Photomerge will take care of the rest. The utility will open all images, combine them as separate layers into a single Photoshop or Photoshop Elements document and then align and blend the source photos. The final result will be the completed panorama.

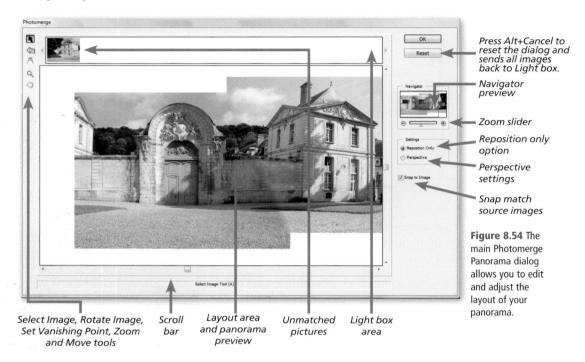

Press Alt+Cancel to reset the dialog and sends all images back to Light box.

Navigator preview

Zoom slider

Reposition only option

Perspective settings

Snap match source images

Select Image, Rotate Image, Set Vanishing Point, Zoom and Move tools

Scroll bar

Layout area and panorama preview

Unmatched pictures

Light box area

Figure 8.54 The main Photomerge Panorama dialog allows you to edit and adjust the layout of your panorama.

The manual (Interactive) workflow

If you have selected the Interactive Layout option in the Photomerge dialog then the Photomerge workspace will display and you will see the utility load, match and stitch the source images together. If the pictures are stored in RAW, or 16-bit form, they will be converted to 8-bit mode during this part of the process as well.

For the most part, Photomerge Panorama will be able to correctly identify overlapping sequential images and will place them side by side in the editing workspace. In some instances, a few of the source files might not be able to be automatically placed and Elements will display a pop-up dialog telling you this has occurred. Don't be concerned about this as a little fine-tuning is needed even with the best panoramic projects, and the pictures that haven't been placed can be manually moved into position in the main Photomerge Panorama workspace. See Figure 8.54.

You can use the Select Image tool to move any of the individual parts of the panorama around the composition or from the layout to the Light box area. Click and drag to move image parts. Holding down the Shift key will constrain movements to horizontal, vertical or 45° adjustments only. The Hand or Move View tool can be used in conjunction with the Navigator window to move your way around the picture. For finer control use the Rotate Image tool to make adjustments to the orientation of selected image parts.

The Perspective settings option, together with the Set Vanishing Point tool, manipulates the perspective of your panorama and its various parts. Keep in mind when using the perspective tools that the first image that is positioned in the Composition area is the base image (light green border), which determines the perspective of all other image parts (red border). To change the base image, click on another image part with the Set Vanishing Point tool. It is not possible to use the perspective correction tools for images with an angle of view greater than 120°, so make sure that these options are turned off. After making the final adjustments, the panorama can be completed by clicking the OK button in the Photomerge Panorama dialog box. This action creates a layered stitched file.

Joiners

Not every set of panorama images needs to marry up imperceptibly into one image. Another approach is to be much looser, abandon strict accuracy and aim for a mosaic that just suggests general appearance. The painter David Hockney explored composite image making this way by 'spraying' a scene with dozens of shots, often taken from more than one viewpoint and distance. The resulting prints, which he called 'joiners', both overlap and leave gaps. They have a fragmented jigsaw effect that suggests the passage of time and movement around the scene, concentrating on one thing after another.

Figure 8.55 Mosaic-type panorama. A contact sheet printed from 20 exposures on one 35 mm film. Always start photographing at top left and finish bottom right.

Figure 8.55 is a rough mosaic in the form of a single sheet of contact prints. It was made by contact from a film of 20 consecutive exposures. The individual pictures, all shot from one position using a hand-held camera and 50 mm lens, collectively make up something approaching a fish-eye view (page 88). For this kind of result, pre-plan how many exposures are needed per row. Don't overlap pictures – in fact, compose trying to leave gaps where the black horizontal bars (rows of perforations and film edges) will stretch across the final picture. The way that inaccuracies in a mosaic such as this restructure the architecture gives it individuality and life, but try to pick a camera position giving a symmetrical view to help hold it all together as one picture.

A similar technique can be employed when working digitally, but instead of composing the images as a contact sheet, simply create a large blank picture document onto which all the source photographs can be placed. Each picture can be imported as a separate layer, allowing the user to move, size and crop the images to suit the composition. Many image editing programs also have the option to display a grid on the picture surface to help with more precise alignment. Once the composition is complete, the grid can then be hidden from display.

1 Using a sequence of pictures, create a visual diary of '5 minutes' in the life of a friend or relative. Try to make sure that each image is linked to the next so that the story flows more like a collection of stills from a movie rather than a bunch of individual pictures.

2 When shooting hand-held in low light, try using your flash together with a long shutter speed. The flash will freeze part of the frame and the long exposure time will create a sense of movement. This technique is often called 'flash-and-blur'.

3 Shoot a series of architectural details concentrating on strong shapes, textures and colors. Then, select a single image and, if you are a film user, print it several times the correct way round as well as reversed. Arrange the prints to form a reflecting kaleidoscope composition. Digital users can achieve the same results by copying the original picture several times and then flipping several of the photographs so that they are mirror reflections. The various pictures can then be arranged into position to form the kaleidoscope.

4 When next on holiday, try making a 'joiner' of a famous landmark. Instead of trying to capture all of the texture, color and detail of the site in a single image, use a series of pictures that focus on various aspects of the scene. After returning home, montage the pictures together, either as prints or via the computer, to produce a rich visual description of the landmark.

5 Produce a series of pictures showing: (a) slow subjects – elderly people, milk floats, tortoises, fat animals, etc., apparently whizzing along; (b) fast subjects made to appear stationary or moving very slowly.

6 Walk around a fairground or lit traffic-filled street at night, holding the camera with its shutter open for 3–5 seconds (at f16, ISO 100 film or setting). Include plenty of pinpoint lights. Keep the camera still for part of each exposure.

7 Make a series of abstract images of the human figure. Consider the possibilities of focus, movement, blur, reflection, refraction and shooting through various semi-transparent materials.

8 Create 'physiogram' patterns. In a darkened room, rest your camera on the floor facing upwards, focused for 1 m and set for f8 (ISO 100 film or setting). Suspend a pen torch pointing downwards so that it hangs 1 m above the lens, on nylon cord firmly anchored to the ceiling. Make the torch swing freely in various directions within an area about 1 m square for 30 seconds with the shutter open.

9 By combining two or more images, construct a photograph of a fantastic landscape.

10 By means of a double exposure, produce either a double profile portrait or show the contents of a household appliance (crockery in a dishwasher, for example) inside its closed opaque unit.

11 Make an imaginative series of five pictures on one of the following themes. Either: (a) the tree as a dominant element in a landscape; or (b) railway and/or road patterns as a visual design feature.

12 Using three consecutive frames, carefully shoot an accurate panorama showing part of the interior of your room. Then use all the rest of the film, or space on the memory card, to shoot a loose 'joiner' of the whole room. Assemble the two results appropriately.

13 Create an interpretive photographic sequence of four to six pictures illustrating your concept of either: (a) transformation; or (b) harmony.

14 Shoot several interior scenes and landscapes, then use montage to combine the foreground of one with the background of another to give an inside/outside fantasy scene.

15 Using a montage of images, illustrate one of the following themes: the mob; stairs and entrances; family ties; street-wise; ecology rules!

(continued)

16 Photograph three ureleated items under similar lighting conditions – bright, direct or soft, diffused light from the same direction – import all three photos into Photoshop or Photoshop Elements. Using the layer structure of the program and eraser or masking techniques montage the different subjects together in a single document.

17 Photograph a series of flowers against plain backgrounds. Convert all pictures to grayscale, paying particular attention to ensuring that the contrast present in the original photo is retained after the conversion. Digitally tone all the pictures and add some texture before outputting the final images as a small series.

18 Find a location with an old world feel. Photograph a historical object or costumed portrait sitter within the environment. After downloading the photograph, add a vignette, some texture and then convert the picture to grayscale before finally toning the photo sepia color.

19 Photograph a series of pictures where one common colorful object features in a range of locations. After downloading the photos to the computer work your way through each of the pictures selectively, converting all of the images except the object to grayscale.

20 Photograph either a landscape, cityscape or shopping mall. Download the photos and then remove all color from the pictures. Next try to recreate the look and feel of the scene by adding the hues back into the pictures using the hand-coloring techniques detailed in this part of the book.

The final stage of photography is to present your results in the most effective way possible. If you made your own prints, either digitally or traditionally, they must be dried and finished, but even if you have received work back from a processing and printing lab, several decisions still have to be made before proceeding to the presentation stage.

Shots need to be edited down to your very best, cropped to the strongest composition, and then framed as individual pictures or laid out as a sequence in an album or wall display. Slides can similarly be edited and prepared for projection either traditionally or viewed as a digital slide show on a computer or television screen. At the same time, negatives, slides, contact prints and digital files deserve protective storage and a good filing system, so that you can locate them again when required.

Now you have the opportunity to review what has been achieved and assess your progress in picture making since starting photography. But how should you criticize the work . . . and also learn to listen to the criticism of others?

Finishing off

Final cropping

This is the final stage in deciding how each picture should be cropped. What began as the original framing up of a subject in the viewfinder concludes here by your deciding whether any last trims will strengthen the composition further. Don't allow the height-to-width proportions of photographic or printing paper to dictate results. Standard size enlargements from a processing lab, for example, show the full content of each negative – and however careful you were in the original framing, individual pictures are often improved by cropping to a squarer or a more rectangular shape. The same is true

Figure 9.1 Using L-shaped cards to decide trim.

for the original capture formats of digital cameras. Often these can be switched in camera from standard 3:2 or 4:3 to widescreen 16:9. Alternatively the cropping can be carried out in your image editing software. When working with printed reults placing L-shaped cards on the print surface (Figure 9.1) is the best way to preview any such trim. Then, put a tiny pencil dot into each new corner to guide you in either cropping the print itself before mounting, or preparing a 'window mat' cut-out the correct size to lay on top (see Figure 9.2).

Figure 9.2 Print taped along one edge to card and covered by a cut-out window mat.

Mounts and mounting

If your finished print is to be shown mounted with a border, choose this carefully, because pictures are strongly affected by the tone or color of their immediate surround. Compare the two identical black and white prints (Figure 9.3). On a white mount dark parts such as the shadows form a strong comb shape, whereas on a black mount the pools of sunlight become more emphasized. Even a thin white border left from the masking easel can change the picture by enclosing and separating it from a dark mount – just as a black edge-line drawn on it would do the same on the white mount.

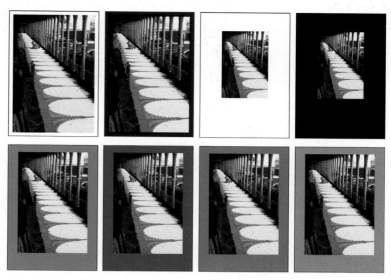

Figure 9.3 How final picture appearance is influenced by different colored mounts and image size in relationship to whole frame.

Don't overdo colored mounts or they may easily dominate your pictures. Color prints usually look best against a mid-gray or a muted color surround in harmony with the picture. If the dominant color scheme of the shot is, say, green, try a gray–green mount. Always use archival quality photographic display board – other card may contain chemicals which in time will stain your picture.

A window mat form of presentation is relatively simple and effective. You attach your (untrimmed) print to the mount along one edge only with high-quality adhesive tape and then secure another card with a correctly measured cut-out 'window' on top. Use a firm, really sharp blade when cutting the window – make sure corners are left clean and free from bits.

If, instead, you simply want to mount directly onto board (surface mount), trim the print first and coat the back with a spray-on or paint-on photo-adhesive, or use wide double-sided self-adhesive sheeting. Then, position your picture accurately on a mounting board, allowing the same width of surround at the top and sides. Some spray adhesives are designed to allow repositioning after mounting and so are useful if you need to adjust the position of the picture.

For the cleanest, flattest most professional-looking mounted result, it is difficult to beat dry mounting. However, to do this job properly you need access to a dry-mounting press and an electric tacking iron. As the image quality of some digitally produced prints will deteriorate when heat mounted, always test a scrap of the printing paper first to make sure that the image is unaffected by the process. Alternatively you can use a cold mount process which involves the application of a double sided adhesive in sheet form to the back of the print and then squeezing the print and backing board through a roller press. As no heat is used this process is suitable for plastic coated paper and digital prints that are produced with inks that are sensitive to heat.

As shown in Figure 9.4, there are four main steps in the heat mount process.

Figure 9.4 Dry mounting. (1) Tacking mounting tissue onto the back of the print. (2) Trimming print plus tissue. (3) Tacking onto mount. (4) Inserting into heated press.

1 Cover the back of your print with an oversize sheet of heat-sensitive mounting tissue. Briefly touch the center of the tissue with the heated iron, to tack them together.

2 Trim print and tissue to the exact size you need.

3 Position your print accurately on the mount, then carefully lifting each print corner, tack the tissue to the board. Keep one hand on the print center to keep it steady.

4 The mounting press must be set to the recommended temperature for your mounting tissue. This may be between 66 and 95°C, according to the type of heat tissue that you are using. Cover your print and board with a sheet of non-stick silicon release paper, insert the whole sandwich into the heated press and close it for about 15 seconds.

Spotting and mark removal

Sometimes, otherwise perfect enlargements show one or more tiny white dust spots. The advantage of working digitally is that any such marks can be removed before making the print. Traditional darkroom workers are not that lucky. If these are discovered after the print has been made then the simplest approach is to spot these in with black watercolor applied almost dry on the tip of a size 0 sable brush. You can also buy spotting dye in gray and sienna, as well as neutral black.

Alternatively, use a retouching pen that has a brush tip and contains its own dye (pens come in different shades of gray). Checking through a magnifier, stipple tiny gray specks into the white area until it disappears. Gray is successful for tiny spots on color prints too, but multi-color sets of pens are also made for this purpose.

As I have already alluded to, digital photographs should never be printed until the whole image is checked carefully on screen (magnified to at least 100 per cent) for dust and scratch marks. Any such problems should be removed from the file using either the Dust and Scratches filter or the Clone Stamp tool. The same approach can be used when spotting a marked print or slide. Start by scanning the original into a computer system and then use retouching software to

correct the fault. You can then print out the mark-free result through any high-resolution digital printer. See Part 7 for more details on digital retouching techniques.

Mounting and display tips

For most photographers, the final result of their picture-making activities is the print. The origins of the picture may be digital, or film, but the end product is very similar. The print is the culmination of all your skill and hard work, and if you are like me then you like to show it off. Good presentation is about showcasing the photography not the presentation.

Some new photographers spend a lot of time and money putting together elaborate mounts or frames that contain bright colors, strong textures and/or a high degree of decoration. The net effect is that the picture is overwhelmed by the visual power of the frame. The following tips have been collated to help you present your images in such a way that the viewer will be left in no doubt that the picture is what is important, not the framing.

1 *Try to create a visual space between the picture and the wall.* This is usually achieved by surrounding the image with a neutral mat board. This is a device that professionals use all the time. Even when they are working with small prints they make sure that the photograph is surrounded by plenty of visual space. This device draws the viewer in towards the picture and makes sure that his or her attention is not distracted by the surroundings.

2 *Provide more space at the bottom than the top and sides.* When positioning your image on a backing or mat board, place it in the center from side to side but move it slightly higher than center from top to bottom. It is an optical illusion, but when pictures are placed absolutely in the center there will always appear to be less space at the bottom than on the sides and the top; counteract the illusion by adding more space to the bottom.

3 *Choose colored surrounds carefully.* Though very attractive when admiring them in the arts supply shop, choosing a vibrantly colored board to surround your picture is a very risky business. It is very easy for the color to dominate the presentation and in some cases make the photograph's colors seem strange in contrast. Neutral tones tend to recede and therefore provide a better presentation platform for your pictures.

4 *Don't use black or white without good reason.* As we have already seen, our eyes automatically adapt to the spread of tones in a scene. Placing your pictures against a brilliant white or deep black background can make them seem too dark, too light, too contrasty or not contrasty enough in comparison to their surrounds. Instead, try to choose light or midtoned hues so that the rich black and delicate white tones in your picture can really shine.

5 *Keep your pictures flat.* There is nothing worse than trying to appreciate the quality of a well-produced photograph if it has become rippled in its frame. As the humidity changes throughout the year, the moisture content of your mounted print will change also. In the more humid months your print will absorb extra moisture from the air and will grow slightly in dimension. When the picture has been mounted by securing the photograph on all four sides, this change will result in the wrinkling of the print's surface. To stop this occurring either:
 – surface mount the picture (so that all the print surface is adhered to the board) to a sturdy backing board; or
 – loosely tack the photograph at the top edges only and then cover with a window mount (this gives the picture three sides to expand).

6 *Protect the images from deterioration.* To fully protect your pictures from the ravages of time, use a framing sandwich of glass, window mat, picture and backing board. These layers are then sealed into the frame using framing staples and tape on all edges. All the parts of the sandwich should be acid free and the picture should be loosely attached to the backing board (on one edge only remember) with acid-free tape (or a couple of 1 penny stamps).

7 *Use the same frames and mounts for a series.* To help unify a group of pictures, use the same size, type and color frame and mounts on all images. The pictures within the frames can change in orientation (portrait or landscape) and size within the frame, but the external dimensions of the frames should remain the same.

Presenting pictures in sets

Print sequences and photo-essays

If you have shot some form of narrative picture sequence, you must decide the minimum number of prints needed to tell your story. Perhaps the series of pictures was planned right from the start, set up and photographed like scenes from a movie. Sometimes, though, it evolves from part of a heavily photographed event or outing, which becomes a narrative story once you begin to sort out the prints.

Often, the only way of making a documentary-type story is simply to photograph an event from beginning to end. All the images taken on the day are then laid out (or viewed on screen) and the best group of six or seven selected. Make your choice based on how well each picture tells the story individually and as part of the greater series. Ensure that all the technical aspects of the images (focus, exposure, depth of field, lighting) are suitable as well. Once you have made a selection, check the sequence of the images. Make sure that each links to each other and they logically fit all together. Be prepared to add, subtract and replace pictures from the group that you originally started with until you are sure that you have the strongest mix of photographs.

When it comes to presenting the series, it may help with the continuity of the group if all the prints are trimmed to the same shape and size. Then, you can present them in rows on one mount so that they read like a cartoon strip, or run them one to a page in a small album or a handmade book, or even hang them as an exhibition at a local library or café.

If you want to caption the photographs, be sparing in what you write. As a photographer it is often best to let your pictures speak for themselves, even though some viewers may differ slightly in the story they read from the sequence. People don't like to have ideas rammed into their heads; unless you can write brilliant copy you will probably only be repeating what can be seen anyway and this can seem precious or patronizing.

Sets of pictures that share a common theme but are not based on a narrative often don't need to be read in a set order. This approach offers you much freedom of layout. Follow some of the layout ideas on the pages of picture magazines and display your work more as a 'photo-essay', presenting half a dozen prints on an exhibition board or page of a large format album. As Figure 9.5 shows, you can make all the picture proportions different in a documentary series, to give variety and best suit each individual composition.

Don't be tempted to slip one or two dull or weak pictures into a photo-essay just because their subject content ought to be included. Every shot should be good enough to stand on its own and each should add strength to the whole series. If you feel that there are gaps in the sequence, then it may be necessary to take some more pictures. Similarly, if one print is a bit too small or large relative to others, be prepared to print it again at a different size.

When laying out your set of pictures, take care over the way you relate one print to another – the lines, colors, textures and shapes, as well as the subject matter they contain, should flow together well, not conflict and confuse.

Figure 9.5 Part of a documentary series on a British country town. Differing print sizes help to give variety.

Storage options
Digital images

One of the real advantages of working digitally is that there is little cost (after your initial equipment purchase) involved in shooting as many images as you like. So, obviously, with no film and printing costs to worry about, many digital photographers are amassing hundreds if not thousands of images each year. This is great for the photographer, but once you have saved your pictures to the hard drive, locating an individual image later can be a major drama.

Recently, editing programs like Photoshop and Photoshop Elements have included image browsing features that make

Figure 9.6 Most image editing programs contain special browsing features that are designed to help locate individual images amongst the thousands stored on photographers' hard drives. Bridge, pictured here, is the browser application that ships with Photoshop.

searching for specific photographs as simple as hunting through an electronic 'contact sheet' displayed on screen (see Figure 9.6). The trick to taking full advantage of these programs is making sure that the sets of images taken for different occasions are stored in aptly named folders. Do not just load all the photographs that you make into the one folder tilted My Photographs, as very quickly you will find that searching for images will become a tedious process of scrolling through hundreds of thumbnails. Instead, make a new folder for each shooting occasion. Name the folder with a title that makes sense and include a date – 'Bill's Birthday, October 2008'.

Most new computers have very large hard drives that can store many thousands of digital photographs, but even with this amount of space, if you are a dedicated photographer there will come a time when you will need to add extra storage. The simplest option is to have another hard drive added to your machine by a technician at the local computer store.

Backing up of important images is another consideration that many new digital photographers need to make. Unlike the situation with traditional photographic images, where new prints can be easily made from the original negatives if the first ones are damaged or misplaced, digital files, once lost, damaged or accidentally overwritten, are gone forever. From the moment that you start making digital photographs you should ensure that your best pictures are always stored in a second place other than your computer's hard drive. This can be as simple as copying your pictures to a data CD or DVD, or even saving them on an external hard drive. Any of these options will guarantee that you pictures are preserved if your main hard drive fails or is infected with a computer virus. Ensuring that you keep up-to-date duplicates of all your important pictures is one of the smartest work habits that the digital photographer can learn.

Where does my image file go when I save it?

One of the most difficult concepts for new computer users is the fact that so much of the process seems to happen inside a small obscure box. Unlike traditional photography, where you can handle the product at every stage – film, negative and print – the digital production cycle can seem a little unreal. Knowing where your image goes when you store it is one such part of this mysterious process.

- *Windows machines.* All devices that are used to store digital information are usually called drives.
 In Windows computer terms they are labelled with letters – the 'A' drive is for your floppy disk drive and the 'C' drive your hard disk. It is possible to have a different drive for every letter of the alphabet, but in reality you will generally only have a few options on your machine. If, for instance, you have a CD or DVD drive, then this will probably be called the 'D' drive, with any card readers attached to your machine being labelled 'E'.

- *Macintosh computers.* If your platform of choice is the Macintosh system, then you need not concern yourself about the letter names above. Each drive area is still labelled but a strict code is not used.

Within each drive space you can have directories (Windows) or folders (Macintosh). These act as an extra way to organize you files. To help you understand, think of the drives as drawers within a filing cabinet and the directories as folders within the drawers.

When you save your files from inside an image editing program, the picture is held within a folder on a specific drive. To locate and open the picture again, you must navigate to this place and select the image that you want to edit, so make sure that when you are making folders and naming files that you use labels that make sense.

Figure 9.7 Your digital photographs are stored as individual files in folders on drives in your computer. You can aid the location of individual pictures by creating new folders for each photographic session and labelling these with titles that reflect their contents.

Decide what to backup

Ask yourself 'What images can't I afford to lose – either emotionally or financially?' The photos you include in your answer are those that are in the most need of backing up. If you are like most image makers then every picture you have ever taken (good and bad) has special meaning and therefore is worthy of inclusion. So let's assume that you want to secure all the photos you have accumulated.

Organizing your files is the first step to guaranteeing that you have backed up all important pictures. To make the task simpler store all your photos in a single space. This may be a particular drive dedicated to the purpose or a 'parent' directory set aside for image data only. If currently your pictures are scattered across your machine then set about rearranging the files so that they are stored in a single location. Now from this time forward make sure that newly added files or older images that you are enhancing or editing are always saved back to this location. See Figure 9.8.

Figure 9.8 Organizing your image files into one central location will make it much easier to back up or archive all your pictures in one go.

Making your first backup

Gone are the days when creating a backup of your work involved costly tape hardware and complex server software. Now there are a variety of simpler ways to ensure that your files are secure.

Create duplicate CD-ROM or DVD discs

The most basic approach employed by many photographers is to write extra copies of all imaging files to CD-ROM or DVD disc. It is easy to create multi-disk archives that can store gigabytes of information using software like Roxio Creator Classic or Toast. The program divides up the files into disc size sections and then calculates the number of blanks needed to store the archive. As each disc is written, the software prompts the user for more discs and sequentially labels each DVD in turn.

Backup from your editing program

Both Photoshop Elements and Photoshop (in conjunction with Version Cue) have backup options.

The Backup feature (Organizer: File > Backup) in Photoshop Elements is designed for copying your pictures (and catalog files) onto DVD, CD or an external hard drive for archiving purposes. To secure your work simply follow the steps in the wizard. The feature includes the option to back up all the photos you currently have cataloged in the Photo Browser along with the ability to move selected files from your

hard disk to CD or DVD to help free up valuable hard disk space.

Adobe has also included sophisticated backup options in its Creative Suite release. By placing your Photoshop files in a Version Cue project you can take advantage of all the archive features that this workspace provides. Backups are created via the Version Cue administration screen. Here individual archive strategies can be created for each of your projects with the user selecting what to back up, where the duplicate files will be saved and when the automated system will copy these files.

Use a dedicated back up utility

For the ultimate in customized backup options you may want to employ the abilities of a dedicated backup utility. Until recently many of these programs were designed for use with high-end networked environments and largely ignored the smaller home or SOHO users, but recent releases such as Roxio's BackUp MyPC are both affordable and well suited to the digital photographer. The program provides both wizard and manual approaches to backing up your photos, includes the option to compress the archive file and gives you the choice of Full (all files duplicated) or Incremental (only backs up changed files since last backup) backup types.

Back up regularly

There is no point having duplicate versions of your data if they are out of date. Base the interval between backups on the amount of work you do. In heavy periods when you are downloading, editing and enhancing many images at a time, back up more often; in the quieter moments you won't need to duplicate files as frequently. Most professionals back up on a daily basis or at the conclusion of a work session.

Store the duplicates securely

In ensuring the security of your images you will not only need to protect you photos from the possibility of a hard drive crash but also from such dramatic events as burglary and fire. Do this by storing one copy of your files securely at home and an extra copy of your archive disks or external backup drives somewhere other than your home or office. I know that this may sound a little extreme but swapping archive disks with a friend who is just as passionate about protecting their images will prove to be less painful than losing all your hard work.

Backup hardware options

CD-ROM or DVD writer –
This option is very economical when coupled with writing software that is capable of writing large numbers of files over multiple discs. The sets of archive discs can easily be stored off site, ensuring you against theft and fire problems, but the backup and restore process of this approach can be long and tedious (see Figure 9.9).

Figure 9.9 DVD writers are available in both external and internal versions and provide a cheap and generally reliable method of backing up your important images. Once your photo collection grows beyond 4.7 Gb then it is a good idea to use spanning software to split the backup across several discs.

BlueRay is a new disc based technology that offers up to 10 times the storage space to standard DVD backup. At the moment write drives and disc blanks are still relatively expensive but these will eventually fall in price making this system the basis of many backyp workflows of the future.

External hard drive –
Connecting via USB or Firewire these external self-contained units are both fast and efficient and can also be stored offsite, providing good all-round protection. Some, like the Maxtor One Touch models, are shipped with their own backup software. Keep in mind that these devices are still mechanical drives and that care should be taken when transporting them (see Figure 9.10).

Backup glossary:

Multi-disk archive –
A process, often called spanning, by which chunks of data that are larger than one disc, can be split up and saved to multiple CD-ROMs or DVDs using writing software. The files can be recompiled later using utility software supplied by the same company whose software wrote the discs.

Version Cue – Version Cue and the backup features it includes is included free when you purchase the Adobe Creative Suite and is not supplied when you buy Photoshop as an individual product.

Full backup – Duplicates all files even if they haven't changed since the last time an archive was produced.

Incremental backup – Backs up only those files that have changed since the last archive was produced. This makes for faster backups but means that it takes longer to restore files as the program must look for the latest version of files before restoring them.

Restore – Reinstates files from a backup archive to their original state on your hard drive.

Figure 9.10 External hard drives are now far more affordable than ever before. They provide a fast, reliable and portable backup solution for photographers with many gigabytes of image files to protect.

Figure 9.11 More and more people are turning to web solutions for their online backup. Given the size of many photo archives though, this can often be a slow way to back up your images. Storing copies of your work online does provide the added benefit that the photos can be accessed anywhere in the world and many image editing programs now provide an online backup feature inside the program.

Internal hard drive –

Adding an extra hard drive inside your computer that can be used for backing up provides a fast and efficient way to archive your files but won't secure them against theft, fire or even some electrical breakdowns such as power surges.

Online or web-based backup –

Not a viable option for most image makers as the number of files and their accumulative size makes transfer slow and the cost of web space exorbitant (see Figure 9.11).

Negatives and prints

Smaller family albums give you less scope for layout ideas but they are a quick, convenient way to sort out your best shots. Most albums are geared to the print sizes produced by the photo labs, laying out two or three to a page. The type that have a 'cling film' overlay on each page allow you to insert, reposition or remove prints at any time without adhesive or mounting equipment. A pocket file (Figure 9.12) is also a handy way of carrying around small prints.

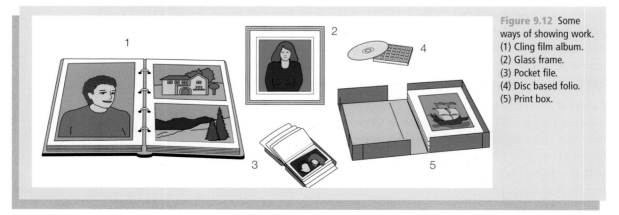

Figure 9.12 Some ways of showing work.
(1) Cling film album.
(2) Glass frame.
(3) Pocket file.
(4) Disc based folio.
(5) Print box.

Unframed enlargements on individual board mounts are most safely stored in boxes made of archival material. You can keep to one standard mount size and buy or make a box that opens into two halves so that anyone viewing your pictures can move them from one half to the other.

Don't overlook the importance of filing negatives and contact prints efficiently too – otherwise you may spend hours searching for an important shot you want enlarged. A ring file with loose-leaf sleeved sheets (negative sleeves), each accepting up to 36 negatives, is ideal. If you make a contact sheet off all your pictures, punch each one and file it next to its set of negatives.

Slides

Processed slides are normally returned to you in plastic, glassless mounts. For maximum protection from finger-marks and scratches it is advisable to transfer your best slides into glass mounts. If you have your own projector, these

Figure 9.13 (Left) Spot the slide mount top right (image upside down) when loading the projector. (Right) Clear plastic hanging sheets have individual pouches for slides and can be numbered for filing.

selected shots can be stored in a magazine, ready for use. Each slide should have a large spot stuck on its mount at the bottom left when you hold the picture correct way up, exactly as it should look on the screen. This gives you a visual guide for loading the slide into the projector. Always make sure that the image is loaded with this spot in the top right facing the lamp. To store a large slide collection, keep them in pocketed clear plastic sheets (Figure 9.13), which can be numbered and hung in any standard filing cabinet.

When projecting slides pick a matt white surface for your screen, as even a slightly tinted wall will distort colors. The slight presence of light will dull colors and turn blacks into flat grays, so make sure that your room is darkened.

Digital presentation

As well as the traditional ways of presenting your work, such as albums, boxes or exhibitions, the world of digital has opened up a whole new range of display options for the photographer who wants to share his or her work. Some, like the digital slide show, mimic traditional techniques whilst others such as web presentations offer completely new ways of presenting and viewing your photographs.

Figure 9.14 With the advent of digital photography, the traditional slide show has been given a new twist. The images are sequenced on the computer and then recorded to CD or DVD ready for showing on a computer or television.

Slide shows without the slides

I'm sure that it wouldn't take too much prompting for many readers to recall the dreaded family slide shows that seem to occur regularly on lazy Sunday evenings in many households around the country. Everyone's favorite uncle would present a selection of the family archives, and we would all sit around amazed at how much we had changed and try not to make rude comments about clothing styles and receding hairlines.

Well, the days when most photographers recorded the family history on slide film are slowly going, but the slide show events that accompanied these images are starting to make a comeback – thanks, in part, to the ease with which we can now organize and present our treasured digital photos on media like CD and DVD discs. Gone too are the dusty projectors, being replaced instead by DVD players linked to widescreen 'tellies'.

Products like Photoshop Elements handle the initial image processing, editing and enhancing, and then the slide show creation, picture sequencing and recording to disc all in the one program suite. Using the following steps, you can produce a CD-based slide show complete with main menu that can be shown on TV or computer screen.

Figure 9.15 The fully featured Slide Show editor in Photoshop Elements provides a variety of output options.

Creating your own slide shows

The Slide Show editor inside Photoshop Elements can produce a range of different types of presentations. The editor contains an easy-to-use interface and options that allow users to create true multimedia slide shows complete with music, narration, pan and zoom effects, transitions, extra graphics, and backgrounds and titles. The finished presentations can be output as a file, burnt to CD or DVD, e-mailed as a slide show, sent directly to your television (Windows Media Center Edition users only) or sent to Premiere Elements for further editing. Creating presentations Photoshop Elements uses an approach that centers all production activities around a single editor interface and it is only at the time of outputting that you choose the type of slide show that you want to create. In this way you can create (and save) a single slide show project and then repurpose the presentation in many different forms by simply selecting different output options (see Figures 9.15 and 9.16).

Figure 9.16 The Photoshop Elements Slide Show editor provides a single workspace for the creation and editing of your presentation creations.

Add photos/video/audio

Output options

Add blank slide

Add text

Preview

②

①

⑥

Extra palettes for adding graphics, text and narration

Extras palettes

Pan & Zoom, duration and Background color settings palette

Transition settings palette

④

③

Jump to Quick Reorder screen

VCR type controller

Preview/Auto edit screen

Individual slides

Transitions

Add audio bar

Slide Show timeline/storyboard

Preview screen

Close and return to main screen

Quick Reorder screen

⑤

Features of the Photoshop Elements Slide Show editor

Though the Slide Show editor may at first seem a little complex, having all the controls in one place certainly means that you can create great multimedia presentations easily and efficiently. The following key features are included in the editor (see Figure 9.16):

- **Automatic editing:** Rotate, size, change to sepia, black and white or back to color and apply Smart Fix and Red Eye Fix to your photos without leaving the Slide Show editor. Click the Preview image to display the Edit options in the Properties palette.
- **Styled text:** Select from a range of text styles with click, drag and drop convenience.
- **Add graphics:** The Slide Show editor now includes a variety of clip art that can be added to your presentations. Double-click or click-drag to place a selected graphic onto the current slide.
- **Transitions:** Add individual transitions between slides by clicking the area in the middle of the slides in the storyboard and then selecting the transition type from those listed in the Properties pane.

- **Pan and Zoom:** Add movement to your still pictures by panning across or zooming into your photos. Simply select the slide in the storyboard and then check the Enable Pan & Zoom option in the Properties pane. Click on the left thumbnail (Start) and set the starting marquee's (green) size and position, then switch to the right thumbnail and adjust the ending marquee's (red) size and position.
- **Quick Reorder:** This new sequencing screen enables you to quickly and easily adjust the position of any one photo in the presentation sequence using click and drag.
- **Music and narration:** Add music and extra audio to the show using the Add Media button and incorporate narration using the built-in slide show recorder.

Creating your first slide show

The Slide Show feature in Photoshop Elements is one of the Photo Project options. Like all of these output projects you multi-select the images to include first inside the Organizer space before opening the feature. Here's how:

1 Preselect the photos to include in the show from within the Photo Browser and then select Organizer: Create task pane > Slide Show.
2 Set the defaults for the presentation in the Slide Show Preferences dialog. See Figure 9.17.
3 Adjust the slide sequence by click-dragging thumbnails within the storyboard or Quick Recorder workspaces.
4 Insert transitions by clicking the space in between slides and selecting a type from the menu in the Properties pane.
5 Add graphics and text by click-dragging from the Extras pane.
6 Record voice-over by selecting a slide and then using the Narration option in the Extras pane.
7 Add existing audio by clicking the soundtrack bar at the bottom of the storyboard.
8 Produce the slide show by selecting File > Output Slide Show and picking the type of presentation to produce from the Slide Show output dialog.

Figure 9.17 When selecting the Slide Show option from the Share task pane in the Organizer workspace the Slide Show Preferences dialog is displayed first, allowing you to set the default options that will apply to the whole presentation. After clicking OK the full Slide Show editor is displayed.

Disc types explained

Most CD and DVD writing software including the recording utilities built into Photoshop Elements can burn slide shows in a variety of disc formats.

The most common formats are VCD, SVCD and DVD. The VCD or Video Compact Disc stores shows with the lowest resolution of the three. SVCD or Super Video Compact Disc is next with DVD (Digital Versatile Disc) storing the highest quality presentation. Most DVD players can read and display the content of any of these formats, but to be sure that your machine is compatible, check the equipment's manual.

E-mail photocards

Sending e-mails is nothing new, but adding your favorite pictures as attachments is a great way to share your photographs. Add some true spice to your next e-mail message by adding a picture postcard featuring images of a recent party or sights from your latest holiday. Or why not combine your love of photography with the speed and convenience of e-mail to produce the twenty-first century equivalent of the 'carte de visite' showcasing the latest family portrait.

Many software packages now make the process of making the photograph suitable for the task by playing around with pixel dimensions, compression settings and special web file formats a simple affair. Operating systems like Windows Vista and XP allow you to e-mail pictures (as attachments) directly from the folder they are stored in. Just select the Send To > Email option from the right-click menu. If you want a little more control, then many of the image editing packages provide this level of flexibility too.

In fact, Photoshop Elements includes two different ways of emailing images – as Photo Mail or as E-mail Attachments. There is also a Contacts Book dialog in place of the old Add a Recipient option found in previous releases. Here you can add individual contacts, make groups from several e-mail addresses, and import and export to and from common e-mail contact formats such as vCards or Microsoft Outlook. See Figure 9.18.

Figure 9.18 Photoshop Elements has two different ways to email your photos. If, instead of using the E-mail Attachments option, you choose the Photo Mail format button then you will be prompted to choose the stationery (1) and decide on the layout (2) of the message in addition to the first couple of steps. The compression and size settings for this option are adjusted automatically.

Figure 9.19 The E-mail Attachments wizard (1) provides the ability to adjust the size and compression (2) used with the photos you attach to your e-mails. Using the feature you can also add and remove contacts, via the Contacts Book, and type your message directly into the window (3). Pressing Next opens your e-mail program (4), adds in your message and recipient details and attaches an optimized version of your picture to the new e-mail document.

E-mailing photos step by step

The E-mail Attachment button starts the e-mailing process. Images are dragged from the content area in the Organizer workspace onto the Items section of the panel. The size and compression settings for the images are selected with the controls directly under the Items area. After clicking the Next button you can add a message and choose who to send the e-mail to from the listed recipients. New recipients can be added with the Edit Contacts button (small person icon) in the top right of the panel. After all the participants have been selected, clicking the Next button will open your e-mail program, create a new message and add in your pictures and recipients. See Figure 9.19.

1 You can select to use a photo that is currently open in the Editor workspace or multi-select images from inside the Organizer workspace.
2 Select the E-mail Attachments option in the Share task pane to start the feature.
3 Add or delete photos from the thumbnail list of those to include with the buttons at the top right of the dialog. Adjust size and compression of the photos and click Next.
4 Choose an existing recipient from the contacts list or add a new contact; add in a message and click Next to open your e-mail program and create the new message.

The second way to send your image by e-mail is to use the Photo Mail option located in both the Share task pane of both the Organizer and Editor spaces. The first couple of screens are the same as the E-mail Attachment feature but, once you have selected the images and recipients to include in the message, clicking the Next button opens a new window where you can adjust the stationery, framing and layout of the images.

1 After selecting the Photo Mail option from the Share task pane use the same steps as above (steps 1–3) to add images, choose recipients and include a message. Click Next.
2 In the new dialog that is displayed select the stationery (frames and background) style for the Photo Mail. Click the Next Step button.
3 Customize the look of the stationery by adjusting the background color, layout, photo size, font, borders and the inclusion of drop shadows.
4 Click Next to open your e-mail program and create the new Photo Mail message.

Creating a web gallery

Putting your pictures onto the web is a great way to create a permanent, 'open all hours' gallery of your work. For many photographers new to the web, the steps involved in putting together a series of linked web pages can seem a little daunting, but there are many software packages on the market that can help make the process easier.

Both Photoshop Elements and Photoshop have wizard-based web gallery production features. In Elements the feature is called Online Galleries and in Photoshop it is titled the Web Photo Gallery.

The Online Galleries feature (previously called the Photo Galleries or Web Photo Galleries) can be found under the Create or Share panes in both the Editor and Organizer workspaces. Clicking the Online Gallery button displays the first window in a five-step wizard. The steps allow you to choose your images, set the template and style of the website, input the heading and adjust the colors used on the pages, and choose where you want the project saved and more importantly how the website is to be shared. The feature even provides the option for free hosting via the Photoshop Showcase website.

Users are able to multi-select pictures from the Photo Browser and the Online Galleries wizard dialog contains a very useful Add/Remove pictures section (+ and – buttons on the top right) which displays a thumbnail list of those photos currently selected for inclusion in the website. In addition, the order that pictures appear in the web gallery can be changed by clicking and dragging thumbnails to new spots in the list.

The feature contains a variety of gallery templates including animated and interactive gallery types as well as the more traditional static thumbnail and display image templates. Selecting which gallery type to produce is a choice made in the wizard step following selecting and arranging the photos to include. See Figure 9.20. The category options are:

Figure 9.20 The websites created with the Photoshop Elements' Online Galleries wizard move beyond simple static pages and now include (1) Interactive, (2) Standard, (3) Animated, (4) Journal, (5) Slideshow, and Video (not shown) options.

Interactive – A variety of designs that allows the user to navigate through the sequence of images or move the photos on screen.

Standard – A set of thumbnail images together with a larger display photo. Clicking on a thumbnail displays the selected photo in the preview space.

Animated – A selection of animated galleries placing framed images against colorful sets or backgrounds. Images change by clicking Forward and Back buttons.

Journal – In a twist of the standard design this gallery provides a large text area on the left of the main preview display. Here, any caption text that is associated with the image is displayed. In addition, a small set of thumbnails for the images is listed across the bottom of the window.

Slideshow – Creates a slideshow of the images which scales to the size of the browser window.

Video – Creates a web page for presenting a video. The movie must be in the Flash video format and be 400 x 300 pixels in dimension.

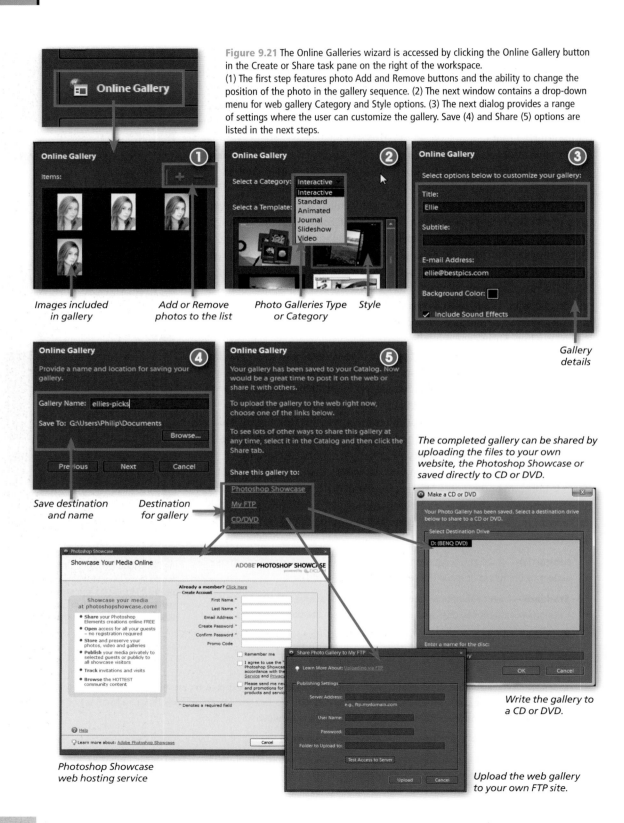

Figure 9.21 The Online Galleries wizard is accessed by clicking the Online Gallery button in the Create or Share task pane on the right of the workspace.

(1) The first step features photo Add and Remove buttons and the ability to change the position of the photo in the gallery sequence. (2) The next window contains a drop-down menu for web gallery Category and Style options. (3) The next dialog provides a range of settings where the user can customize the gallery. Save (4) and Share (5) options are listed in the next steps.

Images included in gallery

Add or Remove photos to the list

Photo Galleries Type or Category Style

Gallery details

Save destination and name

Destination for gallery

The completed gallery can be shared by uploading the files to your own website, the Photoshop Showcase or saved directly to CD or DVD.

Photoshop Showcase web hosting service

Write the gallery to a CD or DVD.

Upload the web gallery to your own FTP site.

Built for speed

In the process of creating the site, all your images will be optimized for web use, so with some gallery styles there is also the option to alter the level of compression that is applied. Rather than having to select the exact compression and image dimensions, the values for these variables are set via the site style selected as well as the entry chosen in the Optimize For section. See Figure 9.22.

Figure 9.22 The option selected in the Optimize For section of the Photo Galleries dialog determines the size and compression setting used for the photos in the gallery. Broadband creates larger, less compressed photos than the dial-up selection.

Going live

With the site completed, the next step is to transfer all the files to some server space on the Net. Companies called ISPs, or Internet Service Providers, host the space. The company that you are currently using for 'dial-up' or broadband connection to the Net will probably provide you space as part of your access contract. As an alternative, there is a range of hosting businesses worldwide that will store and display your gallery for free, as long as you allow them to place a small banner advertisement at the top of each of your pages. In addition Adobe also provides the ability to transfer your web pages to its own hosting service, Photoshop Showcase. Once registered the user can upload their web pages (and images and videos) directly to the hosting space from inside Elements.

Whatever route you take, you will need to transfer your site's files from your home machine to the ISP's machine. In previous versions of Elements this process was handled by a small piece of software called an FTP or File Transfer Protocol program. Thankfully the Online Gallery feature contains an integrated FTP utility within the Share To section of the dialog. You can choose between the following Share options:

Photoshop Showcase – Upload to a free online sharing area provided by Adobe Photoshop Services.

My FTP – Transfer to your own ISP or Net space provider.

CD/DVD – An option for burning the gallery to a CD or DVD.

Step-by-step Online Gallery creation

Use these steps to guide you through creating your first photo website.

1 Select the pictures you want to include in the site from those thumbnails displayed in the Organizer workspace. Hold down the Ctrl key to multi-select individual files and the Shift key to select all the files in a list. Alternatively, you can also drag a selection marquee around thumbnails in the Photo Browser.

2 Make sure the Task pane is displayed (Window > Show Task Pane). Click on the Create or Share tab and then select the Online Gallery button.

Figure 9.23 You can select between six different gallery types or categories in the second step of the Online Gallery's dialog: Interactive, Standard, Animated, Journal, Slideshow and Video (1). The option you pick here then determines the range of templates (2) that is available in the area below the Category menu. Click on one of the template thumbnails to make a selection.

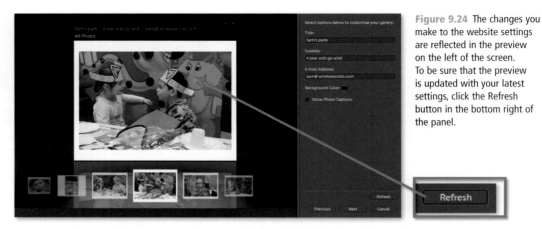

Figure 9.24 The changes you make to the website settings are reflected in the preview on the left of the screen. To be sure that the preview is updated with your latest settings, click the Refresh button in the bottom right of the panel.

3 Add or remove photos from the list of those to be included in the gallery (thumbnails listed in the panel) by clicking the '+' button to add more image or the '–' button to remove ones already listed.

4 Adjust the position of the images in the presentation sequence by click-dragging the thumbnail within the group. Click the Next button to move to the following step.

5 Choose the Category and Template from those listed in the next section of the wizard. Click the Next button to proceed. See Figure 9.23.

6 Automatically Photoshop Elements provides a preview of the web design complete with the images you selected in the main workspace to the left of the window. The content of the right side panel will be determined by both the category and template selected in the previous step. Some web gallery designs have many settings and controls that can be used to adjust the look and feel of the gallery as well as the text included in it; others, particularly the highly automated ones, have few user controlled settings to play with. You will need to click the Refresh button at the bottom of the panel to see the changes displayed in the preview section of the workspace. See Figure 9.24.

7 Many designs, however, do use photo details, like the caption entry, to provide titling for the individual photos. So if you want to, or need to, include these details in the design; exit the wizard by clicking the Cancel button. Add in caption details for your photos by adding text in the Properties palette (Window > Properties) and then restart the Online Gallery process.

8 As well as title, gallery and photo information you may also have the opportunity to adjust the Slideshow settings. With designs that include these settings you can alter the Duration and Transition Effect settings and may also be able to choose compression settings. Select the download speed used by the majority of the viewers who will be surfing your site. Broadband creates a site with better quality and larger photos whereas dial-up makes smaller files for faster loading.

9 If available, adjust the color, opacity and text that will be used for the site and then choose whether you want to include any captions or file names under the display pictures.

10 With all the options set you can preview the way that the website looks and works in the workspace on the left of the panel. To update the preview to reflect your settings click on the Refresh button at the bottom of the panel. Click Next to continue.

11 Input the file name for the gallery and the location of the saved project files in the next step of the wizard. It is important to realize that these Save settings are for the project and not for the completed website. That comes later. Click Next.

12 Now select the way that you want to share your website from the three options listed in this panel. In this example the My FTP option was selected. Add in the details for your FTP site, which can be obtained from your service provider, and then click Upload to transfer the website to the web server.

Figure 9.25 The files produced by any gallery feature need to be uploaded to the web in exactly the same arrangement (folder and files) as they were created in order for your site to function correctly.

Website tips

When Photoshop or Elements creates your site, the program makes three folders or directories, titled 'images', 'thumbnails' and 'pages'. These are placed in your designated Destination folder along with one or two extra files (depending on the style of site you choose) – index.html and thumbnailFrame.html. Together, these are the core components of your website (see Figure 9.25).

To ensure that your site works without any problems, all of these components need to be uploaded to your ISP. You also shouldn't move, or rename, any of the folders, or their contents, as this will cause a problem when the pages are loaded into a web browser. If you want to add extra images to your site, or change the ones you have, then it is easiest to make a completely new site to replace the old version.

In Photoshop:
Photoshop's Web Photo Gallery tool is a purpose-built feature designed to take a folder full of images and produce a multi-page, fully linked, gallery site in the matter of a few minutes. The process is as simple as navigating your way through a series of choices, inputting some text, selecting some pictures and pressing OK.

The result is a website that contains both thumbnails (small index images) and gallery photographs (larger versions of your pictures). Each of the thumbnails is hot linked and, when clicked, opens a larger version of the image or transports the viewer to one of several gallery pages.

Evaluating your results

Is your photography improving, and if so, on what basis can you tell? It's important to develop some way of assessing the success of picture making. One very practical approach is to put prints up on the wall at home for a while and see if you can keep on enjoying them – perhaps seeing something new each time you come back to look.

Another way is to discuss your pictures with other people – both photographers and non-photographers. By this route you may also discover if and why others reach different interpretations of the same photograph, and how these vary from what you aimed to express. Discussion is easiest if you are a member of a group, club or class, putting up several people's latest work and then getting everyone to contribute comments. At worst, it allows you to see your own pictures afresh and also discover what others have been doing. At best, you can get down to learning why pictures are taken and the reaction and influence they can exert on others.

But how do you criticize photographs, deciding what is 'good' and what 'bad'? There are at least three aspects to consider, each varying in its importance according to the stage you have reached and the type of photography you undertake.

Technical quality

This has greatest importance when you are a beginner, needing to gain experience in the use of equipment and processes. It involves questions of whether exposure and focusing were correct. Could the print have better color, be darker or less contrasty, and is there too much grain (or digital noise)? As well as improving your technical ability, this form of criticism is especially valid in photography used for accurate record-making. It is mostly concerned with facts (the negative is either sharp or unsharp, grainy or grain free), but if overdone the danger is that you apply the same rules to every picture, irrespective of subject and approach. This in itself can be a problem.

Communication of ideas

Here results are judged mainly in terms of the approach you have used to express your ideas. This means establishing (or imagining) the purpose of the picture – factual, persuasive, etc. – and then deciding whether your result succeeds in this visual intention. Maybe it is concerned with expressing the relationship between two people. Perhaps the picture is making a broader comment on society in general . . . or captures the peak of some action or event. Again, most of the interest may be in the content of the photograph and what can be read into a picture.

Formal structuring

Another concern is how effectively the visual 'building blocks' of pictures have been used. Your photograph's overwhelming strength may lie in its design – compositional aspects such as framing, use of perspective, color, pattern, tonal values and so on. Relative to these imaginatively used elements, the precise nature of the subject itself might take second place. On the other hand, you may have chosen to allow the subject to remain a key element but made much stronger (in dramatic appeal, for example) through the way you planned and constructed your picture.

Developing a critique

Whatever approach to criticism you adopt, and, of course, several can be used at once, your photograph is a sort of catalyst. On the one hand, there is you the photographer with your own attitudes and interests, and the physical problems you remember overcoming to get this result. In the middle is the photograph itself, which may or may not communicate the facts and ideas. On the receiving end, there is the viewer with his or her interests and background experience, the way they feel at that particular moment and the physical conditions under which your photographs are seen. All these elements contribute to the judgement of just how successful the photograph is deemed to be.

Discussing photography as a whole area, as well as individual photographs, is very much a part of studying the subject. What things can photography do well, and what can painting or drawing do better? How many ways might a particular theme or type of subject be approached? Educate yourself and make your 'eye' more visually literate by looking at the work of other photographers, in exhibitions and collections of their work printed in books.

Photography is essentially a medium, like writing or speaking, for expressing ideas and communicating information. In the hands of an artist, it provides an outlet for personal feelings and offers almost as much freedom as drawing or painting. Used by a scientist, it can report and measure in a detailed, factual way. Thanks to modern technology, everyone can now take photographs which 'come out' – giving unfettered opportunities to develop visual skills and so make pictures with an individual, personal style.

10 Troubleshooting

Everyone makes mistakes some time, but it is how you see these mistakes that will determine whether you will make the same mistakes later on. See each unexpected result as a chance to learn more about photography and its techniques. In fact, I would go so far as to say that if you are not making mistakes then you are probably not learning as much as you could about how to use your equipment and make better pictures.

The best approach when you receive unexpected results from processing or when viewing your day's shooting on your computer is to identify what went wrong. Was it the film, or the camera, or (most likely) the way you used your equipment? Or maybe it's all due to the lab that processed and printed your results? Identifying the source of the error will help you fix the problem, as well as ensure that the mistake doesn't happen again.

Film users: assessing the results

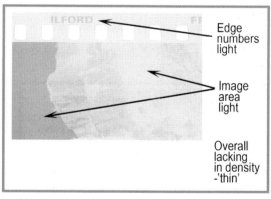

a. Good exposure and development

Half the skill of being able to diagnose a problem negative is in being able to recognize a good negative in the first place. Here are a few hints.

The first place to look is the image area. This should contain a full range of tones – which translates to good detail in shadow, midtone and highlight areas. There should be very few, if any, parts of the frame that contain no detail. The rule of thumb is that if the negative is placed on a page of newsprint it should be still readable. No areas of text should be obscured by the darkness (density) of the image.

The second area to examine is the edge of the film. Take particular notice of the frame numbers. As these numbers are exposed in the factory they can be a good guide to the quality of your processing.

b. Underdevelopment

Underdevelopment is often confused with under-exposure. Both scenarios give you weak, or thin, image area but only underdevelopment will result in light edge numbers. To correct this problem ensure that the developer is freshly mixed, not contaminated with other chemicals, is at the right temperature for processing and that you have calculated the right development time.

Fault prevention: Ensure that the developer is fresh and correctly diluted. Check the temperature of the solution before calculating the development time.

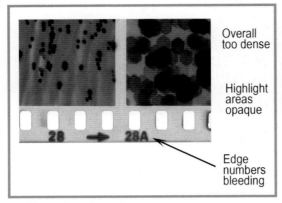

Overall too dense

Highlight areas opaque

Edge numbers bleeding

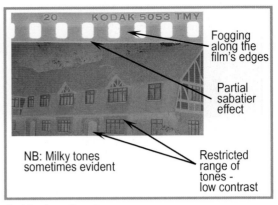

Fogging along the film's edges

Partial sabatier effect

NB: Milky tones sometimes evident

Restricted range of tones - low contrast

c. Overdeveloped

A big misconception in the world of photography is that it doesn't matter too much if you overdevelop your negatives. Sure the effects are not as disastrous as underdevelopment, but careless overdevelopment will result in images that are difficult to print and will never display the beautiful and delicate tones obtained from a good negative. The most notable characteristics of this problem are the dark, bleeding edge numbers and highlight areas appearing as opaque.

Fault prevention: Check to ensure that the developer solution wasn't too strong, or too hot, or that the film was developed for too long.

d. Under-fixed

Proper execution of the fixing step of the film processing sequence is just as important as development in the search for quality negatives. Under-fixing leads to fogging of both the image and edge areas of the film. A sure sign of this problem is if after fixing your film appears milky and the shadow areas are not clear. Refixing the film immediately can sometimes fix the problem, but the best cure is prevention.

Fault prevention: Always make sure that your fixer is fresh and that you fix for the full recommended time for your brand of film.

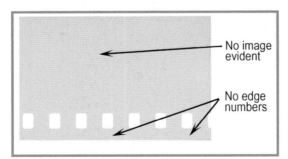

No image evident

No edge numbers

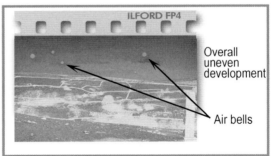

Overall uneven development

Air bells

e. Fixed first

This problem I sometimes call the 'clear film syndrome'. No edge numbers and no image detail are not a sign of no exposure but of fixing the film before developing it. If exposure was the problem then the edge numbers would be apparent.

Fault prevention: Always label your processing chemistry and be sure of the processing sequence before you start.

f. No agitation

Take it from me, regular and repeated agitation is good for your film. Some experts suggest four inversions of the canister every minute, others say once every 30 seconds, the choice is yours. The important thing is that you do agitate your film and that once you have established an agitation routine you stick to it. Consistency is very important if you want to be able to repeat your results.

Uneven development and air bells (small clear circles on the film) are sure signs that your film has received too little agitation during the development stage of processing.

Fault prevention: Check with the film and developer's data sheets what the correct agitation duration and sequence is before starting to process the film

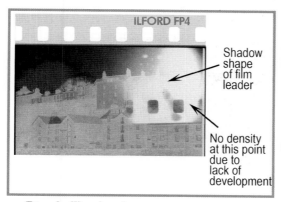

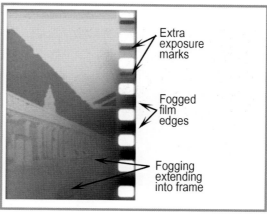

g. Stuck film leader

There is very little space between the grooves of a film spiral. There is enough width to allow free movement of chemistry but if the tongue is not secured at the edges then it can easily come in contact with other sections of the film. With two surfaces in such close contact processing cannot occur. The result is a clear section of the film in the shape of the tongue. To stop this occurring always ensure that the tongue is cut away before loading the spiral.

Fault prevention: Cut the leader from the film before winding it onto the developing spirals.

h. Canister light leak

Even at the processing stage film is very sensitive to the smallest amounts of light. If your processing canister has a small crack or if the funnel-shaped lid is not properly secured then film fogging may occur. If the edges of the film, as well as some of the image area, show signs of exposure then light leak is probably the most likely explanation.

Fault prevention: Preprocessing checks of equipment and careful securing of the processing canister should help prevent this problem from occurring.

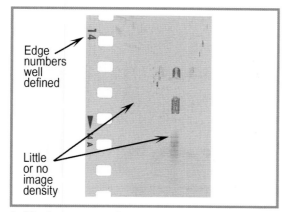

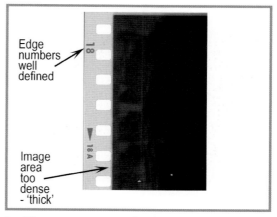

i. Underexposed

Often mistaken for underdevelopment, this problem is caused by not enough light reaching the film when you were shooting. You can be pretty confident that if your edge numbers are well defined but your image area is 'thin' then exposure, and not development, is the problem.

Fault prevention: To stop this occurring again make sure that you always set the correct ISO for the film stock you are using and that your shutter speed and aperture settings are appropriate for the scene.

j. Overexposed

Edge numbers that are well defined, coupled with a very dark image area, is usually a sign of over- exposure – the film receiving too much light at the time of shooting.

Fault prevention: Again check your ISO setting whenever loading your camera and shutter speed and aperture settings before each shot.

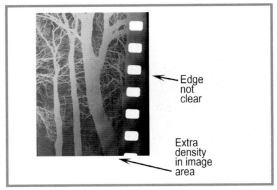

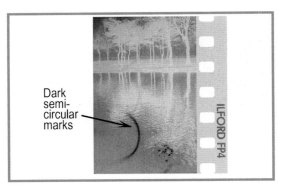

k. Fogged film

This problem looks very similar to 'canister light leak' – the edge area of the film is not clear and there appears to be extra exposure in the image area as well. The difference between the two problems is not the end result (fogging to the film) but the cause. In this instance light leaked through the top of a film canister that was being reused.

Fault prevention: Bulk film loaders are a great idea and do save a lot of money but make sure that you check your canisters regularly to ensure light-tightness.

l. Crescent marks

Crescent marks on your negative are a sure sign that 'all did not go well' when you were loading your film onto the processing spiral. I'm sure we have all had times when the film will just not load, but forcing it will only result in kinking the film which, in turn, produces the tell-tale crescent-shaped marks.

Fault prevention: To help avoid this situation firstly make sure that your spiral is completely dry – a wet-edged film will not load. Secondly, if your film refuses to continue to load try lightly taping the spiral on your forearm, or carefully flexing the spiral edges away from the film. Both these techniques are designed to ease the film away from the spiral track that might be causing the problem.

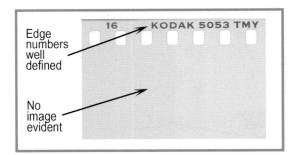

m. No exposure

If your edge numbers are evident but there is no sign of the image, this usually means that you have processed a film that you have not yet exposed. This type of negative can also be produced if you massively underexpose your film at the time of shooting, but most underexposure circumstances produce weak images, not none at all.

Fault prevention: To stop this occurring check that the film is being advanced when you press the shutter button. Do this by watching the rewind lever move when each frame is advanced. Also make sure that you label your films to save processing mix ups.

n. Wrong flash sync speed

If only a slit of your image is well exposed and the rest of the frame is blank and you have been shooting with a flash the problem is an incorrectly set shutter speed. All cameras have a recommended synchronization speed that is the fastest shutter speed that can be used whilst operating a flash. Check your camera manual for details. If you shoot with faster than the recommended speed then only a portion of the frame will be exposed. Unexposed areas can occur horizontally or vertically depending on the type of shutter mechanism your camera employs.

Fault prevention: Double check to ensure that you are using the correct sync speed for your camera when working with flash.

Two images evident

Misalignment of frame edges

o. Multiple exposure

If your film frame appears to contain more than one image, or if you are unable to make out spaces between frames, then your film has received some form of multiple exposure. This can occur if you accidentally reshoot a film that has already been used, if there is a problem with your film advance mechanism or if you have accidentally activated a multiple exposure option on your camera.

Fault prevention: To avoid this problem make sure that you check your camera's manual, label and process your films promptly, and if the problem persists have your camera checked by a service agent.

q. Misloading film

A fault most often experienced by beginners using film cameras happens during the loading of the film. If the leading edge of the film is not properly attached to the take-up spool in the camera or positioned in the area indicated for automatic cameras, then after closing the camera back the film remains stationary even though you wind on after each exposure. Then when you send the film for processing you will receive a blank (clear because it is unexposed) film in return.

Fault prevention: Check that the film is winding on correctly by watching the film rewind lever turn when the film is advancing. Open and reattach the film if it is not turning with each newly advanced frame. Auto-winding cameras should warn of this fault via a beep or an indicator on the LCD panel.

p. Unloading film

Another very common error is to open the camera before you have rewound your exposed film back into its light-proof cassette. Single-use cameras avoid these problems by having the film ready loaded and sealed in.

Fault prevention: Always double check that you have wound back your film before opening the camera back.

r. Marks on prints but not the negatives

When you notice a fault on a print, the first thing to do is to compare it very closely against the returned negative (the film that was initially exposed in the camera). If this negative looks normal and shows a lot more detail in the shadows or highlights than its associated print, or the print shows a blemish that cannot be seen on the negative, ask for a reprint. (If you have shot slides it is often easier to pin down faults, as the chain of processing does not then include possible printing errors.)

Fault correction: Take the offending image back to the processing lab along with the negative, point out the area of concern, such as a dust mark or blemish, and ask for a corrected reprint.

s. One frame black, the rest of the film clear

The film has one frame black, near the beginning. The rest is clear film, although data can be read along its edges. This film was correctly positioned for the first picture but then failed to move on because it became detached from the camera's take-up spool. All your shots were therefore exposed on the one frame.

Fault prevention: Check that the rewind is turning when advancing the film. Open and reattach the film if it is not turning with each newly advanced frame. Auto-winding cameras should warn of this fault via a beep or an indicator on the LCD panel.

t. A line of white spots and beads

This 'necklace' of flare spots is caused by internal reflection within the lens when shooting towards the sun. This happens most easily when using a wide-angle or zoom lens. (On an SLR camera you may not actually see this defect if you are viewing the image at widest aperture.) The size and shape of spots alter as you change f-number.

Fault prevention: Shade the lens with your hand or a lens hood, or shift the camera into the shadow of a building.

u. Black hair shape

This is the result of a small hair being on the actual film surface when this shot was taken (or on a slide scanned into the computer).

Fault prevention: Check the cleanliness of the space between lens and film plane in the (empty) camera. With an SLR, lock the shutter open on 'B' to access this area. Clean slides before scanning.

v. White hair shape

Unlike the previous fault, this is the result of a hair being temporarily on the negative surface during printing or scanning.

Fault prevention and correction: Ensure that negatives are clean before they go into the enlarger. You may be able to disguise the mark by print spotting or via digital manipulation. If this picture was printed by a lab, then request a reprint.

w. Pale print from overexposed negative

This can be caused by a faulty light measuring system or even batteries with a low charge. Similar results can be obtained if the ISO setting is too low for the film being used, if the lens aperture was stuck fully open or the shutter was sluggish.

Fault prevention: Check over your camera functions, looking through the back of the (empty) camera body to ensure that all are working correctly. If in doubt, take the camera to a technician for a service.

x. Print from underexposed negative

When a simple camera is loaded with slow film and used in dim lighting, the negative will be underexposed. The same effect will result if slow film is loaded in the camera but an ultra-fast ISO value is set on the camera.

Fault prevention: Keep to sunny conditions when you are photographing with very basic equipment. If possible, check what ISO value the camera is set for. (As this is typical of the best print possible off a nearly transparent negative, you are unlikely to improve on the result.)

General shooting faults

a. Orange color

If your slides end up with an all-over orange color, it is generally because the film was exposed to a subject lit by domestic-type (tungsten) light bulbs.

Fault prevention: Shoot with a blue (80A) filter over the lens. Daylight color negative film gives a print with a similar cast, but this can be given considerable correction during either darkroom or digital printing. Digital shooters can avoid these problems by selecting a tungsten or auto setting for the camera's white balance feature.

b. Out of focus

Out of focus pictures can be caused by using a fixed focus lens camera too close to the subject

Fault prevention: Don't exceed your camera's closest focus limit – often only about 1 m.

c. Red eye

Red eye is caused by the flash on the camera lighting up the pink retina at the back of the eyes when it is normally shadowed and therefore seen as black.

Fault prevention: Use a camera with a flash unit higher or further to one side of the lens. Better still, bounce or diffuse the flash light.

d. Yellow color cast all over

An overall color cast can be caused by photographing under a colored (yellow) awning, or using bounced flash light that is reflecting off a colored (yellow) surface.

Fault prevention and correction: To prevent this situation, recognize such lighting conditions and use an alternative way to light the scene. To correct the problem after shooting on color negative film, request that the lab reprint the photograph, giving the maximum correction of cast. Digital camera users should turn their white balance setting to automatic to minimize the cast.

e. Only the background is sharply focused

This can occur when an auto-focus camera has been focused for the central zone of the picture, which happens to be the background, rather than the main subject, which is positioned off-center. A similar situation results when the AF mechanism is jammed or when the manual focus lens was set for the wrong distance.

Fault prevention: Use AF lock for off-center subjects. With a manual lens, always set the distance for your main subject – and don't move after focusing.

f. Wrong moment to shoot

Releasing the shutter just as someone or something unexpectedly barges into the picture.

Fault prevention: Try to anticipate what is about to happen between camera and subject. A compact camera has the advantage that, through its viewfinder, you still see some of the scene just outside your picture limits. This lets you anticipate the action more easily. Also, make sure you have enough film left to allow several shots when people are swarming around you. But keep one or two of these 'mistakes' for a special place in the family album.

g. Large white hot spot

Inbuilt flash from the camera reflected straight off the plastic window of this baby's incubator.

Fault prevention: Do not shoot 'flat on' to windows, glass or plastic – angle your viewpoint. Where possible, shoot by natural daylight, loading fast film if necessary (or using a higher ISO value for digital users), to avoid using flash.

h. Entire picture, even static elements, blurred and smudged

This situation is caused by camera shake. In poor light, with slow film, an auto-exposure camera may have selected a slow (1/8 second or longer) shutter speed, at which setting the camera could not be held sufficiently still by hand to record a sharp picture. An alternative explanation is that the firing button was jabbed hard instead of squeezing gently when exposing.

Fault prevention: Use a higher ISO value (digital users) or load faster film when poor light is expected. Watch for 'shake' warning light with auto cameras – then improvise some firm support or use a tripod for shooting. With manually set cameras, select the widest lens aperture possible, to allow the use of the fastest possible shutter speed for the situation (without underexposing).

i. Ring of light

The picture was taken with the camera pointed directly towards the sun. The simple compact camera, having a shiny rim to its lens, reflected the sunlight into the picture.

Fault prevention: Anticipate light flare from these conditions and adjust camera direction to account for them. In this example, tilting the camera downwards or shifting slightly to the right would allow the tree to shade the lens from the sunlight. Alternatively, you can fit a lens hood or shade the front of the lens with your hand.

j. Bands of orange or red, showing up most clearly in dark areas

Light has entered the camera or cassette and has fogged the film. Perhaps the back was opened, or there is a missing screw in the camera body itself.

Fault prevention: Always fully rewind the film immediately after your final exposure, before anyone can open the camera. Never load your camera in strong sunlight.

k. Mis-framed picture

This is caused by an inaccurate framing through the viewfinder and generally occurs when using a compact camera quite close to the subject whilst ignoring its parallax correction guidelines.

Fault prevention: Follow your camera's instructions for viewfinder compensation when photographing near subjects. Always ensure your eye clearly sees all four corners of the rectangular frame line at one time, especially if you wear glasses. Digital users can more accurately frame using the LCD screen on the back of the camera rather than the viewfinder.

l. Main subject too dark

The camera's overall light reading was influenced too much by a large, bright area in the scene. In this case, it is the window behind the main subject.

Fault prevention: Read exposure from close to the figure, then apply the camera's AE lock. Alternatively, use fill-in flash, or pick another background.

m. White dog appears yellow

Fault in printing. The large area of strong blue background in this picture has confused the lab's automatic printing equipment. It has intensified yellow to counteract what it measures as excess blue in the picture, turning the white coat cream.

Fault correction: Return to the photo lab and have a corrected reprint made.

n. Subject appears distorted in shape

The subject was photographed with a short focal length (wide-angle). The head of the diver was too close to the camera.

Fault prevention: Move further back from the subject and then change to a longer focal length (or have the smaller image enlarged out of the center of your picture).

Digital users: checking images on the desktop

a. Marks on the scanned picture

The photograph contains marks on the surface after scanning. This usually occurs because of dust or scratches on the glass plate on the top of the scanner or on the photograph or negative.

Fault correction: Clean the glass plate and photograph carefully before placing and scanning your picture. If you still have marks, use a retouching tool to remove them (see Part 7 for more details about using image editing software to remove unwanted details).

b. The scanned color picture appears black and white

After scanning a color picture it appears black and white on screen. This is the result of the 'original' or 'media' option in the scanner software being set to black and white and not color.

Fault correction: Rescan the picture, making sure that the software is set to color original or color photograph.

c. The scanned picture is too bright

The picture looks too bright overall. Light areas of the photograph appear to be completely white with no details. The picture has been scanned with the wrong 'exposure' or 'brightness' setting.

Fault correction: Rescan the picture, but this time move the brightness or exposure slider towards the dark end of the scale before scanning.

d. The scanned picture is too dark

The picture looks too dark overall. There is no detail in the shadow parts of the photograph. This results from the picture having been scanned with the wrong 'exposure' or 'brightness' setting.

Fault correction: Rescan the picture, but this time slide the brightness or exposure slider towards the light end of the scale before scanning.

e. The scanned picture looks washed out

The picture has no vibrant colors and looks washed out. This occurs when the contrast control in the scanner software is set too low.

Fault correction: Rescan the photograph, altering the scanner's contrast setting to a higher value.

f. Writing in the scanned picture is back to front

The message on a billboard in the picture is back to front. The cause of this problem is the negative or slide was placed into the scanner back to front.

Fault correction: Turn the film or slide over and scan again.

g. The scanned picture has too much contrast

The delicate light areas and shadow details of the picture can't be seen and have been converted to completely white and completely black. This results from the contrast control in the scanner software being set too high.

Fault correction: Rescan the photograph, altering the scanner's contrast setting to a lower value.

h. When I print my scanned picture it is fuzzy

The print of a scanned image is fuzzy, not very clear or is made up of rectangular blocks of color. To get the best quality prints from your scanned pictures you must make sure that you match the scan quality (resolution) with the output requirements. A fuzzy or unclear print is usually the result of using a scan quality setting that is too low.

Fault correction: Rescan the picture using a higher scan quality setting (resolution).

i. Surface puddling when printing

Prints with this problem show puddles of wet ink on the surface of the paper. This situation results from too much ink being applied to the surface.

Fault correction: Select another paper or media type in the printer dialog that better suits the printing paper you are using.

j. Edge bleeding

The edges of the print appear fuzzy and shadow areas are clogged and too dark. This usually occurs when using a watercolor or uncoated paper.

Fault correction: Try choosing a media or paper type such as 'Plain Paper' or 'Backlit Film'. These measures will change the amount of ink being applied and the spacing of the ink droplets to account for the absorbency of the paper.

l. Weird colors

The picture looks great on screen but prints with strange colors. Using inks not made by your printer manufacturer can cause the colors in your print to be radically different to those displayed on screen.

Fault correction and prevention: Replace non-genuine inks with those made by your printer manufacturer.

n. High-contrast photos

Photos taken on a bright sunny day will generally exhibit the opposite scenario where there is too much contrast in the photo. Typically the histogram will show bunches of pixels at either end of the graph with few in between.

Fault correction: To make the photo less contrasty drag the black and white output sliders of the Levels feature towards the center of the graph.

o. Bright pictures

Overexposed photos will appear too light and bright. Use the Levels to redistribute the tones in the picture.

Fault correction and prevention: To darken a bright photo, adjust the black and white point sliders first to ensure that the contrast is acceptable and then drag the midtone input slider to the right.

k. Banding

Thin horizontal white lines appear across the surface of the photograph. This problem usually results from one or more of the print heads being clogged.

Fault correction: Consult your printer's manual to find out how to activate the cleaning sequence. Once completed, print a 'nozzle test' page to check that all are working correctly. If banding still occurs after several cleaning attempts, it may be necessary to install a new cartridge.

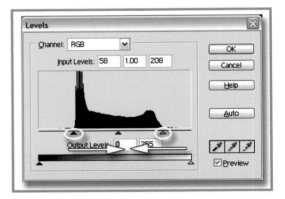

m. Low-contrast photos

The histogram of a photo taken on an overcast day or when the subject is situated in open shade normally displays a bunching of the pixels towards the center of the graph. This indicates that the photo is low in contrast or flat.

Fault correction: Contrast can be added back to the image using the Levels feature in Photoshop or Photoshop Elements. Just drag the white and black input sliders towards the center of the graph until they meet the first lot of pixels.

p. Dark pictures

When you view the histogram of images that are overly dark photos (mainly due to underexposure) you will see most of the pixels are bunched towards the left of the histogram. You can brighten a dark photo using the Levels feature in Photoshop or Photoshop Elements.

Fault correction and prevention: To lighten a dark photo, adjust the black and white point sliders first to ensure that the contrast is acceptable and then drag the midtone input slider to the left.

Appendices

Appendix A **Computer connection types**

Lurking at the back of most computers or hidden beneath a front flap are a series of connections used to attach external devices to your machine:

- *USB* is the standard used for attaching most cameras, scanners and printers.
- *Firewire* is a faster scanner and camera connection than USB.
- *Screen/video* port connects the computer to the screen.
- *Mouse* port is color coded to match the mouse plug.
- *Keyboard* connects to the computer using a similar color-coded plug to the mouse.
- *SCSI* ports are sometimes used to connect scanners and external hard drives.
- *Printer* or *parallel* port connections are not used as much as they used to be. Most printers are now connected via USB.
- *Serial* used to be the connection port for mice and some digital cameras, but now is largely unused.
- *Network* connections are used to link several computers so that they can share files.
- *Modem* ports connect into the telephone socket, allowing you to dial up Internet access from your computer.

Appendix B **Camera memory cards**

Memory cards, or digital film, as they are sometimes referred to, are used to store your camera's pictures. There are five main types, listed in Table B.1.

Table B.1 Main types of memory card

Memory card type	Merits	Camera makes
Compact Flash	• Most popular card • Matchbook size	Most Canon, Nikon, Hewlett Packard, Casio, Minolta and pre-2002 Kodak
Smart Media	• Credit card thickness • Usually colored black • Matchbook size	Most Olympus and Fuji digital cameras, Sharp camcorders with still mode, and some MP3 players
Multimedia (MMC) or Secure Digital (SD)	• Postage stamp size • Credit card thickness • SD are 2nd generation MMC type	Most Panasonic camcorders with digital still mode, some MP3 players, and the Kyocera Finecam S3, KB Gear JamCam, Minolta DiMAGE X and most Kodak digital cameras produced after 2001
xD Picture Card	• Smallest of all cards • About the size and thickness of a thumbnail	Newly released Fuji and Olympus cameras
Memory Stick	• Smaller than a stick of chewing gum • Longer than other card types	Used almost exclusively in Sony digital cameras, camcorders, hand-helds, portable music players and notebook computers

Appendix C Digital camera sensor sizes and resolution (megapixels)

Some cameras have chip resolution approaching 12.0 megapixels and, as you now know, the more pixels you have, the bigger you will be able to print the pictures. This said, cameras with less pixels are still capable of producing photographic prints of smaller sizes. Use Table C.1 to help give you an idea about what print sizes are possible with each resolution level.

Table C.1 Print sizes and resolution levels

Chip pixel dimensions (pixels)	Chip resolution (1 million = 1 megapixel)	Maximum print size at 200 dpi (inches) (e.g. photo print)	Maximum image size at 72 dpi (inches) (e.g. web use)
640 × 480	0.30 million	3.2 × 2.4	8.8 × 6.6
1440 × 960	1.38 million	7.4 × 4.8	20 × 13.2
1600 × 1200	1.90 million	8 × 6	22 × 16
2048 × 1536	3.21 million	10.2 × 7.58	28.4 × 21.3
2304 × 1536	3.40 million	11.5 × 7.5	32 × 21.3
2560 × 1920	4.92 million	12.8 × 9.6	35.5 × 26.6

Appendix D Suggested starting speeds/ apertures for difficult night scenes

Table D.1

Location	Shutter speed, aperture (with ISO 200 setting)
Street scene at night	1/60 second, f4
Very brightly lit street scene at night	1/60 second, f5.6
Floodlit football stadium	1/125 second, f2.8
Fairground at night	1/30 second, f2.8
Theatre stage, fully lit	1/60 second, f2.8
Boxing ring	1/60 second, f4
Floodlit factory at night	1/4 second, f2.8

Appendix E Scanner connections

The connection that links the scanner and computer is used to transfer the picture data between the two machines. Because digital photographs are made up of vast amounts of information, this connection needs to be very fast. Over the years, several different connection types have developed, each with their own merits. It is important to check that your computer has the same connection as the scanner before finalizing any purchase.

Table E.1 Scanner connections

Scanner connection	Merits	Speed rating	
USB 1.0	• No need to turn computer off to connect (hot swappable) • Can link many devices • Standard on many recent computers • Can be added to older machines using an additional card	Fast (1.5 Mbytes per second)	
USB 2.0	• Hot swappable • Can link many devices • Standard on some new models • No need to turn computer off to connect (hot swappable) • Can link many devices • Standard on many recent computers • Can be added to older machines using an additional card	Extremely fast (60 Mbytes per second)	
Firewire	• Hot swappable • Can link many devices • Not generally standard on Windows machines but can be added using an additional card • Standard on newest Macintosh machines	Extremely fast (50 Mbytes per second)	
SCSI-1	• Can link several devices • Standard on older Macintosh machines	Fast (5 Mbytes per second)	
SCSI-2 (Fast SCSI)	• Not generally standard but can be added to machines using an additional card	Fast (10 Mbytes per second)	
SCSI-3 (Ultra SCSI)	• Not generally standard but can be added to machines using an additional card	Very fast (20 Mbytes per second)	
Parallel	• Standard on most Windows-based machines	Very slow (0.11 Mbytes per second)	

Appendix F What resolution should I pick?

Knowing what is the best resolution, or scanning quality, for a particular task can be a daunting task. Some scanning software allows users to pick from a list of output options such as 'web use', 'laser print' and 'photo quality print'. The program then selects the best resolution to suit the selection. For those of you without these choices, use Table F.1 as a guide.

Table F.1 Guide to scanning quality (resolution)

What your scan will be used for	Scan quality (resolution) (dpi)
Web or screen	72
Draft quality prints	150
Photographic quality prints	200–300
Magazine printing	300

Appendix G ISO settings and their uses

Table G.1 summarizes the benefits and disadvantages of different ISO settings. Use it as a guide when selecting which value to use for your own work.

Table G.1 Benefits and disadvantages of different ISO settings

| | ISO and ISO equivalent setting | | |
	100	200	800
Benefits	• Low noise (fine grain) • Good color saturation • Good tonal gradation	• Good noise/sensitivity balance • Good sharpness, color and tone • Can be used with a good range of apertures and shutter speeds	• Very sensitive • Can be used with fast shutter speeds, large aperture numbers or long lenses • Good depth of field
Disadvantages	• Not very sensitive • Needs to be used with fast lens or tripod	• Not the absolute best quality • May not be fast enough for some low light or action scenarios	• Obvious noise throughout the picture • Poor picture quality
Best uses	• Studio • Still life with tripod • Outdoors on bright day	• General hand-held shooting	• Sports • Low light situations with no flash • Indoors

Appendix H

Minimum shutter speeds to stop camera shake

Table H.1 illustrates a simple rule to help eliminate camera shake. It uses the principle of not using shutter speeds that are longer than the reciprocal of the focal length of the lens being used.

Table H.1 Eliminating camera shake

Focal length (millimeters)	Reciprocal	Slowest usable shutter speed without camera support (seconds)
28	1/28	1/30
35	1/35	1/60
50	1/50	1/60
100	1/100	1/125
200	1/200	1/250
300	1/300	1/500

Appendix I

Settings to control depth of field

Use Table I.1 as a quick guide for setting up your camera for either shallow or large depth of field effects.

Table I.1 Settings to control depth of field

DOF effect required	Best aperture numbers	Best focal lengths	Best subject-to-camera distance
Shallow	Low (e.g. f2.0, f2.8)	Longer than standard (e.g. 120 mm)	Close
Large	High (e.g. f22, f32)	Shorter than standard (e.g. 28 mm)	Distant

Appendix J

Suggested starting speeds to freeze the action of different events

Table J.1

Location	Shutter speed (seconds)
Motor sport – straight towards the photographer	1/1000
Motor sport – turning a corner panning	1/125
Athletics – running	1/250
Athletics – long/high jump	1/500
Football	1/250
Ballet dancer leaping – fully lit stage	1/250 (non-pan)
Ballet dancer – fully lit stage	1/125
Pole vault	1/500

Appendix K Flash guide numbers, apertures and distance

Use Table K.1 as a quick reference for the relationship between guide number, aperture, ISO and subject-to-camera distance.

Table K.1 Flash guide numbers, apertures and distance

Guide number of flash	Aperture					
	f2.8	f4.0	f5.6	f8.0	f11	f16
	Distances from camera to subject for good exposure (m)					
10	3.50	2.5	1.78	1.25	0.90	0.62
20	7.10	5.0	3.57	2.50	1.81	1.25
30	10.71	7.5	5.37	3.75	2.72	1.87
40	14.28	10.00	7.14	5.00	3.63	2.50
50	17.85	12.50	8.92	6.25	4.54	3.12
60	21.42	15.00	10.71	7.50	5.45	3.75

NB: This table assumes you are using an ISO of 100, that you are not bouncing, diffusing or zooming the flash, and that the distance measurement is in meters.

Appendix L **Using a hand-held meter**

Modern small-format cameras have a light meter built into the camera measure the light falling on or reflected by the subject to calculate exposure. But you will not find this feature in older cameras, or in most cameras taking larger formats. You then have to buy a separate, hand-held exposure meter. Used properly this will measure the light and read out the appropriate combination of f-number and shutter speed to set for the film you are using.

A small hand-meter simplifies making local readings of highlight and shadow parts as it is easier to bring near to the subject than moving the whole camera. In fact, you can measure exposure without taking out the camera (an advantage for candid work). However, since the meter does not measure light through the camera lens you must be prepared to adjust the exposure settings it suggests when shooting close-ups.

A traditional hand-meter has a light-sensitive cell at the front to measure the light reflected from your subject. You first set the ISO rating of your film or sensor, point the meter towards the subject and press the button to take a reading. The meter will display a suggested shutter speed and aperture setting of the ISO value and the light in the scene. Often it is possible to display other shutter speed and aperture combinations that will result in the same exposure, given the user the ability to adjust settings to suit aesthetic differences such as blurred movement or depth of field effects.

Figures L.1 Making highlight and shadow readings. (Top) Direct from subject itself. (Above) From substitute hands in direct light and shadow.

Different ways of making readings

Any hand-meter pointed generally at your subject from the camera position will give an exposure reading based on the assumption that the subject has roughly equal areas of light and dark. Some hand-meters have a white plastic diffuser, which slides over the cell. You then hold the meter at the subject, its cell facing the camera, when taking your reading. This 'incident light' measurement scrambles all the light reaching parts of the subject seen by the camera, ignoring light or dark unimportant background.

A very accurate way of working is to take two undiffused readings, pointing the meter direct at the darkest important shadowed area, and then at the brightest important highlight area. You then split the difference between the two. For example, for Figure L.1, readings were taken about 15 cm (6 inches) from the lightest and then the darkest parts of the man's head. The camera was then set to exposure settings midway between the two readings.

When a subject cannot be approached so closely try taking readings from nearby substitutes under the same lighting. For example, in Figure L.1 the photographer is reading off the matching skin of his or her own hands – first turned towards, then away from, the same lighting received by the face. In landscapes you can read off the grass at your feet for grass on a distant hill – provided both are under the same lighting conditions. Remember, though, when taking any form of reading, not to accidentally measure your shadow or that of the meter.

Exposure increase for close-ups and filtered images

When you are shooting subjects very close up (using extension rings or bellows to get a sharp image), the image is less bright than with a normal lens setup – even though lighting and f-number remain the same. Inside the camera the effect is like being in a darkened room with a slide projector being moved away from the screen (the film). By extending the bellows you can focus the camera lens for an ever-closer subject, the image becomes bigger but also *dimmer*.

If your camera measures exposure through the lens itself this change is taken into account by the metering system, but when using a separate meter you must increase the exposure it reads. In practice the increase starts to become significant when you focus on a subject closer than about five times the focal length of the lens you are using, growing greater as you focus on subjects closer still, e.g. something 250 mm from a 50 mm lens needs only 1½ times the normal exposure; at 170 mm it requires twice, and at 100 mm four times the exposure the hand-meter shows. To calculate exposure increase multiply the exposure shown on the meter by $(M + 1)^2$, where M is magnification, meaning height of image divided by height of subject.

For example, photographing a 30 mm high postage stamp so that it appears 12 mm high on the film. As magnification is 0.4 you must multiply exposure by 1.4^2 which is 2. You can increase exposure either by giving a slower shutter speed, or by opening up the aperture – one f-number for a × 2 increase, one and a half for × 3, and so on.

Adding a filter to the front of your camera also alters the amount of light hitting the film or sensor. Each filter has an associated Filter Factor that indicates the increase in exposure necessary to compensate for this light loss. The easiest way to take into account the filter factor is to multiply the shutter speed by the factor. For example, applying a filter factor of 4 to shutter speed of 1 second would involve multiplying the exposure by 4 giving a new exposure of 4 seconds. Using the same filter but with a shutter speed of 1/60th second would result in an exposure of 4/60th of a second which equals 1/15th of a second.

Appendix M Batteries

Practically every modern camera relies on some form of battery to power its auto exposure or focus systems, film wind-on, flash, or digital capture and processing systems. When a camera fails to operate, or functions in a sluggish way, the cause can almost always be pinned down to exhausted battery condition or poor contacts. You should always keep your batteries well charged and where ever possible always carry a backup set.

In general, remember that batteries are affected by temperature. Low temperatures slow down their chemical reaction, resulting in erratic or sluggish camera operation. Make sure batteries are inserted with the polarity (+ or –) marked on their contacts matching the terminals in your equipment.

Safety points

Keep batteries away from young children – some tablet types look like sweets. Never allow anyone to try opening a battery or throw it on a fire. Do not attempt to recharge batteries other than those marked possible to do so, recharge with the recommended unit. It is good practice to remove the batteries from photographic equipment you will not be using for some months. Changing non-rechargeable batteries once a year is also advisable – especially before going to a location where the correct replacements might be difficult to buy.

Appendix N Health and safety in photography

The equipment and processes used in photography are not particularly hazardous, provided you take one or two (mostly common sense) precautions. For example, the use of electrical equipment in the studio, or within the darkroom in the presence of water and dim lighting, clearly requires care. Similarly, when you are using photographic chemicals it is best to adopt working habits which pay due regard to your health.

Electrical equipment

Remember that studio spotlights and floodlights produce heat as well as light. The *bottom* of the lamp head is always cooler than the *top*, so only grip the bottom when tilting the light. Never drape any diffusing or filtering material you may be using over a lamp head. Instead, arrange to support it a foot or so in front of the lamp (even just hold it there when you take the picture). Keep lamps and curtains well apart for similar reasons, and don't leave lamps on in an empty room.

Each lighting unit needs a plug fitted with an appropriate fuse. Lamp wattage divided by the supply voltage tells you how many amperes are drawn. Fit a fuse rated just slightly above this figure, e.g. use a 5 A fuse if the lamp draws four or less amperes. Just fitting a 13 A fuse in every plug reduces your protection as its rating is much higher than the amperes drawn by the light. All lighting equipment should be earthed ('grounded') through a third wire.

Watch out, with items like lamps which you move about, that the cable does not fray where it enters the lamp head, and that the connections at each end have not worked loose. Never try to remove a bulb from its socket whilst it is still hot, and make sure your lighting unit is disconnected before fitting a new lamp. Be careful not to have the power cable stretched between socket and lamp head so you can trip over it, or have the unit set up in a way that makes it unstable and top heavy.

Most flashguns have two circuits – a trigger circuit to the shutter which uses a very low and harmless current, and an internal higher powered circuit to the flash tube. Never try opening up the internal electrics to repair your unit. Even though battery operated it may be storing enough electricity to give you a powerful shock.

In the darkroom, where water is present, it is even more important to have your electrical equipment – enlarger, safe light, ventilator – properly fused and earthed. Avoid having sockets or switches where someone might grasp them with a wet hand – near the sink, for example. If possible, have all switches fitted to the ceiling and operated by non-conductive pull-cords. Avoid running wiring under, or close to, sinks, metal drying cabinets, etc. Your power supply outlets should be at benchtop height, never at floor level in case of flooding.

Care with chemicals

Handle photographic chemicals with the same care as other chemicals used around the home. Always read any warning on the label, especially if you are unfamiliar with what you are about to use. If any contents are hazardous the container will have first aid measures labelled.

Avoid splashing chemicals into your eyes or onto your skin, particularly skin that is dry and chapped. A few people may have an adverse reaction to chemicals such as developers, resulting in skin irritation. Waterproof gloves are then essential when film processing or printing. It is always a good idea to wear simple eye protectors and gloves (rubber or plastic) when preparing

chemicals, especially if you are dissolving chemicals in powdered form. Never use a punctured glove though – it can give your hand prolonged contact with trapped liquid chemical.

Wearing gloves can be uncomfortable and impractical if you are working for long sessions, constantly moving from wet to dry bench operations, as in printing. At least keep your hands out of solutions by using tongs or paddles to move chemical-covered prints.

Always try to mix chemicals where the ventilation is good and there is running water nearby to dilute any splashes. If you spill any chemical clean it up as soon as possible. Spilt solution soon evaporates, leaving behind a chemical dust that blows about. This is easily inhaled or accumulates in odd corners of your darkroom.

Don't have food or drink in any room where chemicals are used. Make sure all your storage containers are accurately labelled, and *never store chemicals in food or drink containers*. Someone else may assume they are for consumption. For similar reasons keep all photographic chemicals out of the reach of children. Don't store chemicals, or solutions, in a refrigerator or freezer.

Appendix O Black and white film processing and printing

Processing black and white negatives is in many ways like cooking – you use liquids, and have to control time and temperature quite carefully. You also need some basic equipment. The ten most important items are shown in Figure O.2.

Loading the tank

Before you try using a tank for the first time, practice loading with a scrap film, or an unwanted (and uncut) length of negatives. Do this first in the light, then with your eyes closed, then in a darkened room. It's important not to force and buckle the film during loading, or you may get results as shown in the film troubleshooting section (Part 10) of this book. The shaped tongue must be cut off the front end of the film to give a square shape for loading. If necessary, use a retrieving tool to slip into the cassette without fogging film (Figure O.1). Having pulled out the tip, you can then do your trimming in the light.

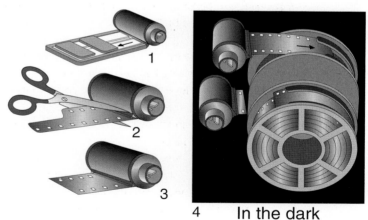

Figure O.1 (Left) Retrieving and trimming the film end, in normal lighting. (Right) Loading into the film reel, in darkness.

The stage after this – winding a whole exposed film into the reel – only takes a few minutes but must be done in total darkness. If you don't have a darkroom use a large cupboard. It is also possible to untuck one side of your bed, pushing your hands in deep under the blankets in between the sheets. Alternatively, buy a light-proof 'changing bag', which pushes onto your arms. Feed film in direct from the cassette (as shown in Figure O.1) or use a cassette or bottle opener to take off one end and withdraw the spool of film. The actual way the film slides into

the reel grooves depends upon your particular make of tank. Some are cranked in, others just pushed. As soon as the whole film is loaded, place the reel in the empty tank and fit on the lid. After this point you can then do all your processing in ordinary lighting.

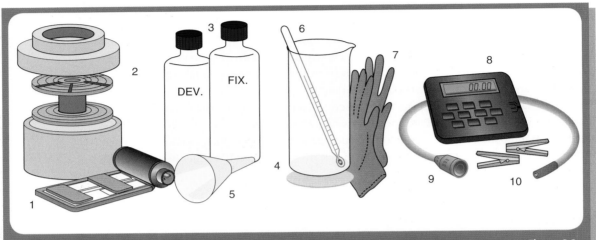

Basic equipment for processing film

Figure O.2

1 *35 mm film-end retrieving tool.* Used to extract the first inch or so of film if wound fully into the cassette, so it can be prepared for tank loading (see Figure 0.1 for the precise steps involved).

2 *Light-tight plastic tank containing a reel.* You push or wind your film into the spiral groove of the reel in the dark; the whole length is held only along its edges, with each turn slightly separated from the next so that processing solutions act evenly over its entire surface. Each solution is poured in through a light-proof hole in the tank lid. You block off the hole and invert the tank at set intervals to agitate the solutions; some tanks have a plastic rod to rotate the reel for the same purpose.

3 *Bottles containing developer and fixing solutions.* Start off by using the developer recommended on your film's packing slip. A standard fine-grain developer such as Ilford ID11 or Kodak D76 (made up from powder) is a good choice. You can also buy most developers in liquid concentrate form, which are quicker and easier to prepare. Made-up developer can be stored for weeks in a stoppered container. The acid hardener fixing solution is simpler and cheaper, and is also known by its main constituent 'hypo' (sodium thiosulfate). Unused fixer keeps indefinitely. Never let developer and fixer mix, because they will neutralize each other.

4 *Measure.* A plastic measuring graduate holding sufficient solution to fill your tank.

5 *Funnel.* A plastic funnel for re-bottling solutions.

6 *Thermometer.* A photographic thermometer clearly scaled from about 13°C (55°F) to 24°C (75°F).

7 *Thin plastic gloves* for handling chemicals (see the safe handling recommendations below before using any chemicals).

8 *A minute timer.*

9 *A flexible plastic tube* for directing wash water down into your tank through the lid hole.

10 *Plastic pegs* to attach to the top and bottom of your processed film when it is finally hung up to dry on a nylon cord.

Using the solutions

The various stages and typical times of processing are shown in Figure O.3. Developer solution, waiting in the graduate at the recommended temperature (normally 20°C), is poured into the

tank and the clock started. The time required depends upon the developer and type of black and white film you are processing. The hotter the developer, the faster it will work. Conversely, developer that is cool will take longer to process the negatives. It is critical for you to measure the temperature of the developer and then use the time/ temperature/film chart (usually supplied with the developer or film) to calculate the length of time that your specific film must be processed. In addition, you must regularly agitate the solution to avoid streaky development, typically by gently inverting the tank several times during the first 30 seconds, and then for 5 seconds every half minute. At the end of development you pour the solution out through the light-tight tank top. It is either poured away (if one-shot only) or returned to its bottle for reuse.

Although you cannot yet look, inside the tank the creamy surface of your film now carries a black image corresponding to where it received light in the camera. For the next step, which is a rinse, you fill the tank to overflowing with water and immediately empty it again. Repeat this process at least five times. This helps to remove developer from the film (alternatively use a 'stop bath' solution, which halts development faster).

Now fixer solution is poured into the tank and initially agitated. Fixer temperature is less critical than developer – room temperature is adequate. The fixer turns creamy silver halides unaffected by development into colorless compounds that can later be washed out of the film. Generally, but depending on your film and developer type, you will need to immerse your film in the fixer solution for about 10 minutes, but after 1–2 minutes most of the film's milkiness will have cleared and you can remove the tank top without having light affect your

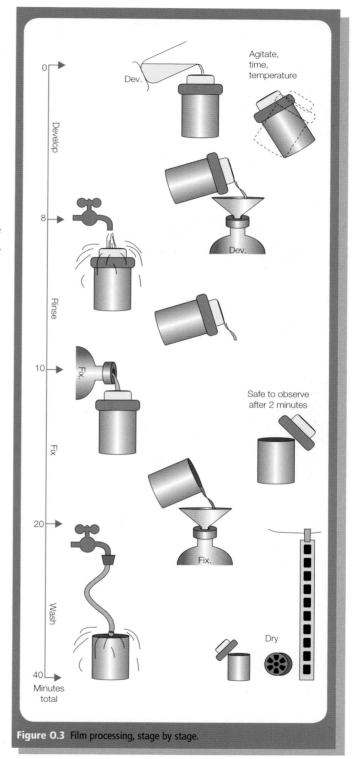

Figure O.3 Film processing, stage by stage.

Figure 0.4 Sleeved pages hold strips of processed 35 mm negatives and fit into a ring binder.

Figure 0.5 Darkroom in adapted bathroom.

results. When the film has finished its fixing time, the solution is returned to its bottle.

Next, a 20-minute wash in cold water removes all remaining unwanted chemicals and you can remove the processed film from the reel and carefully hang it up to dry, with a peg attached to each end. A few drops of photographic 'wetting agent' in the final wash water will help the film dry evenly. Always hold film by its edges only. Once it has fully dried, cut it into convenient strips of five or six negatives and immediately protect these in sleeves made for the purpose (see Figure 0.4).

Contact printing

Film processing does not really require a darkroom, but before you can print or enlarge your negatives you will have to organize yourself some kind of blacked-out room to work in. This might have to be the family bathroom, quickly adapted for the evening (see Figure 0.5). Maybe you can convert a spare room, or perhaps you are lucky enough to have use of a communal darkroom designed for the purpose at a school or club.

The darkroom

The most important features to consider when you are planning a darkroom are:

- **blackout;**
- **ventilation;**
- **water supply; and**
- **electricity.**

Excluding the light

Existing windows have to be blocked off – either temporarily using thick black plastic sheeting or paper, or more permanently with hardboard. Alternatively, buy a fabric roller blind blackout. As long as you have kept out unwanted white light, the walls of the room can be quite pale toned – a matt white finish helps to reflect around the colored illumination from your safe light, designed not to affect the photographic paper.

Ventilation

Working alone for an hour in the darkroom you may not find the air too stuffy, but for groups working for longer times you need a light-tight air extractor fan. A communal darkroom also needs a light trap instead of a door. This helps the circulation of air and makes it easy for people to enter or leave without disturbing others. Wall surfaces inside the light trap are painted matt black, to reduce reflections.

Water supply

In the bathroom, use the bath to wash prints and the hand basin to rinse your hands, free of chemicals. The permanent darkroom has a large, flat-bottomed PVC sink to hold trays for processing solutions, and a tank or tray for print washing. Always separate the wet stages of darkroom work from 'dry' work, such as handling the enlarger and packets of paper. In the larger darkroom, each activity can take place on different sides of the room.

Electricity

Take special care over your electricity supply, needed for the enlarger and safe light, because electricity and water can be a lethal combination. Never let wires or switches come into contact with water or wet hands. Take your supply from a three-pin socket, and include a circuit-breaker of the type sold for garden tools. Metal parts of your enlarger or safe light should be connected to the earth wire ('grounded'). This is especially important in any board-over-the-bath bench arrangement. Take out any temporary wiring as soon as you have finished work, even if you intend to return within a few hours.

Equipment for contact printing
Print processing

Most of the items necessary for contact printing are shown in Figure O.6. You need at least three plastic trays (1) big enough for your prints – 12 in × 10 in is a good size. One is for developer, one for rinsing and washing, and the other for fixing. Print developer (2) is similar to, but much faster-acting than, negative developer. It comes as a concentrated solution, diluted just before use and discarded after your printing session. The fixer is a less concentrated form of negative fixer, and can be reused.

You also need the measuring graduate (3) used for films and a photographic tray thermometer (blue spirit or LCD with red display). The thermometer (4) stays in the developer tray to tell you if the solution is too warm or cold. Plastic tongs (5) – one for developer, the other only for fixer – allow you to keep your hands out of solutions. A washing hose (6) connects the cold water tap to the rinse tray and turns it into a print washing device. Have a clock (8) to time minutes during processing and (if you have no enlarger timer) seconds during exposure.

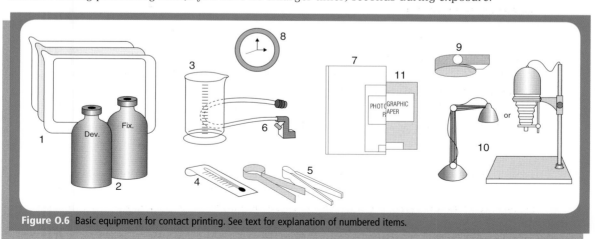

Figure O.6 Basic equipment for contact printing. See text for explanation of numbered items.

Emulsion
side down

Figure O.7 Using an enlarger to give a patch of light for exposing a contact print.

Suitable orange lighting is permissible in the printing darkroom (7), as black and white paper is not sensitive to this color. You can buy a bench or hanging safe light (9), which contains a 25-watt bulb behind dyed glass, or use a fluorescent strip light with a special colored sleeve (10). The safe light is positioned near the developer tray but no closer than specified, usually 1 m (3 ft).

Exposing equipment

To expose your contact print you need an even patch of white light, which will shine through the negatives laid out on the paper. You could use a reading lamp fitted with a 15-watt bulb, but as an enlarger will be needed later for making bigger prints of individual negatives, this can conveniently provide your contact printing light. All you have to do at this stage is raise it to a height where it provides a large enough patch of light for your print, as shown in Figure O.7.

The negative strips can be held down in tight contact with the light-sensitive printing paper during exposure by a sheet of thick glass. Better still, buy a proper contact printing frame – glass with thin plastic grooves on its underside to hold the film, and hinged to a baseboard.

The light-sensitive paper

Most black and white photographic paper is known as bromide paper (due to the silver bromide used in its light-sensitive emulsion). It comes in different sizes, surfaces and types of base, and is available in either grades of contrast or the more popular multi-contrast variety. The 10 in × 8 in size just accommodates seven strips of five 35 mm negatives. Start off with a packet this size of glossy, resin-coated (RC), multigrade paper. You will also need a set of simple enlarger filters to adjust the contrast of the paper.

Printing a contact sheet

It is best to make a contact print from every film you shoot. This way you have a visual file of all your pictures from which to choose the ones to enlarge. Prepare the solutions in their trays and bring the developer to its recommended temperature (usually about 20°C). Now you can change the lighting in your darkroom to safe lighting and open your packet of paper. Position one sheet, glossy side upwards, under the switched off enlarger and re-close the packet. Lay out your negatives in rows on the paper with their emulsion (dull) side downwards. Have all the edge numbers running the same way – it is irritating later to discover one row of pictures upside down. Then cover over the negatives with the glass.

Insert a grade 2 (normal contrast) filter into the enlarger lamphouse. Then, with the enlarger near the top of its column and the lens stopped down two f-settings from widest aperture (usually about f8), give a trial exposure of about 20 seconds. Remove the glass and put your negatives carefully to one side. Slide the exposed sheet of paper smoothly under the surface of the developer. Note the time on the clock and rock the tray gently to keep the paper fully

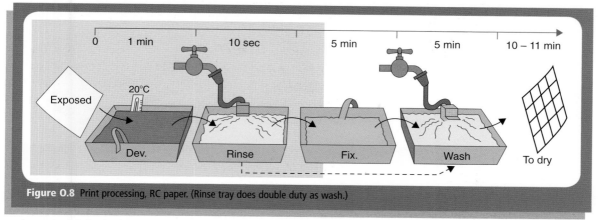

Figure O.8 Print processing, RC paper. (Rinse tray does double duty as wash.)

submerged. Magically, the shapes of the frames on your film appear on the paper, then the pictures themselves – growing darker and stronger all the time. But keep one eye on the clock and remove the print when its recommended development time is up (typically 1 minute at 20°C for RC paper).

Maintain the same time in the developer for each successive print no matter how fast or slowly the print darkens – in the printing process you alter the results by exposure, and always keep development consistent. The print next has a quick rinse (approximately 30 seconds in running water) and then goes face down into the fixer tray. Full fixing generally takes about 5 minutes, although after 1 minute or so you can switch on normal lighting. See Figure O.8.

If results were too dark, you would give a shorter exposure time (less than the original 20 seconds) or reduce the lens aperture (change to a bigger aperture number); if too pale, increase exposure time (more than 20 seconds) or widen the aperture (change to a smaller aperture number).

Prints can be allowed to accumulate in the fixer – for up to half an hour if necessary – before you put them to wash as a batch. Washing also takes about 5 minutes, but keep separating the prints now and again, and prevent any floating face upwards to the surface, where washing will be ineffective.

Drying prints

The simplest way to dry your washed prints is to first wipe off surplus water with a sponge or a flat (window-cleaning type) squeegee. Then peg them on a line, or lay them face up either on clean photo blotting paper or a fiber-glass drying screen or muslin stretched on a frame. Special hot-air driers are made that accept RC black and white paper and all color papers. They give you dry results in a few seconds, but even when left at room temperature these plastic papers will dry within about 15 minutes. See Figure O.9.

If you have made black and white prints on fiber-based paper, which is more like drawing paper, peg them up in pairs back to back to avoid curling. Never attempt to put fiber paper through an RC drier. A few drier/glazers are designed for fiber-based printing papers. Don't try glazing RC papers of any kind – the face of your prints will become stuck to the equipment! Glossy RC paper air dries with a shiny finish.

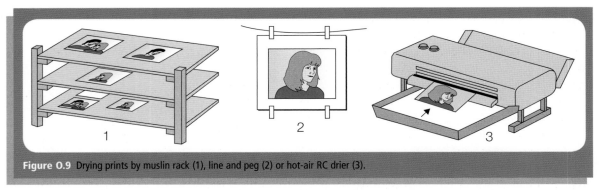

Figure 0.9 Drying prints by muslin rack (1), line and peg (2) or hot-air RC drier (3).

When the print is dry, number your contact sheet on the back with the same reference number you put on your set of negatives. Check carefully to see which images are sharp enough to enlarge, what people's expressions look like, whether the composition works, and so on. Using grease pencil drawn on the print surface, mark up your best shots, showing possible cropping. As you will probably be checking these contacts in the darkroom, don't use pencil marks in a color (reds or oranges) that makes them invisible under safe lighting. If you have several very similar images in your contacts, double-check the edge number to ensure you put the negative that you selected into the enlarger.

Enlarging

Making an enlargement reveals details and gives an impression of 'depth' to your pictures that is lost in a small print. During enlarging you can decide to exclude parts of the negative in order to improve composition, darken or lighten chosen local areas of the picture, and juggle with contrast and density so that (within limits) you can compensate for negatives that are slightly dark (overexposed) or pale (underexposed). It is even possible to construct pictures with the enlarger, by combining parts of different negatives into one print.

The 35 mm enlarger

Up to now, the enlarger has just been a handy source of light for contact printing, but before making enlargements you need to understand it in more detail. Basically, an enlarger is like a slide projector, although it has a much less powerful lamp and is attached to a vertical stand. Inside, to ensure that your negative is evenly illuminated, the light first passes down through large condenser lenses, or a plastic diffusing screen. The negative itself is held flat, its dull (emulsion) side downwards, between two halves of a carrier having a rectangular cut-out the size of one film frame. Alternatively, some models have two sheets of glass in the carrier that sandwich the negative to keep it in place. The negative carrier pushes into a slot in the enlarger just below the condensers or diffuser.

Below the negative is a lens (typically 50 mm focal length), which you can move up or down to focus a sharp image on the enlarger baseboard. Adjustable bellows prevent the escape of any light between carrier and lens. An enlarging lens needs no shutter but has an adjustable aperture, usually scaled in f-numbers. As is the case with our camera lenses, changing from one f-number to another doubles or halves the amount of light, which in turn alters the brightness of the image. (As you can feel and hear the position of each setting by a 'click', it is unnecessary to keep peering at numbers.)

Your enlarger may also contain a filter drawer in the lamphouse, as Figure O.10 shows, to accept contrast-changing filters for variable contrast ('multigrade') paper. Alternatively, a filter holder can be attached to the lens or you can 'dial-in' colored filtration using the dials at the top of the enlarger head.

The whole enlarger head can be moved up or down a firm metal column and locked at any height to control the size of enlargement. On the base board, you will need to place a masking easel, which has a white base surface and a hinged frame with adjustable metal strips. You can move the easel around to compose your enlargement, adjusting the side-strips to give a picture of the chosen size and proportions. During exposure, the bromide paper is held down flat and correctly positioned under the strips on all four sides. The strips also prevent light reaching the paper and so give your enlargement neat white borders. Avoid holding paper down by glass – this upsets sharpness and may introduce dust specks and scratch marks.

If possible, have an enlarging exposure timer – a clock-based switch that plugs in between enlarger and power supply. You set the estimated number of seconds needed, press a button and the lamp switches on for a duration of exactly this time. Another useful aid is a focusing magnifier. This is a tool used to magnify a small part of the

Figure O.10 Parts of a (condenser) enlarger.

image to help fine-tune the print focus. You place this on the masking easel and look through it whilst focusing the enlarger.

The printing paper

For making enlargement prints, you use the same type of light-sensitive paper as for contact printing. In other words, it can have a plastic RC base and so be a fast processing type that uses the same process as outlined in Figure O.8. Or you might prefer a fiber-based paper (better for mounting and retouching, but less readily available and slower to process and dry). The surface may be glossy or semi-matt (again better for any additional handwork later).

Contrast

You can control the contrast of your enlargement – normal, hard (more contrast), soft (less contrast) – in two ways. Either buy packets of graded paper – grade 1 (soft), grade 2 (normal) and grade 3 (hard), or instead use one packet of variable contrast or 'multigrade' paper and buy

a range of filters to tint the enlarger light for each of the different grade effects. Using graded papers means you must buy several packets at once and it can mean that you may run out of a particular grade right when it is needed. 'Multigrade' paper is therefore a more economical approach (once you have bought your multi-contrast filters). In addition, you can make prints that differ in contrast between one chosen part and another.

Making a test print

Start by picking a negative that has plenty of detail and a good range of tones (see Figure O.11). Set the masking frame for the size of paper you are using. Position the negative dull side downwards so that the shot you want to enlarge fills the cut-out part of the carrier. Check that there is no dust on the film surface (a can of compressed air is useful here) and then insert your negative into the enlarger. Fit a grade 2 filter (normal contrast) if you are using multigrade paper. Open the lens aperture fully. Switch on the enlarger and change the darkroom from ordinary light to safe lighting. You can now visually focus the projected image on the white easel

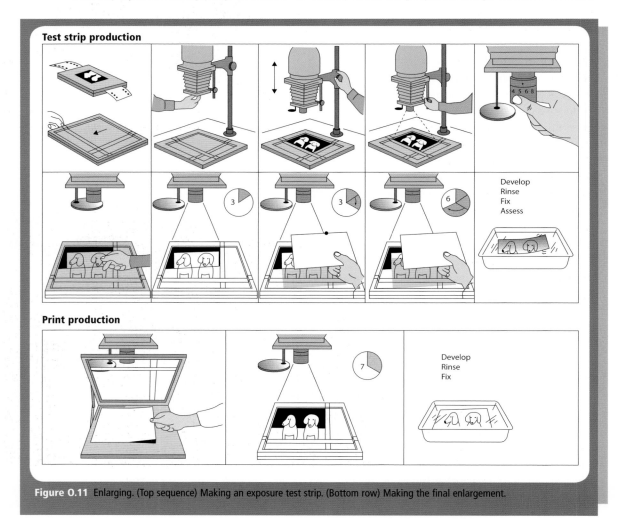

Figure O.11 Enlarging. (Top sequence) Making an exposure test strip. (Bottom row) Making the final enlargement.

surface, making further adjustment to enlarger height if necessary until the picture is exactly the size you want, and sharp. Close down the lens aperture by about two clicks (three clicks if the negative is pale, or one if rather dark). Switch off the enlarger.

Cut or tear part of a sheet of your printing paper to form a test strip, and lay it face upwards on the easel, where it will receive an important part of the image (the puppies' heads). Now, by shading with a piece of card, give the paper three different exposure times, in strips as shown in Figure O.12. Carefully decide the most informative way for each strip of exposure to run. Don't arrange them like the top test strip, in the example, which only shows you how the longest exposure affects one puppy and the shortest exposure the other. Instead, by making each band run lengthways, it allows you to discover how much each exposure time affects the tone of both the dogs.

To get this result, the whole test piece of paper was first given 3 seconds. Then, holding thick card an inch or so above it, two-thirds of the paper received 3 seconds more. Finally, the card was shifted to give the final third another 6 seconds. The combined effect was therefore to give strips of 3, 6 and 12 seconds. By holding the card quite still, a noticeable line of tonal change records on the print, which helps you pick out the different exposure bands when you judge results.

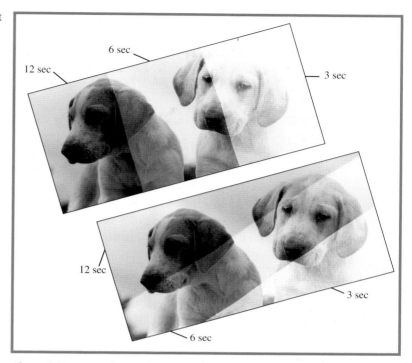

Figure O.12 Processed series of test exposures – the bottom version gives the most information.

Figure O.13 The final enlargement.

The test strip is processed in the same way as the contact sheet on the previous pages. You can then switch on normal lighting to decide which is the best exposure. If all three strips are too pale, make a further test using longer exposure times, or a wider lens aperture. In the example picture, an exposure time of about 7 seconds was judged correct for the puppies. So next a whole sheet was given this exposure and, when processed, produced the result shown in Figure O.13.

Appendix P Chemically treating black and white prints

Even after you have made a black and white bromide print, there are still several ways you can alter the image by chemical means. You can decide to make your picture lighter in tone or bleach away parts to white paper, or tone it so that the neutral black image turns into a color. All these chemical treatments are carried out in trays, working under ordinary room lighting.

Start off with a fully fixed and washed print. If it has already dried re-soak it in water for 2–3 minutes, then blot it or wipe off surplus liquid. Working on a damp print helps the chemicals to act evenly.

Reducing (lightening) the image

Farmer's reducer is a mixture of potassium ferricyanide and hypo (see formula, page 333). This forms a yellow solution which you apply on a cotton wool swab to over-dark parts of the picture. Then immediately hold your print under a cold water tap to halt the reduction. Examine the effect carefully. Repeat the process – just a little at a time – until the part of the print (or the entire image) is sufficiently lightened. If you go too far there is no way you can bring back the image again. Finally re-fix and wash the whole print.

Farmer's reducer has its most rapid effect on the palest tones in an image, so it is excellent for the overall 'brightening up' of pictures with veiled-over (gray) highlights. Don't expect to rescue a really dark print this way, however – if overdone the reducer leaves a yellowish stain and brownish-black tones. Farmer's reducer can also be used to lighten very dense, low-contrast negatives; i.e. overexposed and underdeveloped. At the same time it greatly exaggerates the graininess of the image.

Bleaching to white with iodine

By using an iodine bleacher you can erase chosen parts of your print right down to white paper, without leaving any final stain. It is ideal for removing an unwanted background to a subject, leaving it with a 'cut-out' appearance. Two separate solutions are needed – the bleacher itself and a tray of print-strength fixer.

As Figure P.1 shows, paint over the unwanted area of your print with a swab of cotton wool (changing to a watercolor brush when working close to the edges of fine detail). A strong brown stain immediately appears, with the black image fast vanishing beneath it. Wait until the unwanted parts have lost all their black silver, then rinse the whole print in water for at least 30 seconds. Next put it in the fixer solution for 5 minutes or so until the brown stain has completely disappeared, leaving clean white paper. Finally, wash the print for the same time recommended for your printing paper after regular fixing.

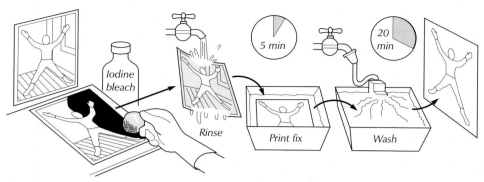

Figure P.1 Erasing the background from a print with iodine bleach.

Sepia toning

Changing the print image from black into sepia is the simplest and most popular toning process. It gives a rich sepia or chocolate color, like a nineteenth-century photograph. Sepia toning is also advisable before hand coloring.

You need two separate solutions, bleacher and toner. Slide the print into the tray of bleacher, face up, and rock it for a minute or so until the once black image is bleached to a pale straw color. You then rinse it under the cold water tap and place it in a tray of toner solution. The picture reappears in a sepia color within a few seconds, but needs 2–3 minutes to reach full richness and depth. You finish off by washing and drying in exactly the same way as when making the print in the first instance.

The image now consists of brownish silver sulfide instead of the usual black metallic silver. This is very permanent – you cannot return a sepia print to black. Remember too that with toners of this kind bleaching is essential before the black image can become sepia. You can therefore *selectively* bleach, say, just the background to your main subject by carefully applying bleacher on a brush or swab. Only this area then becomes sepia in the toner, leaving the main image untoned.

Another alternative is to dilute the bleacher with an equal volume of water to slow its action. You then immerse the whole print but remove it before darkest grays and shadows have lost their black appearance. After completing the toning stage of the process as normal your picture consists of a mixture of sepia and black. Results have deeper brown–black shadows than given by full toning. And if you don't like the result just re-bleach your print to affect the remaining black parts and tone the print again to get a fully sepia image.

Figure P.2 Routine for sepia toning prints.

You can also buy kits of multi-toner chemicals, typically consisting of a bleacher and a range of toners, each of which will result in a different color image. A kit with yellow, magenta and blue toners permits you to mix them in varying proportions (blue and yellow to get green, for example) and so form a wide choice of image hues. Most results are rather garish; some are not very permanent and alter with time.

Multi-brown toner

Moving beyond simple sepia toner it is possible to alter the distinct shade of brown using a two-part brown toner based on thiocarbamide. Sepia provides a constant color change to all your prints. You have no choice about the shade of brown that your images become. In contrast the two-part thiocarbamide toner detailed here will give you a color choice in the toning process. By adjusting the ratio of parts A and B of the toner, you can produce a range of browns from purple brown, through a neutral brown, to yellow brown. In this way you can control the color of the final print.

To start coloring your prints, you must first carefully make up the bleach and toning solutions. Ensure that the print to be toned is fully fixed and carefully washed. Bleach the photograph by gently agitating the picture in a tray of the bleaching solution. Wash the image until all yellow staining is removed. Mix toner parts A and B to the ratio needed for the color you require. Immerse the print into the tray of toner and agitate until all toning stops. Wash the photograph again and dry as normal.

Table P.1 Colors associated with different mixing ratios of part A and B thiocarbamide toner

Thiocarbamide toner ratios and resultant print tones:			
Toner solution part A	Toner solution part B	Water to be added	Print tone
10 ml	50 ml	500 ml	Purple brown
10 ml	30 ml	500 ml	Cold brown
10 ml	10 ml	500 ml	Brown
30 ml	10 ml	500 ml	Warm brown
50 ml	10 ml	500 ml	Yellow brown

It may be helpful to make up a toning palette to assist you with deciding what tone your next print will be. Smaller changes in color can be achieved by adjusting the ratios of the toner parts. Keep in mind when you are experimenting that not all photographic papers are manufactured in the same way using the same emulsions. Such differences will change the way in which the toner reacts with the image. For example, a chlorobromide-based paper will always give you a warmer toned image than a straight bromide paper (see formula below).

Chemicals required

Farmer's reducer and most toners can be bought as packs of ready-weighed powders and liquids from manufacturers such as Tetenal. This is the most convenient and, in the long run,

cheapest way of working. To make up your own solutions, however, prepare them from the following chemicals. Follow the handling precautions described on page 330.

Iodine bleacher

Warm water	400 ml
Potassium iodide	8 g
Iodine	2 g
Water up to	500 ml

Farmer's reducer

(a) Potassium ferricyanide	5 g
Water	500 ml
(b) Sodium thiosulfate	
(hypo crystals)	80 g
Warm water	500 ml

Mix equal quantities of (a) and (b) just before use (does not keep as a single solution).

Sepia toning

Bleach in:

Potassium ferricyanide	20 g
Potassium bromide	20 g
Water up to	1 liter

Tone in:

Sodium sulfide	20 g
Water up to	1 liter

The sulfide in this formula gives off a 'bad eggs' smell, especially when diluted. Use it in a well-ventilated area, away from films and papers.

Thiocarbamide toner formula

Bleach solution:

Potassium bromide	50 g
Potassium ferricyanide	50 g
Water to make	500 ml

Dilute 1 part bleach solution to 9 parts water before use.

Part A solution:

Thiocarbamide	50 g
Water to make	500 ml

Part B solution:

Sodium hydroxide	50 g
Water to make	500 ml

Note: add sodium hydroxide slowly to the water.

Glossary

AE Automatic Exposure metering, i.e. the camera measures the light and sets shutter speed and aperture (either or both).

AE lock (AE-L) Locks an automatic exposure setting in the camera's memory.

AF Auto-focus.

AF lock (AF-L) Locks an auto-focus lens at its present focus distance.

Aliasing The jaggy edges that appear in bitmap images with curves or lines at any angle other than multiples of 90°.

Angle of view The extent of the view taken in by the lens. It varies with focal length for any particular format size. The angle made at the lens across the image diagonal.

Aperture (of lens) Size of the lens opening through which light passes. The relative aperture is calibrated in f-numbers, being the diameter of the beam of light allowed to pass through the lens, divided into its focal length. Widest relative apertures therefore have the lowest f-numbers. All lenses set to the same f-number give images of a (distant) scene at equal brightness.

Aperture preview Button on some SLR cameras to close the lens to the aperture set for photography. Allows you to visually check depth of field in the viewfinder.

APS Advanced Photographic System. Easy-load cameras and film cartridges 30 per cent smaller than 35 mm (see page 54).

ASA Stands for (obsolete) American Standards Association. The initials were once used for a film speed rating system. Now replaced by ISO.

Aspect ratio This is usually found in dialog boxes concerned with changes of image size and refers to the relationship between width and height of a picture. The maintaining of an image's aspect ratio means that this relationship will remain the same even when the image is enlarged or reduced.

Auto-focus (AF) System by which the lens automatically focuses the image of a selected part of your subject.

Av Aperture value. AE camera metering mode by which you choose aperture, and the metering system sets shutter speed (also called aperture priority).

'B' setting Brief or bulb. On this setting the camera shutter stays open for as long as the release button remains depressed.

Background printing A printing method that allows the user to continue working whilst an image or document is being printed from a computer.

Batch processing Refers to a function or a series of commands being applied to several digital files at one time. This function is useful for making the same changes to a folder full of images. In Photoshop Elements, this function is found under the File menu and is useful for converting groups of image files from one format to another.

Bit Stands for 'binary digit' and refers to the smallest part of information that makes up a digital file. It has a value of only 0 or 1. Eight of these bits make up one byte of data.

Bitmap or 'raster' The form in which digital photographs are stored, made up of a matrix of pixels.

Blend mode The way in which a color or a layer interacts with others in a digital photograph. The most important after the Normal blend mode are probably Multiply (which darkens everything), Screen (which adds to the colors to make everything lighter), Lighten (which lightens only colors darker than itself) and Darken (which darkens only lighter colors than itself). Both the latter therefore flatten contrast. Color maintains the shading of a color but alters the color to itself. Glows therefore are achieved using Screen mode, and Shadows using Multiply.

Bracketing (exposure) Taking several pictures of your subject at different exposure times or aperture settings, e.g. half and double, as well as the estimated correct exposure.

Brightness range The range of brightnesses between shadow and highlight areas of an image.

Bromide paper Light-sensitive photographic paper for enlarging or contact printing. Carries a predominantly silver bromide emulsion. Must be handled in appropriate (usually amber or orange) safe lighting.

Burning-in Giving additional exposure time to one selected area, during printing to selectively darken.

Burning-in tool Used to darken a digital image, can be targeted to affect just the Shadows, Midtones or Highlights. Opposite to Dodge. Part of the toning trio, which also includes the Sponge.

Byte This is the standard unit of digital storage. One byte is made up of 8 bits and can have any value between 0 and 255; 1024 bytes equal 1 kilobyte; 1024 kilobytes equal 1 megabyte; 1024 megabytes equal 1 gigabyte.

Camera obscura A dark chamber to which light is admitted through a small hole, producing an inverted image of the scene outside, opposite the hole.

Cassette Light-tight container for 35 mm camera film (see page 54).

CCD Charge-Coupled Device. Electronic light-sensitive surface, digital replacement for film.

CD-ROM Compact disc with read-only memory.

Clone Stamp or Rubber Stamp tool Allows a user to copy a part of a digital image to somewhere else. It is therefore ideal for repair work, e.g. removing unwanted spots or blemishes. Equivalent to Copy and Paste in a brush.

Close-ups Photographs in which the picture area is filled with a relatively small part of the subject (e.g. a single head). Usually photographed from close to the subject, but may be shot from further away using a long focal length lens.

Close-up attachments Accessories which enable the camera to focus subjects that are closer than the nearest distance the lens normally allows.

Color balance A color photograph that closely resembles the original subject appearance is said to have 'correct' color balance. Mismatching film type and lighting (wrong color temperature) gives a cast most apparent in gray tones and pale tints.

Color mode The way that a digital image represents the colors that it contains. Different color modes include Bitmap, RGB and Grayscale.

Color temperature A means of describing the color content of a 'white' light source. Based on the temperature (absolute scale, expressed in Kelvin) to which a black metallic body would have to be heated to match the light, e.g. household lamp 2800 K, photoflood 3400 K.

Complementary colors Opposite or 'negative' colors to the primary colors of light (blue, green and red). Each is made up from the full spectrum less the primary color, e.g. the complementary of red is blue.

Composition The activity of positioning the various subjects in a picture within a frame or viewfinder. Photographers often aim to create a visual balance of all the elements within their photographs. They do this via careful composition.

Compression Refers to a process where digital files are made smaller to save on storage space or transmission time. Compression is available in two types: lossy, where parts of the original image are lost at the compression stage; and lossless, where the integrity of the file is maintained during the compression process. JPEG and GIF use lossy compression, whereas TIFF is a lossless format.

Contact printing Printing with light, the object (typically a negative) being in direct contact with the light-sensitive material.

Contrast (composition) Photographers who position subjects with different characteristics in the frame together are said to be creating contrast in the composition. Sitting a highly textured object against a smooth and even background creates a visual contrast between the two subjects and emphasizes the main characteristics of each.

Contrast (exposure and tone) The difference (ratio) between the darkest and brightest parts. In a scene this depends on lighting and the reflecting properties of objects. In a photograph there is also the effect of exposure level, degree of development, printing paper, etc.

Cropping Cutting out unwanted (edge) parts of a picture, typically at the printing or mounting stage.

Daylight color film Color film balanced for use with flash, daylight or daylight-matching strip tubes (5500 K).

Depth of field Distance between nearest and furthest parts of the subject sharply imaged at the same time. Greatest with small lens apertures (high f-number), distant scenes and shortest focal length lenses.

Developer Chemicals, normally in solution, able to convert the invisible (latent) image on exposed photographic material into visible form.

Developing agents Chemicals (typically phenidone, metol and hydroquinone) able to change light-struck silver halides into black metallic silver.

Diffuse lighting Scattered illumination, the visual result of which is gentle modelling of the subject with mild or non-existent shadows.

Digital image Stream of electronic data, forms visible image on computer monitor.

Digitize This is the process by which analog images or signals are sampled and changed into digital form.

DIN Stands for Deutche Industrie Norm (German Industrial Standard). DIN numbers denoted a film's relative sensitivity to light. Halving or doubling speed is shown by decrease or increase of the DIN number by three. Now incorporated in ISO and distinguished by degree symbol.

Dodge tool For lightening areas in a digital image. See also *Burn*.

Dodging Local shading in enlarging, usually by means of a piece of opaque material on a thin wire to selectively reduce exposure and therefore lighten the print. Has the opposite effect of burning-in.

DPI Dots per inch, a term used to indicate the resolution of a scanner or printer.

DX coding Coding printed onto film cassette denoting speed, length, etc. Read by sensors in the film compartment of most 35 mm cameras.

Dynamic range The measure of the range of brightness levels that can be recorded by a digital sensor.

Emulsion Suspension of minute silver halide crystals in gelatine that, coated on film or paper, forms the light-sensitive material used in traditional (non-digital) photography.

Enhancement A term that refers to changes in brightness, color and contrast that are designed to improve the overall look of a digital image.

Enlarger Optical projector to give enlarged (or reduced) images, which can then be exposed onto light-sensitive paper or film.

Enlarging easel (masking frame) Flat board with adjustable flaps used on the enlarger base board to hold paper flat during exposure.

Exposed A light-sensitive material that has received exposure to an image. Usually relates to the stage after exposure and before processing.

Exposure Submitting photographic material to the action of light, usually by means of a camera or enlarger.

Exposure-compensation dial Camera control overriding film speed (e.g. DX) setting, + or –.

Exposure latitude The amount by which a photographic emulsion may be under- or overexposed, yet still give an acceptable image when processed.

Exposure meter Instrument that measures light intensities falling on, or reflected off, the subject, and indicates or sets corresponding camera settings (shutter and aperture).

Extension tubes Rings or short tubes mounted between camera body and lens to space the lens further away from the film and so allow the sharp focusing of very close subjects.

F-numbers See *Aperture*.

File format The way that a digital image is stored. Different formats have different characteristics. Some are cross-platform and can be used on both Macintosh and Windows machines, others have inbuilt compression capabilities.

Fill-in Illumination to lighten shadows, reducing contrast.

Film speed Measure of sensitivity of film to light. Usually expressed as an ISO figure.

Filter, digital A filter is a way of applying a set of image characteristics to the whole or part of an image. Most image editing programs contain a range of filters that can be used for creating special effects.

Filter, lens Sheet of (usually dyed) gelatin or glass. Used over the camera or enlarger lens mainly to reduce the light (neutral density gray filter) or to absorb particular wavelengths from the light beam.

Fixed focus Camera lens set for a fixed subject distance. Non-adjustable.

Fixer Chemical (basically a solution of sodium thiosulfate plus potassium metabisulfite as acidifier). Used after development to make soluble those parts of a photographic image unaffected by the developer. Photographs can thereafter be handled in normal lighting.

Fixing agent Chemical able to change silver halide into colorless soluble salts.

Flare Scattered light that dilutes the image, lowering contrast and seeming to reduce sharpness. Mostly occurs when the subject is backlit.

Flash contacts Electrical contacts, normally within the mechanism of the camera shutter, which come together at the appropriate moment to trigger the flash unit. Older shutters may be fitted with X and M contact sockets. Use X for electronic flash.

Flash (electronic) Equipment that gives a brief, brilliant flash of light by discharging an electronic capacitor through a small, gas-filled tube. Given time to recharge, a unit gives many thousands of flashes, usually triggered by contacts within the camera shutter.

Flash factor See *Guide number*.

'Flat' images Images that are low in tonal contrast, appearing gray and muddy.

Floodlamp Studio lighting unit consisting of a large reflector containing a photolamp or other pearl glass lamp. Gives diffuse lighting.

Focal length In a simple lens the distance (typically in millimeters) between the lens and the position of a sharp image for a subject a great distance away. A 'normal' lens has a focal length approximately equivalent to the diagonal of the picture format it covers, i.e. 50 mm for 36 mm × 24 mm.

Focal plane The plane – normally flat and at right angles to the lens axis – on which a sharp image is formed. In the camera, the emulsion surface of the film must be in the focal plane at the moment of exposure to record a focused image.

Focus priority (trap focus) Auto-focus camera mode by which you cannot release the shutter until the lens has sharply focused your subject.

Focusing Changing the lens-to-image (or lens-to-subject) distance, until a sharp image is formed.

Fog Allowing random light to reach light-sensitive material, as in opening the camera back accidentally or leaving a packet of paper open. Also caused by bad storage or contaminated or over-prolonged development (chemical fog).

Form An object's three-dimensionality: height, breadth and depth.

Format Height and width dimensions of the picture area.

Front page Sometimes called the home or index page, refers to the initial screen that the viewer sees when logging onto a website. Often, the name and spelling of this page file is critical if it is to work on the web server. Consult your ISP staff for the precise name to be used with your site.

Gamma The contrast of the midtone areas of a digital image.

Gamut The range of colors or hues that can be printed or displayed by particular devices.

Gaussian Blur When applied to an image or a selection, this digital filter softens or blurs the image.

GIF Graphic Interchange Format. This is an indexed color mode that contains a maximum of 256 colors that can be mapped to any palette of actual colors. It is extensively used for web graphics as buttons and logos, and small animated images.

Glossy paper Photographic paper that can give prints with a shiny, glossy surface.

Grade, of paper Classification of black and white photographic papers by the gradation they offer between black and white. Soft (Grade 1) paper gives a wider range of gray tones than Hard (Grade 3). See also *Variable contrast paper*.

Grain Irregularly shaped, microscopically small clumps of black silver making up the processed photographic silver halide image. Detectable on enlargement, particularly if the film emulsion was fast (ISO 1000 or over) and overdeveloped. Hard grade paper also emphasizes film grain.

Grayscale A monochrome digital image containing tones ranging from white through a range of grays to black.

Guide number (flash factor) Figure denoting the relative power of a flash source. The GN is the light-to-subject distance (usually in meters) multiplied by the f-number for correct exposure, e.g. GN of 16 = 2 m at f8 or 1 m at f16. (Unless film speed is quoted, factor refers to ISO 100 film.)

'Hard' image Image with harsh tonal contrasts – mostly blacks and whites with few intermediate gray tones.

'Hard' light sources Harsh source of illumination, giving strong clear-cut shadows. Tends to dramatize form and texture.

Histogram A graph that represents the distribution of pixels brightness within a digital image.

Hot linked This term refers to a piece of text, graphic or picture that has been designed to act as a button on a web page. When the viewer clicks the hot-linked item, they are usually transported to another page or part of a website.

HTML The Hyper Text Mark Up language is the code used to create web pages. The characteristics of pages are stored in this language and when a page file is downloaded to your computer the machine lays out and displays the text, image and graphics according to what is stated in the HTML file.

Hue Refers to the color of the image and is separate from how light or dark it is.

Hyperfocal distance The closest focus distance to the camera where, given a specific lens and f-stop, details at infinity are rendered sharp. When a lense is focused for the hyperfocal distance, depth of field extends from half this distance to infinity.

Hypo Abbreviation of hyposulfate of soda, an incorrect early name for sodium thiosulfate. Popular name for fixing bath.

Image layers Images in programs like Photoshop Elements can be made up of many layers. Each layer will contain part of the picture. When viewed together, all layers appear to make up a single continuous image. Special effects and filters can be applied to layers individually.

Incident light attachment Diffusing disc or dome (usually of white plastic) placed over the cell of a hand-held exposure meter to make readings towards the light source. Calculator dial is then used in the normal way. Gives results similar to reading off an 'average' subject or gray card.

Infinity A distance so great that light from a given point reaches the camera as virtually parallel rays. In practice, distances of about 1000 times the focal length or over. Written on lens focusing mounts as 'inf' or a symbol like an '8' on its side.

Infinity lock Control that sets (auto-focus) lens for distant subjects only. Useful if shooting through windows.

Inkjet printer Digital printer, forms images using a very fine jet of one or more inks.

Interpolation This is the process used by image editing programs to increase the resolution of a digital image. Using 'fuzzy logic' the program makes up the extra pixels that are placed between the original ones that were generated at the time of scanning or capture.

Inverse square law 'When a surface is illuminated by a point source of light the intensity of light at the surface is inversely proportional to the square of its distance from the source.' In other words, if you double the lamp distance, light spreads over a larger area and illumination drops to $1/2 \times 1/2 = 1/4$ of its previous value. Forms the basis of flash guide numbers and close-up exposure increases. Does not apply to large diffuse sources or, in practice, the (extremely distant) sun.

ISO International Standards Organization. In the ISO film speed system, halving or doubling of speed is denoted by halving or doubling number. Also incorporates DIN figure, e.g. ISO 400/27° film is twice as sensitive as ISO 200/24°.

ISP The Internet Service Provider is the company that hosts or stores web pages. If you access the web via a dial-up account, then you will usually have a portion of free space allocated for use for your own site; others can obtain free (with a small banner advert attached) space from companies like www.tripod.com.

JPEG A file format designed by the Joint Photographic Experts Group that has inbuilt lossy compression that enables a massive reduction in file sizes for digital images. Used extensively on the web and by press professionals for transmitting images back to newsdesks worldwide.

Juxtaposition Juxtaposing is the act of placing two objects side by side so that they are compared. In photographs, unlike subjects are often placed next to each other, or 'juxtaposed', so that their differences are exaggerated.

K (kelvin) Measurement unit of lighting and color temperature.

Large-format cameras Normally refers to cameras taking negatives larger than 120 rollfilm size.

Latent image The invisible image contained by the photographic material after exposure but before development. Stored protected from light, damp and chemical fumes, a latent image can persist for years.

Layer opacity The opacity or transparency of each image layer in a digital photograph can be changed independently. Depending on the level of opacity, the parts of the layer beneath will become visible. You can change the opacity of each layer by moving the Opacity slider in the Layers palette.

LCD Liquid Crystal Display. A display screen type used in preview screens on the back of digital cameras and in most laptop computers.

Line (composition) Line is one of the strongest visual elements that photographers can use to help compose their pictures. Often, line is used to direct the attention of the viewer towards a certain part of the frame or at a specific focal point. The lines used in photographs may be actual, such as a power cable in a landscape, or may be created by changes of tone or texture, such as the edge between a shaft of sunlight and the dark background.

Liquify A digital filter that uses brushes to perform distortions upon selections or the whole of an image.

Live View A feature on some digital SLR cameras that allow for the scene to be viewed, and the photograph composed, on the LCD screen on the back of the camera.

Long focal length lens Lens with focal length longer than considered 'normal' for picture format. Gives larger detail and narrower angle of view. Almost all such lenses are telephoto types.

Macro lens Lens intended for close-up photography, able to focus well forward from its infinity position for subjects a few inches away, gives highest quality image at such distances.

Macrophotography Photography at very close subject range.

Marquee A rectangular or elliptical selection used to isolate a portion of a digital photograph made by clicking and dragging to an opposite corner.

Masking frame See *Enlarging easel.*

Mat or overmat Card with cut-out opening, placed over print to isolate finished picture.

Megapixel One million pixels. Used to describe the resolution of digital camera sensors.

Monochrome image Single colored. Usually implies a black image, but also applies to one which is toned, i.e. sepia.

Montage An image constructed by combining what were originally several separate images.

Mood The mood of a photograph refers to the emotional content of the picture.

Multigrade Multi-contrast printing paper. See *Variable contrast paper.*

Negative image Image in which blacks, whites and tones are reversed, relative to the original subject. Color negatives have subject colors represented by their complementaries.

'Normal' lens The lens regarded as standard for the picture format, i.e. having a focal length approximately equal to its diagonal.

Optical resolution The resolution that a scanner uses to sample the original image. This is often different from the highest resolution quoted for the scanner, as this is scaled up by interpolating the optically scanned file.

Options bar Long bar beneath the menu bar in an image editing program, which immediately displays the various settings for whichever tool is currently selected. Can be moved to other parts of the screen if preferred.

Overdevelopment Giving too long or too much agitation in the developer, or having too high a temperature, or developer too concentrated. This results in excessive density and exaggerated grain structure in the developed material.

Overexposure Exposing photographic material to too much light because the image is too bright or exposure time too long. Results in excessive density in the final image.

Palette A window in the image editing program that is used for the alteration of the characteristics of a digital photograph.

Panchromatic Photographic materials sensitive to all visible wavelengths of light, recording them in various shades of gray. Should be processed in total darkness or an exceedingly dark safe light. All general-purpose films are of this kind.

Panning Rotating or swinging the camera about a vertical axis.

Parallax error Viewpoint difference between the picture seen in the viewfinder and as seen by the camera lens (see page 32).

Pattern (composition) Repeating subjects that have similar characteristics such as color, shape and texture create a strong visual element that is often referred to as pattern. Pattern can be used in a similar way to tone, line and color as a way to balance compositions and direct the viewer's eye throughout the frame.

Photo CD CD format for storing photographs as digital files. Disc typically holds up to 100 images, stored in various levels of resolution.

Photographic lamps Generalized term now often applied to both 3200 K studio lamps (floods and spots) and the brighter, short-life 3400 K photoflood lamps.

Pixel Short for picture element, refers to the smallest image part of a digital photograph.

Polarizer Gray-looking filter, able to darken blue sky at right angles to sunlight, and suppress reflections from (non-metallic) surfaces at angles of about 30°.

Polycontrast See *Variable contrast paper.*

Printing-in See *Burning-in.*

'Pushing' Slang term for uprating film speed.

Rapid fixer Fixing bath using ammonium thiosulfate or thiocyanate instead of the normal sodium thiosulfate. Enables fixing time to be greatly reduced, but is more expensive.

Reciprocity law failure Normally the effect of dim light, or small lens aperture, can be

counteracted by giving a long exposure time. But this reciprocal relationship (half the brightness = double the exposure time) increasingly breaks down with exposure times beyond 1 second. The film then behaves as if having a lower speed rating. Color films may also show incorrect balance.

'Red eye' The iris of each eye in portraits shows red instead of black. Caused by using flash directed from close to the lens.

Reflex camera Camera with viewfinder system using a mirror and focusing screen.

Refraction Change of direction of a ray of light passing obliquely from one transparent medium into another of different density, e.g. from air into glass. The basic reason why lenses bend light rays and so form images.

Resin-coated (RC) bromide paper Bromide paper having a water-repellent plastic base. RC papers require less washing, dry more rapidly and generally process faster than fibre-based papers.

Reversal film Film that can be processed to give a positive image, such as a color slide film. Some black and white films can be reversal processed.

RGB All colors in a digital image are made up of a mixture of Red, Green and Blue colors. This is the typical mode used for desktop scanners, painting programs and digital cameras.

Rollfilm Photographic film, usually 6.2 cm wide (known as 120), attached to a numbered backing paper and rolled on a flanged spool.

Safe light Darkroom light source filtered to illuminate only in a color to which photographic material is insensitive. The correct color varies with type of emulsion, e.g. orange for bromide papers.

Selective focusing Using a shallow depth of field (i.e. by means of a wide lens aperture) and focusing so that only one selected zone of the subject is sharply recorded.

Shading, in printing Preventing the image light from acting on a selected area of the picture for a time during the exposure. See *Dodging*.

Sheet film Film supplied as individual sheets, usually 10 or 25 to a box.

Shutter Mechanical device to control the time the light is allowed to act on the film. Usually consists of metal blades within the lens, or two blinds passing one after another just in front of the film, the exposure occurring in the gap between them (focal plane shutter).

Silver halides Light-sensitive compounds of silver with the halogens (iodine, bromide, etc.). Normally white or creamy yellow in color. Used as the main sensitive constituent of photographic emulsions.

Single lens reflex (SLR) Camera in which the viewfinder image is formed by the picture-taking lens.

Soft focus Image in which outlines are slightly spread or diffused.

'Soft' light sources See *Diffuse lighting*.

Sponge tool Used for saturating or desaturating part of a digital photograph, that is exaggerating or lessening the color component as opposed to the lightness or darkness.

Spotlight A compact filament lamp, reflector and lens forming one light unit. Gives hard direct illumination, variable from narrow to broad beam.

Stop-bath Stage in processing that arrests the action of the previous solution (e.g. a weak solution of acetic acid used between development and fixation).

Subject The person, scene, situation, etc. being photographed. (Tends to be used interchangeably with object.)

'T' setting Setting found on some large-format camera shutters for time exposures. Pressing the release opens the shutter, which then remains open until pressed for a second time.

Target audience The group of people whose experience, understanding and appreciation are catered for when creating a picture, or taking a photograph. The content or style of picture may change depending on the nature of the target audience who will be viewing the work.

Telephoto lens Long focus lens of compact design (lens is physically closer to the film than its focal length).

Test strip One of a series of test exposures on a piece of printing paper, then processed to see which gives the most satisfactory result.

Texture Surface qualities such as roughness, smoothness, hairiness, etc. Like line, pattern and color, texture is a compositional element that can be used to help balance a photograph.

Through-the-lens (TTL) metering Measuring exposure by a meter built into the camera body, which measures the intensity of light passing through the picture-taking lens.

Thumbnail A low-resolution preview version of larger digital image files used to check before opening the full version.

Time exposure General term for a long duration exposure.

Tone (subject matter) Tone can also refer to the mood of a picture. When the tone of a photograph is said to be 'dark', then the subject matter and/or the way that the content is depicted can be emotional, complex, sometimes sad, confronting and generally thought-provoking.

Tones, tonal values Areas of uniform density in a positive or negative image that can be distinguished from darker or lighter parts.

Translucent Transmitting but at the same time also diffusing light, e.g. tracing paper.

Transparency Positive image film.

Tungsten lamps Lamps that generate light when electric current is passed through a fine tungsten wire. Household lamps, photofloods, studio lamps, etc. are all of this type.

Tungsten light film Also known as 'Type B' or 'Artificial light'. Color film balanced for use with 3200 K studio lighting.

Tv Time value. AE camera metering mode by which you choose shutter speed and the metering system sets aperture (also called shutter priority).

Twin lens reflex Camera with two linked lenses – one forming an image onto film, the other giving an image on a focusing screen.

Underdevelopment Giving too short a developing time, using too low a temperature, too great a dilution or old or exhausted solutions. This results in insufficient density being built up.

Underexposure Exposing photographic material to too little light, because the image is too dim or exposure time too short. Results in insufficient density and shadow detail in the final image.

Uprating Shooting film at more than the manufacturer's suggested speed rating, e.g. exposing 400 ISO film as if 800 ISO. The film is then given extra development.

Variable contrast (multigrade) paper Black and white printing paper that changes its contrast characteristics with the color of the exposing light. Controlled by enlarger filters typically ranging from yellow to purple.

Viewpoint The position from which camera, and photographer, view the subject.

Wetting agent Chemical (e.g. weak detergent) that reduces the surface tension of water. Facilitates even action of developer or final wash water.

Wide-angle lens Lens with a focal length much shorter than the diagonal of the format for which it is designed to be used. Gives a wide angle of view and considerable depth of field.

Zoom lens A lens that offers continuous variation of focal length over a set range, maintaining the same focus setting.

Index

SHY DIVE

STEPHEN RICHARD

Ransom

Main parachute.

Helmet.

Jump suit.

Yellow toggle.
Pull it to cut away
the main parachute.

Altimeter.
Tells me how
high I am.

THE RED DEVILS

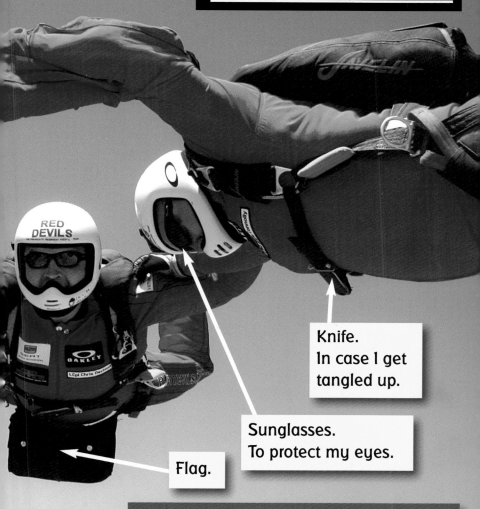

Knife.
In case I get
tangled up.

Sunglasses.
To protect my eyes.

Flag.

SKY DIVE DATA

Jump height: 13,000 feet
Free fall time: One minute
Parachutes: Two. (Just in case)
Top speed: 193 km/hour (120 mph)

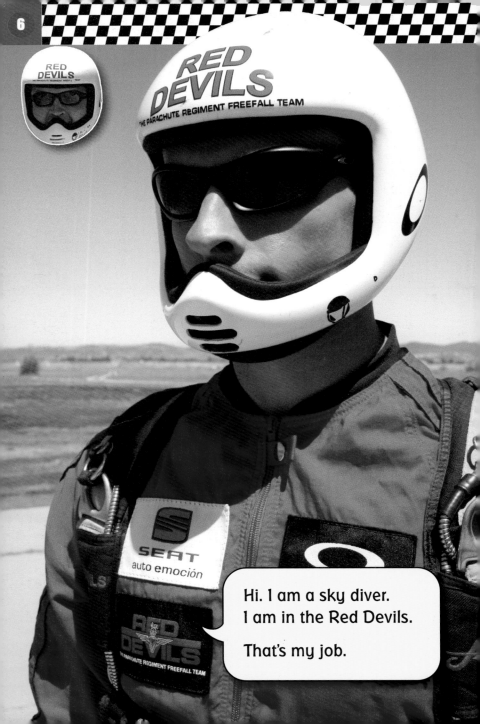

We put on shows.

The crowds can see us.

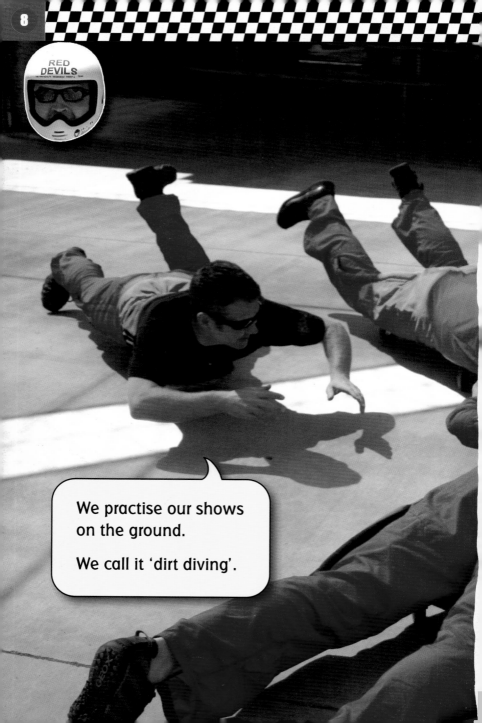

We practise our shows on the ground.

We call it 'dirt diving'.

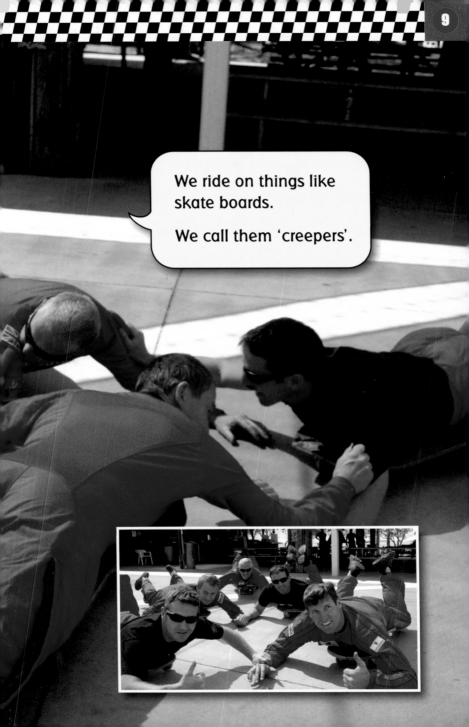

We ride on things like skate boards.

We call them 'creepers'.

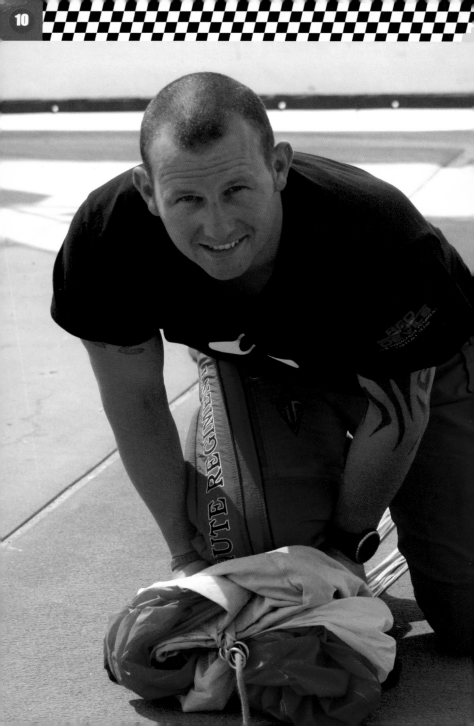

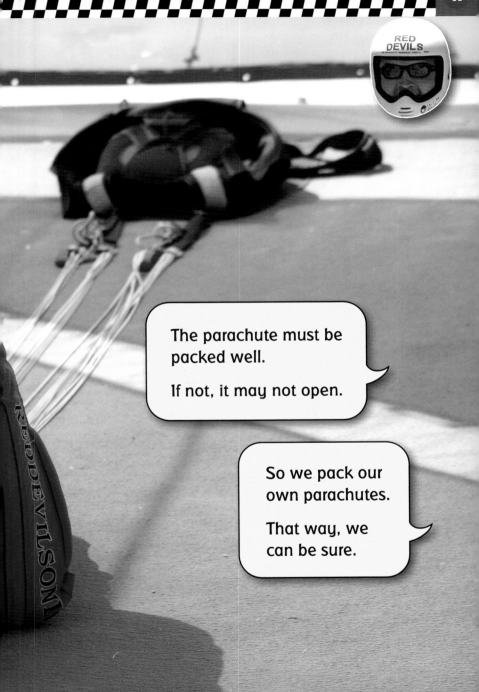

The parachute must be packed well.

If not, it may not open.

So we pack our own parachutes.

That way, we can be sure.

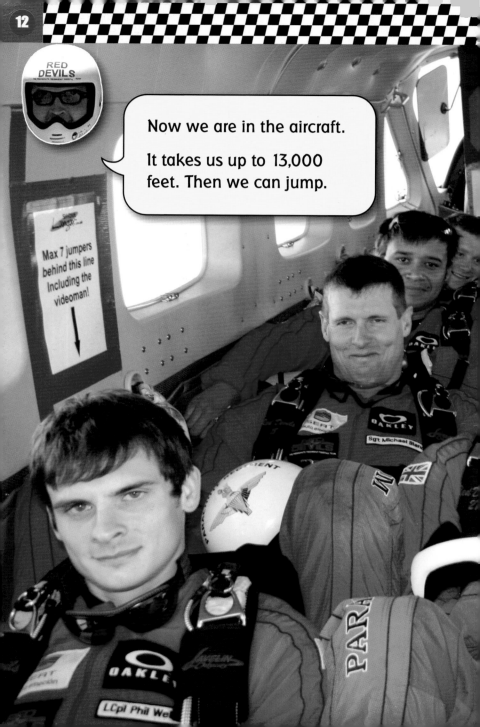

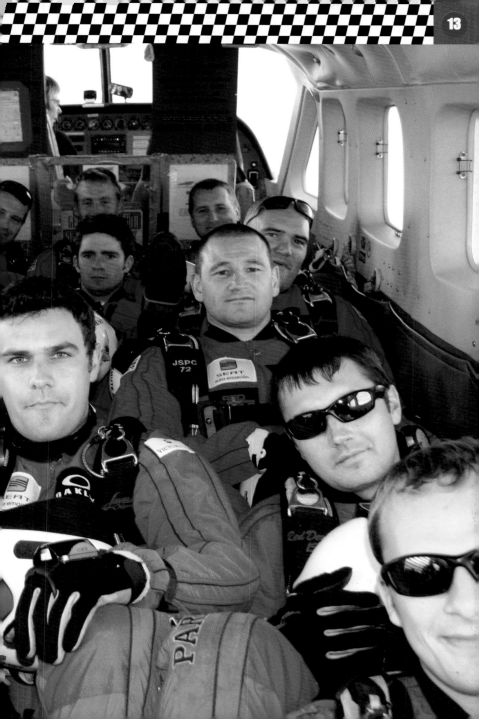

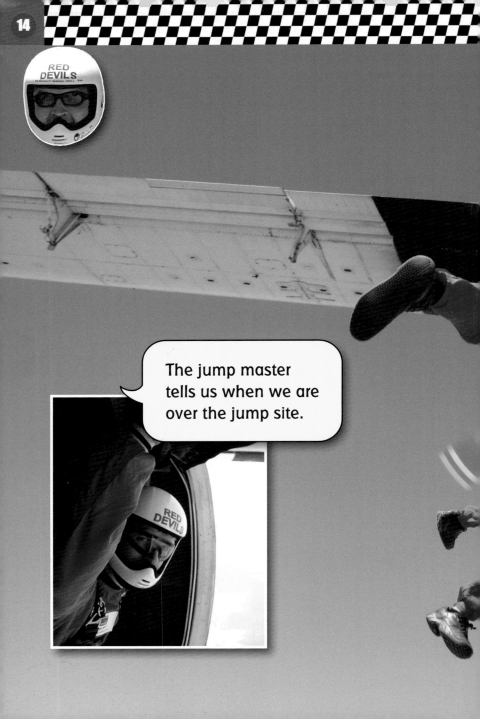

The jump master tells us when we are over the jump site.

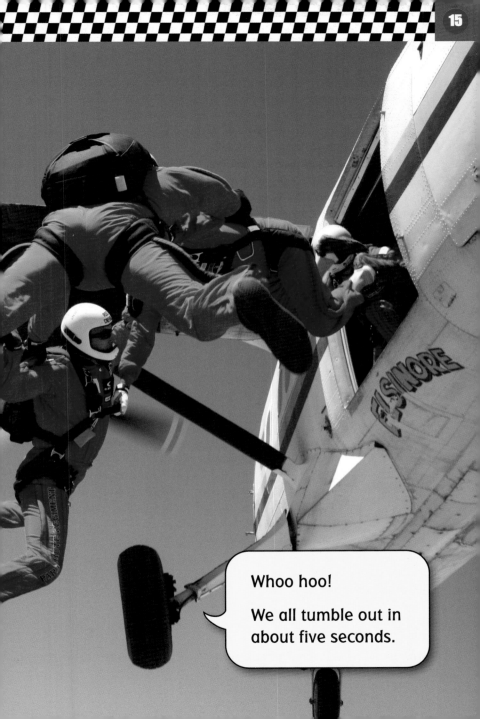

As I jump, I can see the guys in front of me.

Some of us have smoke cans tied to our feet.

They will make smoke trails as we fall.

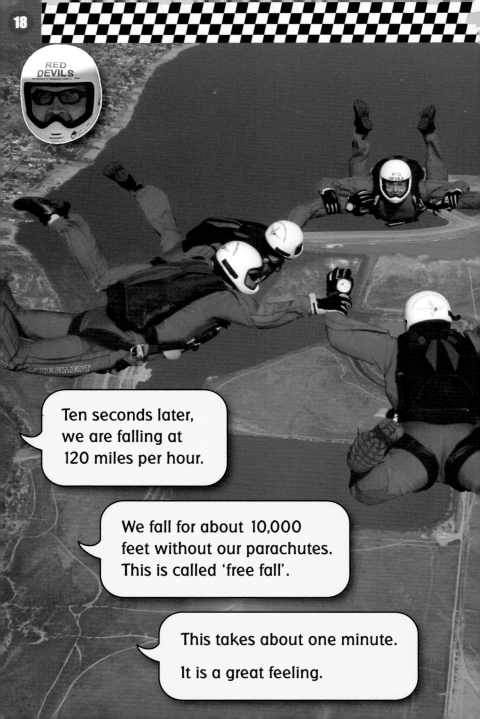

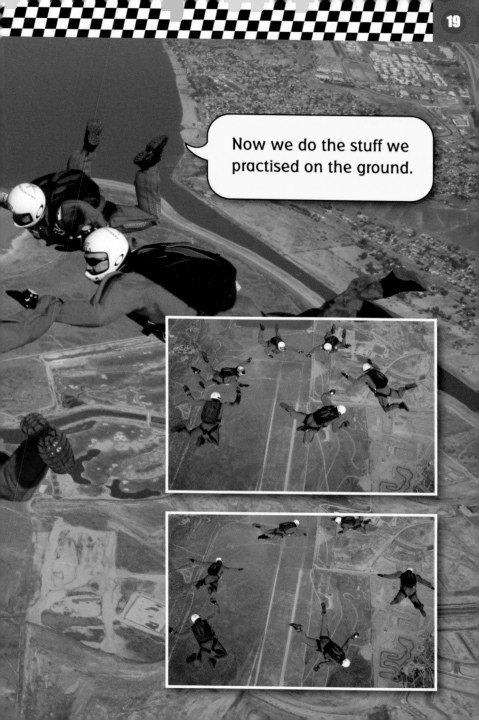

I'm as free as a bird.

But birds can go up, too.

OK. I'm as free as a falling rock.

This bit is all pretty safe.

You don't get hurt in the air.

If you do get hurt, it'll be when you hit the ground.

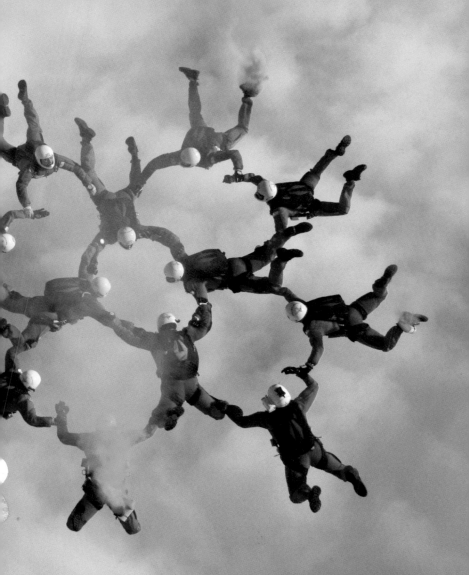

2,500 feet. Time to open my 'chute.

If I open it any later, I will be going too fast when I hit the ground.

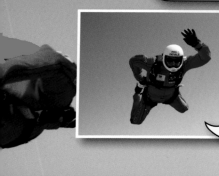

I pull the toggle. My 'chute opens.

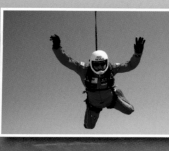

We call this 'dumping out'.

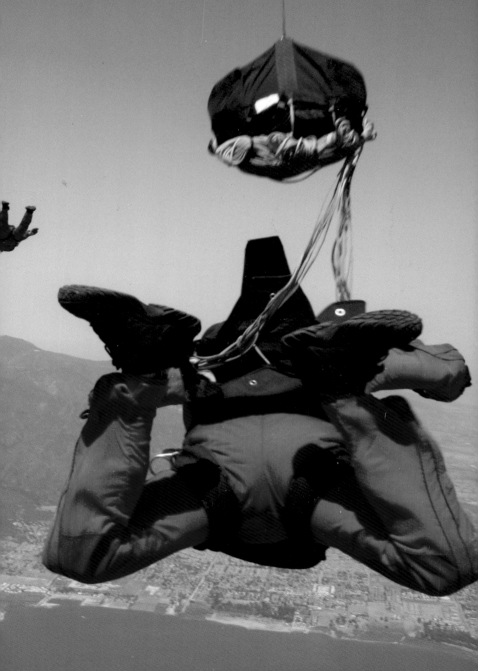

My speed quickly slows from 120 mph to about 10 mph.

Now we carry on with our show.

We call this shape 'the diamond'.

You just need four guys and a flag.

This is called 'the chain of death'.

The smoke makes it look cool.

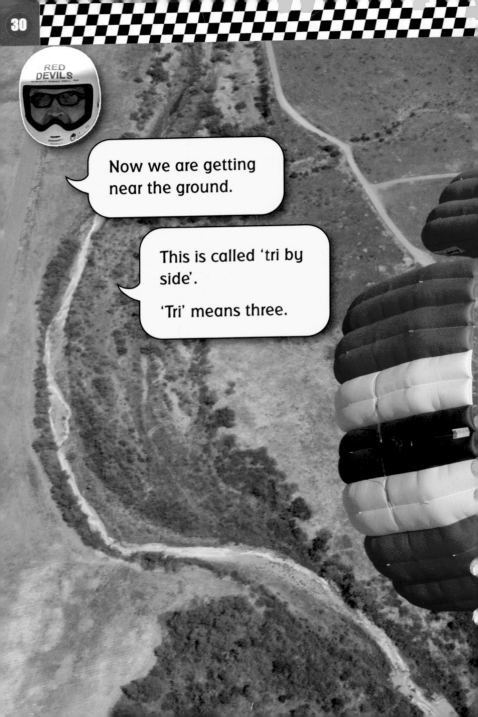

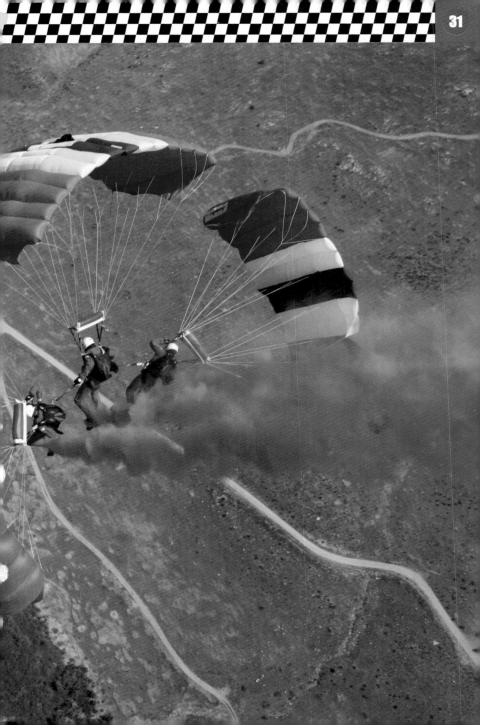

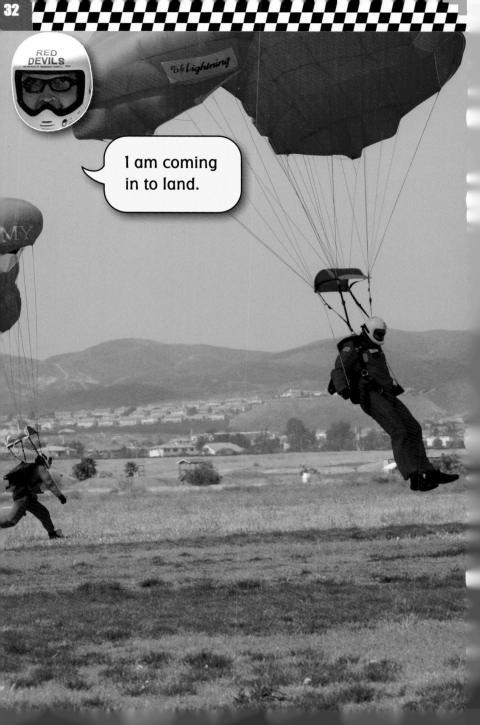

When we are down, we pick up our parachutes.

We carry them off the drop zone.